P9-CKF-772

CHRONICLES OF AMERICA

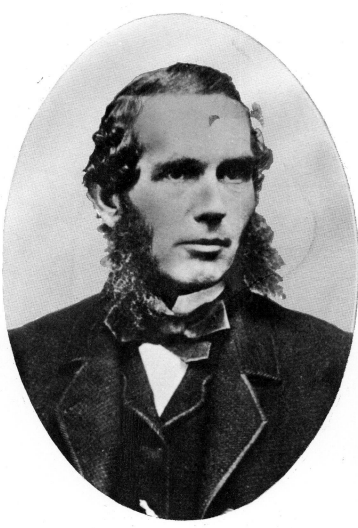

NATHANIEL CURRIER

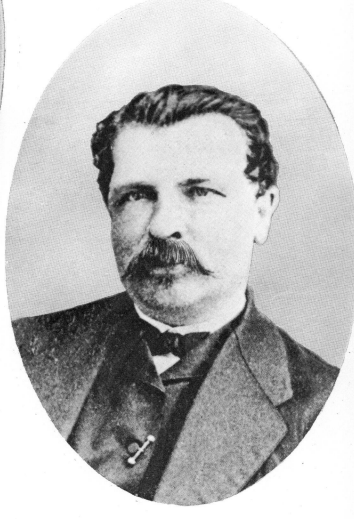

JAMES MERRITT IVES

Photos — Museum of the City of New York

Currier & Ives

CHRONICLES OF AMERICA

Edited by John Lowell Pratt

Introduction by A. K. Baragwanath, Curator of Prints,
The Museum of the City of New York

Color Plates reproduced from
The Original Hand Colored Stone Prints
by N. Currier and Currier & Ives

HAMMOND INCORPORATED
MAPLEWOOD, NEW JERSEY

*Entire Contents © Copyright 1968 by Hammond Incorporated
All rights reserved. No part of this book may be reproduced
or utilized in any form or by any means, electronic or
mechanical, including photocopying, recording or by any
information storage and retrieval system, without
permission in writing from the Publisher.
Library of Congress Catalog Card Number 68-13933
Printed in the United States of America*

This book is gratefully dedicated

to the memory of

HARRY T. PETERS

who recognized and preserved

the major works of N. Currier and Currier & Ives.

It is doubtful that without his zeal,

scholarship and enthusiasm,

their contributions to the story of our country

would now be available for posterity.

FOREWORD

Some years ago I interviewed a bright young man who had just graduated from one of our large Eastern universities. I was most impressed with him as an individual but he stopped me cold when, in reply to my question as to why he wanted to get into book publishing, he answered, "I want to get into communications." Until then I had never associated the word "communications" with book publishing. I soon learned I was behind the times and that our business (some publishers think of it as a profession) was a segment of the maze of big business which "communicated" to people via the printed word, the printed picture, the motion picture, the radio voice and the television picture and voice.

When N. Currier began his print publishing business in 1834 there were newspapers, a few magazines and only a small number of book publishers. The pulpit and the political stump took care of the spoken word. The theater and the concert stage in this country were in their infancy. Later, the stage with *Uncle Tom's Cabin* was to have a profound political effect.

The use of color in illustrations, via the printing press, was virtually unknown. Illustrations in books, magazines and newspapers were in black and white save for a few books which had hand-colored illustrations such as *Godey's Lady's Book*. When Mr. Currier (he was joined by Mr. Ives in 1852) perfected the assembly-line technique by using women, under supervision, to hand color the black and white lithographs pulled from stone, he literally communicated realism to his audience. In some cases the original artists guided the women in their coloring. However, the colors in the prints often varied with the whims of the colorists. Currier's process was the forerunner of color printing and color television.

While there were many Currier & Ives prints published in black and white (most of these were either political or humorous), Currier & Ives are best known as the publishers of color prints depicting the America they knew and loved. In the case of the Civil War, they were reporters and historians. They were biased historians and, in some cases, they were inaccurate, but they were reporters of what they believed to be the facts.

The selection of the prints for this book was made with the following criteria in mind: Important events in the history of our country, the social life of the times, the economic life of the times, life in the city, life in the country and, finally, the quality of the art reproduced in the prints.

Harry T. Peters, who was more responsible than any other one individual for documenting the contribution of Currier & Ives, estimated that there were well over 7,000 individual prints published. The number of copies of each print published is unknown because, in many cases, no records were kept and, in others, the records were destroyed. It is safe to say that there is no complete collection of prints by N. Currier and Currier & Ives extant today.

Individual collectors, to a great extent, are guided by their own special interests. Civil War buffs go after the prints of Civil War battles, for the most part done by anonymous artists. Maritime enthusiasts have exciting finds in store in the works of J. E. Butterworth, Charles Parsons, and many others. George Catlin's prints remain for those interested in the American Indian and the West. A. F. Tait's prints are highly prized by the hunter and the fisherman. Louis Maurer, John Cameron, Thomas Worth and the indefatigable Fanny Palmer all rank high as faithful delineators of their contemporary American life. And, finally, G. H. Durrie's *Home to Thanksgiving* is as typical of the country life of the times as any and, justifiably, the best known of its type.

The purpose of any book is to tell a story. It may be fiction, it may be a story of fact or facts but it must entertain with information or fantasy. I believe that this book conveys a story of America as it was and that Currier & Ives were the leading "communicators" of their times.

New York, N. Y. JOHN LOWELL PRATT
February 22, 1968

CONTENTS

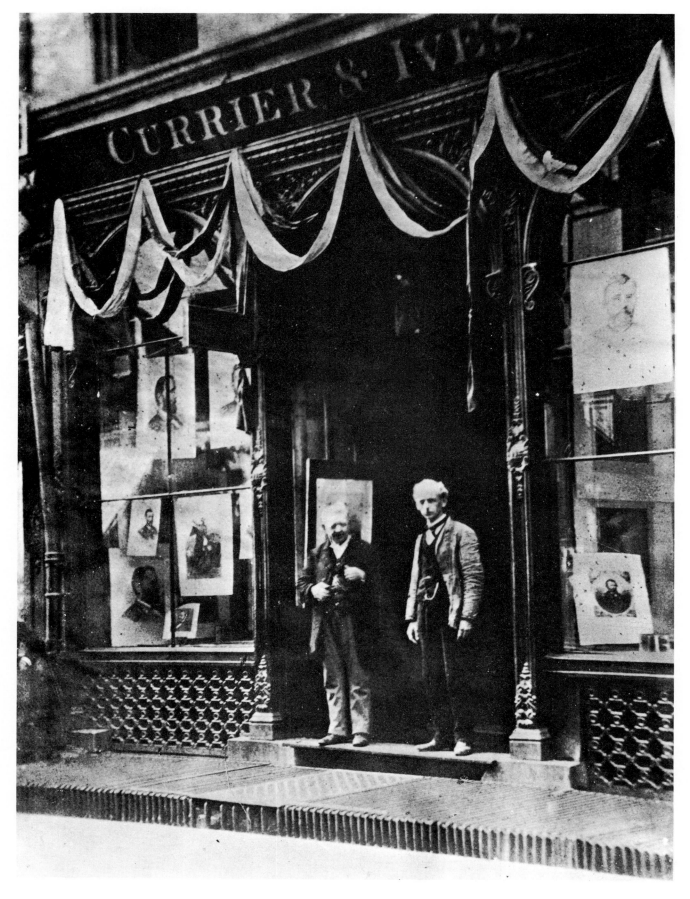

Photo Courtesy — The Museum of The City of New York

SHOP FRONT OF CURRIER & IVES, 1885

INTRODUCTION

When Nathaniel Currier published a lithograph in 1835 showing Planter's Hotel in New Orleans after the fire, a new era of pictorial journalism had begun. This first print established the firm which was to gain its greatest fame as "Currier & Ives" after 1857 when James Merritt Ives became a partner.

With the scarcity of illustrated news it is significant that this hotel fire was treated by Currier in a reporter's fashion with full title reading: *"Ruins of the Planter's Hotel, New Orleans, Which Fell at Two o'clock on the Morning of the 15th of May, 1835, burning 50 persons, 40 of which escaped with their lives."* During the nearly seventy years of the firm's existence this emphasis on important events of the day was never overlooked. However, as the demand for decorative and relatively inexpensive lithographs increased, this firm published prints depicting almost every aspect of American life. Within the more than 7,000 different lithographs estimated to have been produced, the range was most impressive. Scores of prints delineated the growth of cities, the bucolic countryside, the romantic appeal of the pioneer and westward expansion, the life of the Indian, the sweep of the clipper ships, the new age of steam on rail and sea, and the panorama of America's historical past featuring its wars and heroes. Hunting, fishing, horse racing, boxing and all the sports of the day were documented. Partisan politics with portraits and cartoons received great attention; humor vied with sentimentality for the buyer's choice. Religious themes and portrayals of the rightness of temperance flourished. Hundreds of prints of pretty girls, children, fruits and flowers were published to decorate Victorian living rooms. Even nostalgic views of Scotland, Ireland and Europe were available for the homesick immigrants. The life of the fireman, the chores of the farmer, and even the woes of the bachelor were popular subjects. The firm used many artists who specialized in these varying subjects. Among them were Frances (Fanny) F. Palmer, Louis Maurer, Charles Parsons, George Catlin, Thomas Worth, George Henry Durrie, A. F. Tait, and James E. Butterworth.

There was a print for every taste. Although a general coating of sentimentality glossed almost all the work of Currier & Ives, there still remains a true documentation of the latter half of the nineteenth century. It is doubtful that any series of prints so fully captured a period of life in any other time or country as did these lithographs portraying a rich pageant interpreted with all the sentimentality, morality and prejudice of the day.

Nathaniel Currier (1813-1888), who established the firm at 1 Wall Street in 1834, had begun his apprenticeship in lithography at the age of 15 with William and John Pendleton of Boston, America's first lithographers of note. Although probably his first lithograph was the burning of the Planter's Hotel, the print which brought him immediate local attention was *The Ruins of the Merchants Exchange,* issued four days after the great fire of December 16th and 17th, 1835!

In 1852 Currier engaged as bookkeeper James Merritt Ives (1824-1895), who had recently married the sister-in-law of Nathaniel's brother Charles. Ives evidenced a shrewd insight into the public's taste, combined with business acumen and an eye for technical perfection. As a result, Nathaniel Currier made him a partner in 1857 and the now familiar term "Currier & Ives" came into being. The firm prospered until the deaths of Nathaniel Currier in 1888 and Ives seven years later. Their sons headed the firm until 1907 when advances in photography, newer lithography techniques, and uninspired management forced them to close.

A rare catalogue issued by the firm about 1860 lists 738 subjects hand-colored and 218 prints uncolored, all available from their shop at 152 Nassau Street. The prices ranged from 8 cents to $3.75. It is interesting to note that recently a print of *The Life of a Hunter: A Tight Fix,* by A. F. Tait, sold at auction for $6,800.00!

Finally, as for Currier & Ives' competitors and their lithographs, Harry T. Peters says in his *America on Stone:* "It was left to the lithographers to mirror the life of our ancestors in all its phases, and to satisfy their hungry minds and eyes — to be, in short, the printmakers to the American people. Chief among these printmakers, because they served over a longer period, seem to have issued more prints, and more good prints, and filled the need most completely, were Currier & Ives, who had predecessors and competitors, but really no rivals."

A. K. BARAGWANATH

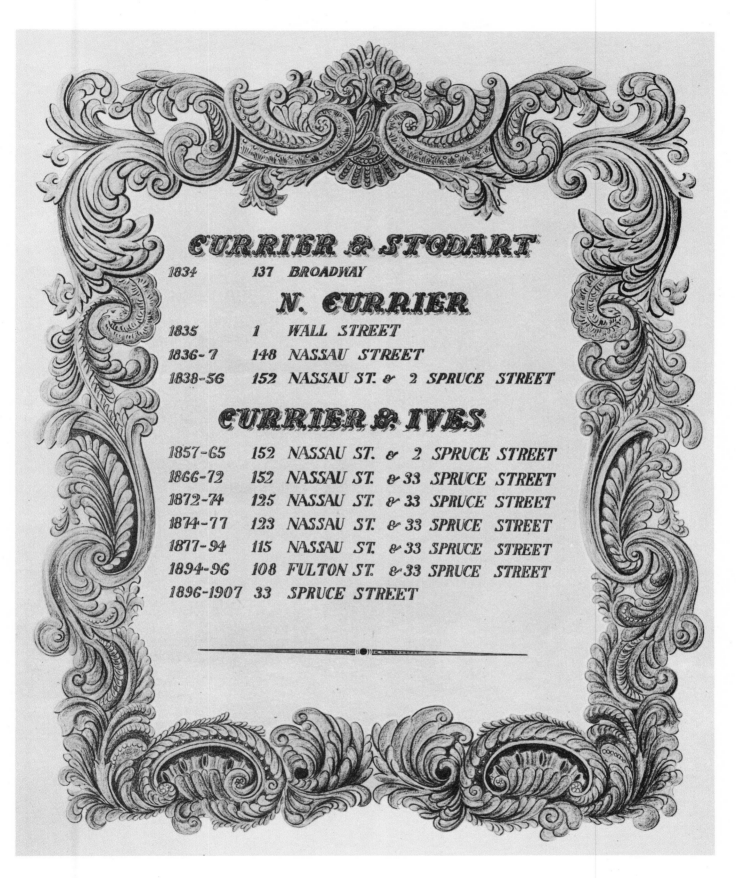

CURRIER & STODART
1834 137 BROADWAY

N. CURRIER
1835 1 WALL STREET
1836-7 148 NASSAU STREET
1838-56 152 NASSAU ST. & 2 SPRUCE STREET

CURRIER & IVES
1857-65 152 NASSAU ST. & 2 SPRUCE STREET
1866-72 152 NASSAU ST. & 33 SPRUCE STREET
1872-74 125 NASSAU ST. & 33 SPRUCE STREET
1874-77 123 NASSAU ST. & 33 SPRUCE STREET
1877-94 115 NASSAU ST. & 33 SPRUCE STREET
1894-96 108 FULTON ST. & 33 SPRUCE STREET
1896-1907 33 SPRUCE STREET

Photo Courtesy — The Museum of The City of New York

CHRONOLOGY OF CURRIER & STODART, N. CURRIER AND CURRIER & IVES

This book was published by Hammond Incorporated under the following editorial direction: Ashley F. Talbot, *Executive Editor;* Emily D. Highfield, *Copy Editor;* Isabelle Reid, *Book Designer.* Original color photography of Currier & Ives prints was done at The Museum of The City of New York by Helga Photo Studio, Inc., New York.

All creative operations were coordinated by Andrew F. Kuber in cooperation with Herbert Pierce, *Director of Carto Arts,* and E. V. Ballman, *Director of Photography.* Type was set in Times Roman in the composing room of Hammond Press. Color plates and camera work were done by the staff of Hammond. The paper was made specially for the book by Weyerhaeuser Company, Tacoma, Washington. It was printed by Zabel Bros., and bound by Van Rees Book Binding Corp.

ACKNOWLEDGMENTS

First and foremost I wish to express my appreciation to The Museum of The City of New York for permission to examine the magnificent Harry T. Peters Collection. This collection was given to the Museum by his family (Mrs. Natalie W. Peters, Harry T. Peters, Jr., and Mrs. Natalie P. Webster) during the years of 1956, 1957 and 1958. In total, the collection of prints numbered 2,885. With two exceptions, as noted below, all the prints included in this book were selected from the Museum's collection.

Mr. A. K. Baragwanath, the Curator of Prints of The Museum of The City of New York, gave unstintingly of his time and graciously contributed the Introduction as well as the text for two of the chapters of this book. His assistant, Miss Edna Spiess, was invaluable in aiding me to make the final selection of the prints.

The other contributors, whose works speak for themselves, made possible this pictorial appreciation of the story of our country as understood by N. Currier and Currier & Ives and their artists.

Thanks are also due to the Kennedy Galleries, New York, for permission to reproduce *The Surrender of General Burgoyne at Saratoga* and to The Old Print Shop, New York, for permission to reproduce *The Battle of Gettysburg*.

J.L.P.

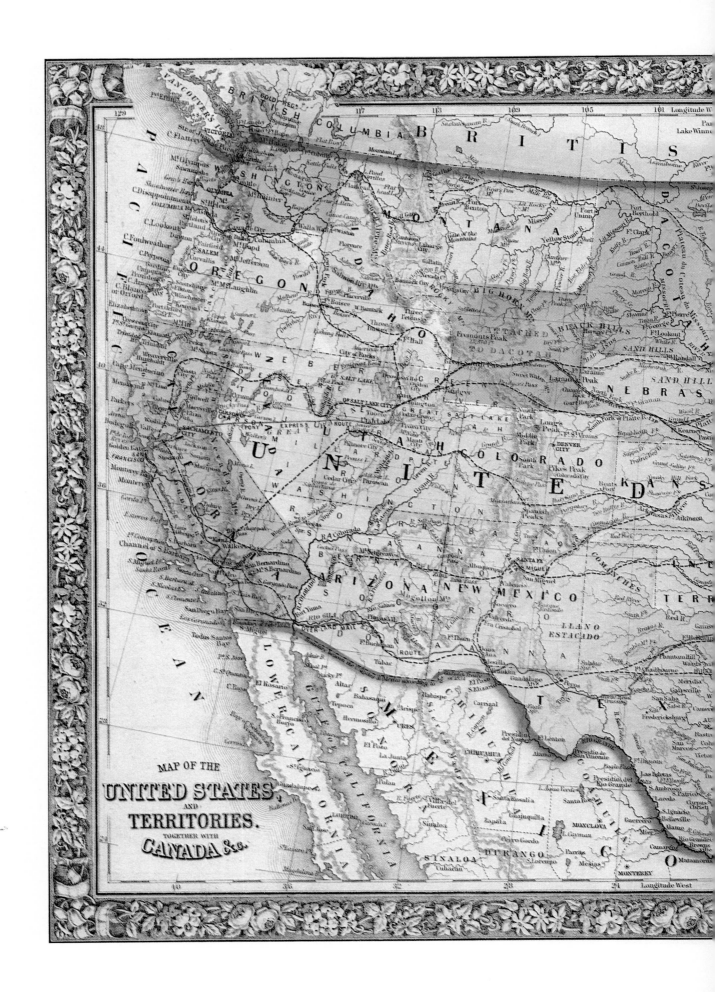

MAP OF THE
UNITED STATES
AND
TERRITORIES.
TOGETHER WITH
CANADA &c.

THE UNITED STATES IN 1865

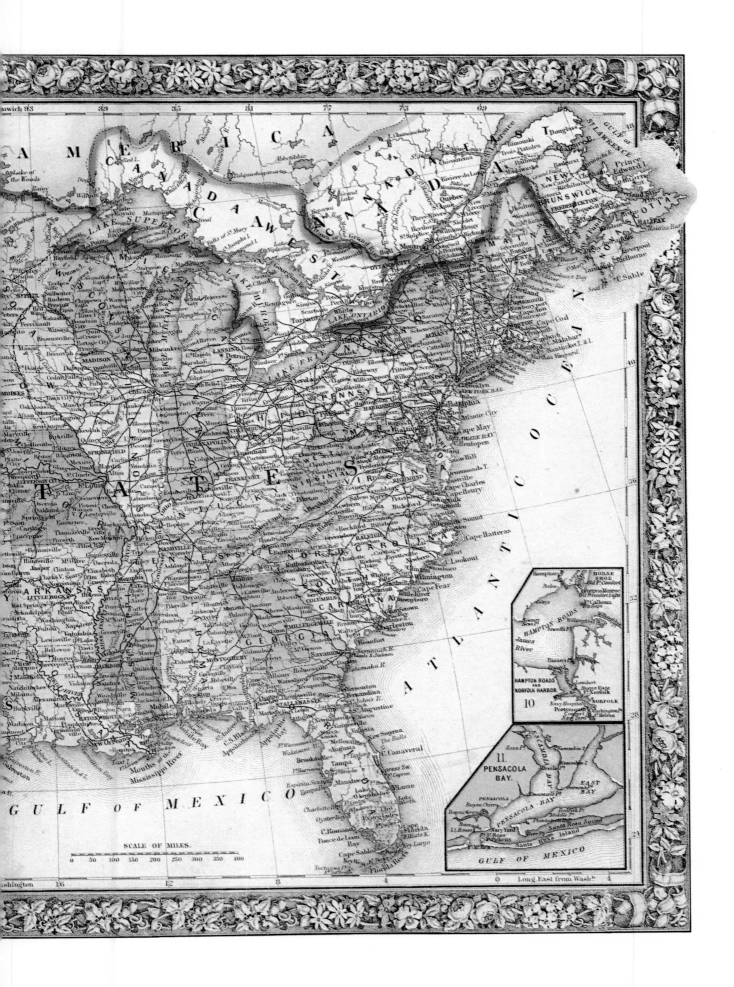

From MITCHELL'S NEW GENERAL ATLAS, *S. Augustus Mitchell, publisher, Philadelphia.*

CHRONICLES OF AMERICA

I THE BEGINNING

The lithographs of Currier and Ives reveal, with great clarity and force of execution, the image of themselves and of their history which nineteenth-century Americans esteemed. The Currier and Ives workshop flourished during the years of national consolidation and expansion when all Americans were engaged in a quest to establish the national identity. Many of their prints reflect the common themes which contemporary artists and writers employed and to which the public enthusiastically responded. Americans were proud of their present and past; they wished to see and hear their nation's praises. And because they were baffled and disturbed by the vast social and economic changes which every year of the nineteenth century brought, they wanted reassurance from the books they read and the pictures they viewed that America was a powerful and virtuous land.

In their histories and schoolbooks, Americans learned to see the development of the nation from its earliest years as the slow unfolding of foreordained and natural greatness. It is no accident that, of all the colonial events they might have chosen, Currier and Ives, always shrewd businessmen, saw fit to reproduce those epic scenes which had become embedded in the consciousness of Americans as evidence of the courage, ingenuity, and genius of their forefathers. Christopher Columbus, the Pilgrims, William Penn, and Benjamin Franklin—all are represented at the moment of their greatest heroism and achievement. They personify those ancestors who journeyed from Europe to bring order, religion, peace, law, and science to a virgin land and to its savage people. The colonization of America promised a glorious future, and in Columbus' standard, the Pilgrim's piety and republicanism, Penn's signature, and Franklin's kite one finds the symbols of progress and achievement.

At the same time that they limned these themes, Currier and Ives made clear that America began and prospered through the efforts of individuals. Americans liked to think of themselves as independent and rugged, qualities exemplified in the self-reliance of Columbus the discoverer, Penn the man of peace, Franklin the scientist, and the persevering Pilgrims. Yet the artists always provided a complementary theme. The printmakers perceptively introduced the balancing motif of an environing community, of the larger society which sustained and gave meaning to the individual. Neither Columbus nor the Pilgrims, for example, act alone. The explorer—tenacious of purpose and clothed in imperial grandeur—appears the fearless and triumphant individual, yet his is a joint enterprise within an association of intrepid men. Americans have always vaunted their self-reliance, but Currier and Ives suggest as well that they were no less concerned with the common good.

What is perhaps most interesting about these scenes of colonial America is that, romanticized as they may be, they remain credible and true to the spirit of the event portrayed. The subtle combination of romanticism and realism in each case underscores the common historical themes they illustrate. If the artists surrendered part of the realism of what we know to have been a trying voyage filled with hardship and division by showing the Pilgrims setting foot on land in clean dress and good order, they also retained the complementary truths of fatigue, emotional torment, uncertainty, and relief which swept the small band upon its arrival. Thus they heightened the impression of these people's fortitude, piety, and stoicism in the face of adversity. Moreover, if the entire truth about the Mayflower Compact—the fact, for example, that it was executed in order to bring under control a group of near-mutinous passengers—is not, and perhaps cannot be, included, the artist's caption underlines the more important lesson of the early colonists' capacity and determination for self-government.

This same combination of realistic portrayal and romantic interpretation permeates the scene of Penn's treaty. Errors of detail abound: Penn, who received his charter from King Charles II in 1681 and who remained in England until 1682, concluded his renowned land-purchase treaty with the Indians only in 1683. What is more, the treaty was in fact broken, and by none other than Penn's sons who, starting in the 1730s, began to obtain more land for their proprietorship from the Indians by fraud and chicane. Thus here, fittingly, the dominant note is critical as well as inspirational: Penn is the benevolent fair-dealer and man of law and justice, an image of themselves which Americans have always fostered. Offsetting this motif, nevertheless, is the implicit critique of the caption: other treaties were dishonored, other pledges broken.

Ben Franklin's inclusion in the Currier and Ives gallery is also instructive of nineteenth-century American values. Out of Boston, Franklin brought the ultimate practical instruments of science and Yankee common sense. After establishing, among other things, a printing shop, a circulating library, a philosophical society, and a fire company in Philadelphia, Franklin carried out his famous kite-flying experiment with his son in 1752. In 1876, Currier and Ives depicted this widely-known event in its well-accepted hues. Franklin, the practical genius, revealed the mysteries of experimental science to an admiring and somewhat incredulous Old World. As the Pilgrims governed themselves and Penn influenced the savage with law and kindness, so Franklin tamed nature with his lightning rod. In this scene, the simplicity of the setting is set off against the power and promise of the occasion, a theme which recurs in the next historical episode which the artists take up—the American Revolution.

JAMES M. BANNER, JR.

THE LANDING OF COLUMBUS AT SAN SALVADOR, OCTOBER 12, 1492

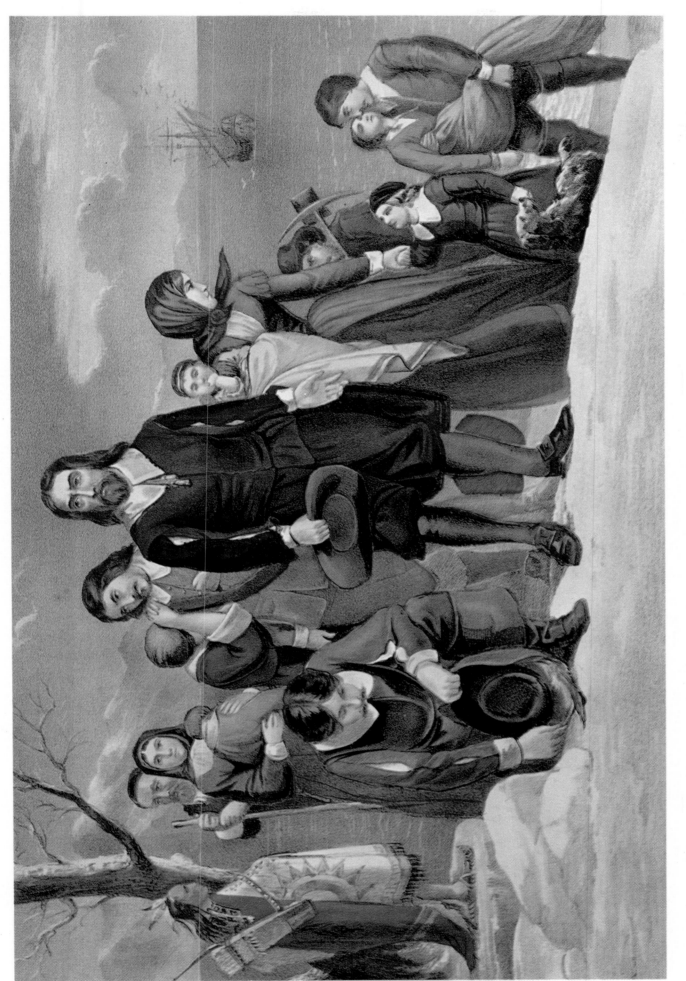

THE LANDING OF THE PILGRIMS AT PLYMOUTH, MASS. ON DECEMBER 22, 1620

The "Mayflower" left Delft Haven in Holland, Sept. 6, 1620 and after a boisterous passage of sixty-three days, anchored within Cape Cod. In her cabin the first republican government was solemnly inaugurated. That vessel thus became truly the "Cradle of Liberty" rocked on the waves of the ocean.

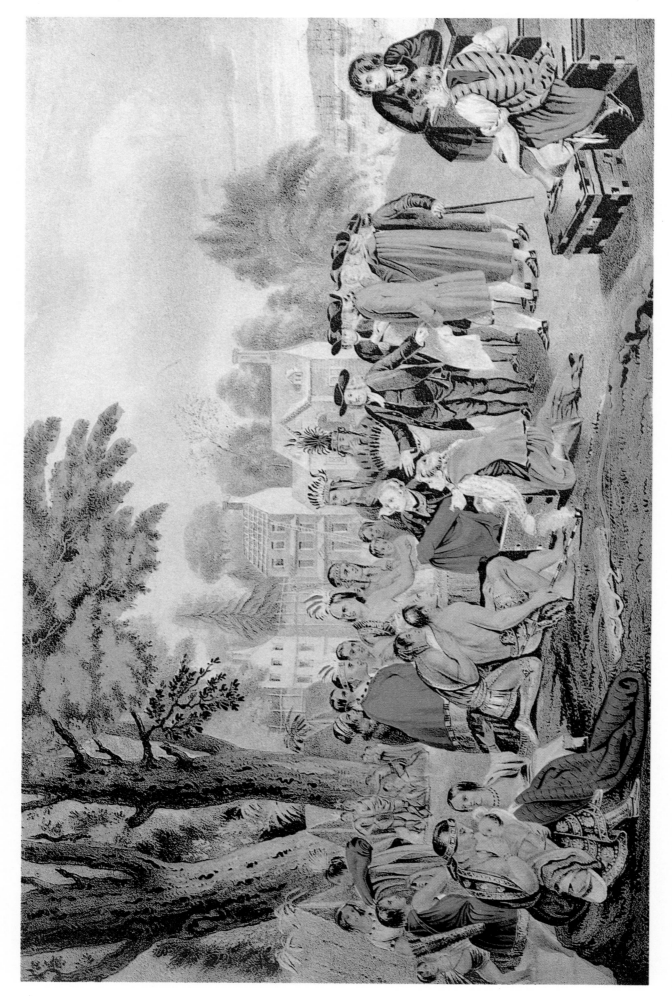

Wm. PENN'S TREATY WITH THE INDIANS WHEN HE FOUNDED THE PROVINCE OF PENNSYLVANIA IN 1661

THE ONLY TREATY NEVER BROKEN

26

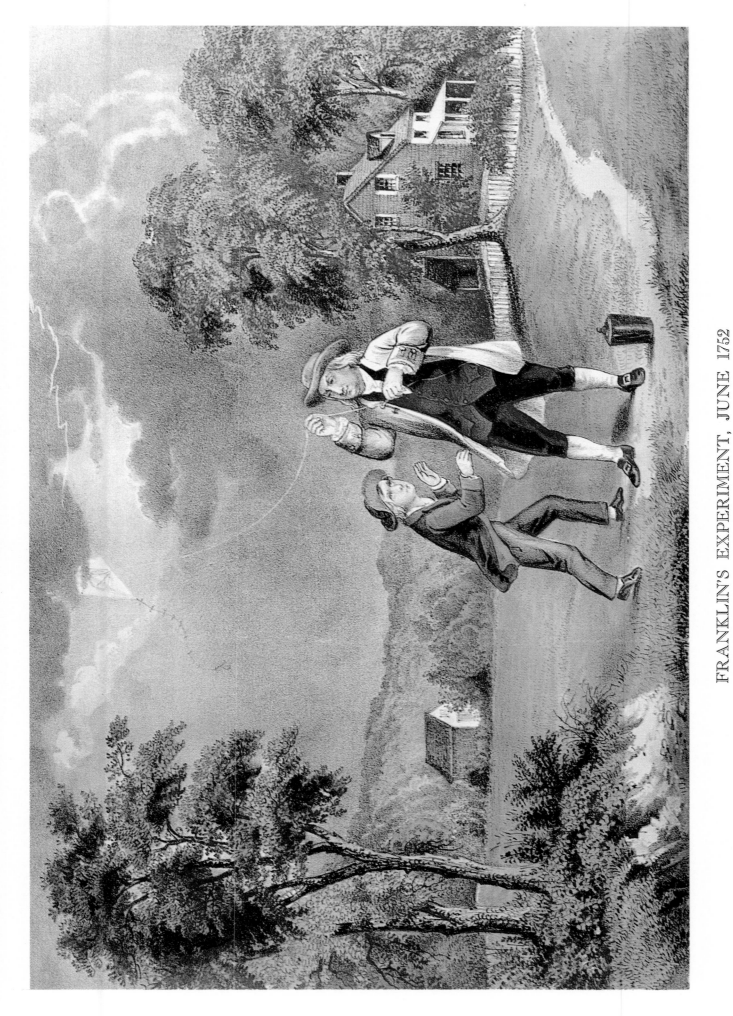

FRANKLIN'S EXPERIMENT, JUNE 1752

DEMONSTRATING THE IDENTITY OF LIGHTNING AND ELECTRICITY, FROM WHICH HE INVENTED THE LIGHTNING ROD.

II THE AMERICAN REVOLUTION

To Northerners of Currier and Ives' generation, burdened with their own contest for union and for the preservation of the republican experiment, few events proved more inspirational than the American Revolution. In their thinking—nourished on the nationalism of Daniel Webster's speeches, George Bancroft's histories, and Lincoln's firm leadership—the distant war with Great Britain was a reminder of union born, battles won, patriotism tried, national self-government commenced. Who wished to recall the "other" reality, the hesitant steps to independence, the tatterdemalion forces put together by not-always-competent officers, the reverses at Brooklyn Heights and Fort Washington, fiscal mismanagement and profiteering? Who sought to learn of families divided in their loyalties, of civil war between brothers, of division and disunity and the failure of government after peace? What Americans wished to remember and what the publishers of popular art discerningly sought to provide—indeed, perhaps, what every young nation must have—were the "truths" of another kind: the heroism of the day, the unifying events, the successes of war and of the arts of self-government. These the enterprising skills of Currier and Ives offered in abundance.

Scenes and episodes which had already been immortalized in print and on canvas were now made widely available to Americans everywhere. And the keynotes of these lithographs were unmistakable: Nation and Union, North and South inseparable and indivisible. Along with the symbols of order, religion, law, and practical science now appeared for the first time the motifs of the hero and of patriotism. Washington, the unimpeachable champion of union and independence, dominates many of these pictorial descriptions, not simply, however, as hero but also as soldier-statesman. He personified the kind of figure historically respected and, one hastens to add, often elected to high office by his countrymen. The nineteenth century, and particularly the decades in which Currier and Ives produced their enduring work, abounded in such men—Andrew Jackson, William Henry Harrison, Zachary Taylor, Ulysses S. Grant, Northerners and Southerners alike. There is no question that Americans were drawn to Washington rather than to the likes of philosopher-statesmen Jefferson and Adams or to the Machiavellian figure of Hamilton—or that Currier and Ives directed their artists' efforts with this in mind. Nothing better highlights the symbolism of the soldier-statesman than the scene from Washington's first inauguration in which the first President stands somber and erect, one hand on the Bible and the other around a sword, a fitting symbol of the characteristic American identification of government, might, and the nation's divine mission.

The minor themes of these Revolutionary War scenes are no less revealing. Washington's forces, so often ill-clothed, ill-provided, and ill-trained, are orderly here, smartly uniformed, and highly disciplined—the way in which one always wishes to recall an army of national independence. A hint, however, of the other aspect of a difficult war—of the hit-and-run harassment tactics so well-suited to a self-created militia in an untenanted countryside—is evoked in the picture of Francis Marion, the "Swamp Fox" and hero of the Southern theater. This portrait also points up the gentlemanly quality of eighteenth-century warfare, as Marion treats a British officer to his victuals. At the same time, these lithographs emphasize the military tradition which contemporaries found fully reconcilable with the life of a revolutionary republic. And we can discern a complementary interest in the ceremonies and events of civil government, especially in the signal episodes of July 4th and the First Inaugural, and in the remarkable group of founding fathers, especially Jefferson, Franklin, and John Adams, seen here offering the Declaration of Independence to the seated John Hancock, president of the Second Continental Congress.

It is difficult not to take special note of the print of the Boston Tea Party. A splendid rendering of an important event of the pre-revolutionary years, it conveys with exceptional precision the spirit and significance of the moment. Except for the fact that the destruction of the tea took place under cover of night, here we see the tea party members carrying out their republican labors as they occurred, in full view of a well-dressed male throng which rends the air with loud huzzas. The artist brilliantly captures the combination of elation and high playfulness, of citizen unity and concern, which was in fact so evident on the occasion. Much of Boston turned out for the affair, and so firm was the understanding between the townspeople, those men proudly attesting their solidarity with the costumed men in this most famous act of defiance against British authority, that the authorities never found a witness to testify to the deed! This was one of the high points in the movement toward what John Adams later called "a Revolution the Most Complete and Remarkable in History." If time and events have qualified the validity of the statement, who would have denied Adams had he witnessed the events in Boston?

JAMES M. BANNER, JR.

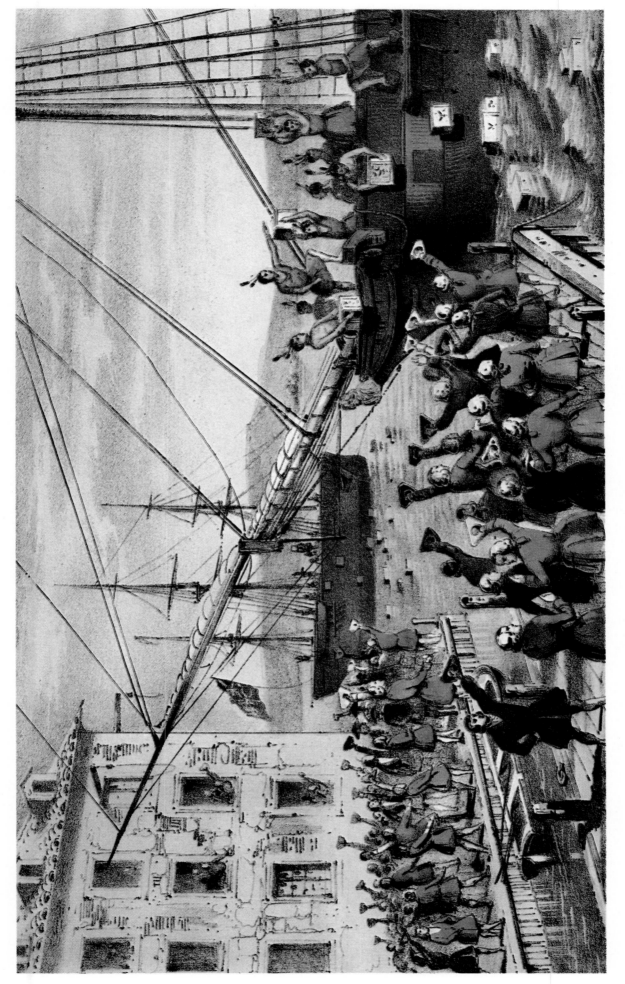

THE DESTRUCTION OF TEA AT BOSTON HARBOR, DECEMBER 16, 1773

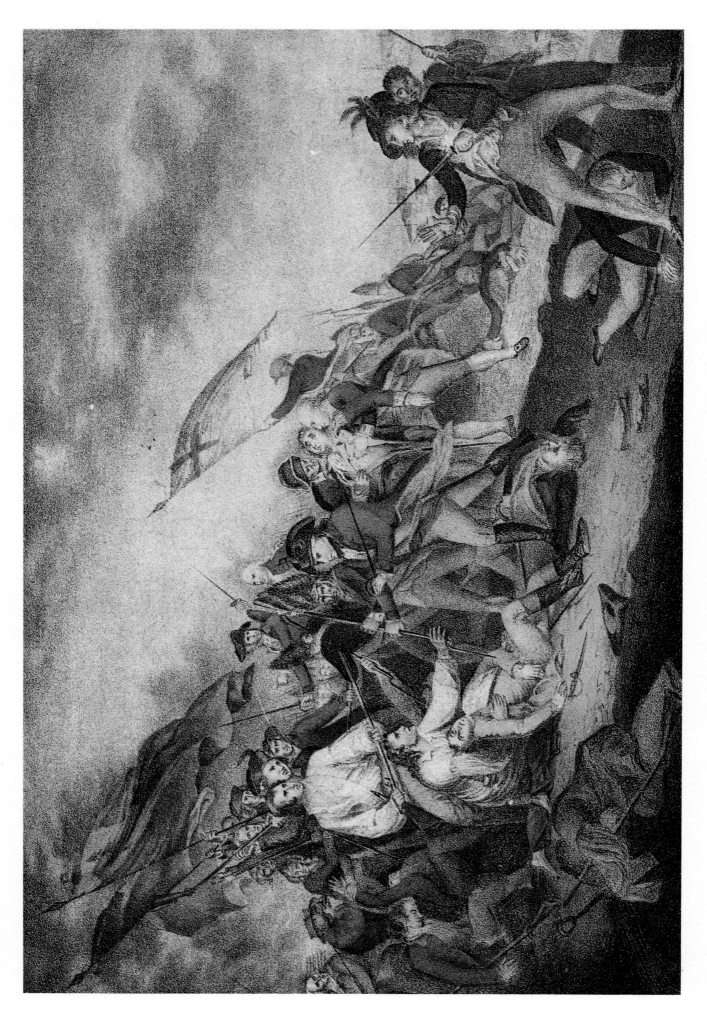

BATTLE AT BUNKER'S HILL, JUNE 17, 1775

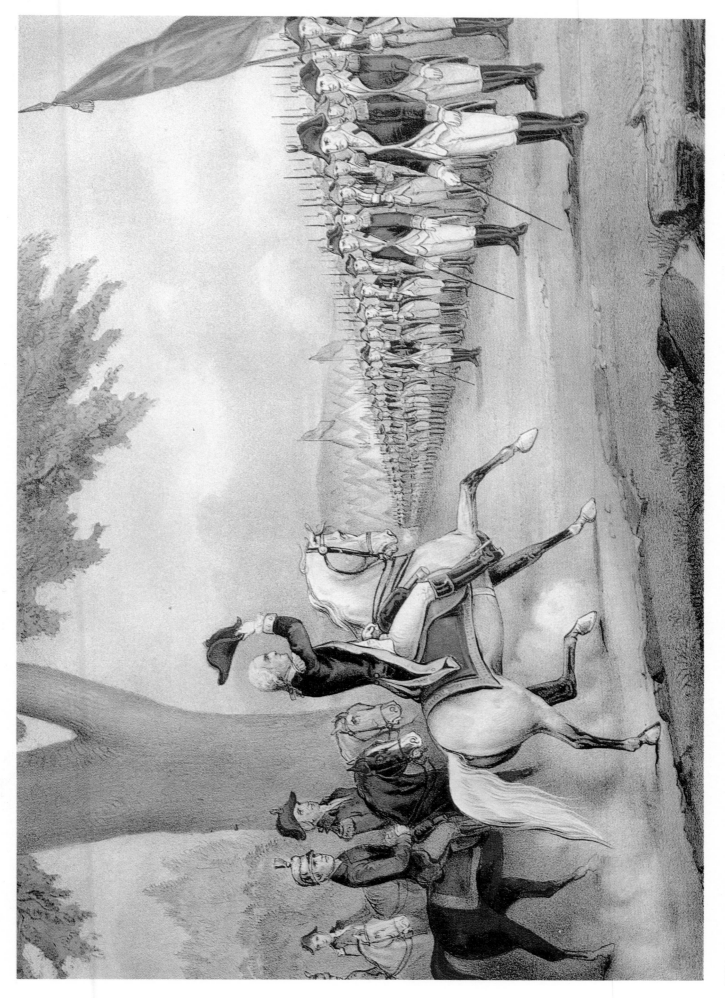

WASHINGTON TAKING COMMAND OF THE AMERICAN ARMY AT CAMBRIDGE, MASS., JULY 3, 1775

THE DECLARATION OF INDEPENDENCE, JULY 4, 1776

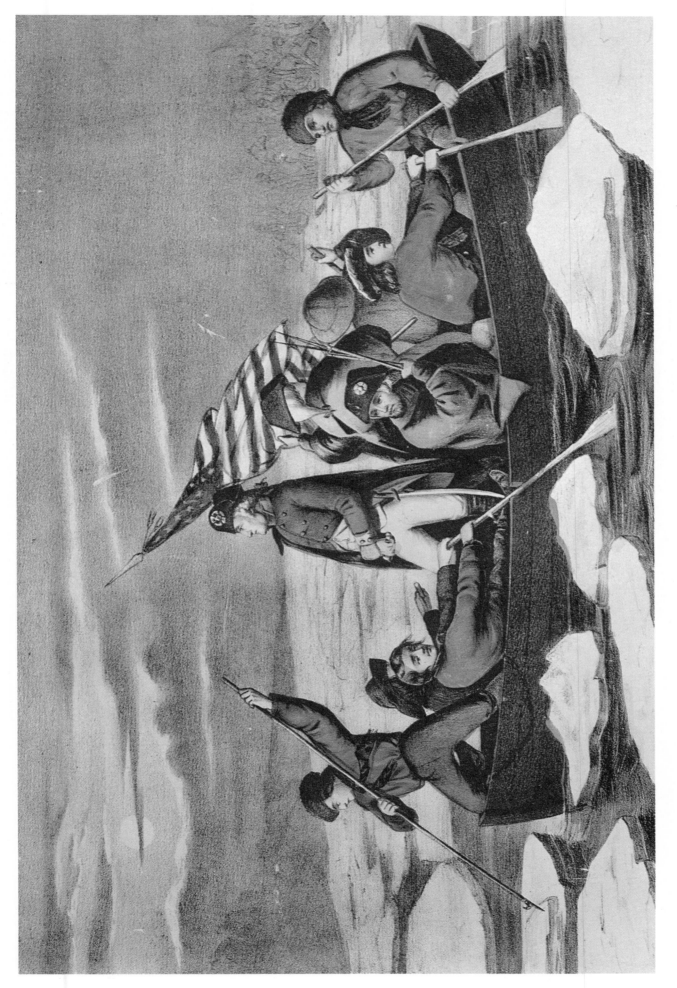

WASHINGTON CROSSING THE DELAWARE, DECEMBER 25, 1776

THE EVENING PREVIOUS TO THE BATTLE OF TRENTON

(Taken from the painting by Emanuel Leutze, owned by the Metropolitan Museum of Art)

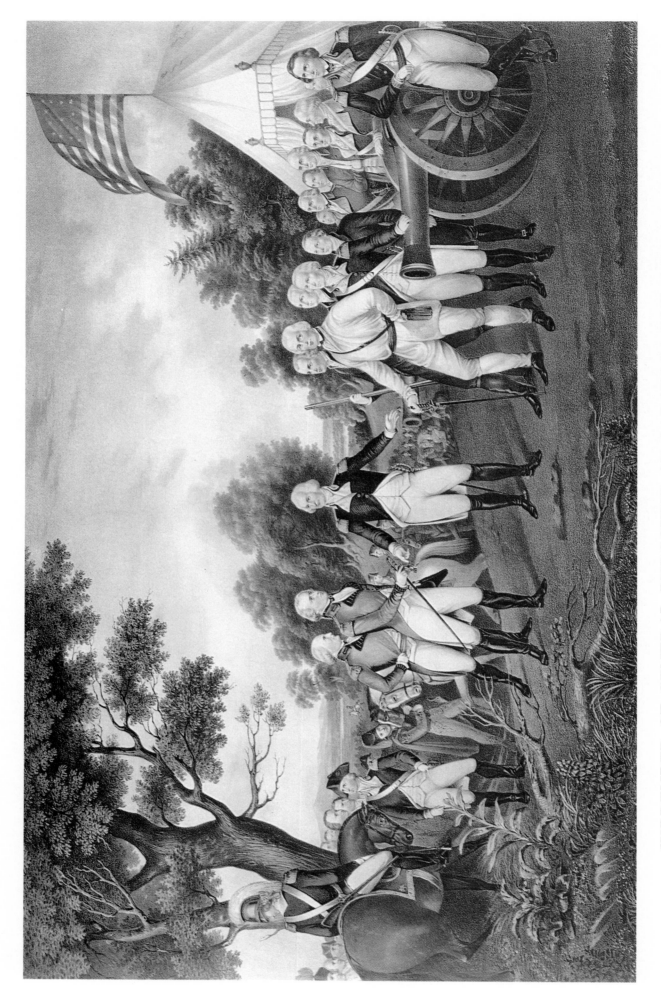

SURRENDER OF GENERAL BURGOYNE AT SARATOGA N.Y. OCT. 17th 1777

FROM THE ORIGINAL PAINTING BY COLONEL TRUMBULL IN THE CAPITOL AT WASHINGTON.

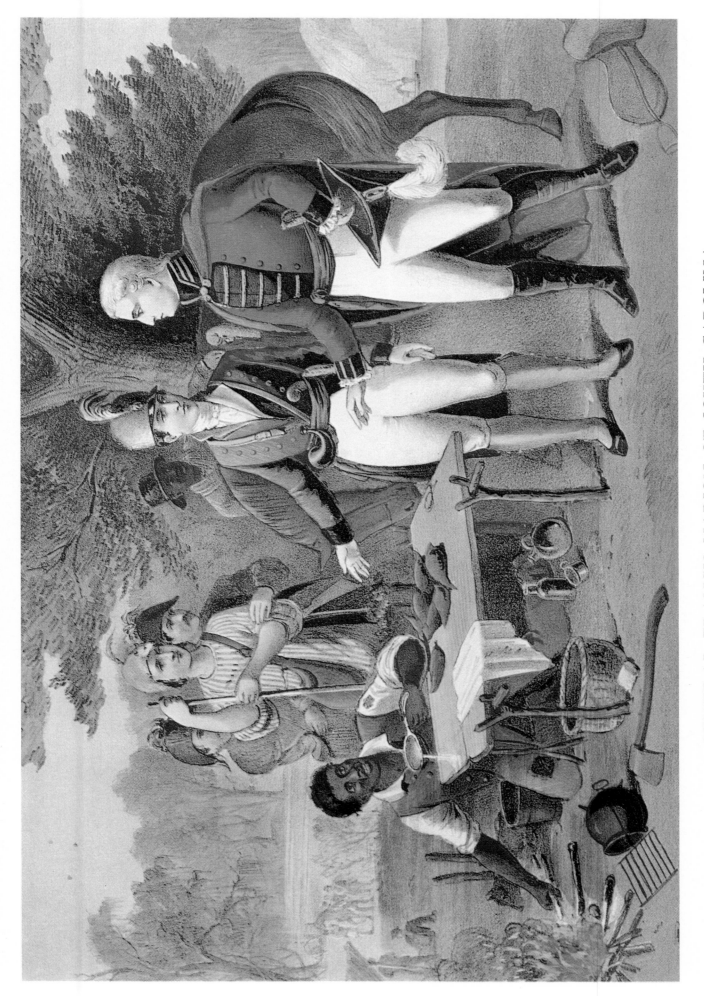

GENERAL FRANCIS MARION OF SOUTH CAROLINA

THE "SWAMP FOX" OF THE REVOLUTION IN THE SOUTH

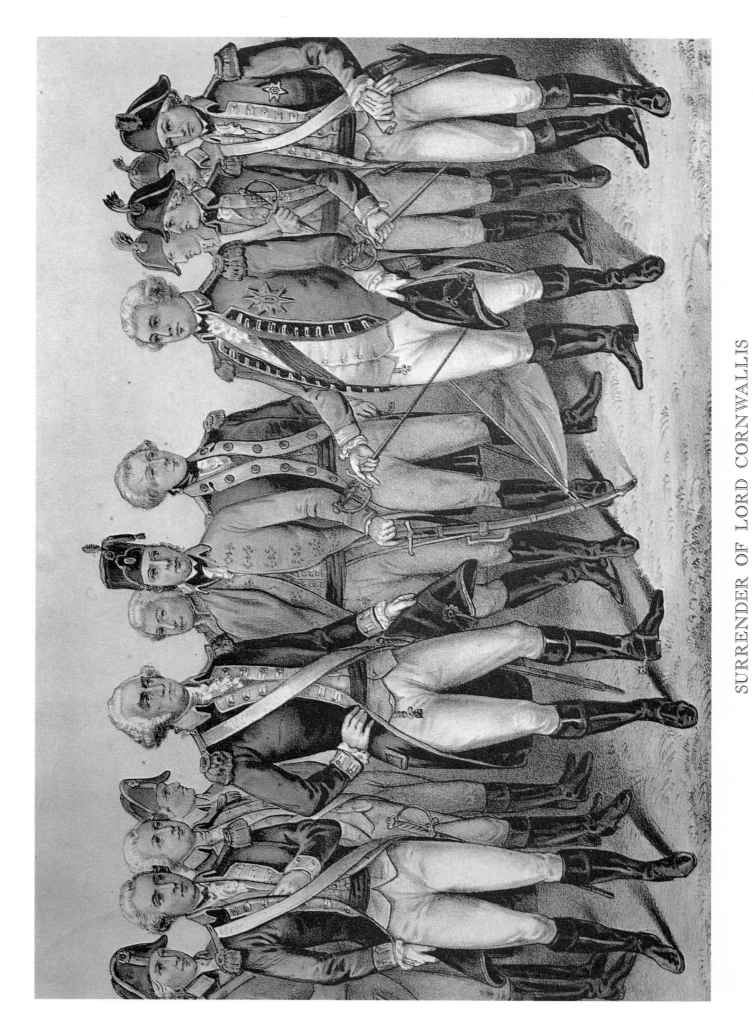

SURRENDER OF LORD CORNWALLIS

AT YORKTOWN, VA., OCT. 1781

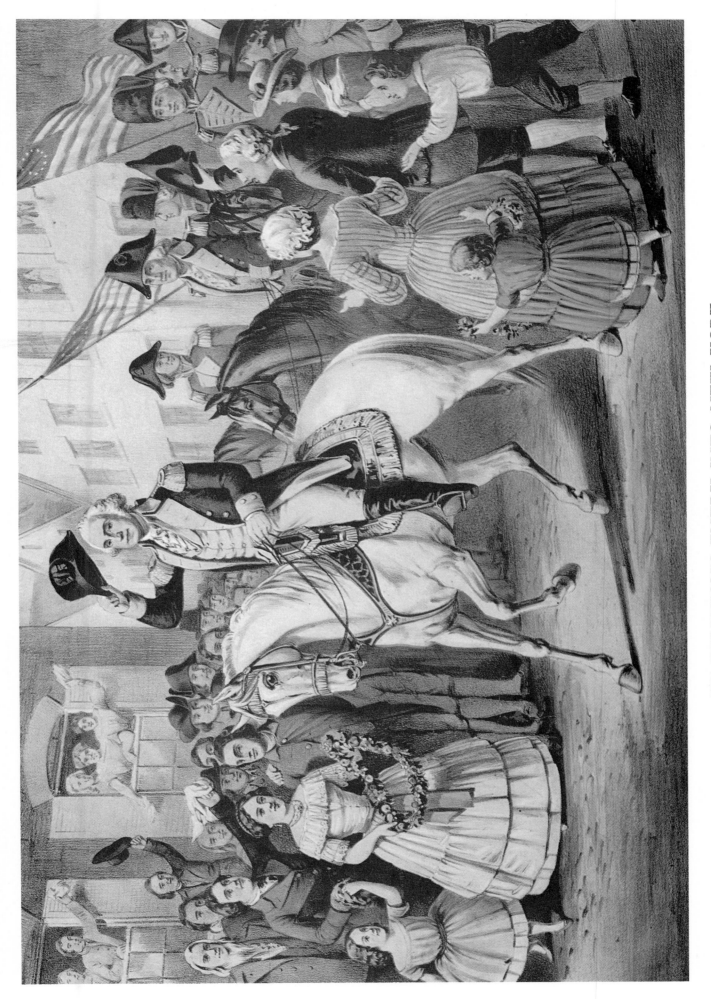

WASHINGTON'S ENTRY INTO NEW YORK

ON THE EVACUATION OF THE CITY BY THE BRITISH, NOVEMBER 25, 1783

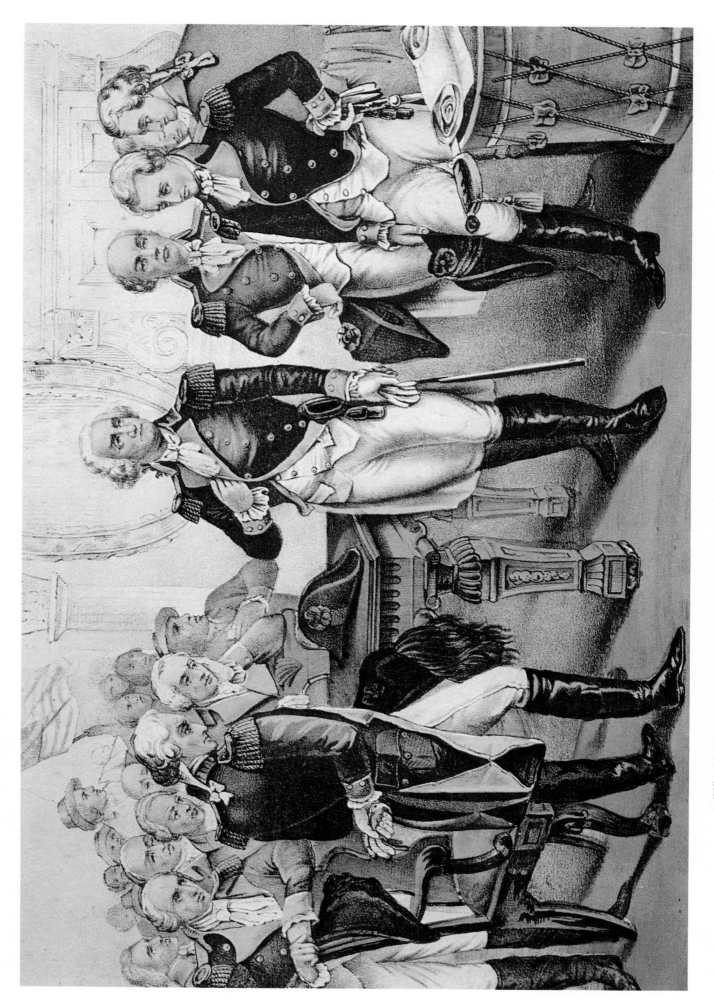

WASHINGTON'S FAREWELL TO THE OFFICERS OF HIS ARMY

AT THE OLD TAVERN, CORNER BROAD AND PEARL STS., DEC. 4TH, 1783.

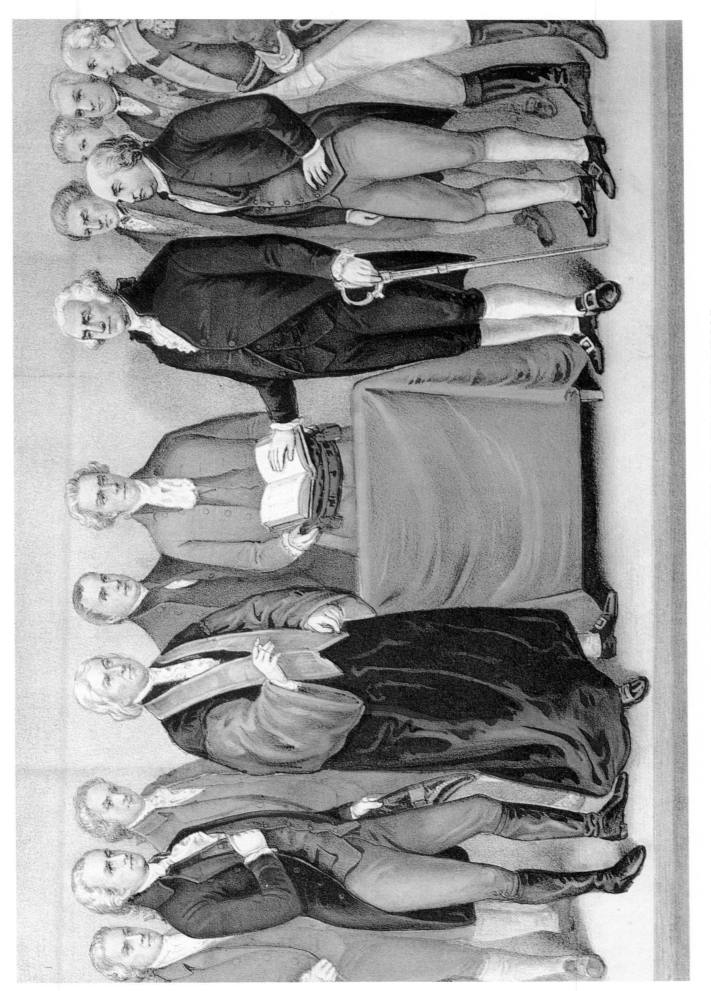

THE INAUGURATION OF WASHINGTON

As the first president of the United States at the old City Hall, New York, on April 30, 1789. The oath of office was administered by Chancellor Livingston of the State of New York. Mr. Otis, the Secretary of the Senate holding up the Bible on a crimson cushion.

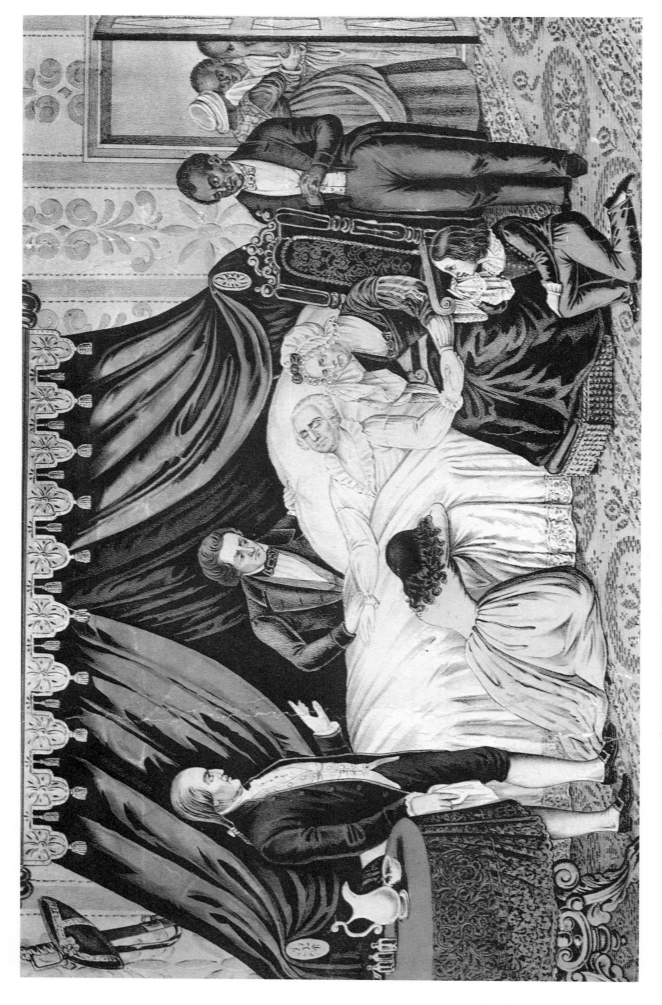

DEATH OF WASHINGTON, DECEMBER 14, 1799

III THE WAR OF 1812

Compared to the exhilarating War for Independence, the War of 1812 was a grim and disappointing affair. And Americans have never really succeeded in getting right with it. The conflict provided its worthy additions to the pantheon of national heroes and gave the nation another warrior-statesman in Andrew Jackson. Sometimes called the Second War for Independence, it secured once and for all the territory gained by the Treaty of 1783 and made the point that the United States meant to be, and could in fact remain, independent of any European power.

But it was nevertheless a war perhaps at best forgotten. Americans long treated it as a joke, as a demonstration of military blundering and governmental ineptitude which divided the nation and compromised their young and fragile faith in the future of republican government. Thousands of contemporaries had been scornful of risking what they believed to be the "world's best hope of a republic" in a war with the world's strongest naval power, and decades of controversy have never convinced all students of the times that Napoleonic France was not the real scourge of the world, that the nation should not have warred on this great revolutionary nation rather than on Britain. In the war itself, Detroit was surrendered without a shot, New York troops refused to pursue the British into Canada, the town of Washington was put to the torch, and the government became nearly bankrupt. The nation was also treated to the spectacle of President Madison riding off on horseback through the countryside to avoid capture by the British troops. Needless to say, it was a war whose precise meaning was, and remains, difficult to capture.

Fortunately, however, it had its redeeming moments: McDonough's victory on Champlain, Perry's triumph on Lake Erie, Harrison's skirmish at Tippecanoe (left to later exploitation in the 1840 Log Cabin and Hard Cider campaign), and, most of all, Jackson's notable feat at New Orleans. All of these events could be remembered with pride even if the larger conflict was obscured. This was also the war, it must be recalled, in which the American Navy emerged as a potent force in the face of its great maritime adversary and in which the seamanship of the average sailor and privateer proved up to the task—facts which Currier and Ives' artists appropriately record.

Nothing, however, captured the attention and won the praise of Americans of that day and afterwards more than Jackson's New Orleans victory. Curiously enough, it took place some days after a peace had been concluded in Ghent; under modern conditions of communications, it might not have occurred at all. Its principal significance, therefore, turned out to be psychological rather than diplomatic. After an otherwise dismal war, it demonstrated the nation's residual strength. It restored confidence. And it gave the nation new heroes: the outnumbered frontiersmen who could vanquish the best regulars and veterans of Europe's wars in a swift, one-half-hour battle from behind hastily constructed breastworks; and, most important, the bluff and practical general from the trans-Appalachian Tennessee West, a new embodiment for a yet insecure nation of power, honor, and union.

The Currier and Ives artist who depicted the Hero of New Orleans accurately caught the image of Jackson held by his contemporaries and now deeply inscribed in the national literature. In this illustration, he is at once the frontiersman as republican hero and, as his uniform and caparisoned horse so vividly attest, the President as commander. Thomas Hamilton, the English visitor, described everything about him as possessing "a natural and most peculiar warlikeness. He has, not to speak disrespectfully, a *game cock* all over him. His face is unlike any other. Its prevailing expression is energy; but there is, so to speak, a lofty honorableness in its worn lines." He was King Andrew to his enemies, the defender of American democracy to his admirers—a mixture, as in this lithograph, of the regal and the republican.

JAMES M. BANNER, JR.

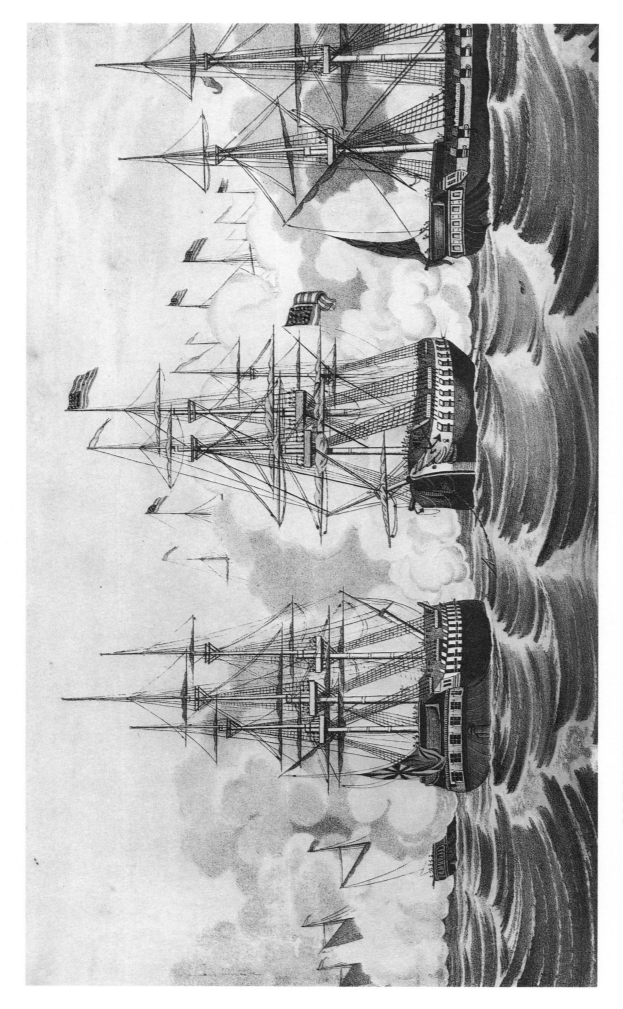

McDONOUGH'S VICTORY ON LAKE CHAMPLAIN, SEPTEMBER 11, 1814

American Loss 52 Killed 58 Wounded
British Loss 84 Killed 110 Wounded

American Guns 86
British Guns 95

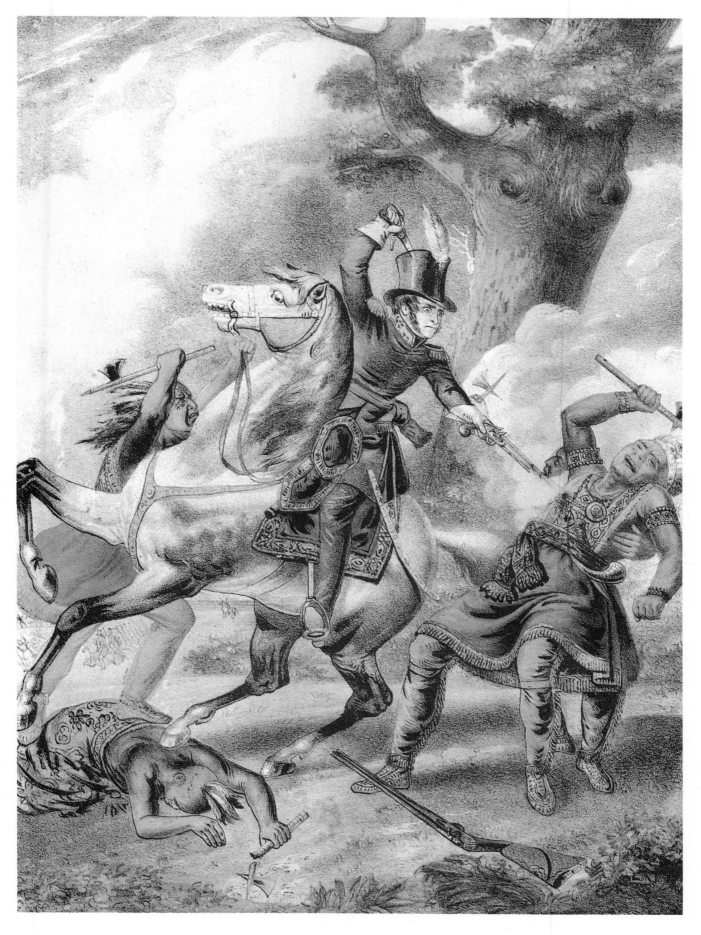

DEATH OF TECUMSEH

BATTLE OF THE THAMES, OCT. 18, 1813.

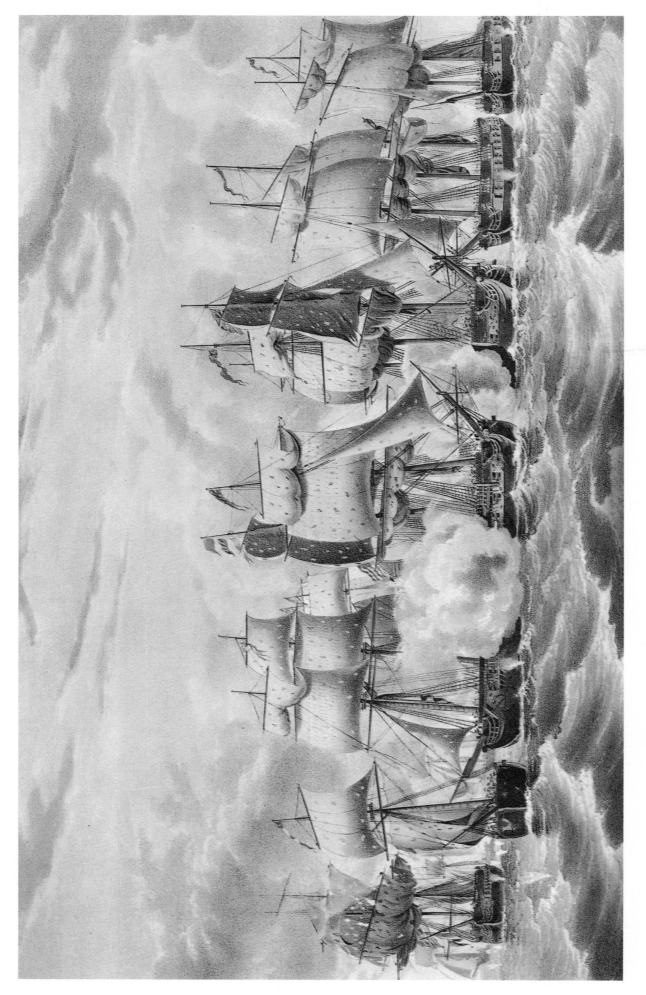

PERRY'S VICTORY ON LAKE ERIE, SEPTEMBER 10, 1813

This plate represents the position of the two fleets when the "Niagara" is pushing through the enemy's line (Center) pouring her thunder upon them from both broadsides forcing them to surrender in succession to the American Flag. Commodore Perry having a short time before left the "Lawrence" (Far Left) in a small boat amidst a tremendous fire from the British Squadron and hoisted his flag on board the "Niagara."

"We have met the enemy and they are ours." Commodore O. H. Perry

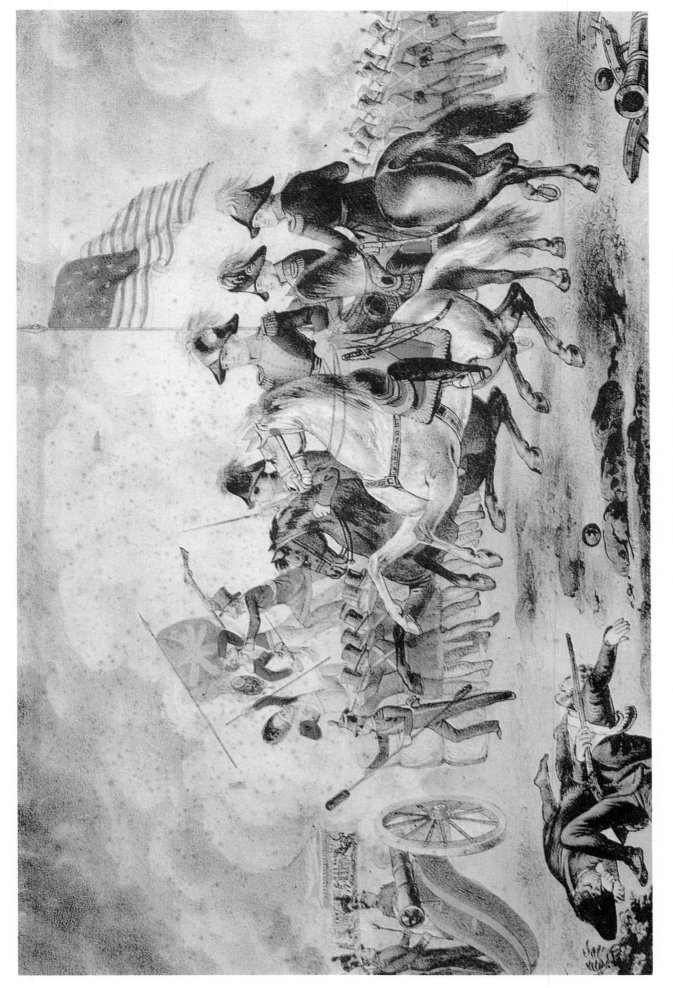

THE BATTLE OF NEW ORLEANS, JANUARY 8, 1815

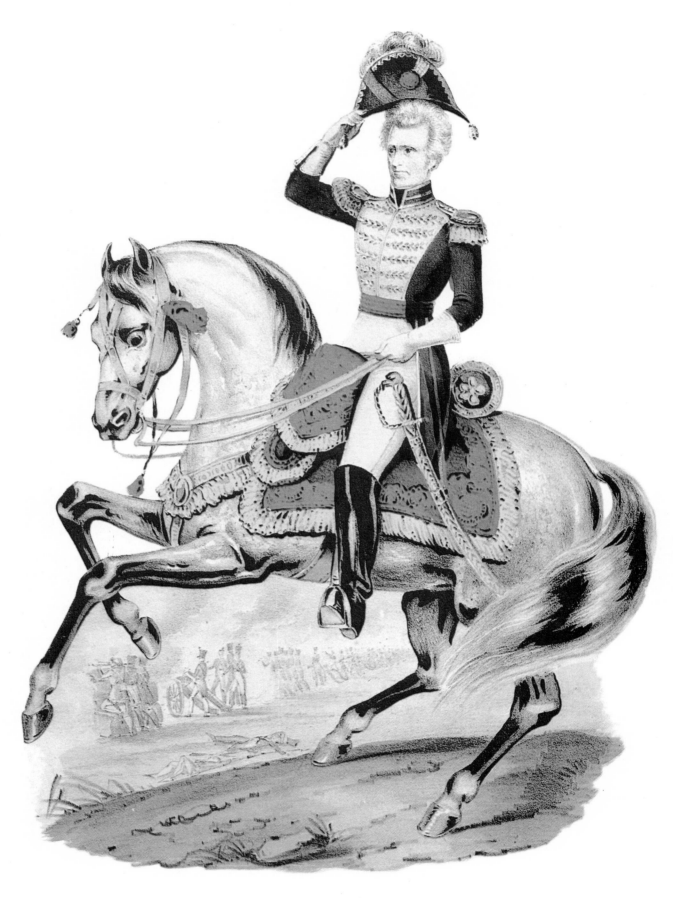

GENERAL ANDREW JACKSON

THE HERO OF NEW ORLEANS.

IV THE MEXICAN WAR

Just as the meaning of the War of 1812 long remained shrouded to most Americans, so the Mexican War came to hold an ambiguous position in the national consciousness. Like the earlier conflict, there were some good reasons, particularly among Northerners of Currier and Ives' generation, to forget it. The war was, after all, an unabashedly offensive thrust, especially popular in the South and West, which required the special and strained justifications reserved for that sort of affair. It was also undertaken at a time of severe and deepening domestic crisis. Indeed, its very origins in the quest for more land reflected the swelling controversy over the fate of slavery in the territories. Moreover, the addition of still more land to a continental empire did nothing to resolve the prickly issue of settling and administering the millions of acres already held. The expedient of the Great Compromise of 1850 was necessary to resolve, and then only temporarily, the passions let loose by a war opposed widely from within. And only the Civil War could liquidate completely the issues created by contending pro- and anti-slavery forces seeking dominion in the new territories. Finally, it was a war encouraged not by external threat nor by military considerations but primarily by political leaders of various stripes who were determined to solve the long-smouldering controversy over Texas annexation and to round out the "natural" boundaries of the nation.

Nathaniel Currier's enterprise rose to prominence in this very period of expansion and sectional controversy. His workshop was roughly ten years old when the Mexican War broke out. Whereas his artists' illustrations of the early events in the national past had possessed a necessarily retrospective and somewhat mannered quality, now for the first time, depicting contemporary events, their work began to have a more reportorial cast. That all Americans were brought closer to the war's action by the dispatches of the first modern battlefield correspondent no doubt contributes to the heightened sense of immediacy of these scenes. It also helps to explain the artistic attention not simply to the commanding generals but to the more common acts of bravery, like those of Colonel Harney at Madelin and Captain May at Resaca de la Palma.

The War itself, largely improvised despite the American initiative, provided a series of heady triumphs for a nation growing restless and insecure from domestic strife. Not unexpectedly, Currier and Ives chose to satisfy the national need for reassurance; and in these lithographs, as in the real war, the Mexicans fought valiantly, but the Americans seemed always to win. In the rough and ready commander of Buena Vista and Monterrey, the nation found another soldier-champion but one who, unfortunately, proved a poor statesman after 1848 as the last Whig President. In Winfield Scott of Vera Cruz—"Old Fuss and Feathers" and one of the few military figures to escape from the War of 1812 with reputation enhanced—the nation later discovered an experienced army chief-of-staff who helped formulate the basic Northern strategy in the Civil War. More ominously, the war gave experience to many of those, such as Grant and Lee, "Stonewall" Jackson and W.T. Sherman, Longstreet and McClellan, who would lead the opposing Blue and Gray forces fifteen years later. When the smoke had cleared from their battlefields, the United States had come into possession of what is today California, Nevada, Utah, and parts of Arizona, New Mexico, Colorado, and Wyoming, as well as Texas, whose annexation in 1845 lay behind the war, and Oregon, Washington, and Idaho which Britain peaceably ceded in 1846. From a continental nation the United States had become also an imperial one and, as many foresaw and as we now can see so strikingly, the fact could provide no solace. The fruits of war bore the seeds of disunion. Civil war was close at hand.

JAMES M. BANNER, JR.

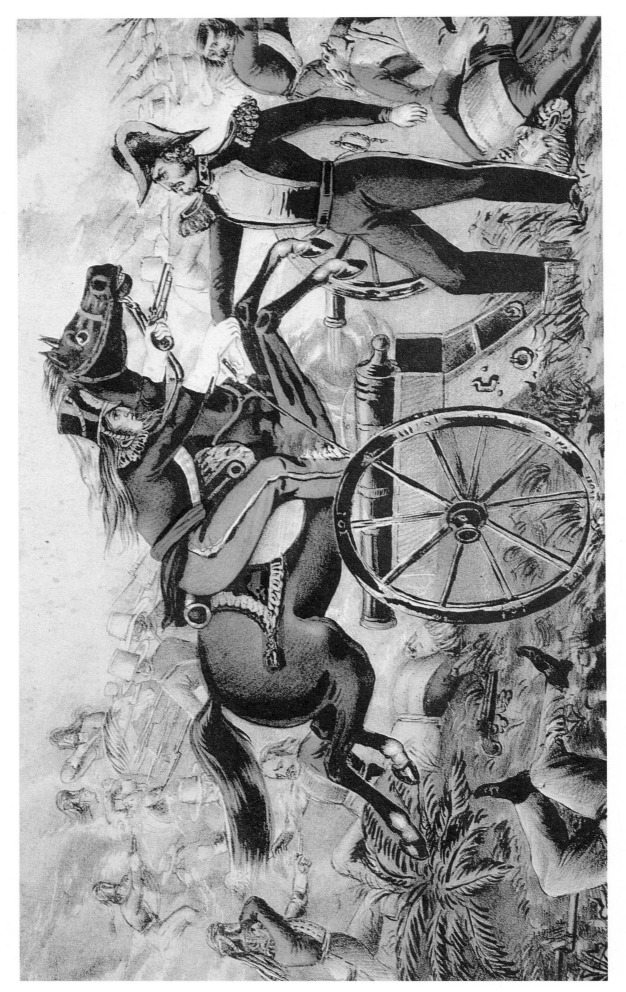

BATTLE OF RESACA DE LA PALMA, May 9th, 1846

CAPTURE OF GENL. VEGA BY THE GALLANT CAPT. MAY

Before war was officially declared (May 13, 1846) General Zachary Taylor fought the Mexican troops and repulsed the enemy's cavalry attack. Some 1700 Americans faced 5700 Mexicans, driving them across the Rio Grande. This success made "Old Rough and Ready" Taylor a popular hero.

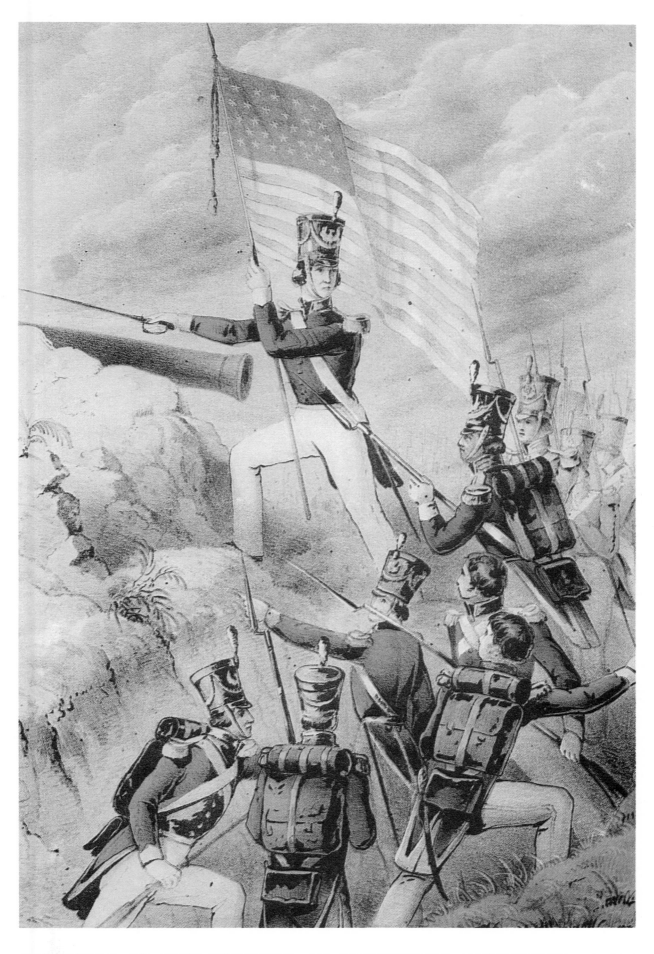

STORMING OF THE HEIGHTS AT MONTEREY, SEPTEMBER 21, 1846

49

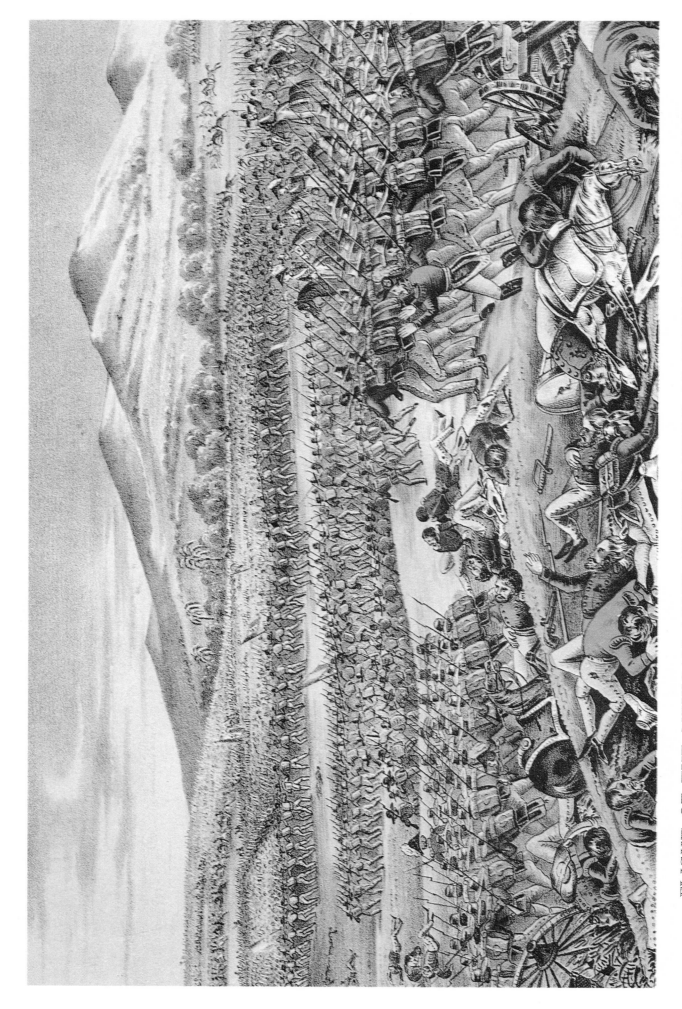

FLIGHT OF THE MEXICAN ARMY AT THE BATTLE OF BUENA VISTA, Febr. 23, 1847

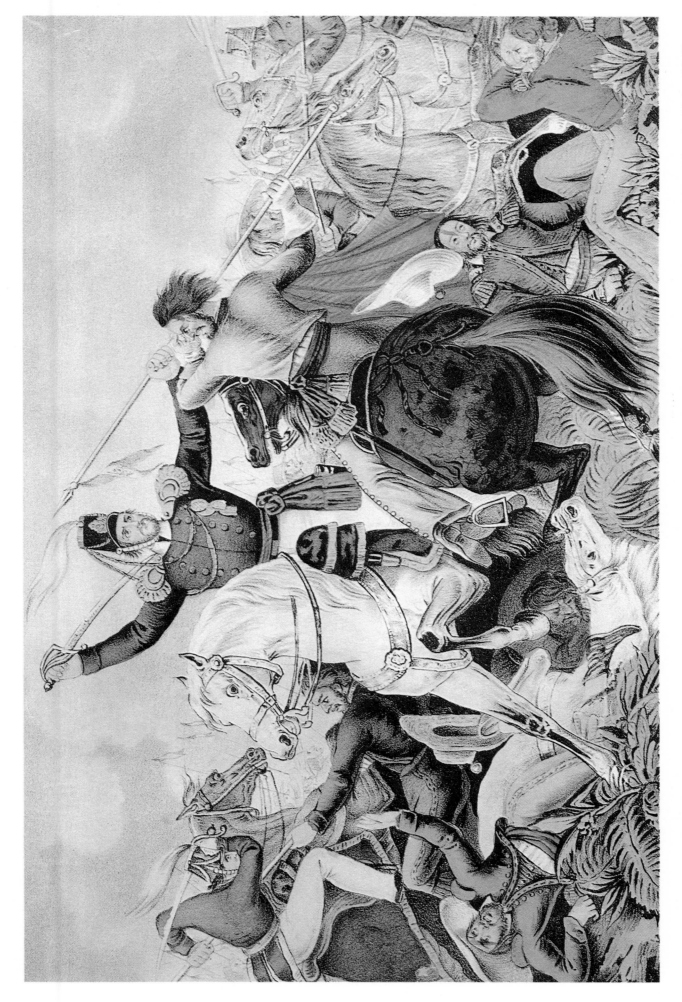

COLONEL HARNEY AT THE DRAGOON FIGHT AT MADELIN, NEAR VERA CRUZ, March 25th, 1847

51

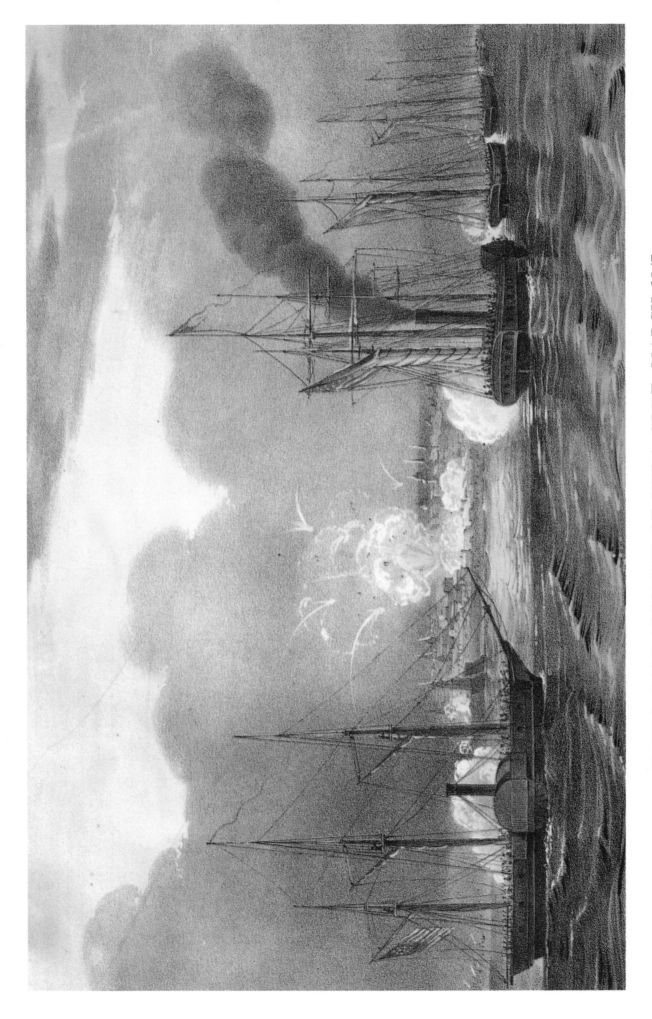

NAVAL BOMBARDMENT OF VERA CRUZ, MARCH 1847

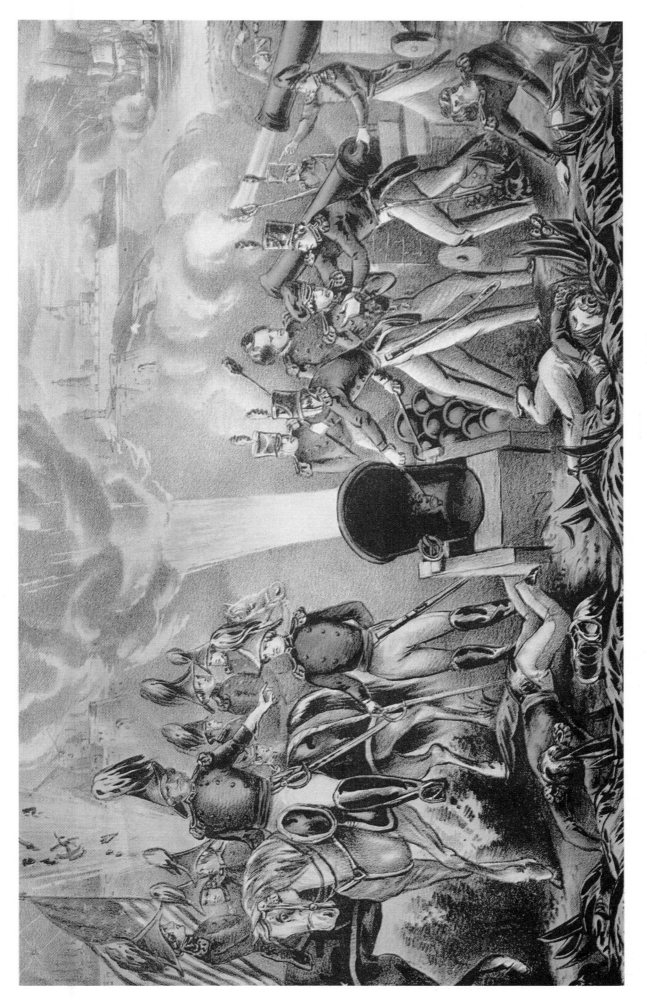

SIEGE OF VERA CRUZ, MARCH 1847

U.S. ARMY UNDER GENL. SCOTT 12100. U.S. NAVY UNDER COM. PERRY.
U.S. LOSS 15 KILLED AND 50 WOUNDED.

The bombardment commenced on the 22 of March at four-fifteen P.M., and was incessant day and night until the morning of the 26, at which time overtures were made by the enemy for a capitulation of the city and also the Castle of San Juan de Ulloa (The Gibraltar of America). On the 27 of March the garrisons of both city and Castle surrendered as prisoners of war to the victorious arms of the United States.

V THE SEA AND SHIPS

The Clipper Ships

It comes as no surprise that during the dozen or so years prior to the Civil War Mr. N. Currier, later joined by Mr. Ives, devoted considerable attention to the sea and ships. From the earliest beginnings at Jamestown and Plymouth the sea had played a commanding role in the life of the colonists whose very existence during those tenuous early years depended solely on the sea as the broad highway between the Old and New World and a source for provender to fend off starvation. During the American Revolution the sea proved to be a powerful ally virtually nullifying the ability of England to supply adequately her troops in an alien land. Again, in the War of 1812 it was the sea that tipped the scales in favor of the upstart country, and down through the decades of the nineteenth century the sea was to continue its strong impact on the life of every American. If ever a nation could be said to have been born of Neptune, it is America.

To many, the period 1845 - 1860 represents the most glorious period in our maritime history — The Age of the Clipper Ship — The Golden Age of Sail. The clipper ship did not simply come about; it was an evolution closely associated with the development of the United States as a maritime power. Both had their beginnings in necessity in which speed was the essential ingredient for success. For a century American ships had to depend upon courage, seamanship, and above all *speed* to avoid capture, impressment or sinking at the hands of more numerous and more powerful foreign men-of-war; or, even worse, capture by pirates. Quite ironically our youthful government added fuel to our lust for speed when, in 1807, it adopted the Embargo Act which limited American ships to American ports as a deterrent to capture by British or French ships on the high seas. Repeal of this Act two years later and substitution of the Non-Intercourse Act (which forbade foreign trade with England and France) simply whetted the appetites of American seamen who turned again with vigor and enthusiasm to the lucrative "illegal" smuggling trade they had practiced in their youth. American privateers added more sail to their small vessels, concentrated on building faster ones, sailed harder and sailed circles around the United States naval forces and all the foreign competition.

By the 1840's American seamen had discovered other rich treasure houses available primarily to the swift. The flourishing East India trade was expanded to include the China tea trade in which New York and London merchants paid handsome bonuses for speedy deliveries. Likewise, the Atlantic packet service, since the inception of the first scheduled packet service between New York and Liverpool by the Black Ball Line's *James Monroe* in January 1818, was making fortunes for those who owned fast ships.

I think it not inaccurate to say that the discovery of gold in California in 1848 gave final impetus to the most glorious decade in American maritime history. On land America was ill-prepared for the Gold Rush; the West was still unexplored, expansion was in its infancy and no railroads or wagon roads far from the eastern seaboard existed. The sea, however, offered a different story — and here almost overnight the seaman's worship of speed became the worship of a deity. For decades American shipbuilders had been building better and faster ships; it took but this final convulsion of national excitement, this wild, mad scramble to get to San Francisco, to bring the evolution to its climax in the American extreme-clipper ships, the most beautiful vessels ever fashioned by the hand of man.

To sail these ships America had also produced an incredible breed of seamen — men with years of experience in sailing their vessels to the limits of their designed speed and beyond in fair weather and foul, wise in the ways of the sea, superior seamen in all respects. Finally, America had developed great sea captains — men like Captain "Nat" Palmer, Bob Waterman, E. C. Gardner, Samuel Samuels — men accustomed to driving their vessels to the brink of disaster week after week, worshiped and cursed by their crews as they raced their ships down the miles of the sea to a niche in history. Their incredible races around the Horn, the records they set and the speeds they attained provide a saga as gripping as any in recorded history and brought a great surge of pride and confidence to a boisterous nation.

As reporters and as businessmen aware of the national fascination for the clipper ships and their countless record-breaking runs on the seven seas, Currier & Ives employed such notable marine artists as James E. Butterworth, Charles Parsons, and the McFarlane brothers to produce portraits of the more famous clippers and to record the dangers of the Cape Horn passage, storms at sea and other calamities that befell these hard-driven ships.

It is tragic that any discussion of the clipper ships must end with an epitaph. Their glorious career was short-lived; yet lean, graceful, over-rigged, hard sailed, the epitome of speed and beauty, their usefulness was limited solely to satisfying the violent momentary urge for speed at any price without regard for cargo capacity or capability to deliver large amounts of goods to world ports at satisfactory profit. For a moment in history they met a crisis, caught the world's fancy, accented America's supremacy on the seas, set records for voyages to the corners of the world that will never be equalled under sail. For a moment they enthralled America, caught every nuance of a youthful nation flexing its muscles.

Yet as quickly as the clippers flowered, representing the ultimate of America's heritage of skill, exuberant courage, and adventurous spirit, so they vanished. Thus in faithfully depicting the clipper ship in all its glamour and achievement, Currier & Ives performed an additional unexpected service — to record for posterity the Golden Age of Sail and the climactic role played by American designers, shipbuilders, owners, seamen, and captains in presenting to the world the skill and initiative of the New World until then unrecognized by the Old.

WALDO C. M. JOHNSTON

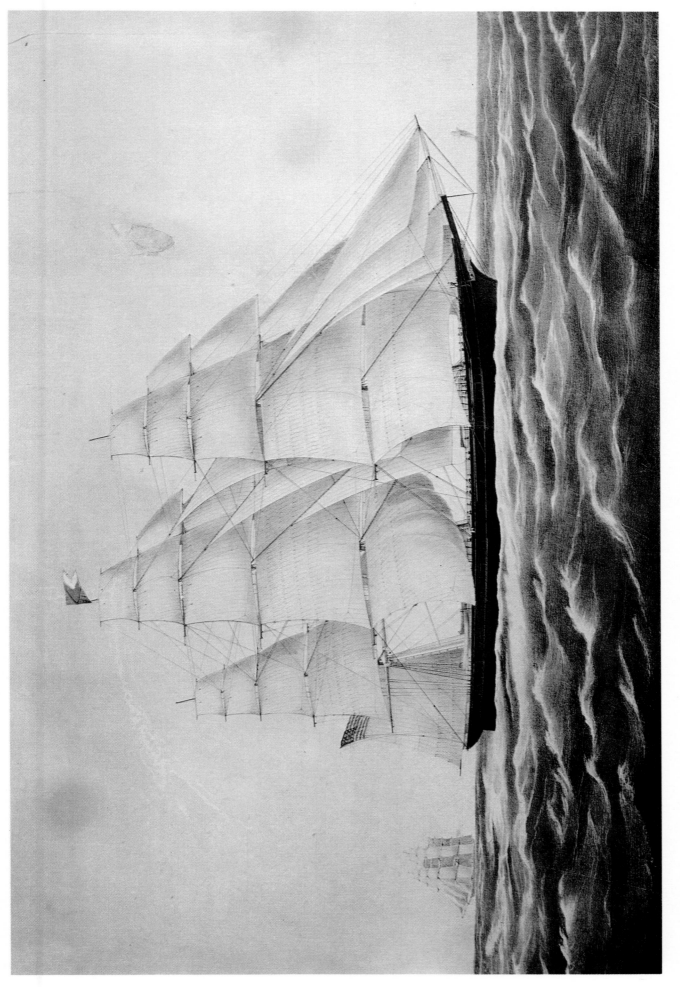

CLIPPER SHIP "FLYING CLOUD"

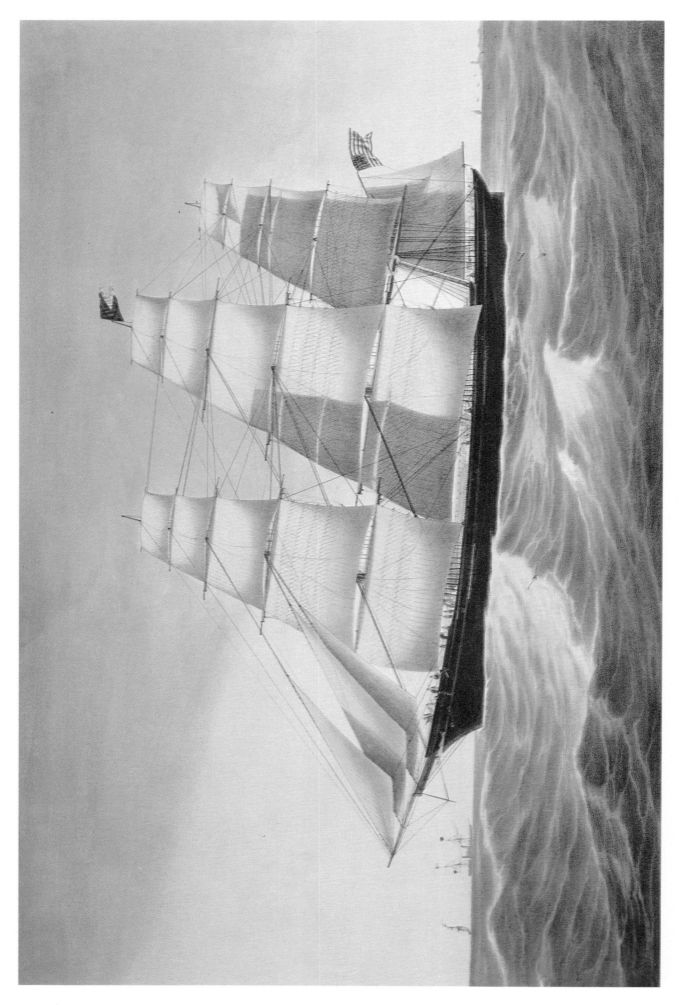

CLIPPER SHIP "SOVEREIGN OF THE SEAS"

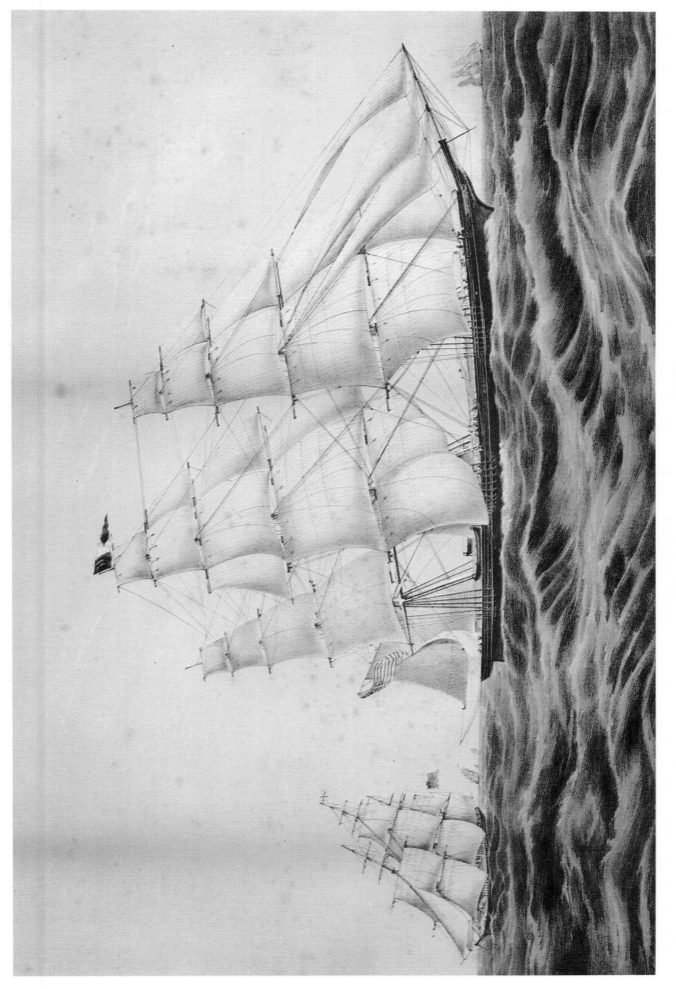

CLIPPER SHIP "SWEEPSTAKES"

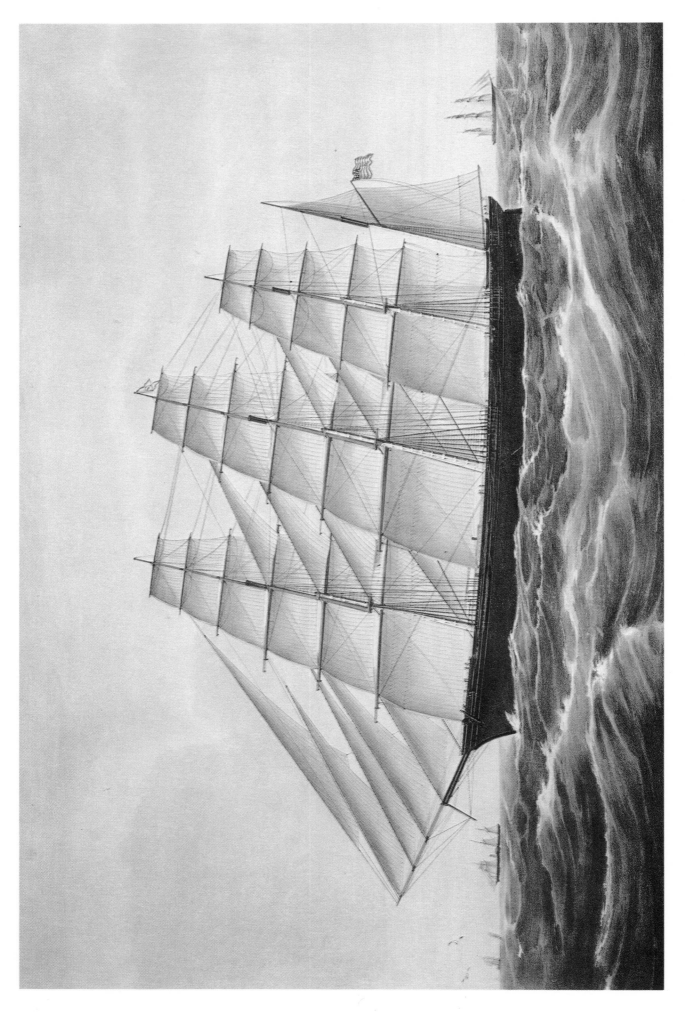

CLIPPER SHIP "GREAT REPUBLIC"

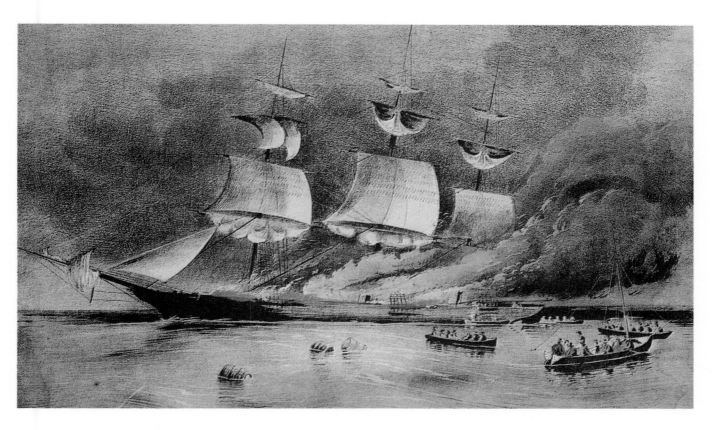

BURNING OF THE CLIPPER SHIP "GOLDEN LIGHT"

The "Golden Light" sailed from Boston for San Francisco, February 12, 1853 at Nine O'Clock P.M. On the 22nd of February during a thunderstorm she was struck by lightning and set on fire. At Six P.M. of the 23rd, all hands were driven to the boats leaving the ship entirely in flames.

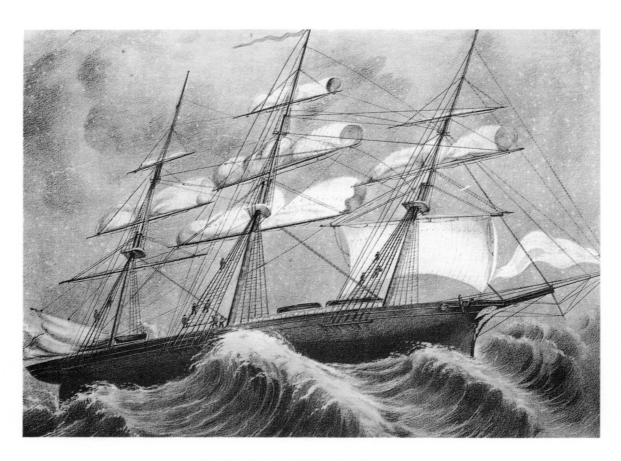

A SQUALL OFF CAPE HORN

A VIEW OF THE CLIPPER SHIP "DREADNOUGHT" ABOUT 1872

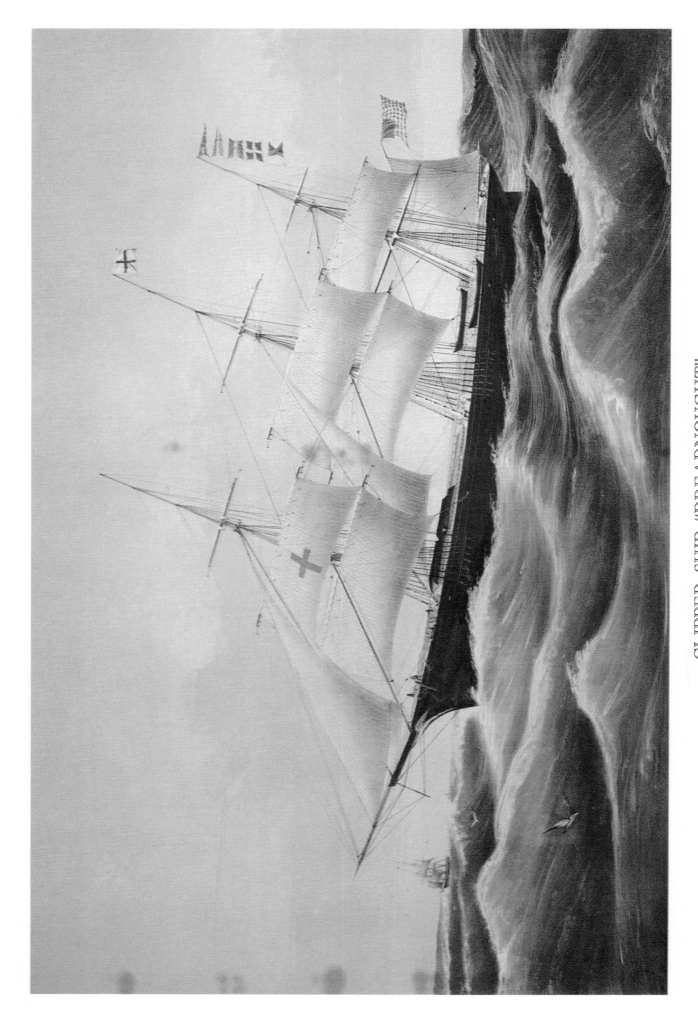

CLIPPER SHIP "DREADNOUGHT"

OFF SANDY HOOK, FEBRUARY 23, 1854, NINETEEN DAYS FROM LIVERPOOL.

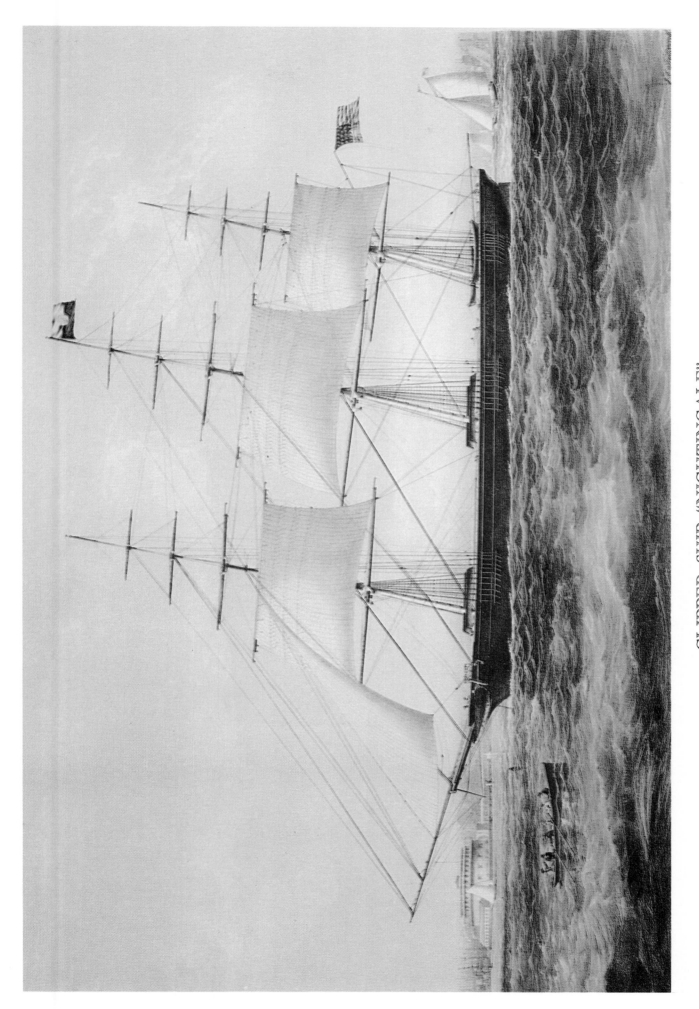

CLIPPER SHIP "NIGHTINGALE"

GETTING UNDER WAY OFF THE BATTERY, NEW YORK.

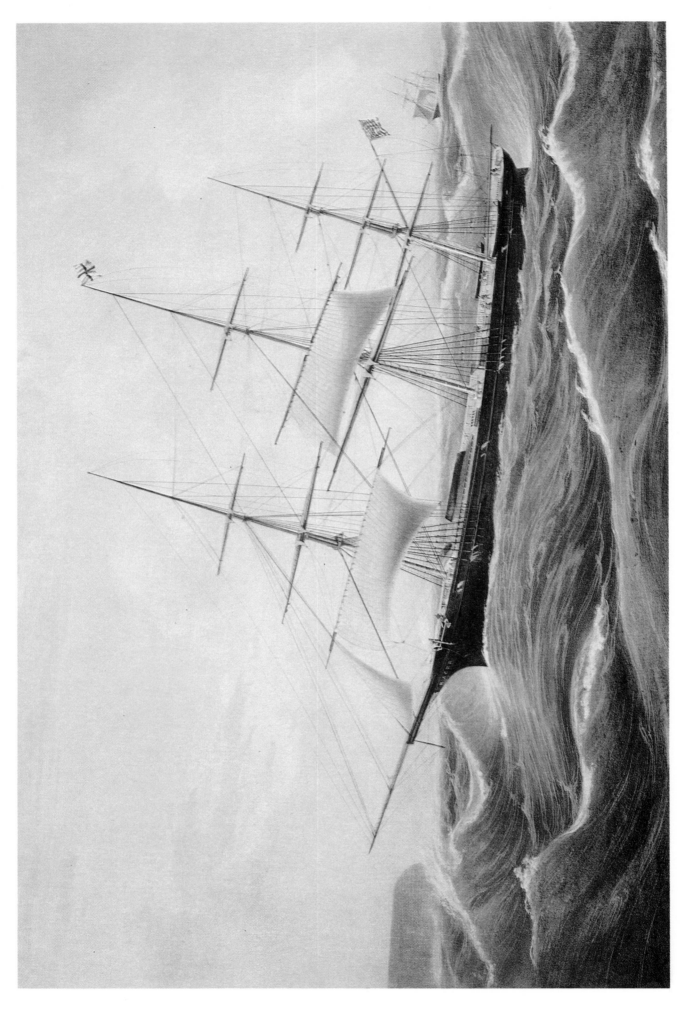

CLIPPER SHIP "RACER"

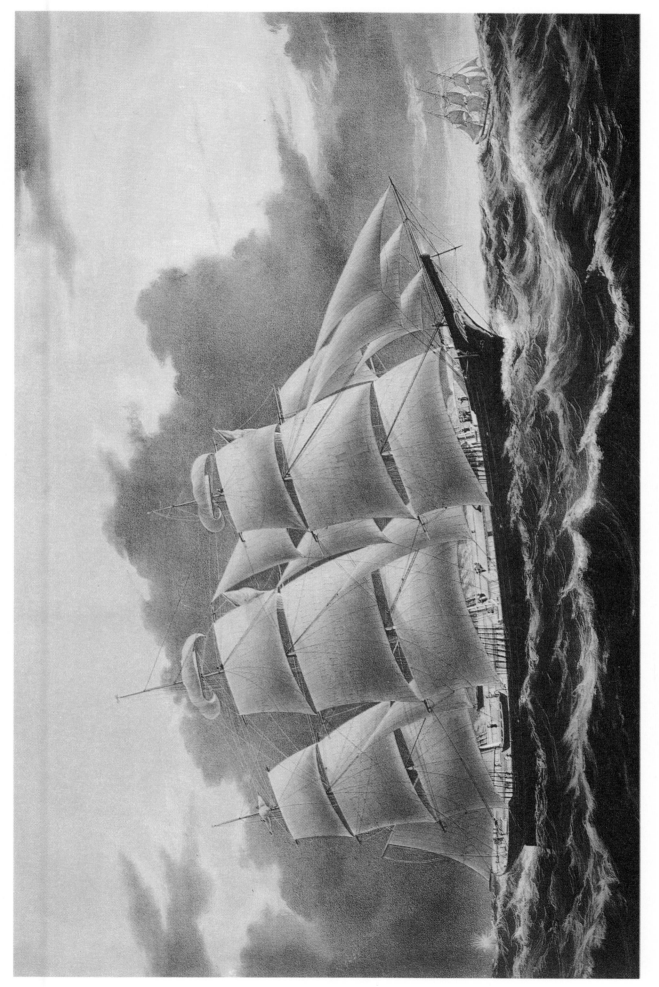

CLIPPER SHIP "DREADNOUGHT" OFF TUSKAR LIGHT

Twelve and one-half days from New York on her celebrated passage into dock at Liverpool in thirteen days, eleven hours, Dec., 1854.

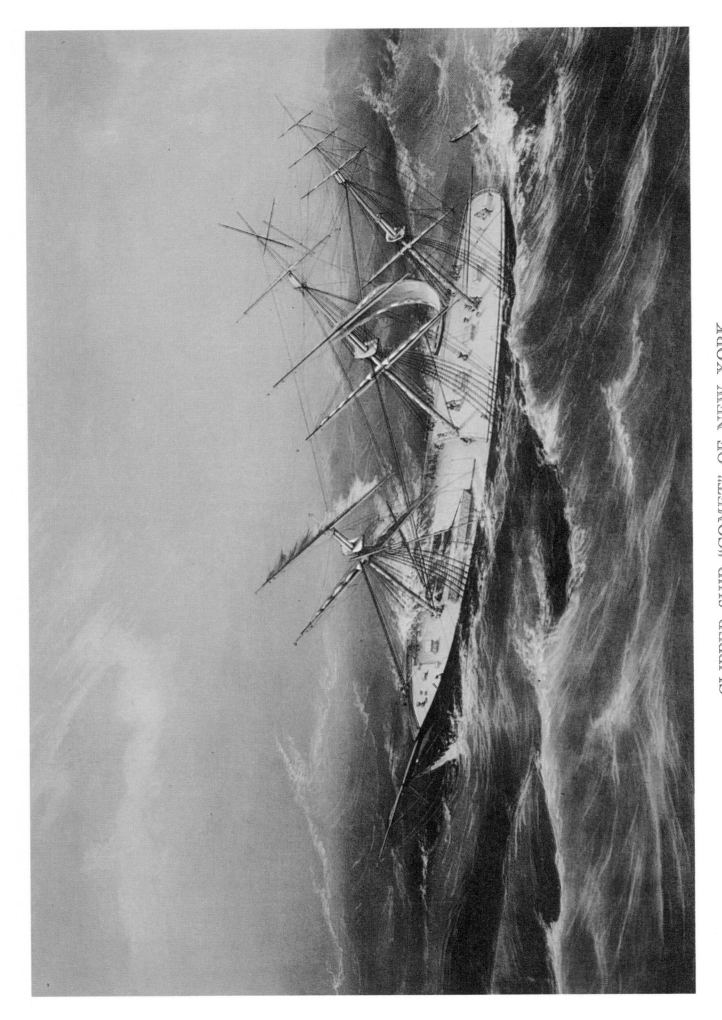

CLIPPER SHIP "COMET" OF NEW YORK

IN A HURRICANE OFF BERMUDA ON HER VOYAGE FROM NEW YORK TO SAN FRANCISCO, OCT. 2, 1852.

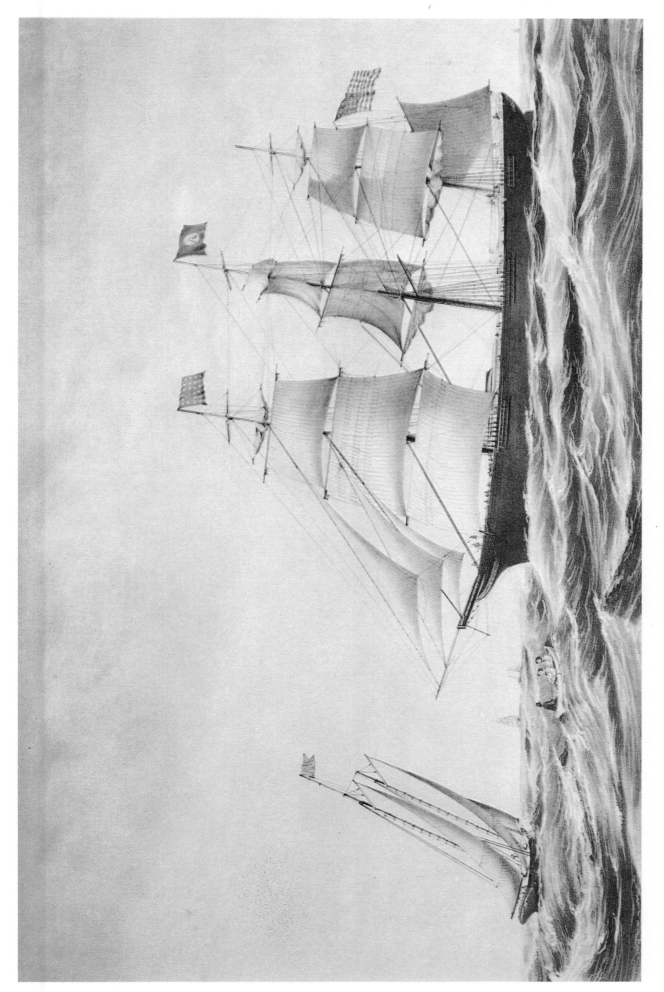

"HOVE TO" FOR A PILOT

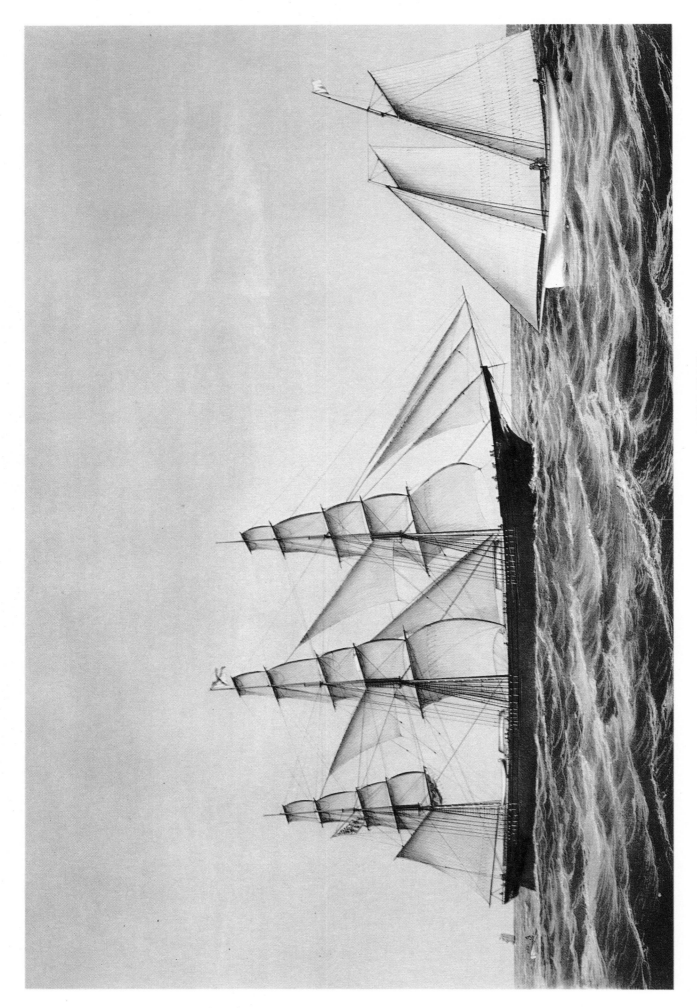

CLIPPER SHIP "OCEAN EXPRESS"

OUTWARD BOUND "DISCHARGING THE PILOT."

Whaling

For a nation literally born of the sea, it was natural that the New England seacoast should develop the art of fishing almost from colonial days. Of all fishing activities the hunting and killing of whales, the largest mammals on earth, logically developed into the most lucrative and exciting industry of all.

During the eighteenth century the great whale pods off Cape Ann, Cape Cod, in the waters of Buzzards Bay and Nantucket Sound were plentiful. Oil for the lamps of Boston, New York, Baltimore and Philadelphia was in great demand, as was to a growing extent the need for whale oil to lubricate machinery and whalebone for milady's fashion and other domestic use. Those hardy New England seafarers not otherwise engaged in privateering or smuggling were quick to see the potential profits from whaling. By the close of the eighteenth century New England whaling had become a firmly established industry.

At first, relatively small vessels were used and Nantucket became the center of whaling. As the great pods were decimated and local whales driven off, larger and larger vessels were needed, staunch seagoing ships able to hunt far from American shores, vessels too deep to venture across the bar at the entrance to Nantucket harbor. As a result Nantucket went into decline and the mainland coast ports of Salem, New London and New Bedford became the leading whaling ports of the world. The extent of the wealth and influence of whaling is apparent in 1846 — a year in which the American whaling fleet numbered 736 ships. In 1856, the zenith of American whaling, the whaling fleet of New Bedford alone numbered more than three hundred vessels.

Thus while America was reaching pinnacles of glory and renown in world commerce in the first half of the nineteenth century, fortunes and the power of empire were being laid in New England whaling. American whaleships hunted relentlessly the seven seas, cruising the waters off Cape Horn and the Cape of Good Hope, the far reaches of the Pacific and the Indian Oceans, even the ice packs of the Antarctic. The average whaling voyage lasted three years, and life aboard ship was indescribably harsh, yet incredibly exciting and full of adventure, usually rewarding, and often fatal. Fate and superb seamanship held the aces; a successful voyage could bring great profit to owners and the captain.

As part of the American maritime pageantry, Currier & Ives faithfully depicted scenes of the whale hunt and the sailors' courage against the mightiest beast on the face of the earth, a beast that played a leading role in the development of this nation.

WALDO C. M. JOHNSTON

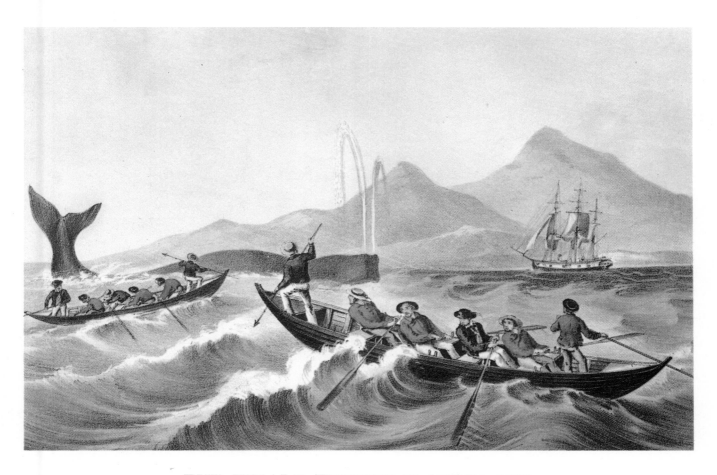

THE WHALE FISHERY "LAYING ON"

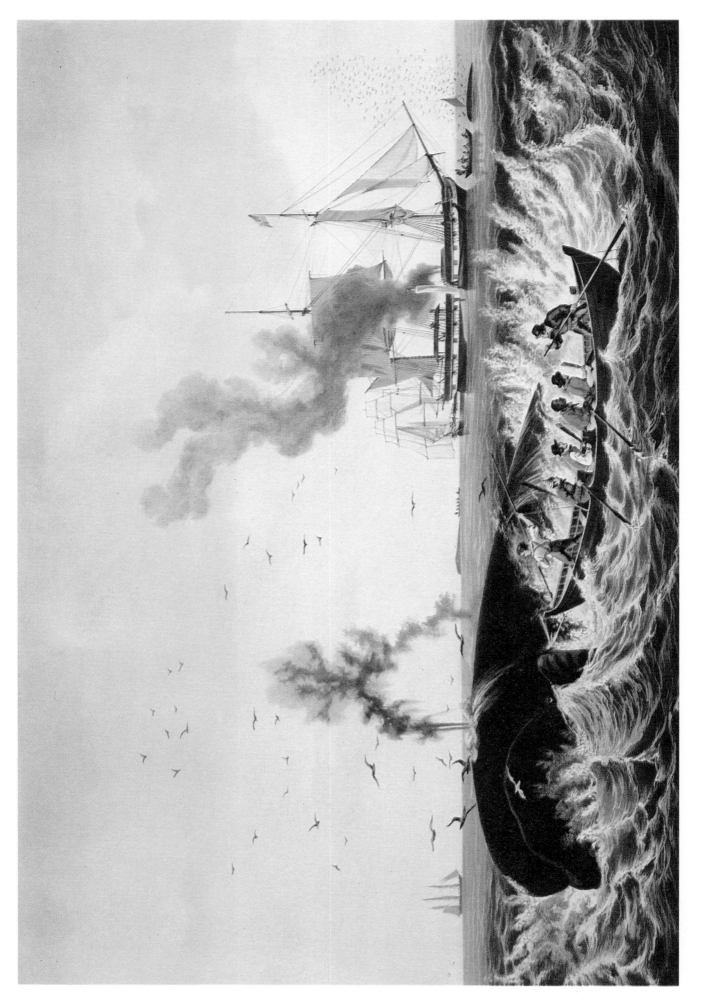

THE WHALE FISHERY

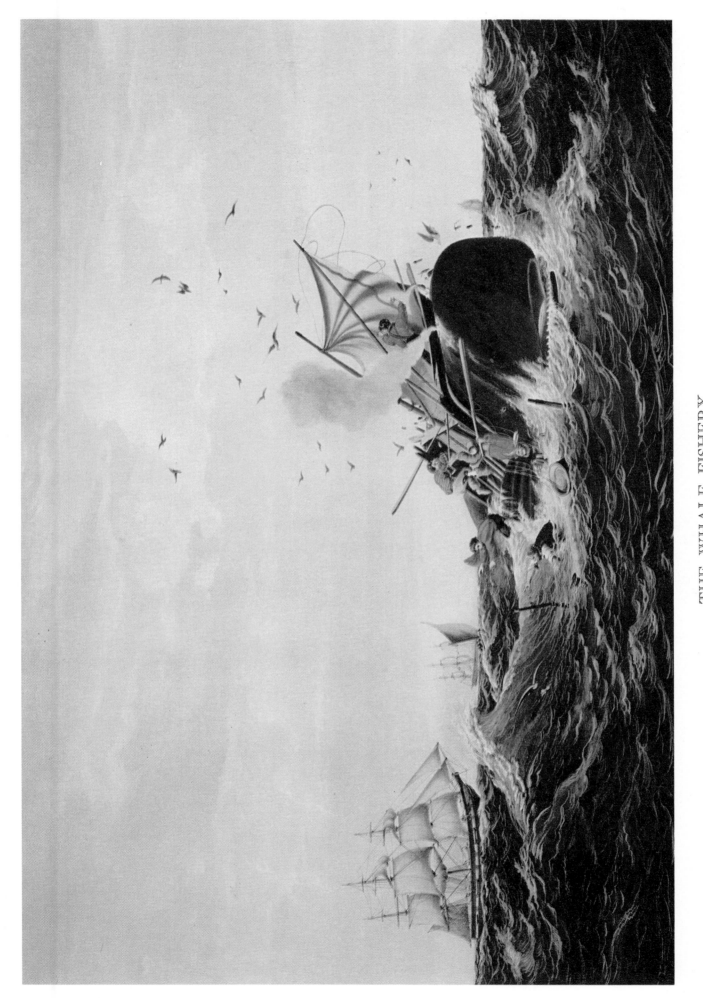

THE WHALE FISHERY

THE SPERM WHALE "IN A FLURRY"

While an exuberant America was flexing its boisterous muscles and showing the stern of its vessels to the world's commerce in the mid-nineteenth century, other elements of American superiority on the sea were beginning to manifest themselves. American yachtsmen were appearing in Boston and New York. These men were a handful of wealthy ship-owners who had a little time to play and vast wealth or shipyards which enabled them to build personal vessels for their own enjoyment.

Conceivably the first yachtsman in America was Adriaen Block, a Dutch fur merchant in Nieuw Amsterdam, who, aboard his own little boat, *Onrust,* was cruising Long Island Sound in 1614 before the Pilgrims landed at Plymouth Rock. Though he did not discover it, Block Island was one of his favorite spots and subsequently was named in his honor.

Other sailors were engaged in "yachting" in the early decades of the nineteenth century, but if I were pressed to name a date signifying the birth of American yachting it would be that of the formation of The New York Yacht Club which took place aboard John Stevens' schooner *Gimcrack* in New York Harbor on July 30, 1844. From this moment on, much of the illustrious history of American yachting centers around this famous club.

Stevens and his small group of fellow members were ardent sailors and owned fast yachts. They organized cruises to Newport and other New England harbors; they raced among themselves at every opportunity, and kept such notable designers as George Steers busy designing faster yachts. News of their exploits reached London. Could these upstart American yachtsmen really sail and did they presume to think their schooners a match for England's finest? International conjecture became a subject of increasing debate in yachting gams in both nations.

It was inevitable that a gauntlet be tossed and an opportunity extended to settle the dispute. In 1850 in response to a veiled challenge from London, Commodore John Stevens and some clubmates built the schooner yacht, *America,* and sailed her to England via Le Havre in July 1851. On the morning of her arrival in English waters, *America* was greeted by a new English yacht, *Laverock,* and enticed into an immediate impromptu race. Even though she was in cruising ballast, *America* gave *Laverock* a sound thrashing, a victory that so stunned British yachtsmen that nary a one dared step forward to accept the visitor's open challenge to a match race. In some desperation, Stevens entered *America* in a rather nebulous "International Yacht Race" around the Isle of Wight that had been promoted some months earlier by the Royal Yacht Squadron. A nondescript "100 Guinea Cup" was offered to the winner.

Word of the American entry in this race created a sensation; at once all eyes were focussed on the race and seventeen English yachts entered to dispel the myth of *America*. The spectacular defeat of the Royal Yacht Squadron's finest by *America* off Cowes on August 22, 1851 signaled to the world our emergence as a nation of the world's greatest amateur sailors just as vividly as our clipper ships demonstrated their superiority by one record-breaking run after another. The nondescript "100 Guinea Cup" was to become known as the "America Cup" which might even be called the yachtsman's Holy Grail. For 117 years there have been numerous unsuccessful attempts to win the Cup from its revered niche in the New York Yacht Club.

The impact of the *America*'s victory did not go unnoticed in New York, and Mr. Currier was quick to order a portrait of the yacht to be lithographed and made available to the public. Over the succeeding decades Currier & Ives continued to portray the magnificence of American yachts whose beauty rivaled the clippers, particularly when a number of them could be depicted together in a regatta. Over the decades, achievements of American yachts were plentiful, giving Currier & Ives full scope to their talents. They proudly recorded these events for American drawing rooms — the spectacular Atlantic match race of *Fleetwing, Vesta* and *Henrietta,* in the dead of winter in 1866 won by *Henrietta* (13 days, 21 hours, 55 minutes from Staten Island to the Needles off the Isle of Wight), the successful defense of the America Cup[1] by *Sappho* against the English yacht, *Livonia,* in 1871 and the successful defense by *Madeleine* against the Royal Canadian Yacht Club challenger,[1] *Countess of Dufferin,* in 1876.

These and other yachting scenes were colorfully recorded by Currier & Ives. Had they lived, with what pride and enthusiasm would they have depicted modern yachts — the beautiful "R" boats of the early 1900's, the spectacular "J" boats of the 20's and 30's, the Bermuda Race fleet, such tireless ocean pacemakers as *Finisterre* and *Ondine,* the Cup defenders *Columbia, Weatherly* and *Intrepid!* Lastly, one might hope that they might have just sketched on the walls of Valhalla a portrait of *Gipsy Moth* marking the single-handed global passage of Sir Francis Chichester, the greatest yachting voyage of all.

[1]*Currier & Ives erroneously captioned three of the races here illustrated. The race for "The Queen's Cup" on August 25, 1851 was never officially entered by America. The "100 Guinea Cup" won by America on August 22, 1851 became known as the "America Cup." In each case illustrated, "Queen's Cup" should read "America Cup."*

WALDO C. M. JOHNSTON

THE CLIPPER YACHT "AMERICA" OF NEW YORK

WINNER OF "THE CUP" IN THE GREAT MATCH FOR ALL NATIONS AT COWES, AUGUST 22ND, 1851.

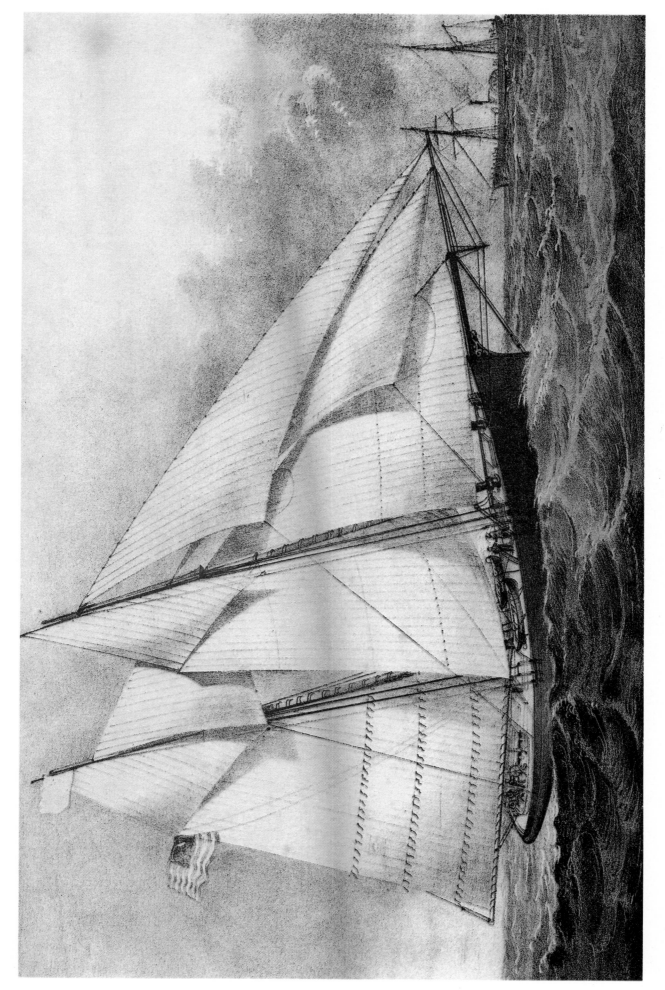

THE YACHT "HENRIETTA" OF N. Y. 205 TONS

OWNED BY MR. JAS. GORDON BENNETT, JR.

WINNER OF THE GREAT OCEAN YACHT RACE, FROM NEW YORK TO COWES, DECEMBER 1866.

It left Sandy Hook, Dec. 11, 1866, and arrived off the Needles, Isle of Wight, England, at 5:45 P.M. Dec. 25, 1866. Making the run in 13 days 22 hours mean time.

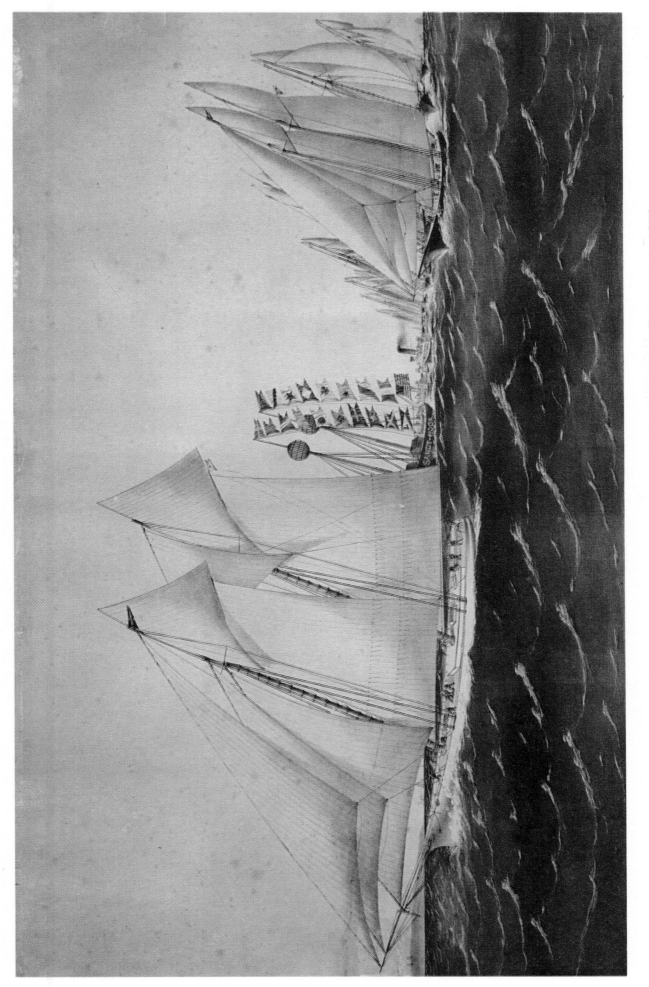

THE GREAT INTERNATIONAL YACHT RACE, AUGUST 8, 1870

FOR THE QUEEN'S CUP WON BY THE AMERICA AT COWES, IN 1851.

From the Club house, Staten Island, N.Y. around the s.w. spit to and around the light ship off Sandy Hook and back, 40 miles. Seventeen American and the English Yacht CAMBRIA *started at 11.21 A.M. The race was won by the* MAGIC, *which rounded the home stake boat in 3 hours, 33 minutes, 54 seconds. The Yachts Tidal Wave, Widgeon, and Alarm failed to complete the race and were ruled out.*

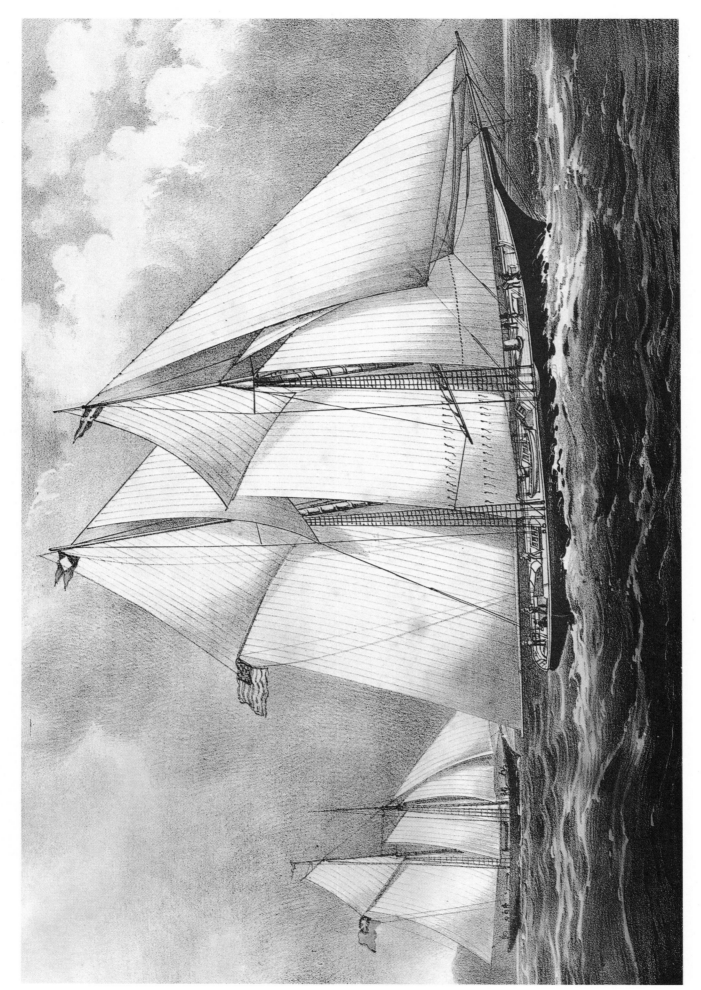

THE RACE FOR THE QUEEN'S CUP

BETWEEN THE AMERICAN YACHT "SAPPHO" AND THE ENGLISH YACHT "LIVONIA," IN NEW YORK HARBOR, OCTOBER 23RD, 1871.

Won by the Sappho, time 4:38:5. Livonia's time 5:4:41.

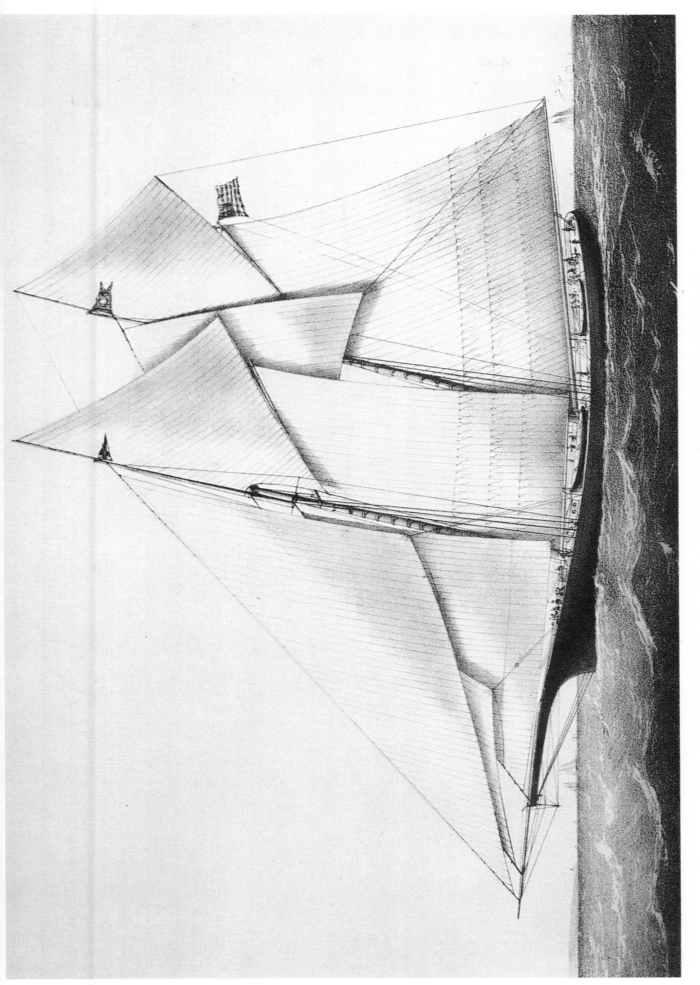

THE YACHT "MADELEINE," N.Y. YACHT CLUB

OWNED AND COMMANDED BY COMMODORE JOHN S. DICKERSON.

Winner of both matches against the Canadian Yacht "Countess of Dufferin" in her challenge to recover the "Queen's Cup" won by the America from the Royal Yacht Squadron, at Cowes, Aug. 22, 1851. The Madeleine won the first match Aug. 10, 1876 over the Club course, N.Y. Harbor, by 10 min. 59 sec. and the second Aug. 11, 1876, from buoy 5½ off Sandy Hook, 20 miles to windward and back, by 27 min. 14 sec.

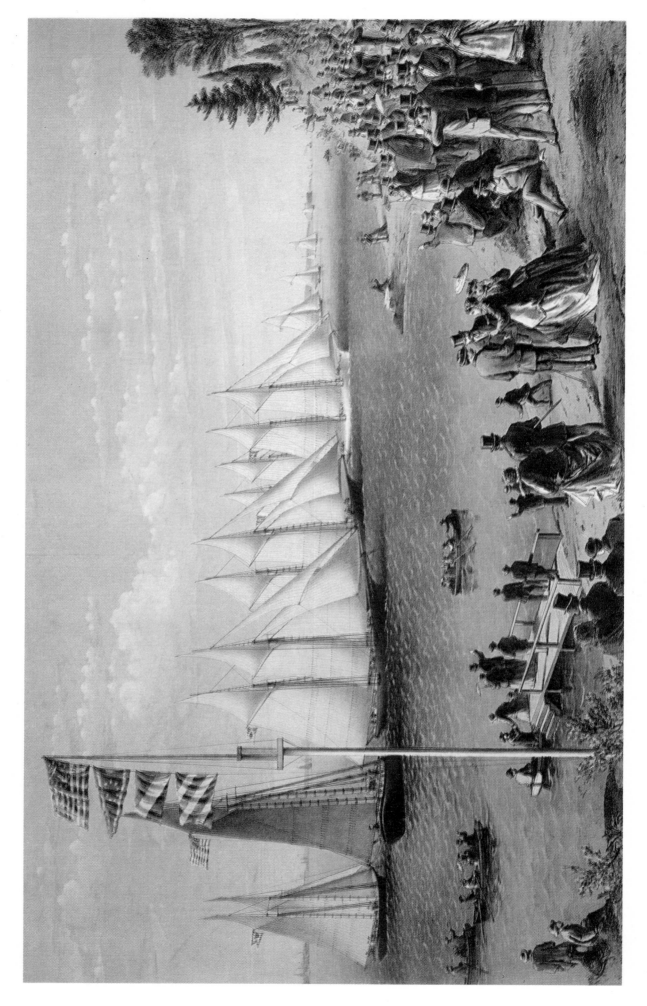

THE NEW YORK YACHT CLUB REGATTA

THE START FROM THE STAKE BOAT IN THE NARROWS,
OFF THE NEW CLUB HOUSE AND GROUNDS, STATEN ISLAND, NEW YORK HARBOR.

From the days of the ancients, Man has constantly searched for apparatus that would add strength to his muscles and comfort to his environment. The earliest sailor can presume to have been aware of the power in the winds that buffeted his fragile craft, and his effort to harness this power to drive his boat while he rested on his oar is recorded in the earliest history of all peoples who ventured on the sea.

Over the centuries mariners developed ever more sophisticated sails, rigging, and vessels to improve speed and performance, reaching a peak of perfection in the age of the clipper ship. Certainly these ships were universally admired. As fast, efficient sailing machines of incredible beauty they were inspirational — but, like every sailing vessel, they could not sail directly into the wind and were subject to the wind's vagaries.

At the beginning of the nineteenth century events were taking place ashore that went unnoticed by the square-rigger men. Able engineers in America, England, and France were eying the heavy, ponderous, inefficient steam engine with thoughtful purpose. Could this awkward machine that dribbled and shook and huffed and sighed like a fat man with a perpetual cold — could this contraption be harnessed to give a vessel the ultimate freedom of movement to sail at will in any direction regardless of unfavorable wind, foul currents, calms; to move under its own power, unshackled by the whims of Aeolus? They were men of varied backgrounds, education, and experience, but they must have shared a mutual urge to tinker and invent and a universal dream to make Man's life easier by propelling vessels under power. As early as 1783 the Marquis de Jouffroy d'Abbans built a little steamboat that was able to move on the Saône. In the succeeding years men like James Rumsey, John Fitch, William Symington and the Scotsman, Henry Bell, were tinkering independently; but Robert Fulton seems to have captured most of the credit by the successful trip of his *Clermont* up the Hudson in 1807. In 1809 the steamboat, *Phoenix,* became the first to venture on the open sea. Her timid voyage from New York to Philadelphia took thirteen days because she only dared to move when the seas were absolutely calm. Since any respectable square-rigger could run from New York to Philadelphia in two days or less, the slow, cautious passage of the *Phoenix* only heightened the disdain toward steam heard in fo'c'sle gossip. In 1819 Captain Moses Rogers, of *Phoenix* fame, took the *Savannah,* a full-rigged ship carrying steam and paddle wheels as auxiliary power, from New York to Liverpool. Though he only used his steam engine about 85 hours on this passage, Rogers' feat convinced some far-sighted shipping men that the steamboat had potential for long passages.

To most, however, the steamboat remained an awkward, slow, chuffy phenomenon whose use was solely limited to the calm waters of rivers and harbors — more a novelty than a means of safe, practical waterborne transportation. Obvi-ously the fragile paddle wheels, the noisy inefficient steam engines, the slow speed, and the ravenous appetite for cordwood or coal which consumed most of a vessel's cargo capacity offered no challenge to the square-riggers.

Yet advances continued over the middle years of the century. The screw replaced the paddle wheel for deep water operation; development of the compound steam engine, increase in steam pressure, use of iron in place of wood for hulls; all contributed to the rapid advance of the steamship as a fairly efficient oceangoing vessel that could challenge the speed of most windjammers, could move in any direction regardless of wind or calm and could maintain fixed schedules.

One of the great designers of the time was Isambard Brunel, son of a gifted English architect and engineer. His greatest ship, the *Great Eastern,* was designed in 1852, and "vast" is the only word to describe her. Almost 700 feet long, she was designed to carry 4,000 passengers, an enormous vessel even by modern standards. Her engines burned 330 tons of coal a day, fed from bunkers designed to carry 12,000 tons. Her iron hull was actually two hulls, one built inside the other; she also was multi-compartmented, and for propulsion was equipped with paddle wheels and screw. A truly fabulous vessel, she was far ahead of her time and a costly failure. She had a brief moment of usefulness during the years immediately after the Civil War when she laid Cyrus Field's Atlantic telegraph cable. For this one unheralded feat *Great Eastern* performed a useful purpose. In 1888 she died on the scrap heap, an ignominious end to the unfulfilled life of an extraordinary ship.

As faithful reporters, Currier & Ives recorded the development of the steamboat from the *Clermont* down through the century that was to mark its eventual victory over sail. I feel, however, that their coverage of the steamship lacks their customary perfection — undertaken perhaps more from a sense of obligation to record than interest. In my opinion, their steamship lithographs lack the artistic quality and fidelity of most of their work — or perhaps this is my prejudiced view as a sailor with an intense dislike for any form of mechanical propulsion in a vessel. Their work recovers some of its customary flavor in depicting river scenes, small steam vessels and catastrophes such as *The Awful Conflagration of the Steam Boat Lexington in Long Island Sound,* a spectacular event for onlookers but hard on the passengers and crew. Perhaps they shared the view of many contemporaries that the steamship was not here to stay — at best a cranky, fussy, dirty, unglamorous method of propulsion — or perhaps they foresaw that the steamship's short day in the sun would but serve the solitary purposes of shrinking the world's trade routes and initiating further advances in the development of turbine and nuclear power at sea as Man continues his relentless search for new ways to harness power for the betterment of his environment.

WALDO C. M. JOHNSTON

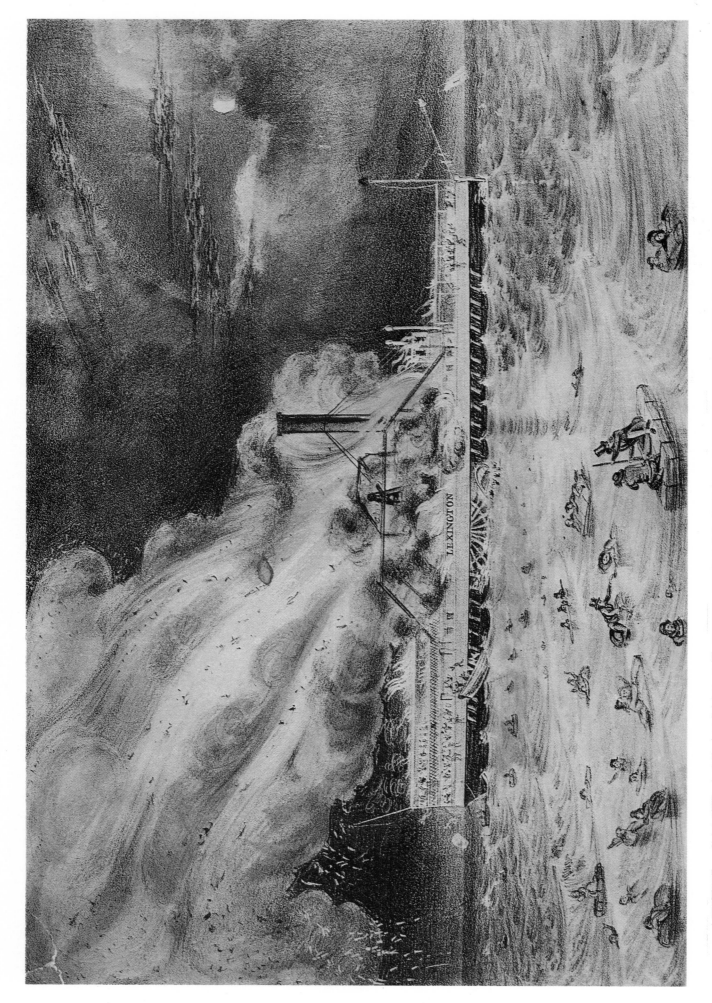

AWFUL CONFLAGRATION OF THE STEAM BOAT LEXINGTON IN LONG ISLAND SOUND

ON MONDAY EVE'G, JAN'Y 13TH 1840, BY WHICH MELANCHOLY OCCURRENCE, OVER 100 PERSONS PERISHED.

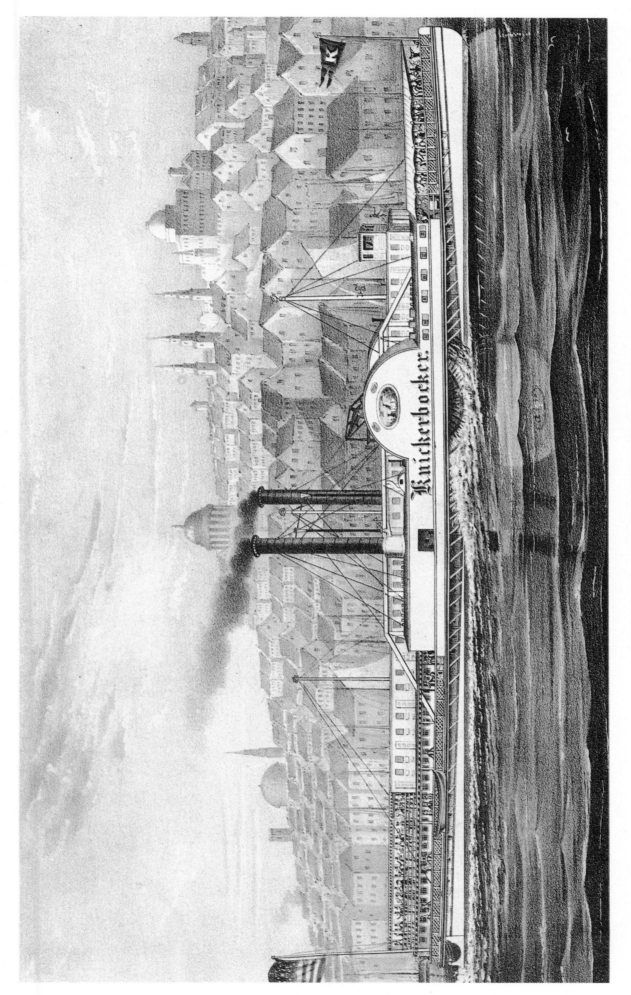

STEAM-BOAT "KNICKERBOCKER"

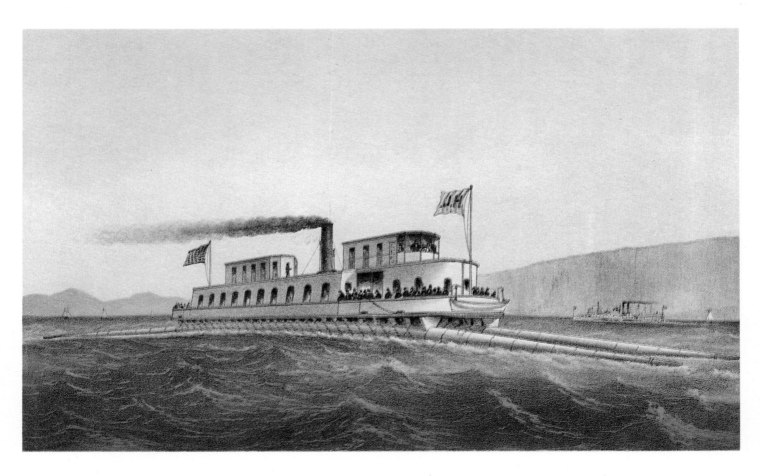

STEAM CATAMARAN "H. W. LONGFELLOW"

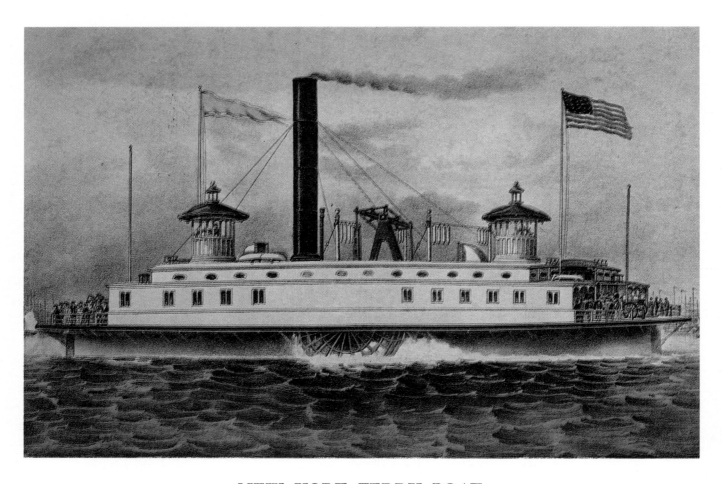

NEW YORK FERRY BOAT

THE SHIPS "ANTARCTIC" OF NEW YORK, AND "THREE BELLS" OF GLASGOW RESCUING THE PASSENGERS AND CREW FROM

THE WRECK OF THE STEAM SHIP "SAN FRANCISCO"

DISABLED ON HER VOYAGE FROM NEW YORK TO SAN FRANCISCO DEC. 24TH 1853 AND IN A SINKING CONDITION.

THE ENTRANCE TO THE HIGHLANDS

HUDSON RIVER — LOOKING SOUTH.

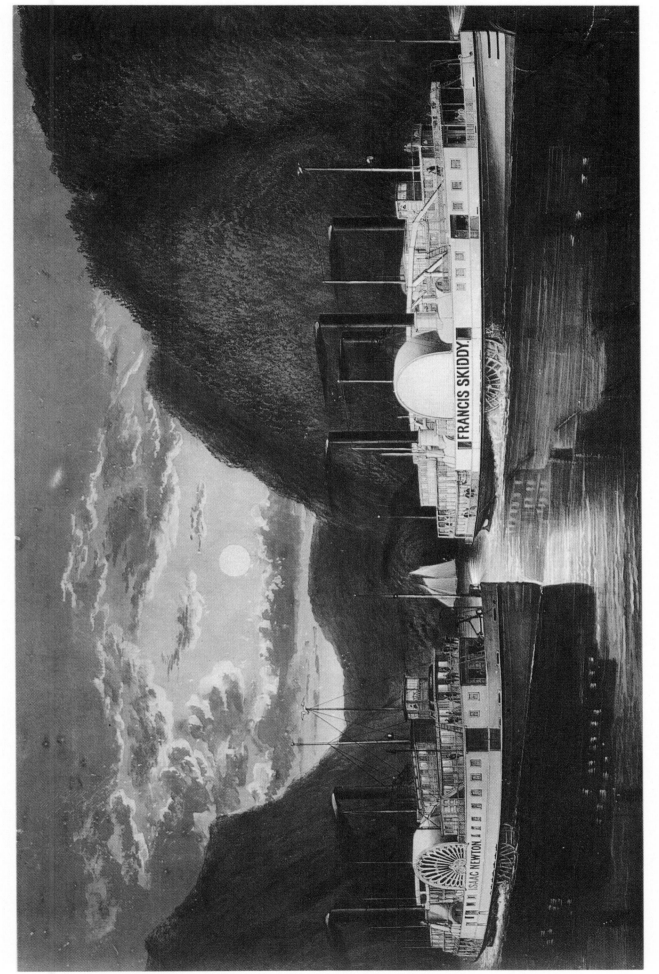

A NIGHT ON THE HUDSON
"THROUGH AT DAYLIGHT."

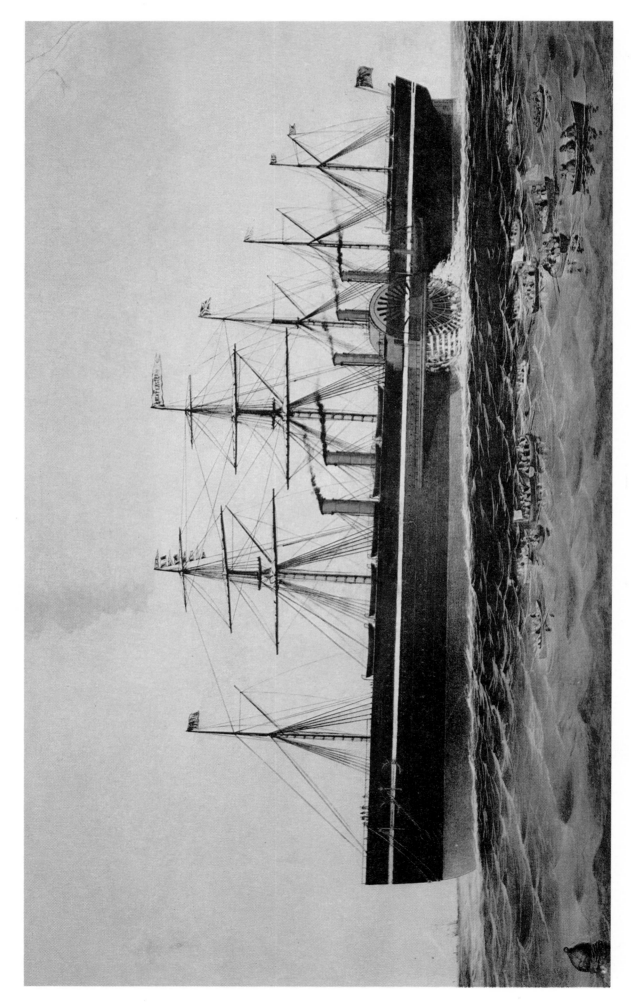

THE IRON STEAM SHIP "GREAT EASTERN" 22,500 TONS

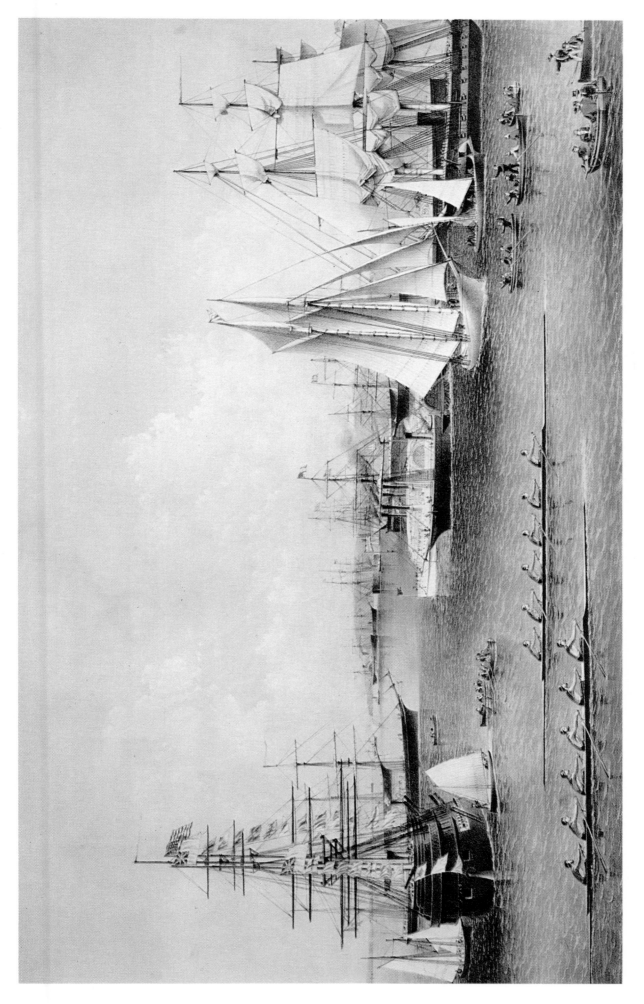

SUMMER SCENES IN NEW YORK HARBOR

VI THE WEST

The North American Indian

The first popularized pictures of the North American Indian were those of George Catlin (1796-1872). He was born in Wyoming (now Wilkes-Barre), Pennsylvania, the scene of a bloody battle and massacre in 1778. His parents had settled there shortly after the Revolution. Educated as a lawyer, Catlin practiced for two years and then sold his law library to take up portrait painting. Not long after this shift he was struck by the dignity and grace of some Indians in their native dress. Foreseeing their doom, he declared: "The history and customs of such a people, preserved by pictorial illustrations, are worthy the life-time of one man, and nothing short of the loss of my life shall prevent me from visiting their country and becoming their historian."

From 1832 through 1839 he traveled from the Rocky Mountains to South Carolina, Florida, Texas, and the Canadian border, painting portraits and scenes from daily life, and collecting costumes and manufactures of the people. He returned with 310 portraits in oil and 200 other paintings and a collection of objects ranging in size from a wigwam to a quill or rattle.

Like Audubon, Catlin was well received in Europe. *Manners, Customs, and Conditions of the North American Indians,* in two volumes, illustrated with 300 engravings from Catlin's paintings, was published in London in 1840. The fourth edition appeared in 1844. It has since gone through many editions.

The volumes made a vivid impression on a world not yet jaded by pictorial journalism. His engravings were pirated to illustrate other books. Inevitably Currier and Ives found subjects to their liking in this rich store.

They were not mere copyists, but altered scenes to suit their ideas and composition. The group on page 87 is not in *Manners, Customs, and Conditions* but combines three of Catlin's figures. The illustrations of the bear dance of the Sioux and the snowshoe dance of the Chippewa (Ojibwa) show some alterations of figures and body paint not shown by Catlin. The former dance was performed to ensure success in the bear hunt, the latter to thank the Great Spirit for sending snow to make hunting easy. The scene showing Indians attacking the grizzly bear is not in any edition of *Manners, Customs, and Conditions* that is available to me. On page 91 there is a faithful reproduction of the slaughter of a buffalo herd by Hidatsa on horseback. The products of such hunts provided the Indians with food, clothing, and shelter. An engraving somewhat resembling *Singling Out* reproduced on page 92 appears as Catlin's fig. 107 but *Buffalo Bull Chasing Back* has no counterpart. Although Catlin describes such an event, he did not paint it — he was too busy avoiding the bull and aiding his friend Chardon, who was rammed and unhorsed by another. *Antelope Shooting* was witnessed by Catlin when his companions Bogard and Ba'tiste decoyed the curious animals with a kerchief on a ramrod, waiting for a chance to get two or three with a single shot.

The wild horses seen at play between the False Washita and the "Great Comanche Village" on page 95 were typical of the herds that sprang from animals that escaped from the Spanish colonists in Mexico or were stolen from them by the Indians. It seems unlikely that the Rocky Mountains would have been in view from this location; the identification of the hill in the background appears to be another artistic license.

DOUGLAS S. BYERS

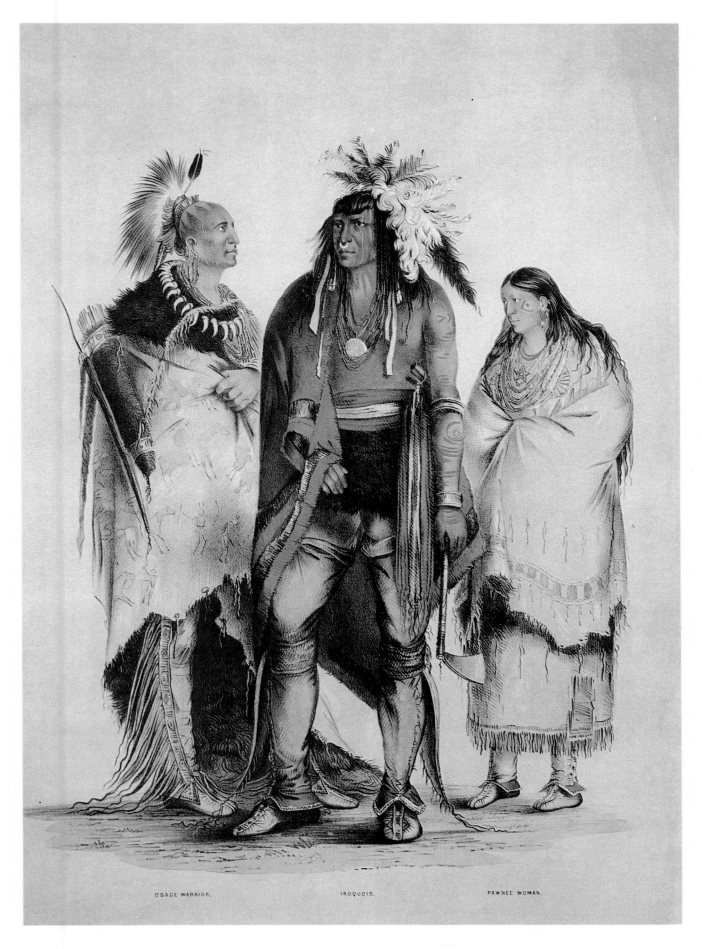

OSAGE WARRIOR. IROQUOIS. PAWNEE WOMAN.

NORTH AMERICAN INDIANS

87

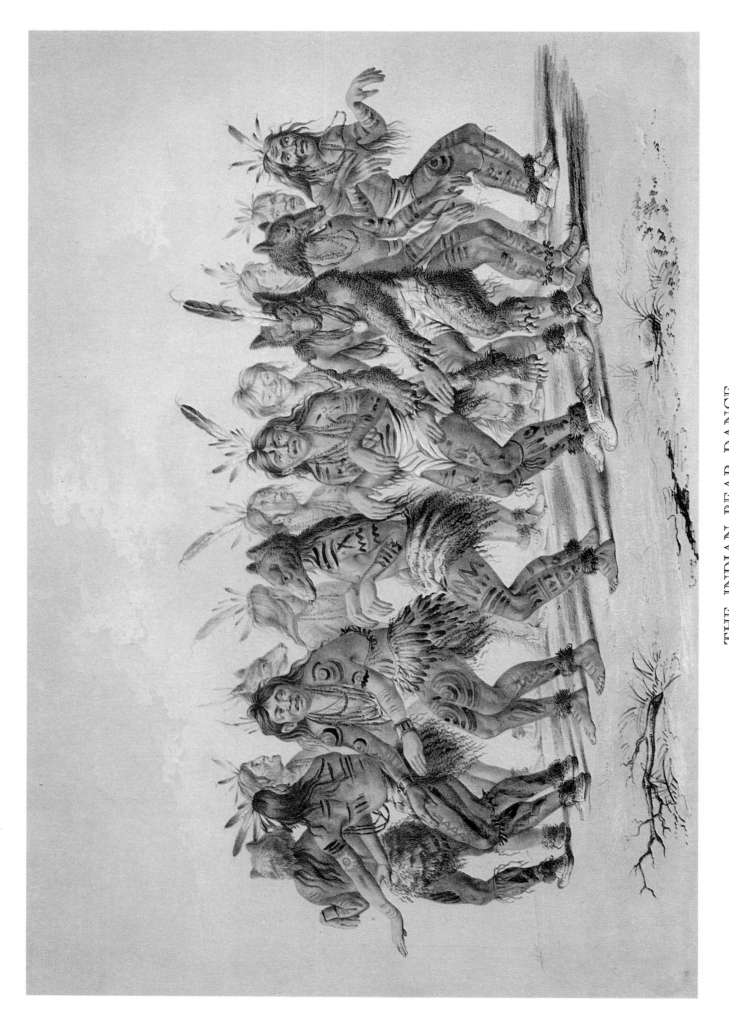

THE INDIAN BEAR DANCE

INVOKING THE AID AND PROTECTION OF THE BEAR SPIRIT.

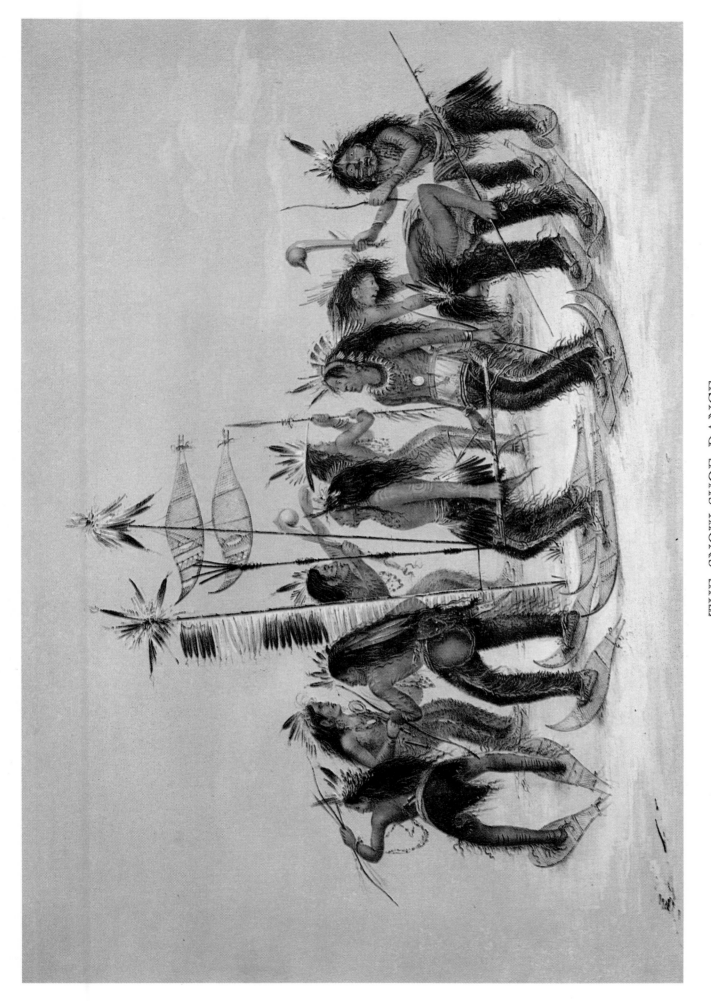

THE SNOW-SHOE DANCE

TO THANK THE GREAT SPIRIT FOR THE FIRST APPEARANCE OF SNOW.

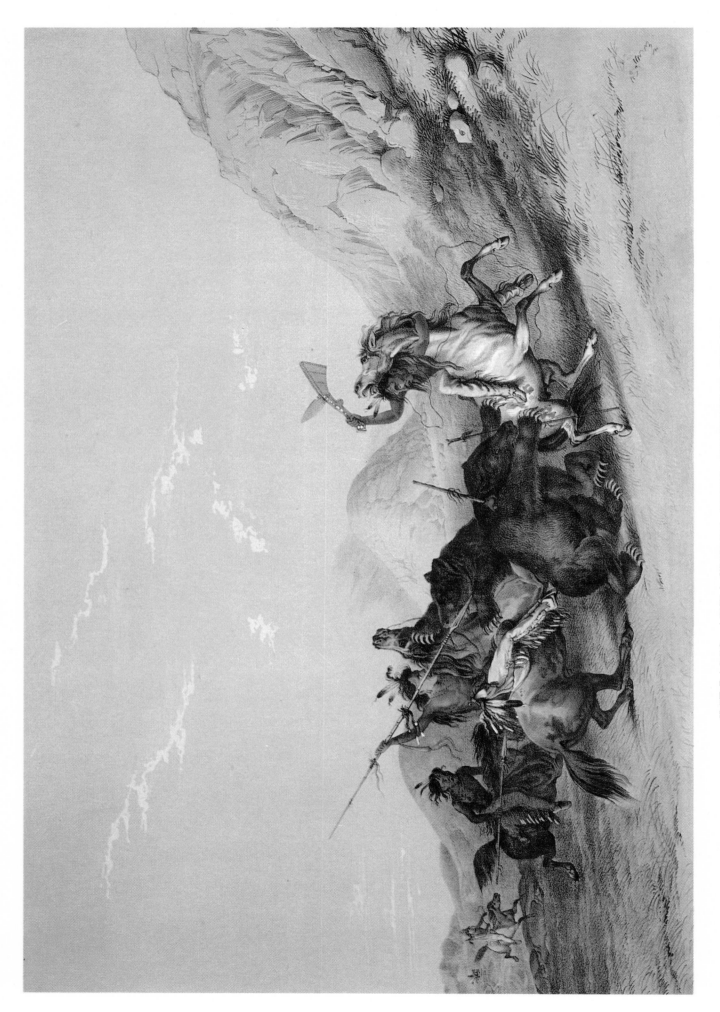

INDIANS ATTACKING THE GRIZZLY BEAR

THE MOST SAVAGE AND FEROCIOUS ANIMAL OF NORTH AMERICA.

90

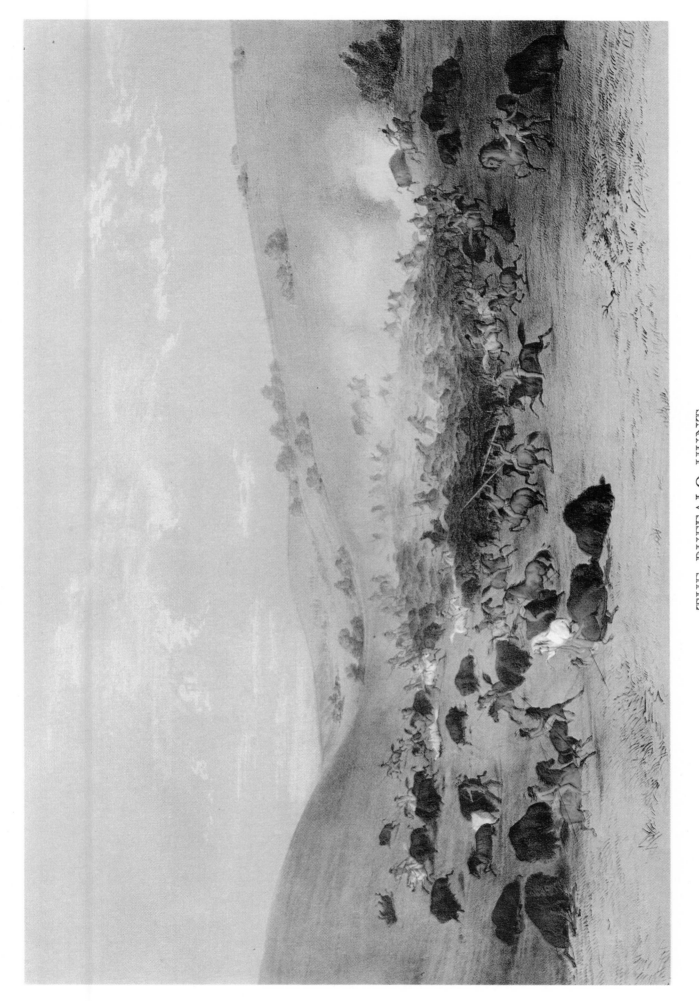

THE BUFFALO HUNT
SURROUNDING THE HERD.

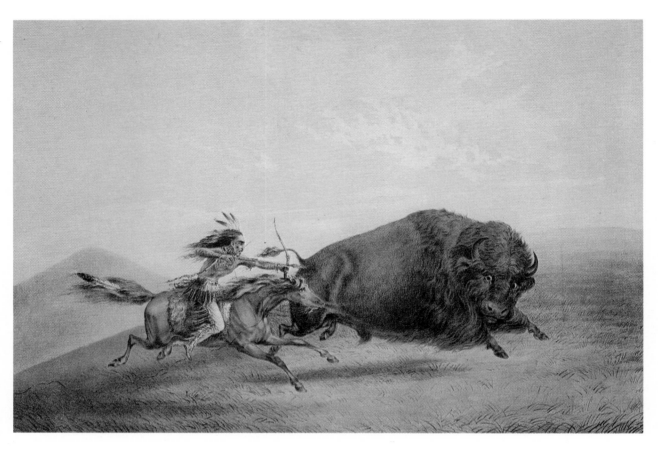

THE BUFFALO CHASE
SINGLING OUT.

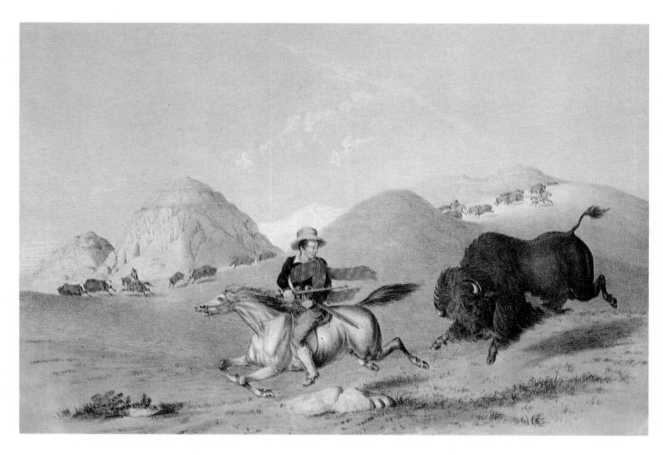

BUFFALO BULL CHASING BACK
TURN ABOUT IS FAIR PLAY.

ANTELOPE SHOOTING

FATAL CURIOSITY.

The Prairies and the Mountains

Once prairie grass swept from the Missouri far to the west, to the end of the rainfall country where the land shoulders upward toward the Rockies. Today there is nearly none. A little survives at Badlands National Monument in southwestern South Dakota — a shallow basin of perhaps a couple of hundred acres, edged with telephone poles and an insistent house or two. Only after a little looking will you find the one point of view from which all the modernisms are hidden, so that there is an illusion that the grass stretches away as it once really did, unending, to the Black Hills on the skyline.

That view out of a vanished past suggests the scale of the uninhabited West that fed American imagination through the nineteenth century. Men dreamed in those years of the endless plains, the broad rivers, the shining mountains; of strange fierce animals and fighting Indians; of land and wealth and wild adventure. Yet the look of that big country was known to few. By the 1830's and 1840's, artists had seen and painted the West. Catlin, Bodmer, Alfred Jacob Miller, and others had recorded, with varying talent, the wild scenes and people. Still, not many ordinary Americans can have been familiar with their pictures. The visual vacuum was probably filled only in the 1850's by the illustrated magazines and by the prints of Currier & Ives and others.

A few of the Currier & Ives western scenes were taken from Catlin's work and show his personal knowledge of the arid landscape — the thin grass and the high sky. But A. F. Tait and Fanny Palmer and John Cameron, who also did western pictures, had never been West and their work shows it. Cameron, the Scottish hunchback, made grass and cactus grow improbably together in a corner of *A Parley*. Fanny Palmer painted a scene the forty-niners never saw in *The Mountain Pass* with its awkward bear and impassive Indian. Though western grass grew tall in some places, Tait's *Prairie Hunter* and *A Check* look faintly like a cultivated grain field, and his *On the War-Path* takes place in a damp, rocky hardwood forest more like his own familiar Adirondack woods of northern New York than like the high plains of the West.

Tait, at least, did serious homework. We know he studied Bodmer's illustrations in a library, and there is a tradition among his descendants that he knew Catlin in Europe — a tradition supported by the resemblance of his Indians in *The Last War-Whoop* and *The Pursuit* to Comanches whom Catlin drew with plumed lances and round rawhide bucklers. Tait's mounted trappers are much like the man in William Ranney's *The Trapper's Last Shot* even to the shape of the stirrups, and Ranney (whom Tait almost certainly knew) had been in the southwest just after the Texan War for Independence. But in spite of any research that went into them, these western prints are often more romantic than real.

Yet no matter. Accurate or not, realistic or not, derivative or not, these pictures caught the enthusiastic spirit of a westward-looking people. Details aside, the prints *are* the West as Americans saw it in their minds — a West they were in the process of creating in actuality.

The title of the last print in our series, *Westward the Course of Empire Takes Its Way,* was curiously prophetic. The line was part of a poem written long before by Bishop Berkeley, the eighteenth century Irish clerical philosopher, but by the strange alchemy which transmutes some words into resonant bell-metal, it lived to become a true expression of nineteenth-century America. The picture shows a West that existed only in dreams in the 1850's. The neat log village with its school and church; the cheerful industrious pioneers; the wagon road falling to disuse; the Indians barred off from the white man's culture by the smoke and clatter of the train; and above all the inexorable iron rails, making finite the vastness of western America — these were all symbols, gathered into one cheap chauvinistic print sold for pennies to people who had mostly never been west of Lake Erie. But of all the western prints here shown, this one most truly represents the spirit and the future of the nation Nathaniel Currier knew. In the coming years, the unlikely prophecy of the print was realized. Our people flooded west and changed the landscape and the world; they destroyed the Indians and built the towns and the fences and the rails and later the highways. They established their pattern on the West, as the print predicted, and of the endless empty grassland they left only the few acres that one can still see at Badlands, blowing in the Dakota wind.

H. J. SWINNEY

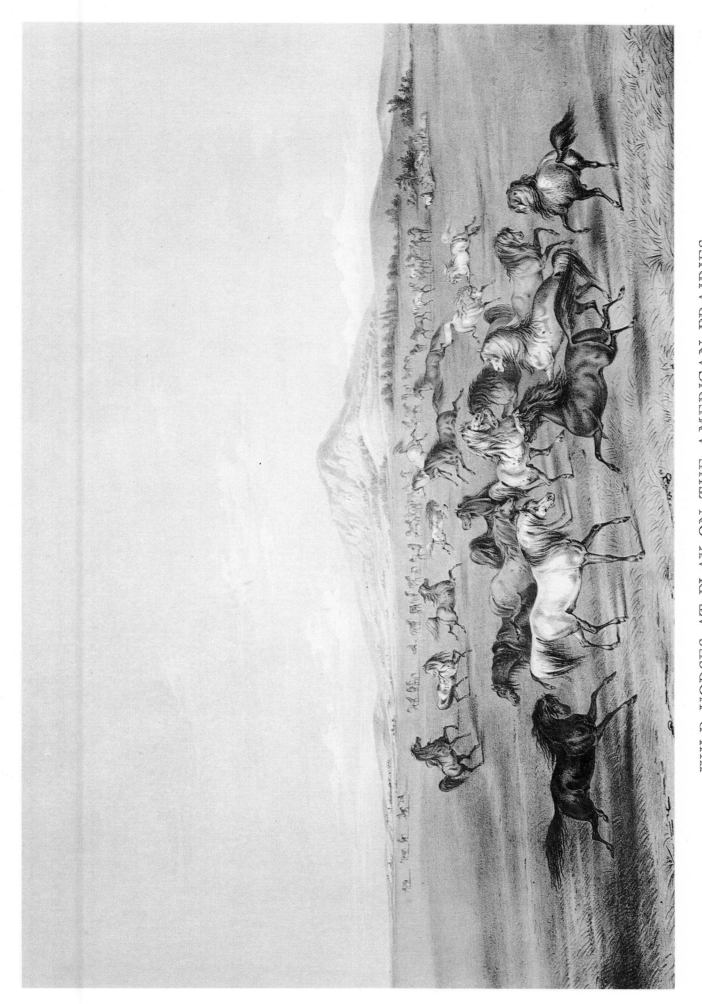

WILD HORSES AT PLAY ON THE AMERICAN PRAIRIES

THE ROCKY MOUNTAINS IN THE DISTANCE

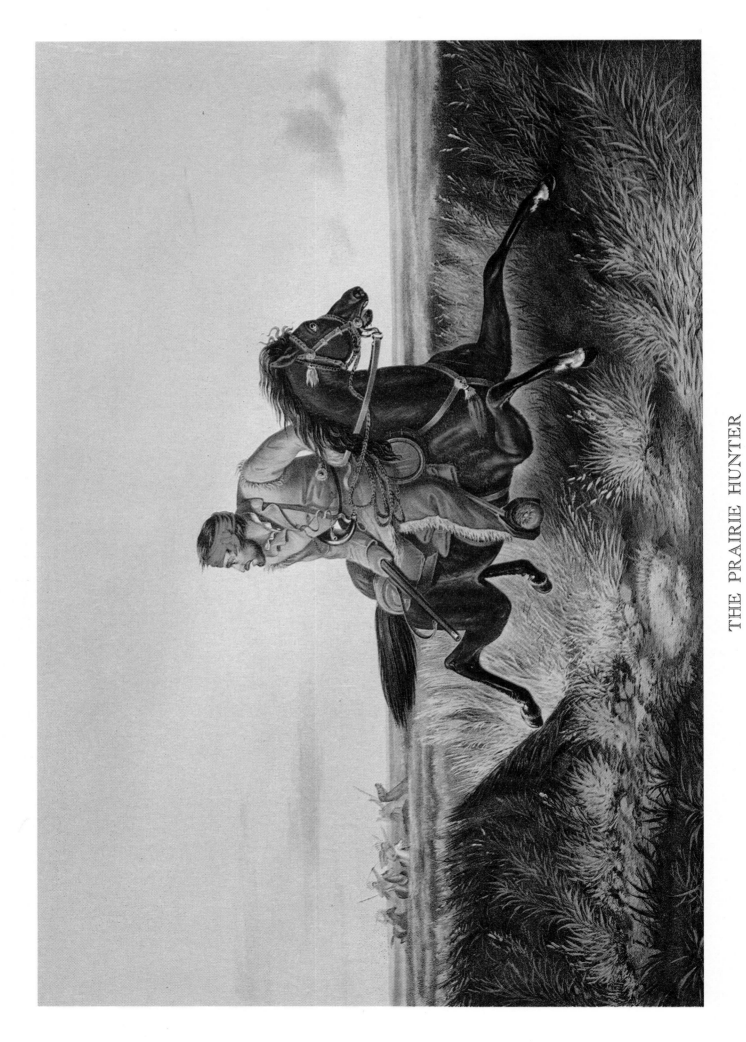

THE PRAIRIE HUNTER
"ONE RUBBED OUT!"

96

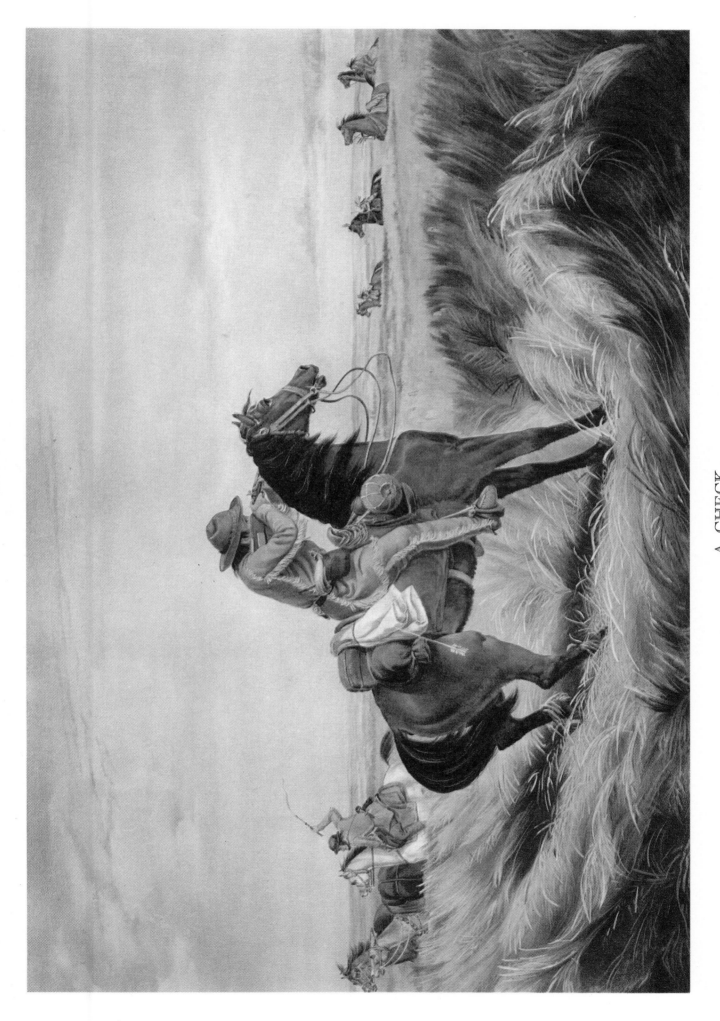

A CHECK

"KEEP YOUR DISTANCE"

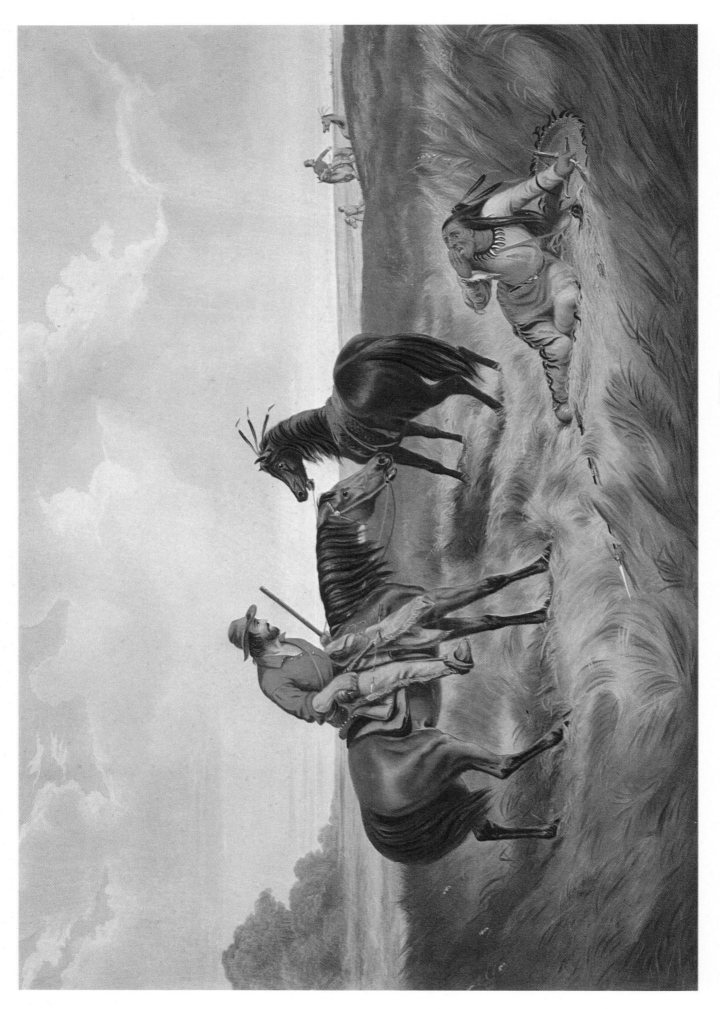

THE LAST WAR-WHOOP

98

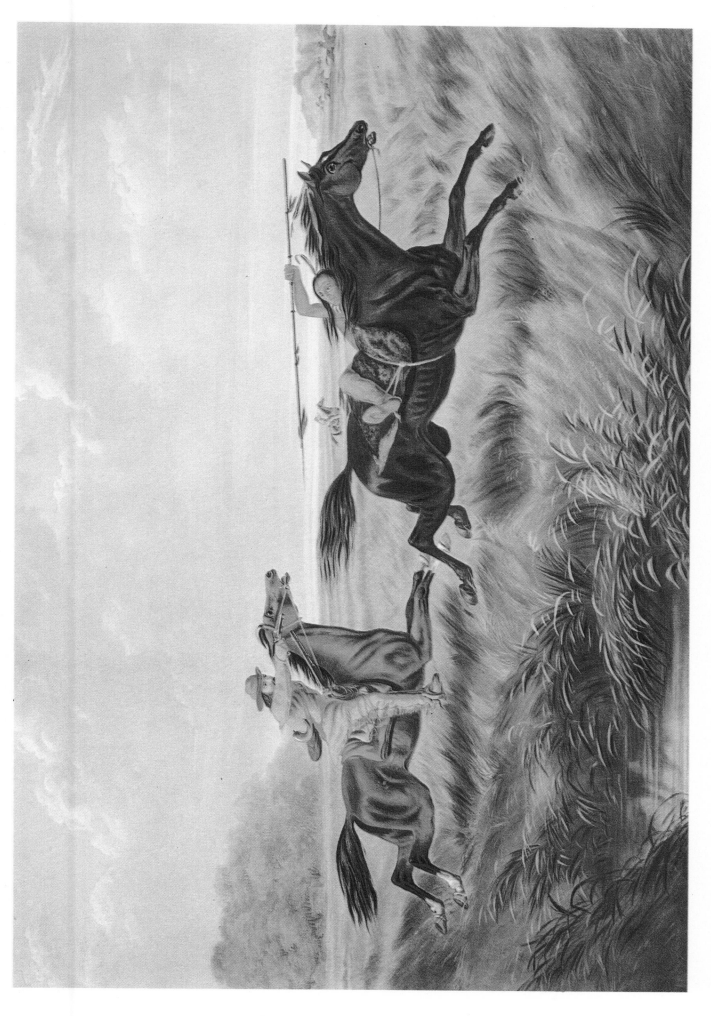

THE PURSUIT

LIFE ON THE PRAIRIE

THE TRAPPER'S DEFENCE. "FIRE FIGHT FIRE."

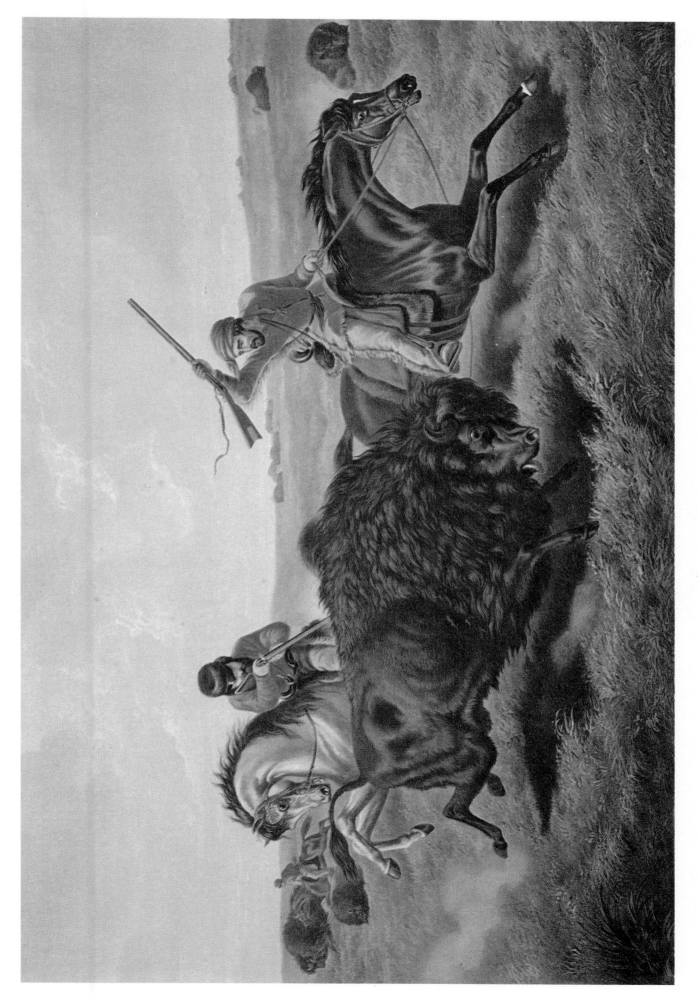

LIFE ON THE PRAIRIE

"THE BUFFALO HUNT"

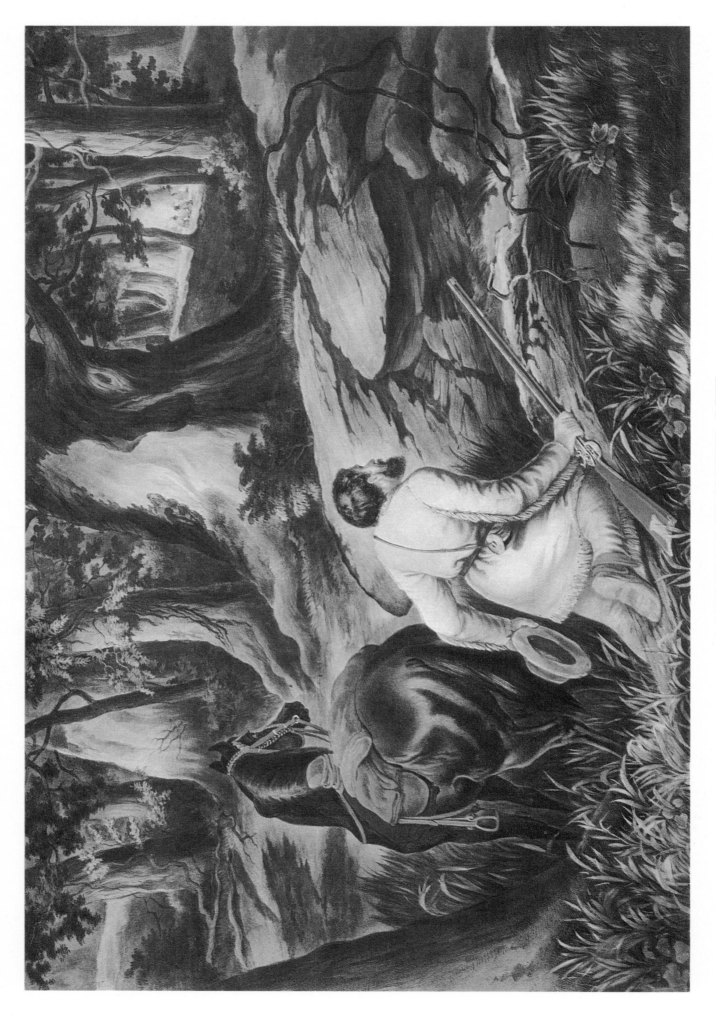

AMERICAN·FRONTIER LIFE
ON THE WAR-PATH.

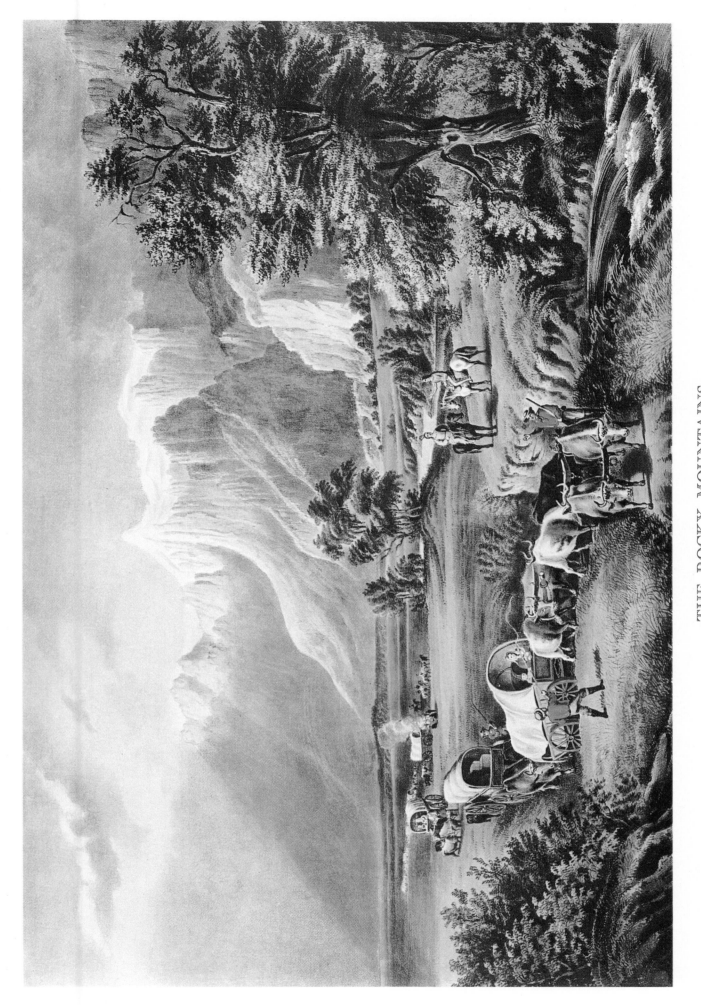

THE ROCKY MOUNTAINS

EMIGRANTS CROSSING THE PLAINS.

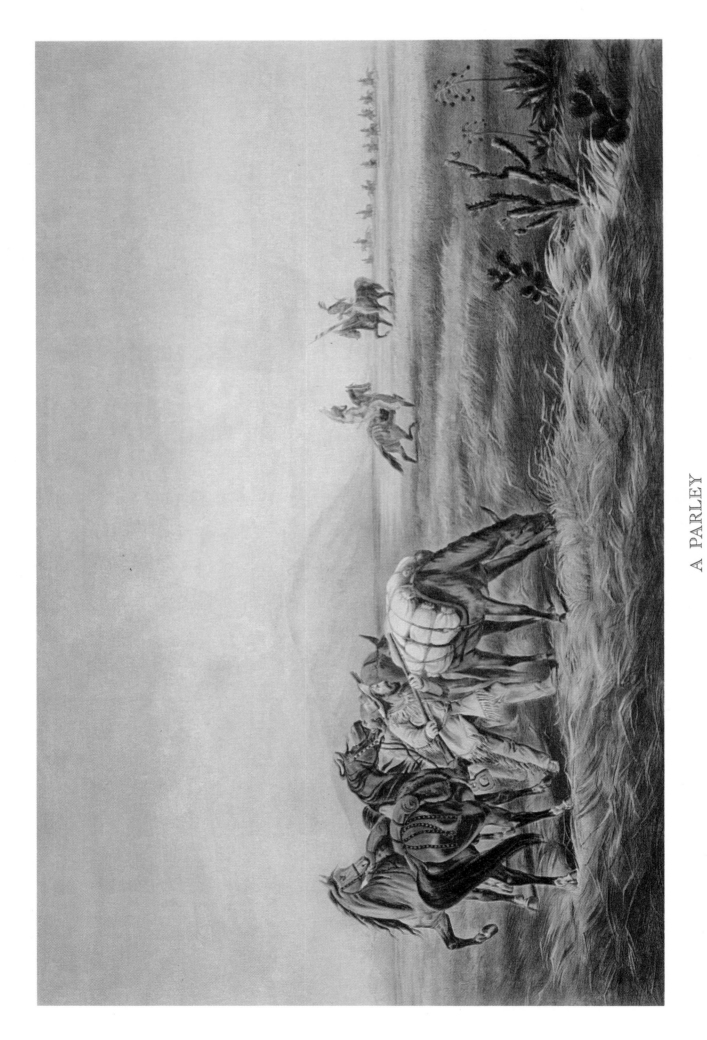

A PARLEY

PREPARED FOR AN EMERGENCY

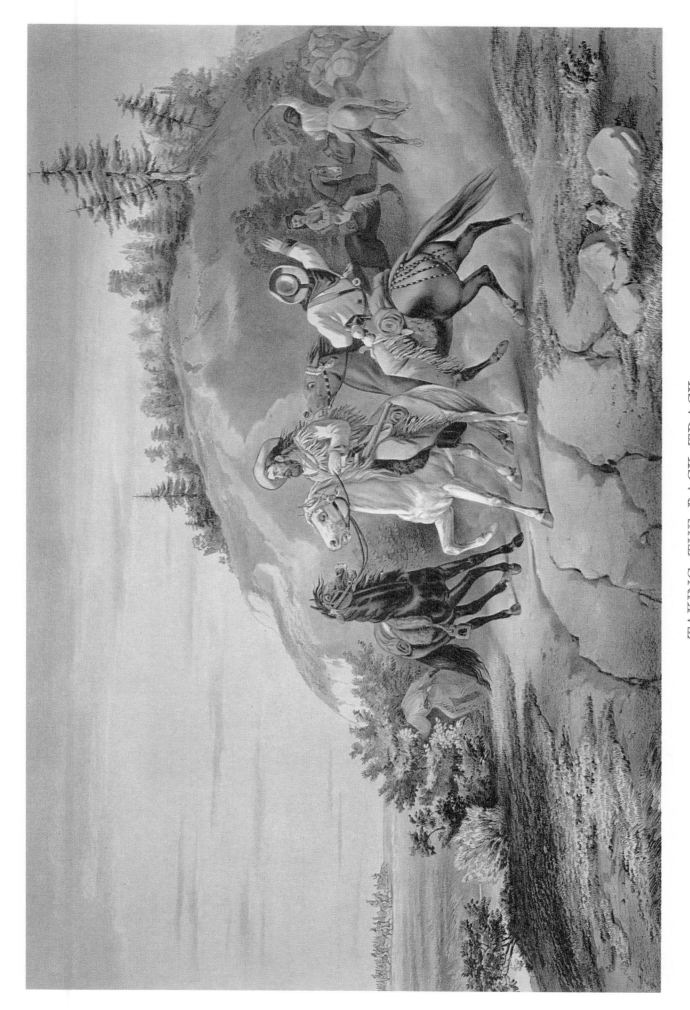

TAKING THE BACK TRACK

A DANGEROUS NEIGHBORHOOD.

THE MOUNTAIN PASS
SIERRA NEVADA.

106

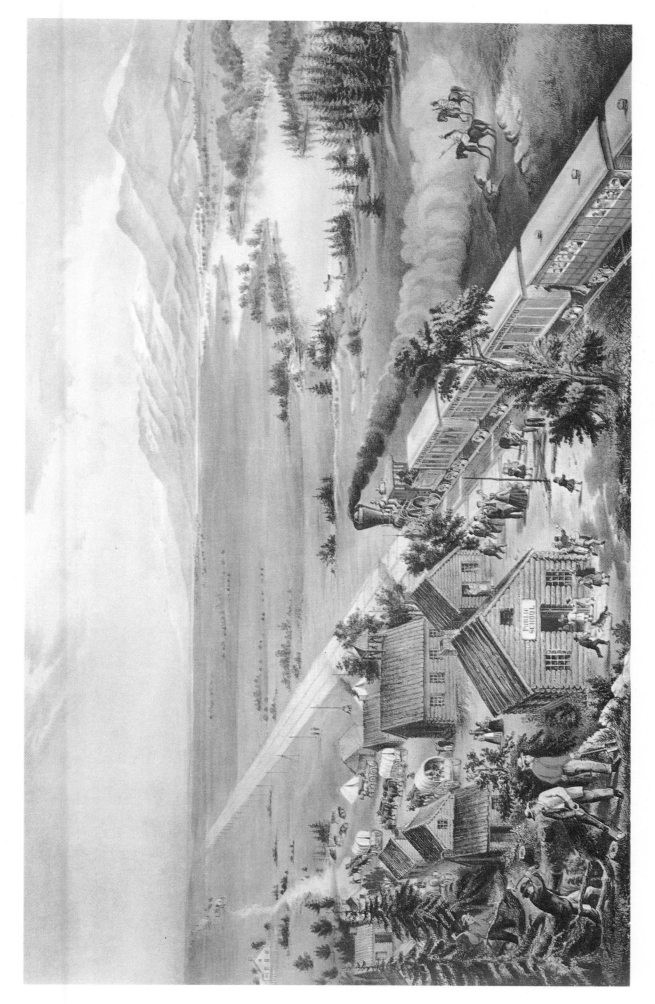

ACROSS THE CONTINENT

"WESTWARD THE COURSE OF EMPIRE TAKES ITS WAY."

VII NEW YORK CITY

"New York, the Great Metropolis of the Nation, and most favored City in America, owes its commercial prosperity and great wealth mainly to its natural position, as regards land and water — the Island being surrounded by tide-waters and navigable rivers, with a spacious and well-protected harbor contiguous to the Atlantic Ocean. This, in connection with its healthy climate and fruitful soil, by which it is surrounded . . . altogether make its position unrivaled either in the Old or New World." Thus begins a city guidebook for the year 1876. It is in this mood that Currier & Ives delineated New York in almost 150 lithographs.

In 1835 Nathaniel Currier, newly established in the city, had his print of the *Ruins of the Merchants Exchange* for sale in the streets four days after the disastrous fire which began on December 16th. This lithograph brought immediate local attention to the name Currier and this name continued to be associated with New York City views until the firm closed its doors in 1907. The first view for its own sake was the charming *New York from Weehawken* done also in 1835 and one of the last views was *The Great East River Suspension Bridge* in 1892. The firm chose to do sixteen different renderings of the Brooklyn Bridge!

During these years New York City was a city of great growth and change. The population rose from approximately 257,600 in 1835 to one and a half million by 1892. The telegraph, the Atlantic Cable, and elevated railroads came into being; the first skyscraper, the Brooklyn Bridge, and the Statue of Liberty commanded the view; the beauty of Central Park was created — an accomplishment which Anthony Trollope praised in 1862: ". . . the glory of New York is the Central Park." Currier & Ives captured this feeling of growth and excitement but were always careful to emphasize the charm and graciousness of city life. "Contrasts of poverty and wealth in the 'iron age' could be softened by the glow of sentiment."

The lithographs of Currier & Ives made no attempt to "document" the city: they were interested in depicting those scenes which the visitor or the resident would find most pleasing or interesting. Thus an exciting new building like the Crystal Palace, the fireworks at the opening of the Brooklyn Bridge, the new ferries and steamboats in the harbor were depicted with the pastoral views along the shores of Astoria, Harlem, Staten Island, and Bay Ridge. Even the scenes of commercial activity on lower Broadway were treated with a degree of elegance. These widely sold views served as nostalgic souvenirs of the city of promise. Speaking of the American views in general Harry T. Peters says: "They have a tourist quality . . . and were purchased by visitors from all parts of the world, and carefully treasured for future generations." Of these the New York City views were the most prolific and perhaps the most artistic.

A. K. Baragwanath

NEW YORK AND BROOKLYN

CENTRAL PARK, WINTER

THE SKATING POND.

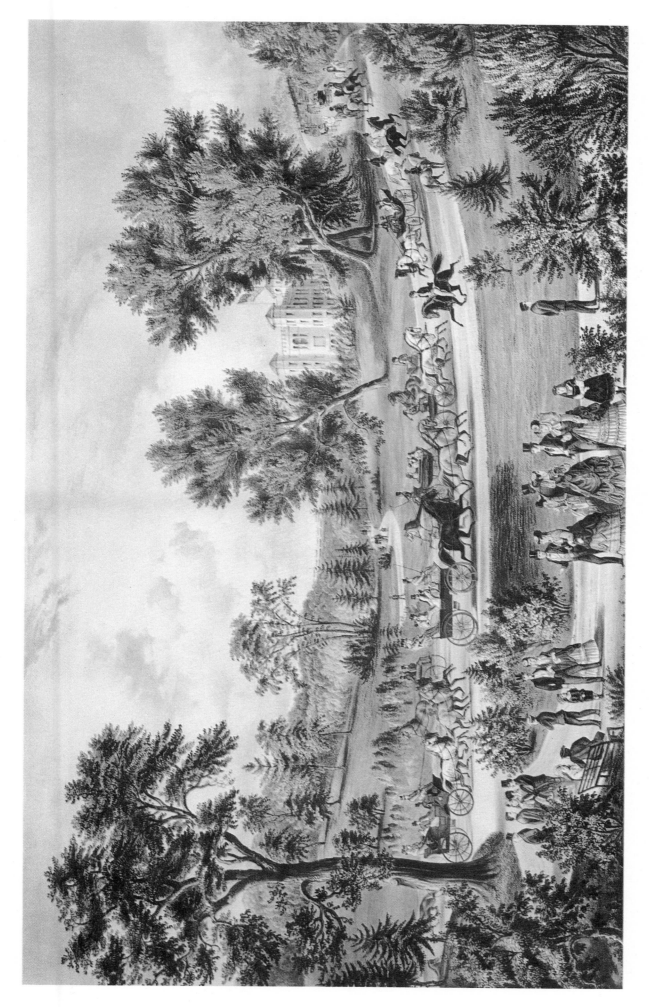

THE GRAND DRIVE, CENTRAL PARK, N.Y.

NEW YORK BAY, FROM BAY RIDGE
LONG ISLAND.

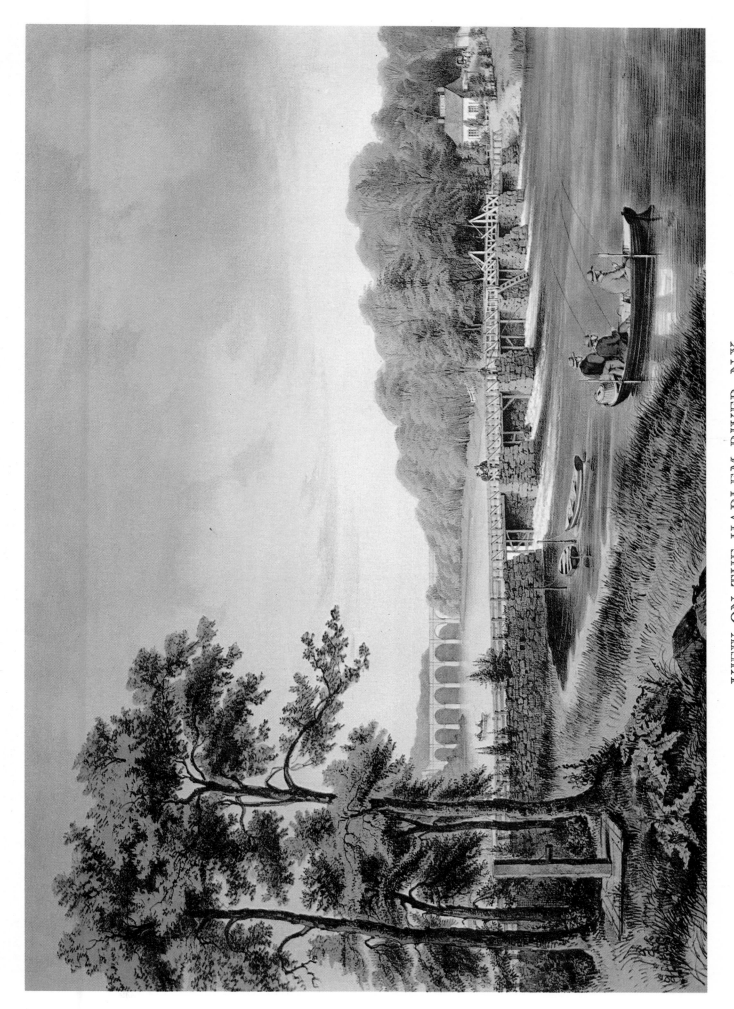

VIEW ON THE HARLEM RIVER, N.Y.

THE HIGH BRIDGE IN THE DISTANCE.

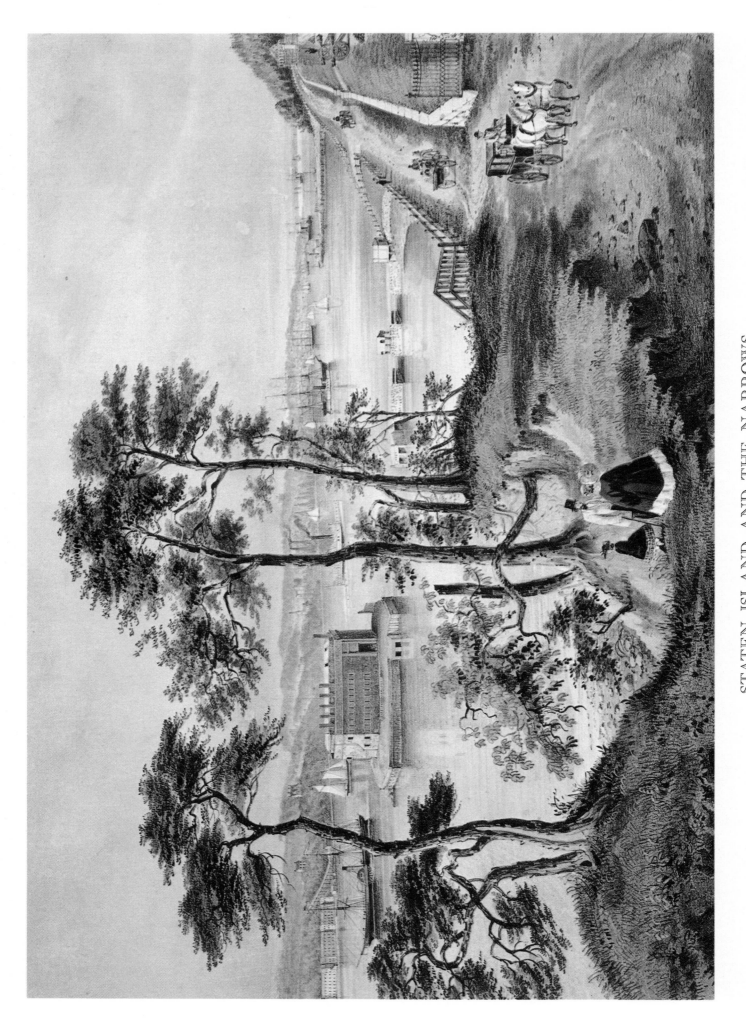

STATEN ISLAND AND THE NARROWS

FROM FORT HAMILTON.

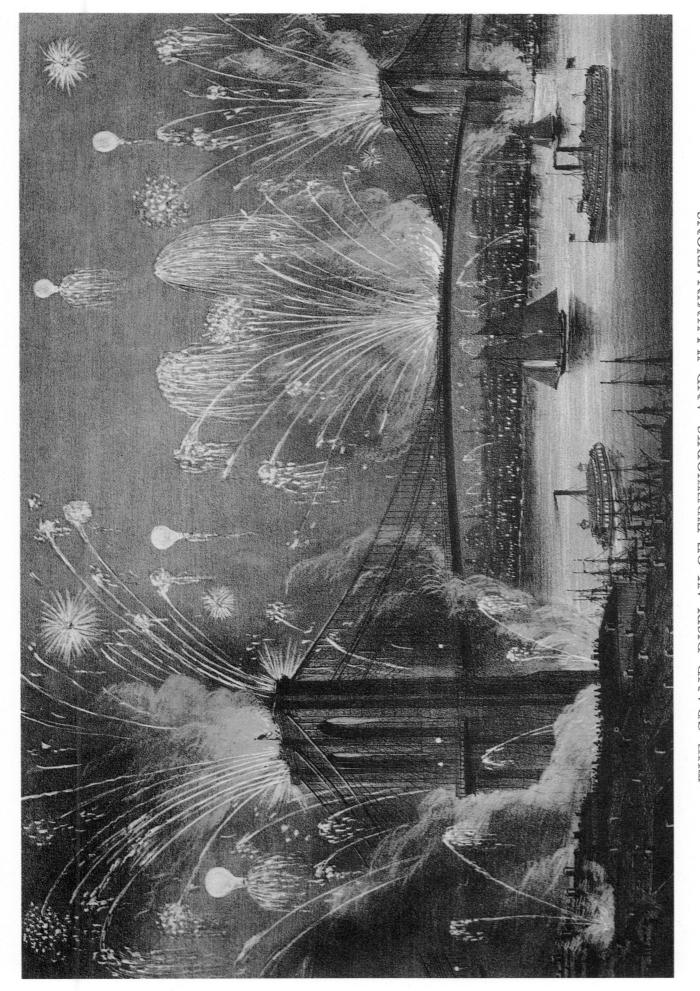

THE GRAND DISPLAY OF FIREWORKS AND ILLUMINATIONS

AT THE OPENING OF THE GREAT SUSPENSION BRIDGE BETWEEN NEW YORK AND BROOKLYN ON THE EVENING OF MAY 24, 1883.

VIEW OF NEW YORK
FROM BROOKLYN HEIGHTS.

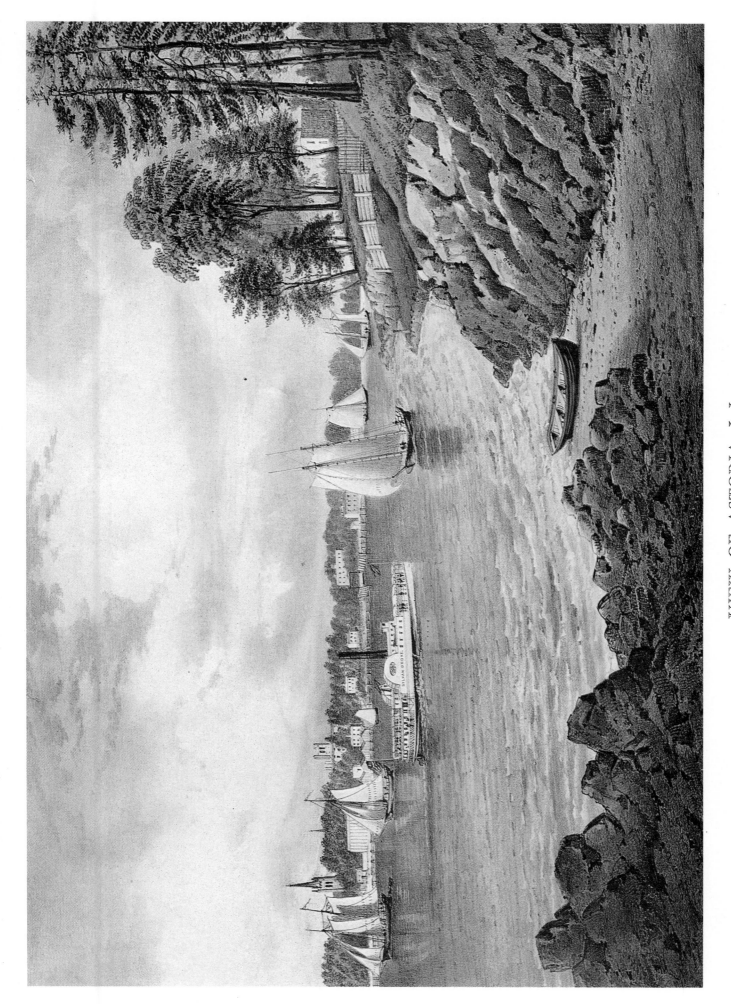

VIEW OF ASTORIA, L. I.

FROM THE NEW YORK SIDE.

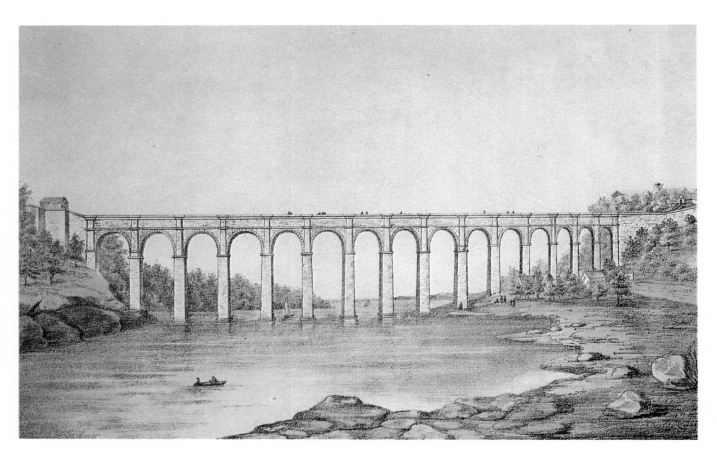

THE HIGH BRIDGE AT HARLEM, N.Y.

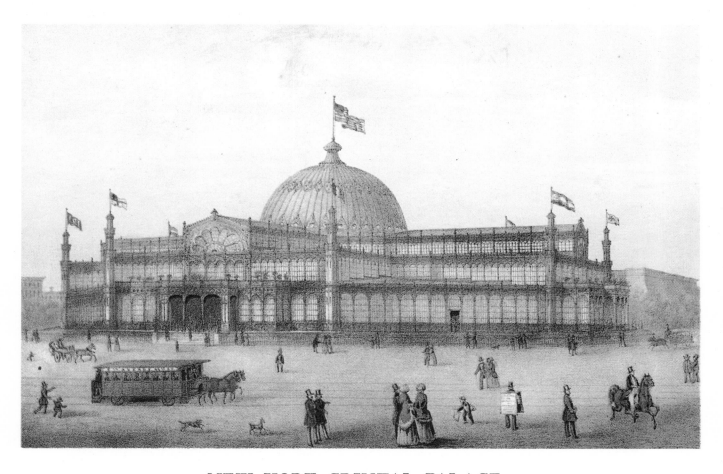

NEW YORK CRYSTAL PALACE

FOR THE EXHIBITION OF THE INDUSTRY OF ALL NATIONS. CONSTRUCTED OF IRON AND GLASS.

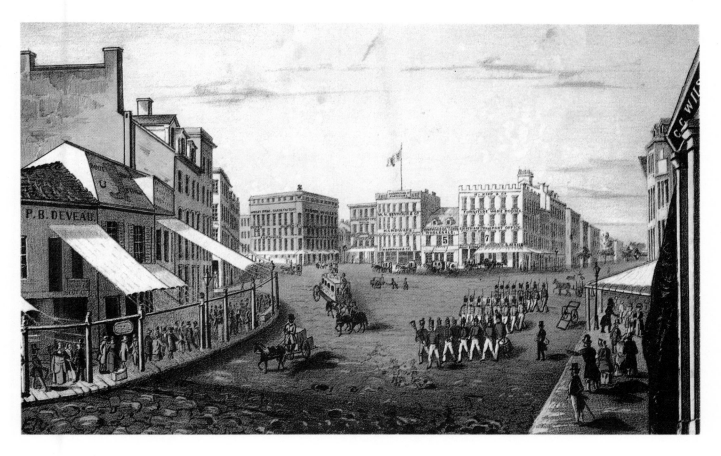

CHATHAM SQUARE, NEW YORK

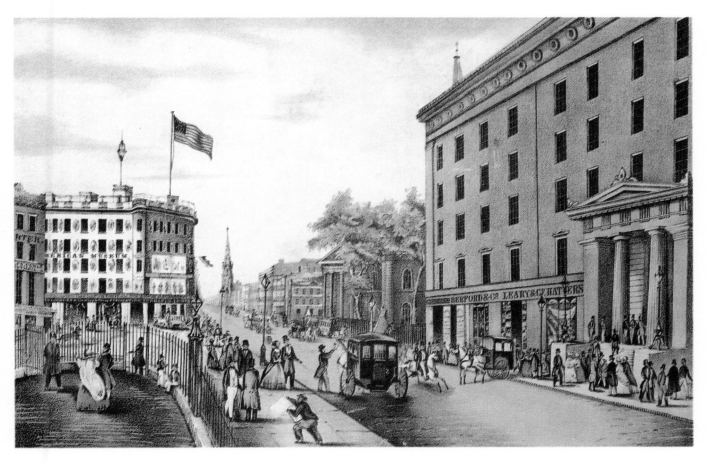

BROADWAY NEW YORK

SOUTH FROM THE PARK.

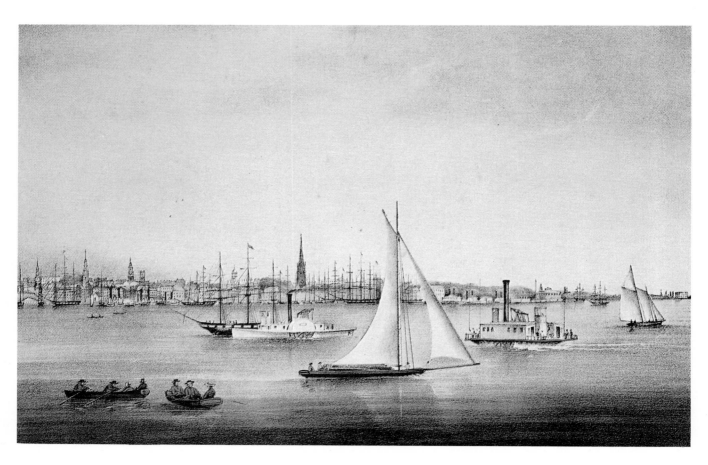

CITY OF NEW YORK

FROM JERSEY CITY.

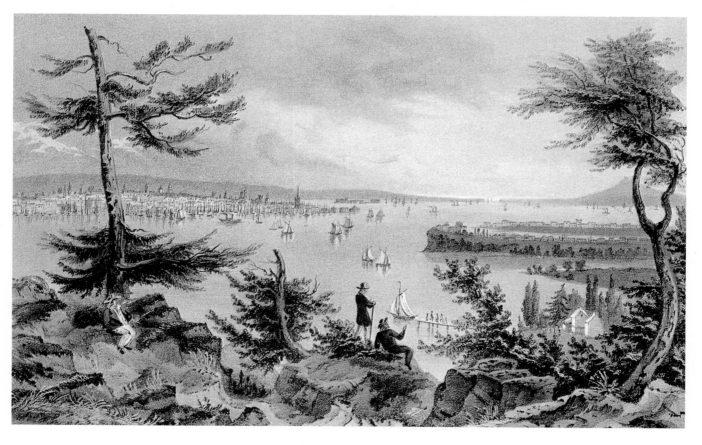

VIEW OF NEW YORK

FROM WEEHAWKEN.

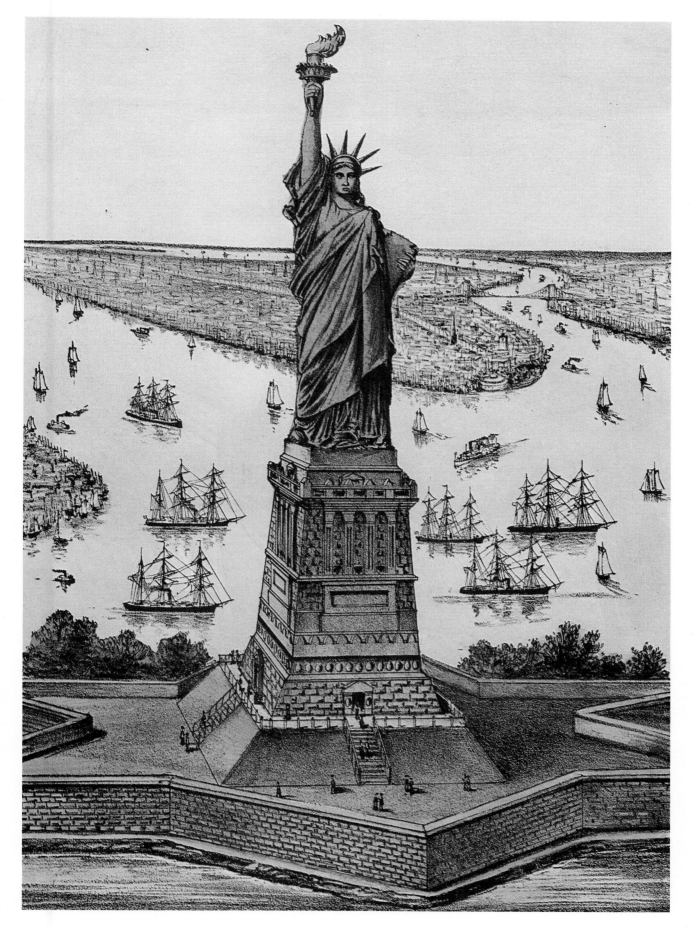

THE GREAT BARTHOLDI STATUE

LIBERTY ENLIGHTENING THE WORLD. THE GIFT OF FRANCE TO THE AMERICAN PEOPLE. (STATUE OF LIBERTY)

(From the Edward W. C. Arnold Collection. Lent by the Metropolitan Museum of Art. Photograph courtesy Museum of The City of New York)

VIII FIRE FIGHTING AND FIRES

If Currier and Ives had issued only the six large folio lithographs which comprise "The Life of a Fireman" series, their reputation would have been fully established. These prints, based on the work of Louis Maurer, John Cameron, and Charles Parsons, depict with great accuracy all the excitement and color of the New York Volunteer Fire Department in its boisterous heyday. As Russel Crouse wrote in *Mr. Currier and Mr. Ives:* "The organization was born of civic pride, and into it crowded the fathers and sons of the best families of the day. They received no pay, but membership was considered an honor. Companies popped up all over the city. When the fire bell sounded merchant princes and wealthy scions dropped whatever was at hand, rushed to their firehouses, donned their leather hats, dragged their pet engines through the streets, and proceeded to risk their lives. . . . Companies raced each other to the fire and were intense rivals in the matter of efficacy." The excessive rivalries and temperamental aspects of these volunteer units contributed to their demise in 1865 when the Metropolitan System with paid firemen was created. Not only was there the passing of the volunteer system which had been established in 1737, but the equipment itself was changing markedly; gone were the gooseneck and piano-style handpumpers, the elaborately decorated hose carriages; now steam was substituted for manpower to thrust the water streams to higher buildings and horses were replacing men for the race to the fire. Unified alarm systems were being initiated and the volunteer no longer listened for the particular tone of his firehouse bell.

Currier and Ives and their artists in "The Life of a Fireman" and "American Fireman" series not only captured the drama of the fires with the converging equipment but also documented the actual scenes — the locations and even portraits of specific firefighters were carefully delineated. The lithograph of *The American Fireman — Always Ready* is actually a portrait of Nathaniel Currier!

Perhaps the outstanding fire print of the firm is the *Burning of the New York Crystal Palace*. Here the "fireproof" building, created to house New York's first world's fair, is shown being gutted by fire. Its steel and glass structure crumbled in minutes as a result of the intense heat and it was almost a miracle that the more than 2,000 visitors within escaped without injury.

The hypnotic fascination of a fire is present in all the Currier and Ives fire prints, but fortunately for the historian they went beyond this obvious appeal to leave a true document of firefighting methods and the actual scenes with a veracity often lacking in other areas of their pictorial coverage.

A. K. BARAGWANATH

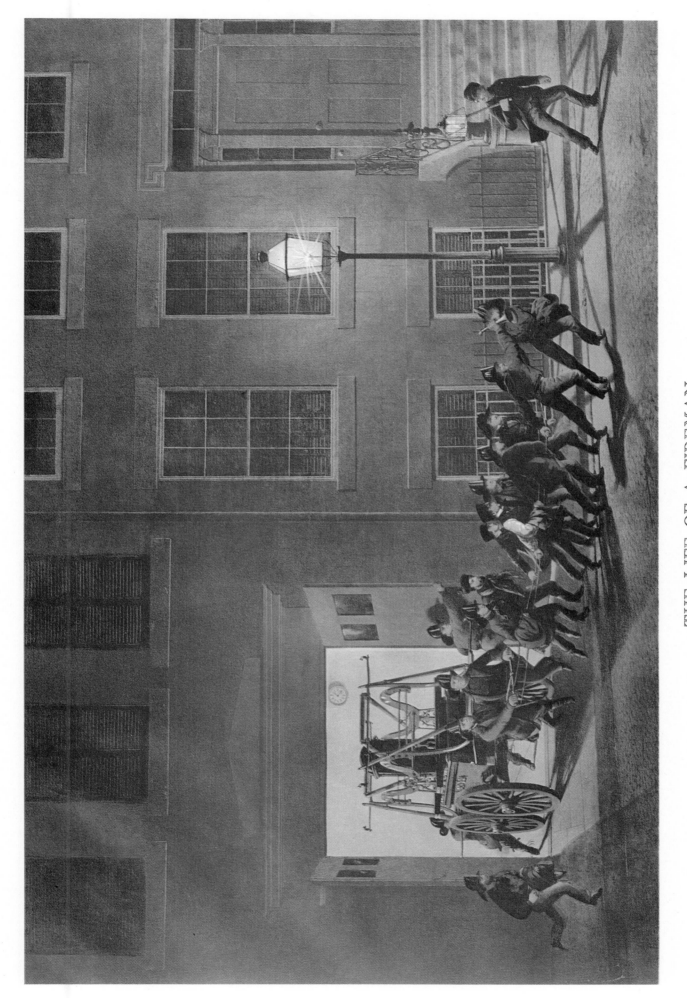

THE LIFE OF A FIREMAN

THE NIGHT ALARM.—"START HER LIVELY BOYS."

THE LIFE OF A FIREMAN

THE RACE. — "JUMP HER BOYS, JUMP HER!"

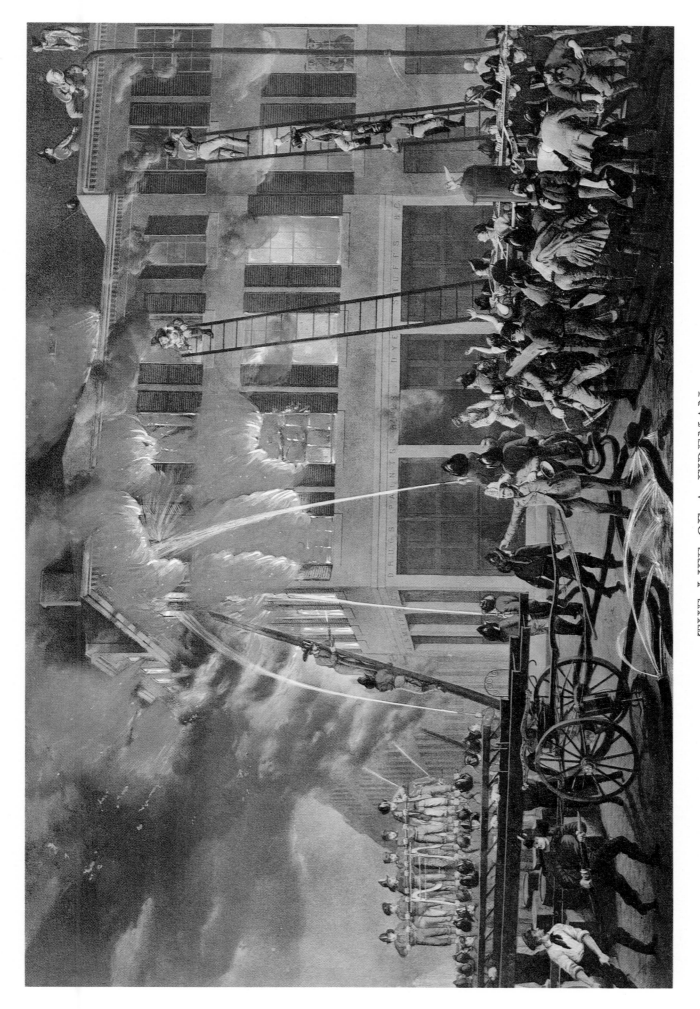

THE LIFE OF A FIREMAN

THE FIRE.—"NOW THEN WITH A WILL—SHAKE HER UP BOYS!"

THE LIFE OF A FIREMAN

THE RUINS.—"TAKE UP." "MAN YOUR ROPE."

126

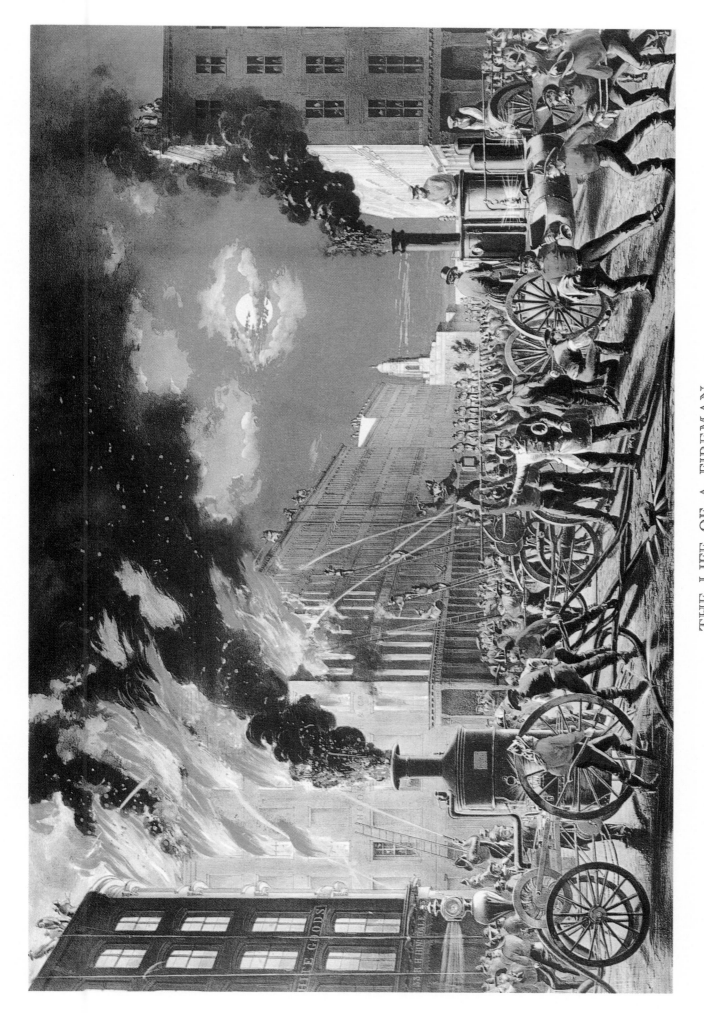

THE LIFE OF A FIREMAN
THE NEW ERA.—"STEAM AND MUSCLE."

THE LIFE OF A FIREMAN
THE METROPOLITAN SYSTEM.

THE AMERICAN FIREMAN
ALWAYS READY.

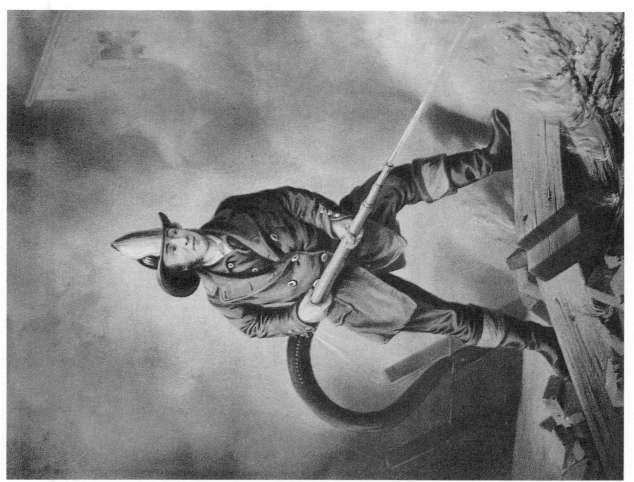

THE AMERICAN FIREMAN,
FACING THE ENEMY.

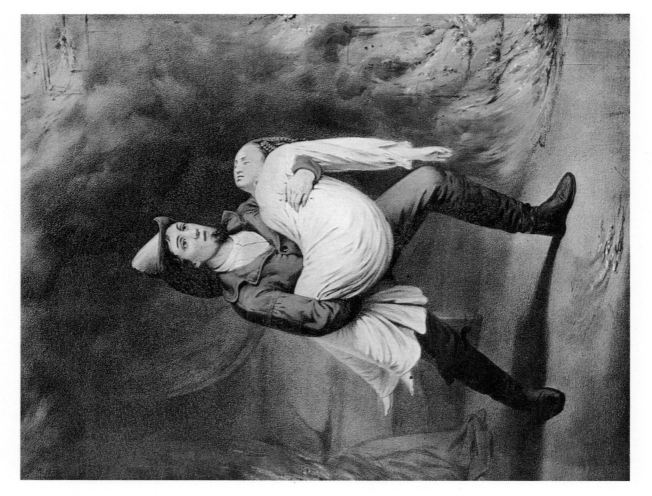

THE AMERICAN FIREMAN,

PROMPT TO THE RESCUE.

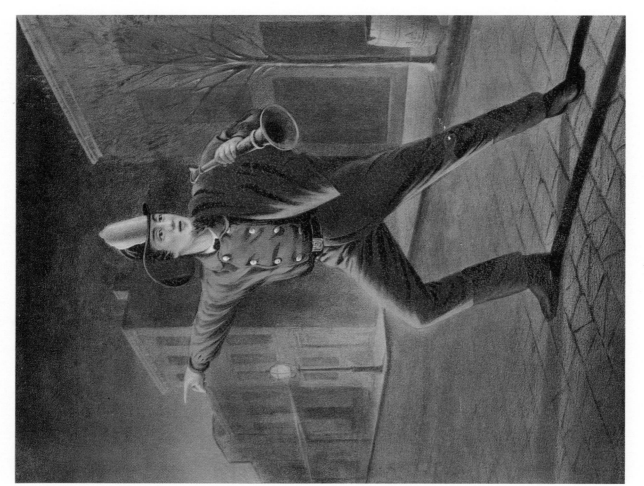

THE AMERICAN FIREMAN

RUSHING TO THE CONFLICT.

130

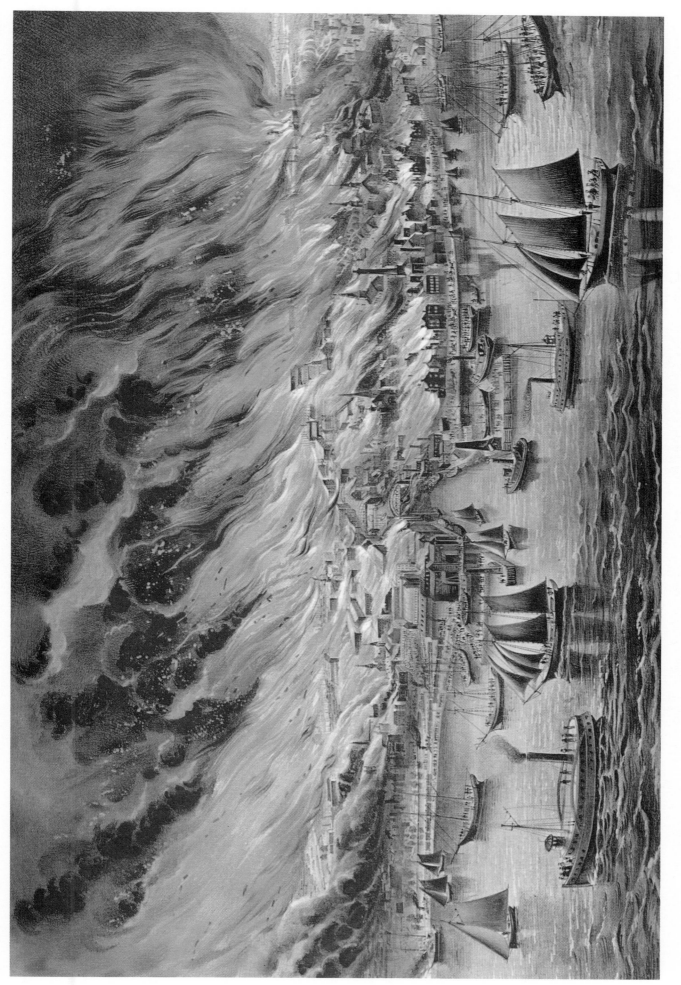

THE GREAT FIRE AT CHICAGO, OCT'R 8th 1871

The Fire commenced on Sunday evening Oct. 8th and continued until Tuesday Oct. 10th consuming the Business portion of the City, Public Buildings, Hotels, Newspaper Offices, Rail Road Depots and extending over an area of Five square Miles. About 500 lives were lost and property valued at 200,000,000. of Dollars was destroyed.

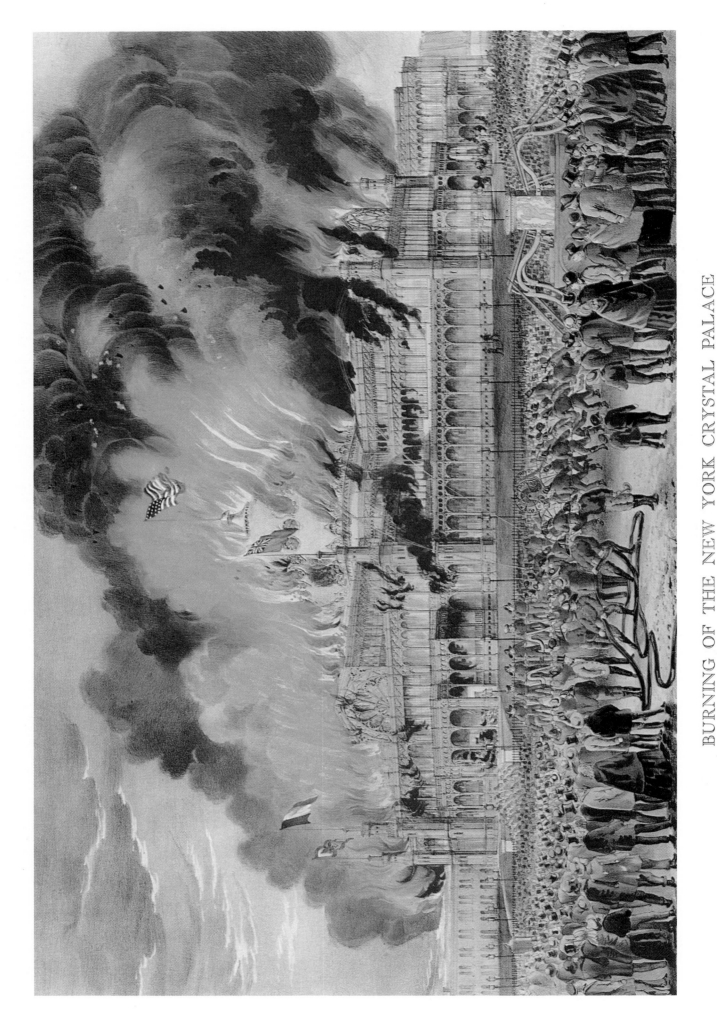

BURNING OF THE NEW YORK CRYSTAL PALACE

ON TUESDAY OCT. 5th 1858, DURING ITS OCCUPATION FOR THE ANNUAL FAIR OF THE AMERICAN INSTITUTE.

IX RAILROADS

Whistle screaming and drivewheels flashing, the great American steam engine fitted easily — and profitably — into the Currier & Ives pattern. What more dramatic experience could race through the mind than steam locomotives hurtling down the track, smokestacks fire-branding the night with livid red cinders? Could one depict grander purpose than building the Great West with the aid of steel rails and the steam cars? Or more certain excitement than a seething, simmering iron monster encountering another of its kind on the pathway, each rocketing toward certain disaster?

Steam in all its nineteenth century forms was indeed the prime mover, the great industrial fact, and of all these forms, the train was perhaps the most engaging. Steamboats bore a sad, tranquil kind of majesty; steam fire engines were sure to quicken the pulse during their infrequent sorties. But the steam train was present in every town, actively so, and boys from eight to eighty thrilled at the far-off whistle, conjuring a thousand romantic dreams, and connoting motion, urgency and progress.

The train bespoke travel to distant, unknown and beckoning places There was a yearning mystery to the farm boy of what glories lay beyond that last curve in the shimmering rails. To the girl, it spelled a finite link to the great city of which she had heard (in the penny dreadfuls) and must some day dare to visit. For a rural America, the train was everything that had not been before, in terms of comfort and ability to move no matter what the conditions underfoot. To the business traveler, it meant a fivefold jump in travel advantage relative to the horse-drawn stage, and a tenfold jump compared with the sleepy canal barge.

For the lithographer chronicling the westward expansion of America, the train became synonymous with the push of people to settle plains and mountains. It was also a chance to examine engineering wonders pictorially as the railways black powdered their way through stony barriers and flung spidery trestles across great ravines and churning rivers. Every component of the railroad, from complex locomotive to sprawling freight yard, evoked the highest engineering skills, and whether Currier & Ives prints were "the moloch of bad taste and mass-production," as has been suggested, the series could still satisfy all but the most technical fussbudget. Hairsplitters could, of course, find monstrous fault with the impossible spacing of crossties or in the apparent broadness of track gauge, seemingly all out of scale with actual fact. True enough, the regulars of railroad art, such as F. F. Palmer, sometimes sacrificed perspective and proportion in the interest of depicting a well-turned drivewheel or a fluted siderod.

Railroad lithographs yielded still another chance to depict life as Victorian sentimentality wished it. There was the bold engineer at the controls, masterful, alert and skilled. His equal was the doughty conductor, lord of all he surveyed, the skipper of a great landbound ship. It was an age in which high officials, combining God and Caesar, rode elegant parlor cars, while in adjoining smokers sat humble immigrants, savings sewn in their linings and hopes mounting with each click of the railjoint.

It was a pioneer country, which necessarily left little time for playtime art. Artistic aims and commercial aims were not always differentiated, witness hundred upon hundred of mechanical drawings set to color to illustrate the latest product of Baldwin, Manchester or Paterson, among other nineteenth century locomotive builders. Yet the railroad and the steamboat lithographer could produce a passable blending of landscape techniques, meanwhile paying full attention to mechanical detail. It was pride in America's inventiveness that above all created a demand for explicit, detailed renderings of all these wonderful products of the Industrial Revolution, an appeal not unlike that of the automobile and airplane of this century.

Small wonder they served a multitude of buyers, from the farmer or millworker who could afford two-dollar "art" to gentlefolk intent on rounding out their collections of the latest prints from Currier & Ives.

EDGAR T. MEAD, JR.

THE DANGER SIGNAL

THE "LIGHTNING EXPRESS" TRAINS
"LEAVING THE JUNCTION"

THE EXPRESS TRAIN

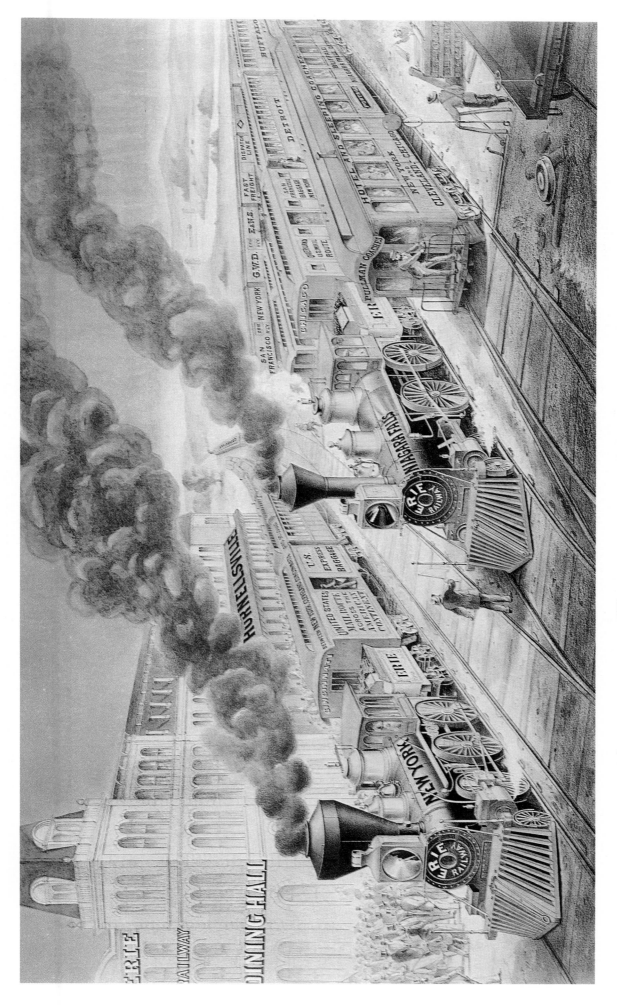

AN AMERICAN RAILWAY SCENE, AT HORNELLSVILLE, ERIE RAILWAY

The Great Trunk Line and United States Mail Route between New York City and the Western States and Territories, renowned for its Beautiful Scenery, its substantial road bed, Double Tracked with steel rail, and its well appointed Passenger trains, equipped with the celebrated Pullman Hotel, Drawing Room and Sleeping Coaches.

137

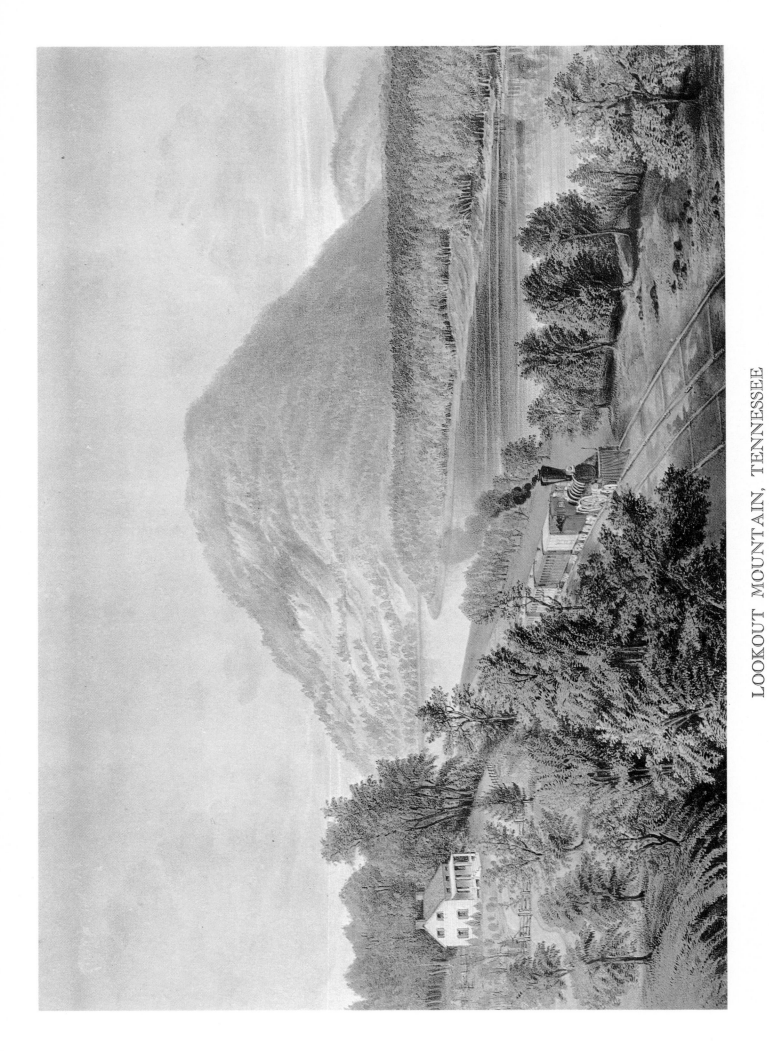

LOOKOUT MOUNTAIN, TENNESSEE,
AND THE CHATTANOOGA RAIL ROAD.

AMERICAN RAILROAD SCENE

SNOW BOUND.

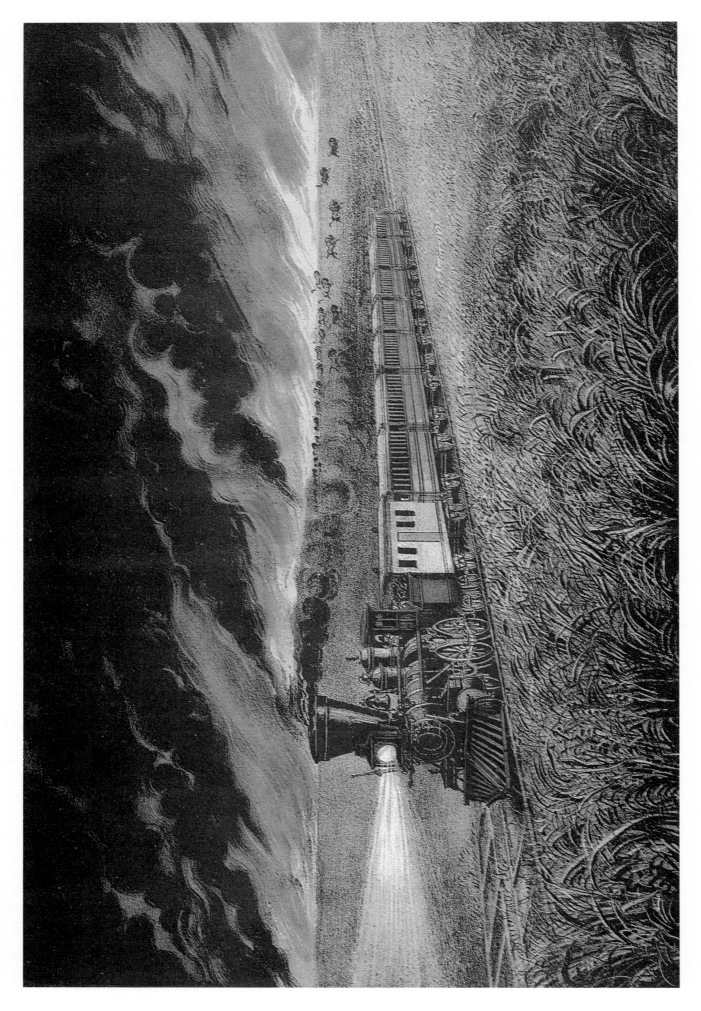

PRAIRIE FIRES OF THE GREAT WEST

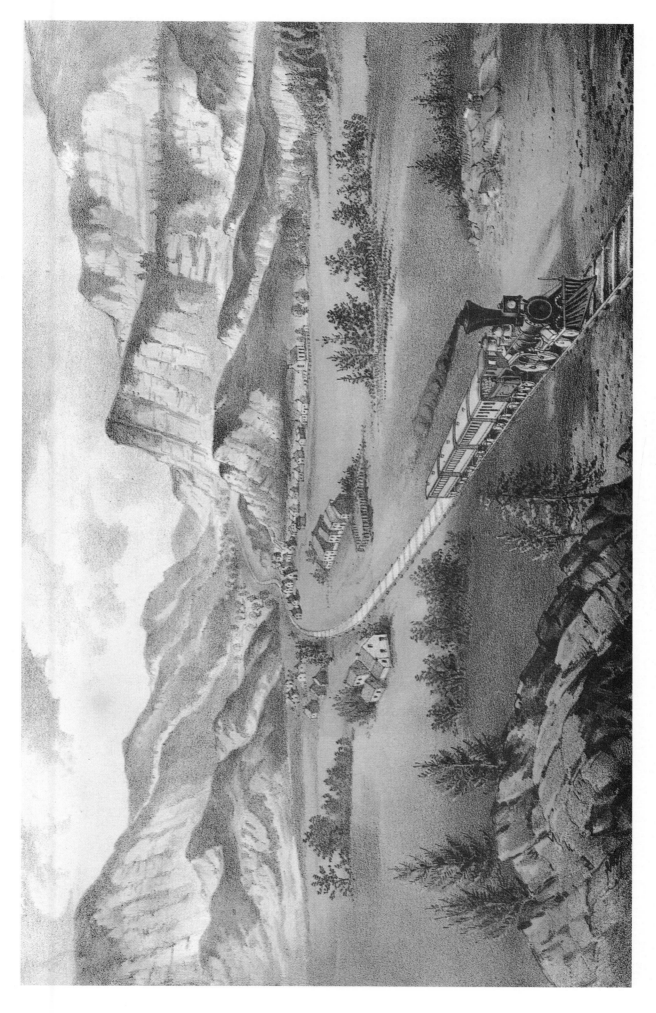

THE GREAT WEST

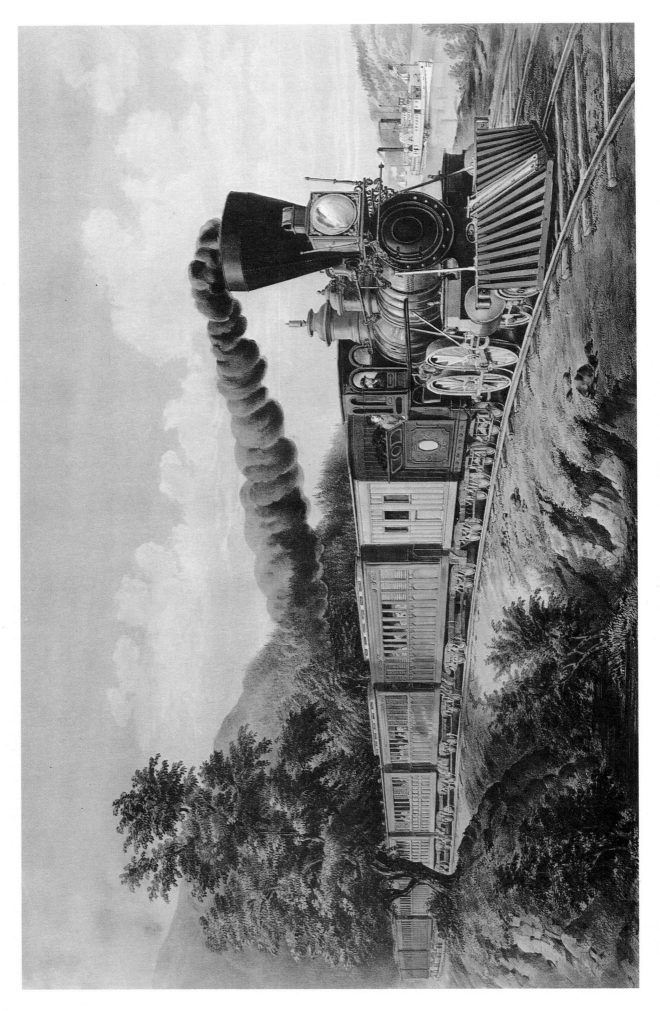

AMERICAN EXPRESS TRAIN

142

X THE CIVIL WAR

Nothing in the national history compares in drama and tragedy with the Civil War. No American war has been bloodier. None has aroused the passions nor bequeathed a more enduring legacy of suspicion and bitterness. For this was, as its many names imply, a war about many things which left no citizen unaffected, no issue untouched. It was a civil war between brothers, a war between the states over the perennial question of national and state powers, a war for Southern independence from a powerful North, and a war over the relationship of the nation's black and white races.

It was also a new kind of war, named by the twentieth century total war. It called for the mobilization of the entire society, involved innocents and non-combatants (as in the vividly depicted burning of Richmond), and aroused all the arts of propaganda. Furthermore, in this war, the tactics and strategy developed in the Napoleonic conflicts and taught to that generation of West Pointers who later commanded the Blue and the Gray just did not work. The new long-range rifle made obsolete the bayonet and cavalry charges, required trenches and static fortifications, and gave the advantage to the defensive force. Interior railroad lines made for the rapid movement and concentration of masses of army men and materiel. Industrial skills made possible the adequate provisioning of huge armies. And the application of steam and iron-cladding helped to revolutionize naval tactics and permitted the penetration of naval vessels deep into the interior network of rivers.

Against this background, the contemporary art of Currier and Ives takes on meanings which transcend the recognized high quality of illustration. This is, first of all, art as propaganda. No defeats are recorded here. The flight of the Northern troops at the first Battle of Bull Run and the spectacular exploits of the Confederates under "Stonewall" Jackson, "Jeb" Stuart, and Jubal Early find no place in this gallery. The battle of Antietam, scarcely a "splendid victory" which supposedly saw the soldiers in blue "utterly routing" the enemy, was effectively a standoff, although no one would guess it from the Currier and Ives pictorial view. Nor would one suspect from the onrushing masses of Union troops that one of the chief defects of the Northern effort early in the war was precisely the failure, especially under McClellan (scarcely the "invincible" leader of the caption), to press the offensive and engage the Confederates in battle. It required more than two years for Lincoln to find the right commander in Grant. What the artists' workshop offered was a limited Northern perspective on the battlefield.

Currier and Ives' lithographs offered, in the second place, the war as pageant. Armies move in well-ordered ranks across open fields into each other's withering fire. Standards are carried high, rifles erect. Contrary not only to the facts but to the caption statement that this is a war of entrenchments, these entrenchments are scarcely to be seen in the view of the battle of Fredericksburg. Ships move in formation against the fortresses on shore, their rigging secure and the air filled with cannon bursts reminiscent of Fourth of July celebrations. This interpretation of military tactics—not always accurately reported in the press from which Currier and Ives gleaned their information—not only corresponded to a dominant image of warfare fostered by earlier modes of battle but compensated for a recognition, North and South, that the war had become a bitter, difficult, and deadly affair, full of heroes but empty of splendor.

On the other hand, Currier and Ives' art accurately recorded the larger implications of the war. One gains from it the indelible impression of mass armies engaged in total battle. One witnesses in the faces of the soldiers in the foreground the real terror, pain, and anguish of battle and in the larger scene much of the tumult and confusion which must overcome even the best-ordered of armies. Compared with the illustrated episodes of the Mexican War, these Civil War prints correctly capture the transformation in the style of warfare and suggest the awesomeness of the struggle.

Only occasionally in these prints do we get a glimpse of the place in the conflict of the ex-slave, and when we do it is in sharp contrast to the figure of the shambling, humorous "darky" which fills so many other Currier and Ives' lithographs. In the sole appearance of the freed Negro among these scenes, there is a special quality to the art, an almost Goya-esque rendering of the famous battle of the 54th Massachusetts, of the ex-slaves' force and courage, and of the tragic death of Robert Shaw—as if the artist's commitment to his subject is deeper and more profoundly experienced than in the other battle scenes. That the ex-slaves fought valiantly for the Union, suffered greatly, and acquitted themselves fully in the conflict in which they had so much at stake has only belatedly been recognized. And it is testimony to the sympathies of Currier and Ives that they sought to capture this in their art.

In the end, the Civil War was a conflict, one scarcely need be reminded, of unbroken tragedy, heroism, and pathos. It was also so divisive of the fabric of union and brotherhood that Americans, especially Northerners, have always afterwards been exceptionally willing to recognize the heroes of the "other" side as national heroes and, as if more easily to forget the rift and bind the wounds, to emphasize the symbols of reconciliation. The likenesses here of the principal figures in the drama, Lincoln, Grant, and Lee, are suffused with this spirit. Lincoln appears serene and filled with inner resolve, the statesman of union, responsible more than any other, as chief strategist and master politician, for the Northern success, firm yet filled with compassion. Grant possesses the very qualities in these portraits which recommended him to Lincoln. He was a businesslike warrior, heedless of ceremony, fair to the enemy, and concerned only with catching the adversary and ending the war. And whatever the accuracy of detail and caption in these illustrations, it was his spirit which seems to pervade all the scenes. Finally, there is Robert E. Lee, the vanquished leader of the Lost Cause, sitting with dignity and composure before a gracious and magnanimous Grant at Appomattox, just as it occurred, signing the deed of surrender. With this scene fittingly concludes the series of Currier and Ives' war illustrations, and with it art expresses hope.

JAMES M. BANNER, JR.

143

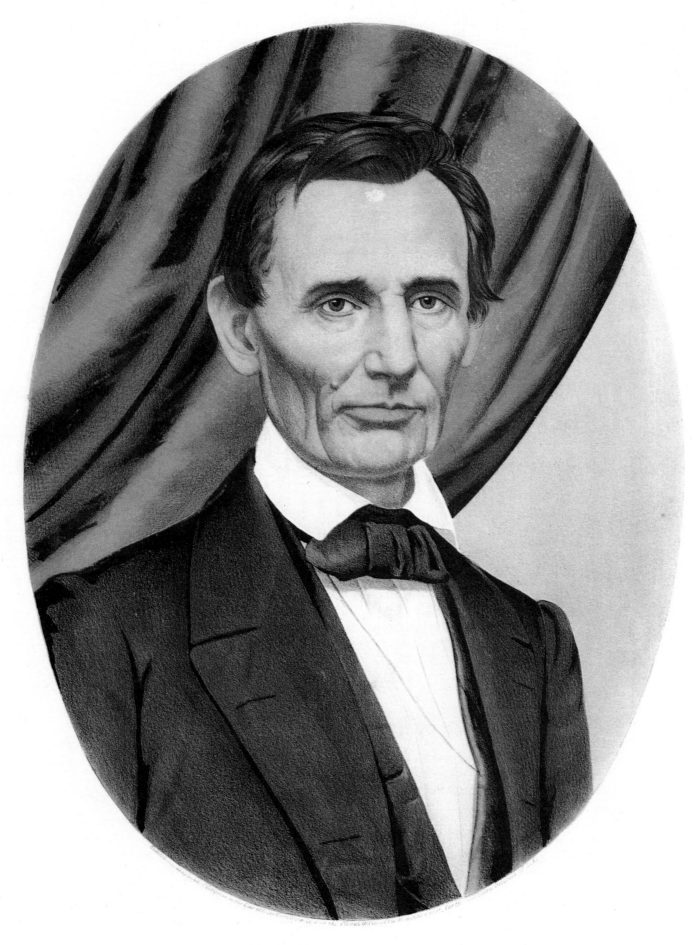

HON. ABRAHAM LINCOLN

REPUBLICAN CANDIDATE FOR SIXTEENTH PRESIDENT OF THE UNITED STATES.

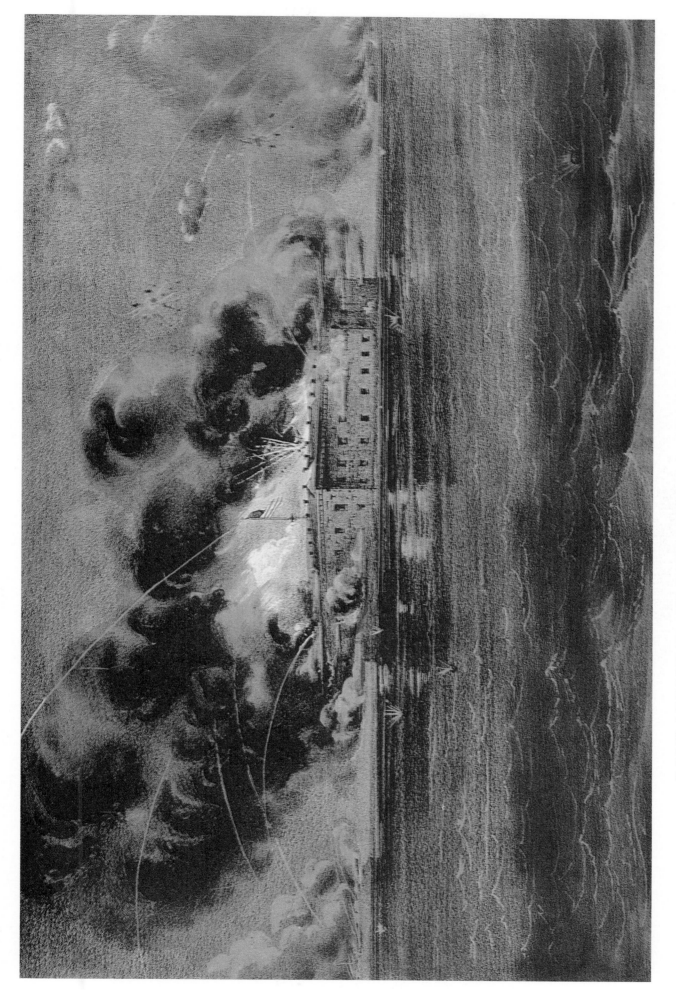

BOMBARDMENT OF FORT SUMTER, CHARLESTON HARBOR

12TH & 13TH OF APRIL, 1861.

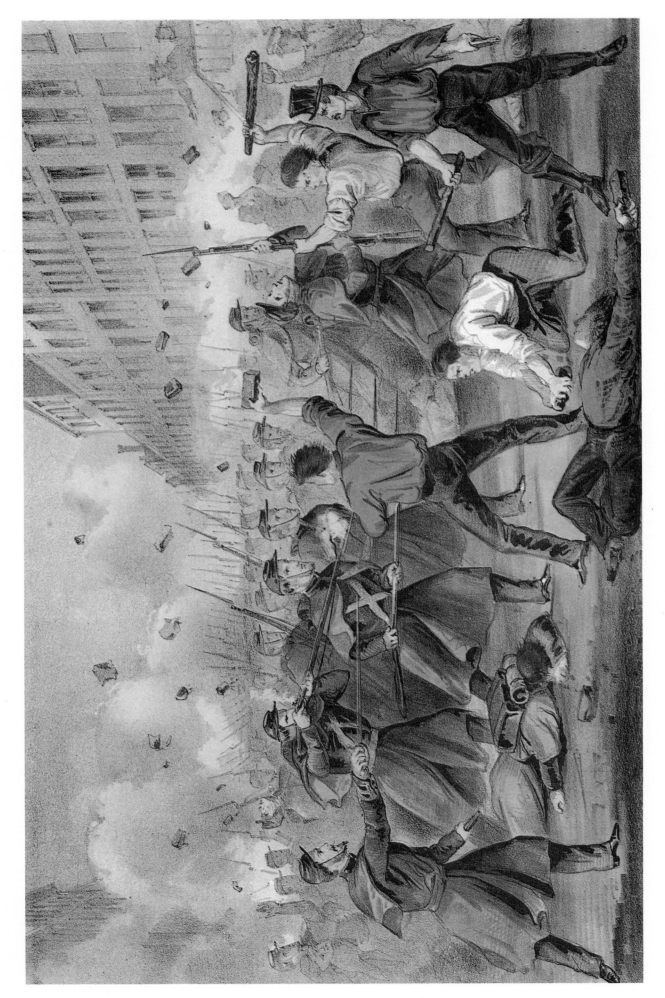

THE LEXINGTON OF 1861

The Massachusetts Volunteers fighting their way through the streets of Baltimore on their march to the defence of the National Capital, April 19, 1861. Hurrah for the Glorious 6th!

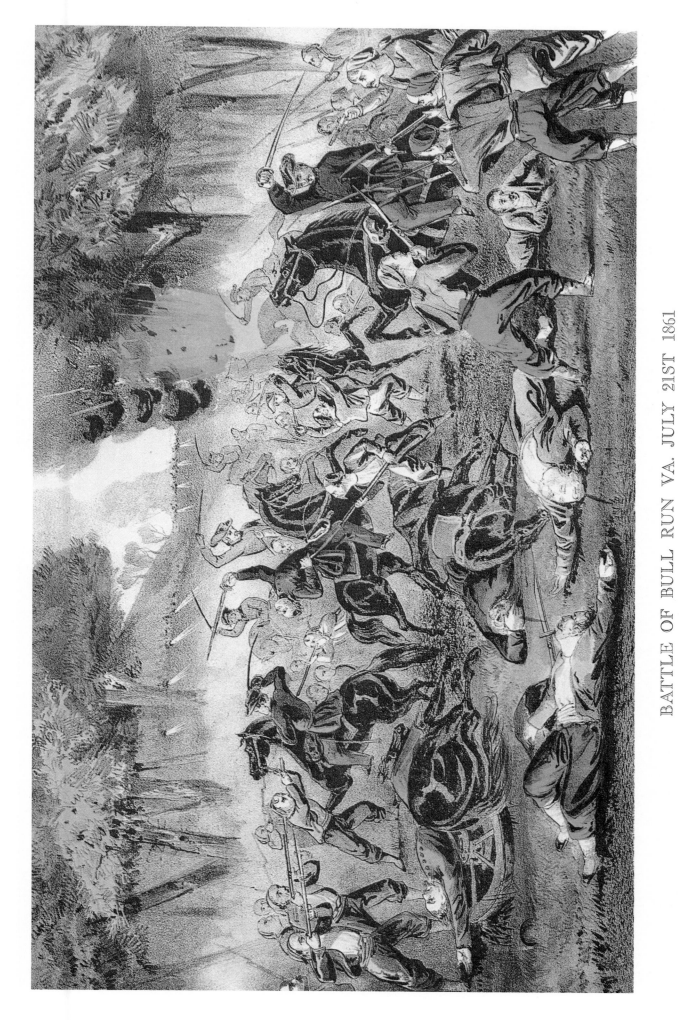

BATTLE OF BULL RUN VA. JULY 21ST 1861

GALLANT CHARGE OF THE ZOUAVES AND DEFEAT OF THE REBEL BLACK HORSE CAVALRY.

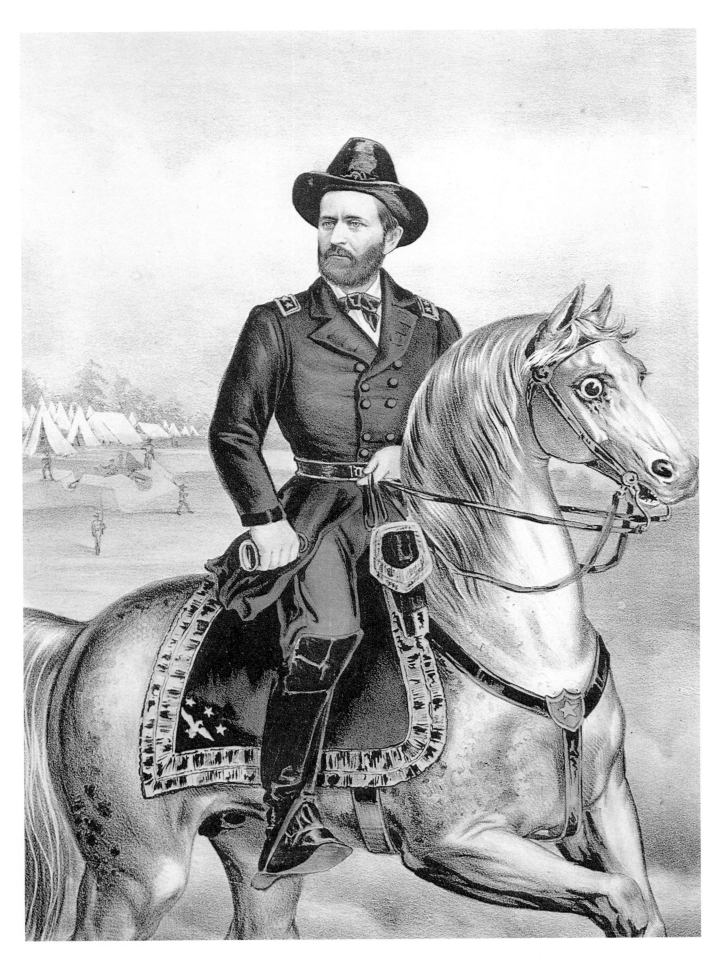

LIEUT.-GENL. ULYSSES S. GRANT

GENERAL IN CHIEF OF THE ARMIES OF THE UNITED STATES.

THE STORMING OF FORT DONELSON, TENN., FEB. 15, 1862

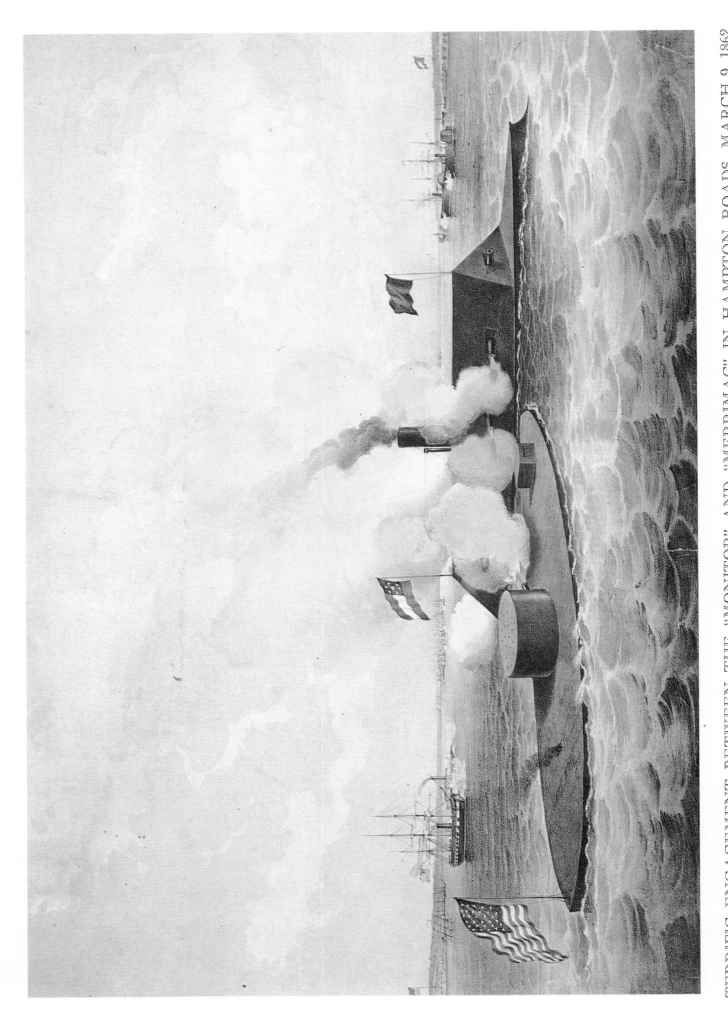

TERRIFIC ENGAGEMENT BETWEEN THE "MONITOR" AND "MERRIMAC" IN HAMPTON ROADS, MARCH 9, 1862

THE FIRST FIGHT BETWEEN IRON SHIPS OF WAR IN WHICH THE "MERRIMAC" WAS CRIPPLED AND THE WHOLE REBEL FLEET WAS DRIVEN BACK TO NORFOLK

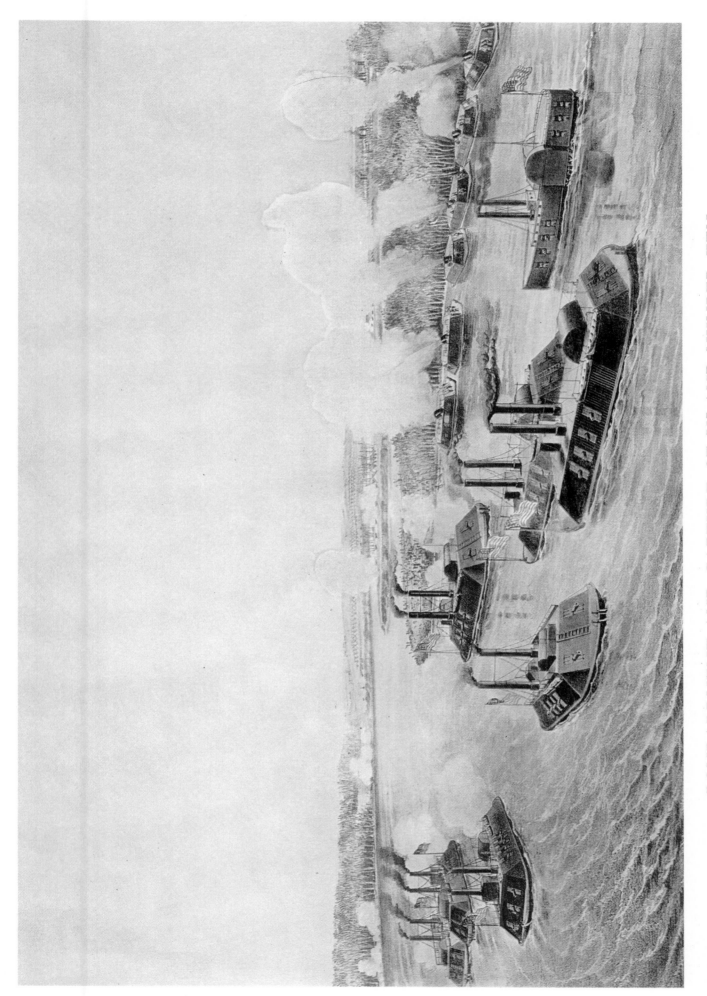

BOMBARDMENT AND CAPTURE OF ISLAND NUMBER TEN

ON THE MISSISSIPPI RIVER, APRIL 7, 1862 BY THE GUNBOAT AND MORTAR FLEET UNDER COMMAND OF COM. A. H. FOOTE.

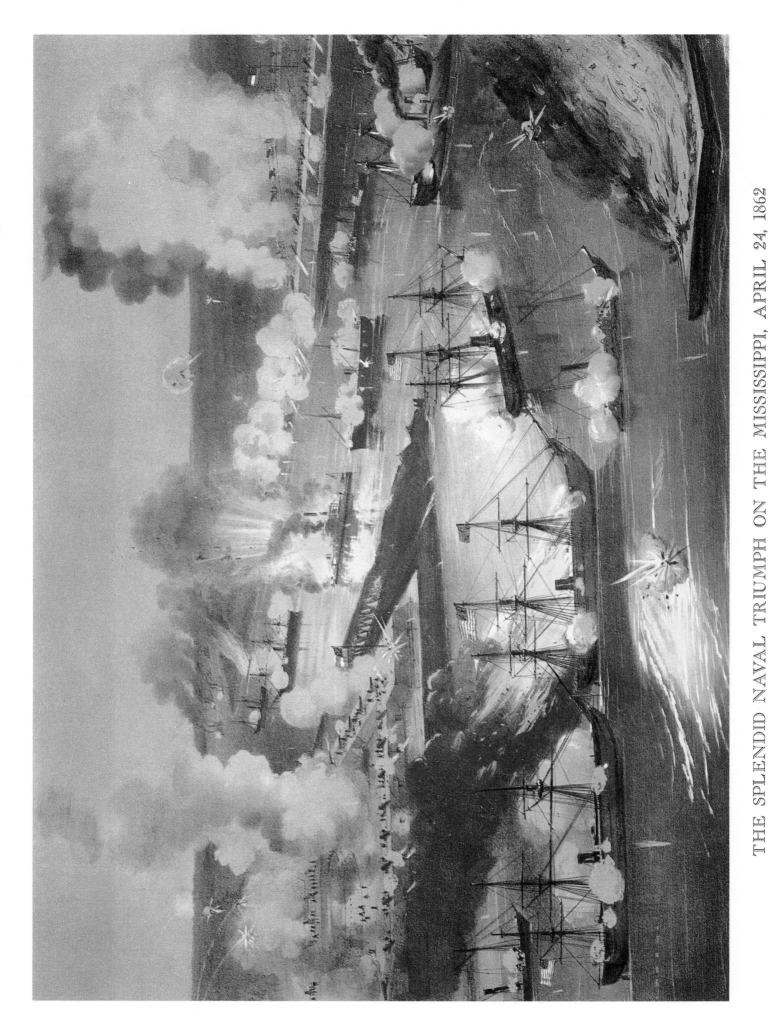

THE SPLENDID NAVAL TRIUMPH ON THE MISSISSIPPI, APRIL 24, 1862

DESTRUCTION OF THE REBEL GUNBOATS AND IRON CLAD BATTERIES BY THE UNION FLEET UNDER FLAG OFFICER FARRAGUT

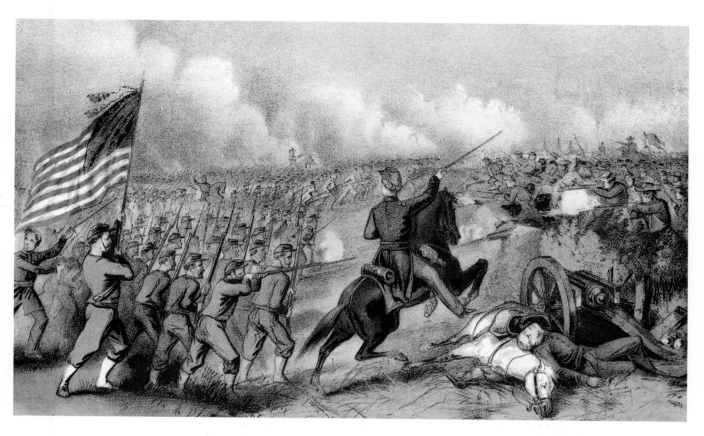

BATTLE OF WILLIAMSBURG, VA., May 5th 1862

*Victorious charge of the gallant soldiers of the North and East under
Genl. McClellan, the invincible leader of the Army of the Potomac.*

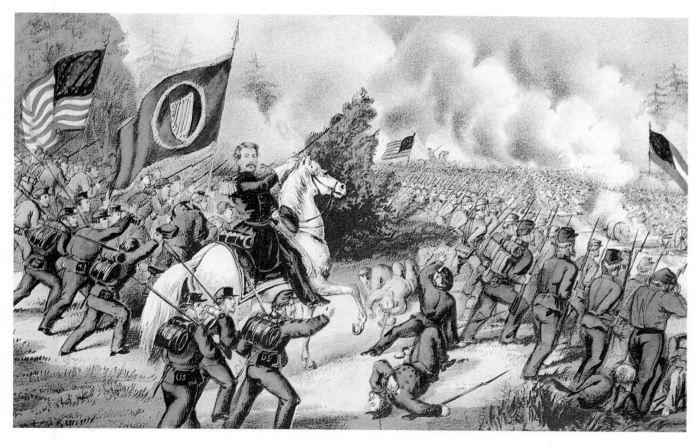

GENL. MEAGHER AT THE BATTLE OF FAIR OAKS, VA., June 1st 1862

The bayonet charge of the Irish Brigade was the most stubborn, sanguinary and bloody of modern times.

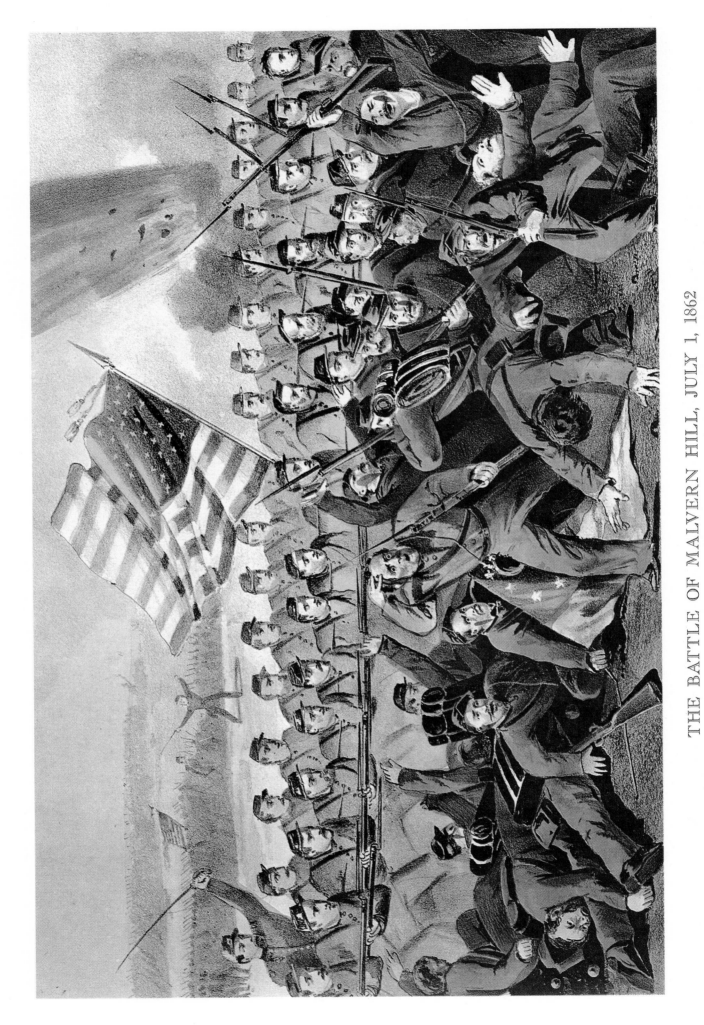

THE BATTLE OF MALVERN HILL, JULY 1, 1862

TERRIFIC BAYONET CHARGE OF THE FEDERAL TROOPS AND THE FINAL REPULSE OF THE REBEL ARMY

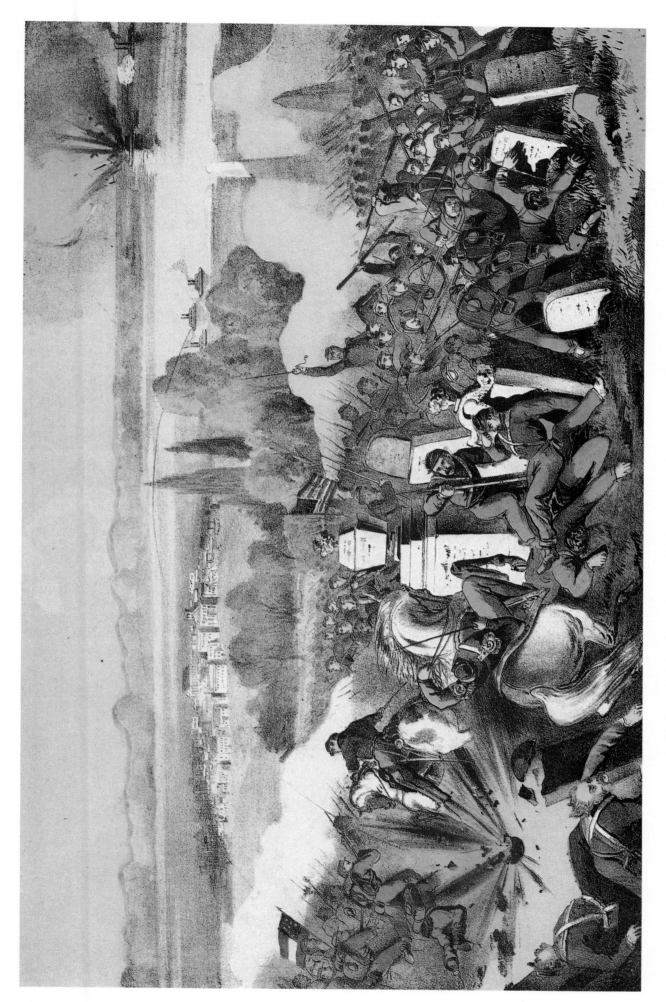

THE BATTLE OF BATON ROUGE, LA. AUG. 4TH 1862

The attack was made by the Rebels under Genl. Breckinridge with fifteen regiments and ten pieces of Artillery, the Union forces consisted of 2500 men and a few pieces of artillery under Genl. Williams, the fight lasted six hours when the Rebels were repulsed and forced to retreat, the great rebel iron clad ram gunboat "Arkansas" also approached to cooperate with the rebels but was promptly attacked by the Essex, under Commodore Porter, and after a short engagement set on fire and destroyed.

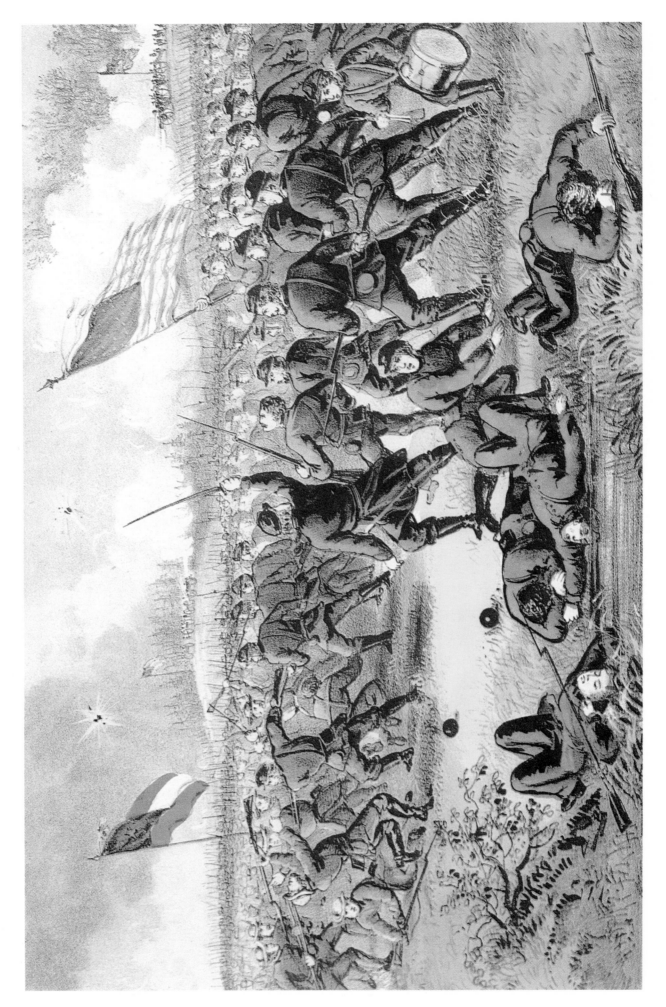

BATTLE OF CORINTH, MISS., OCT. 4, 1862

Between Federal troops under General Grant and the combined Rebel forces under Generals Van Dorn, Price and Lovell. The Rebels were utterly defeated and driven from the field, throwing away their arms and accoutrements and everything that could impede their flight.

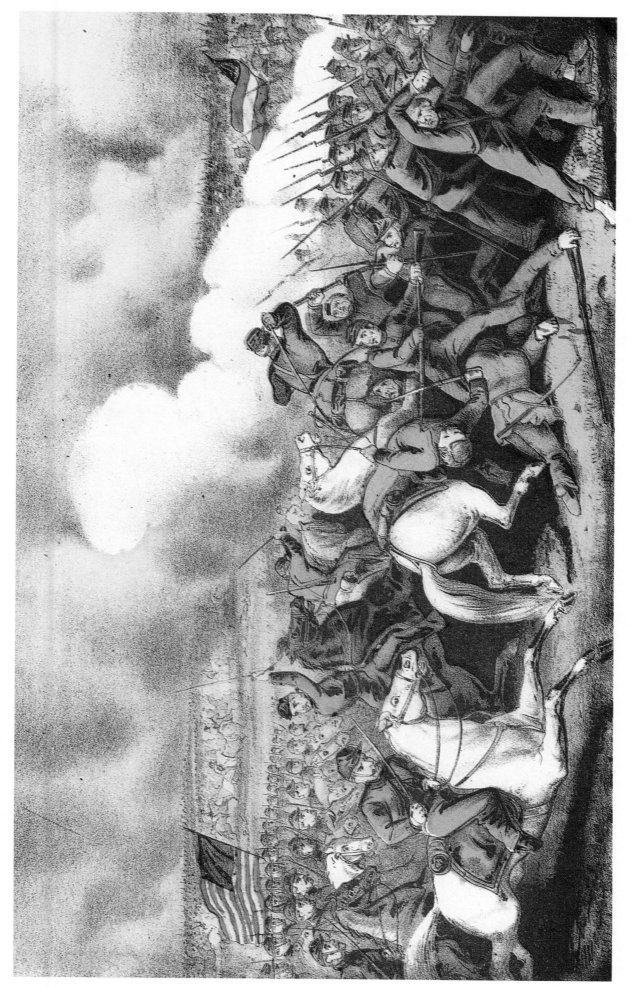

THE BATTLE OF ANTIETAM, MD., SEPT. 17, 1862

This splendid victory was achieved by the Army of the Potomac commanded by the great General Geo. B. McClellan over the Rebel Army under Lee, Jackson and a host of others, utterly routing and compelling them to a precipitate retreat across the Potomac to save themselves from capture and annihilation.

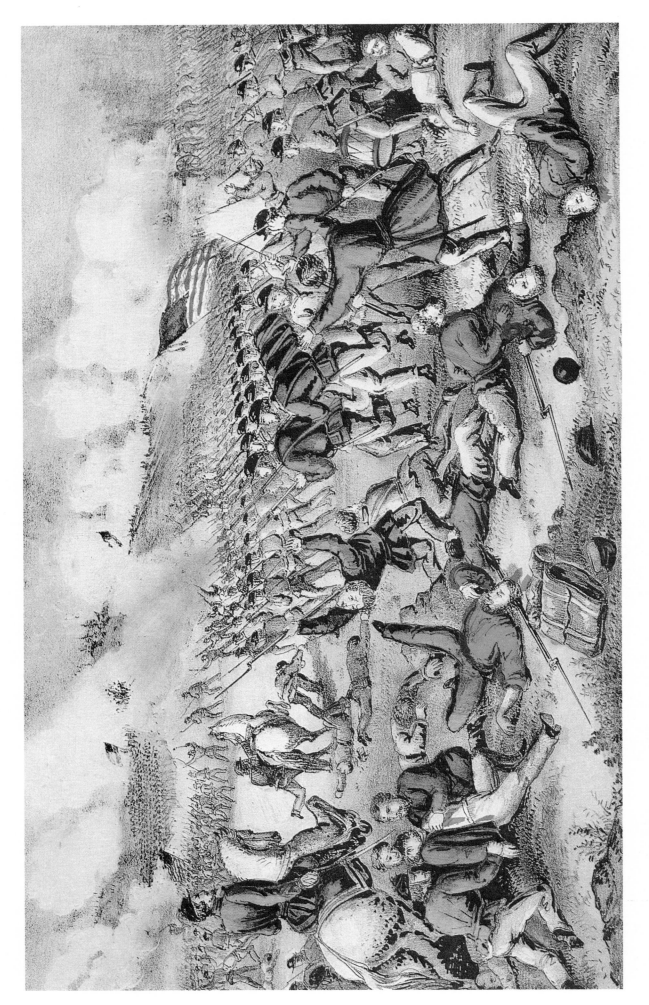

THE BATTLE OF FREDERICKSBURG, VA., DEC. 13, 1862

This battle shows with what undaunted courage the lion-hearted Army of the Potomac always meets its foes. After forcing the passage of the Rappahanock on the 11th in the face of murderous fire from the concealed Rebels, and taking possession of Fredericksburg on the 12th, on the morning of the 13th the Army rushed with desperate valor on the entrenchments of the enemy, and thousands of its dead and dying tell of the fearful strife which raged all night and put an end to the carnage. Though driven back by an intrenched and hidden foe the soldiers of the North are still as ready to meet the traitors of the South, as in their days of proudest victory.

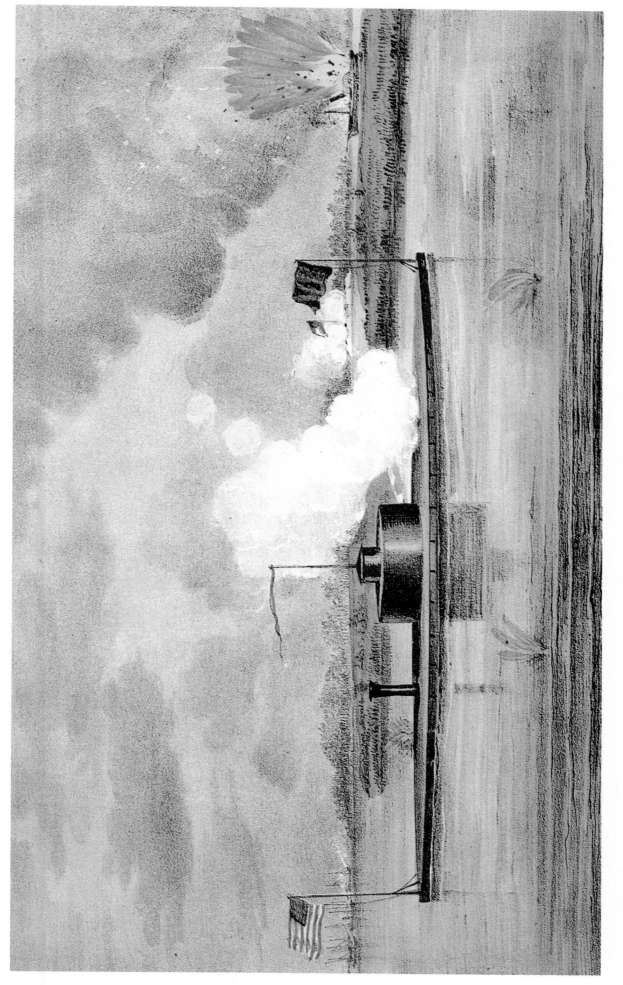

THE UNION IRON CLAD MONITOR "MONTAUK" DESTROYING THE REBEL STEAMSHIP "NASHVILLE"

IN THE OGEECHEE RIVER NEAR SAVANNAH, GA., FEB. 27, 1863

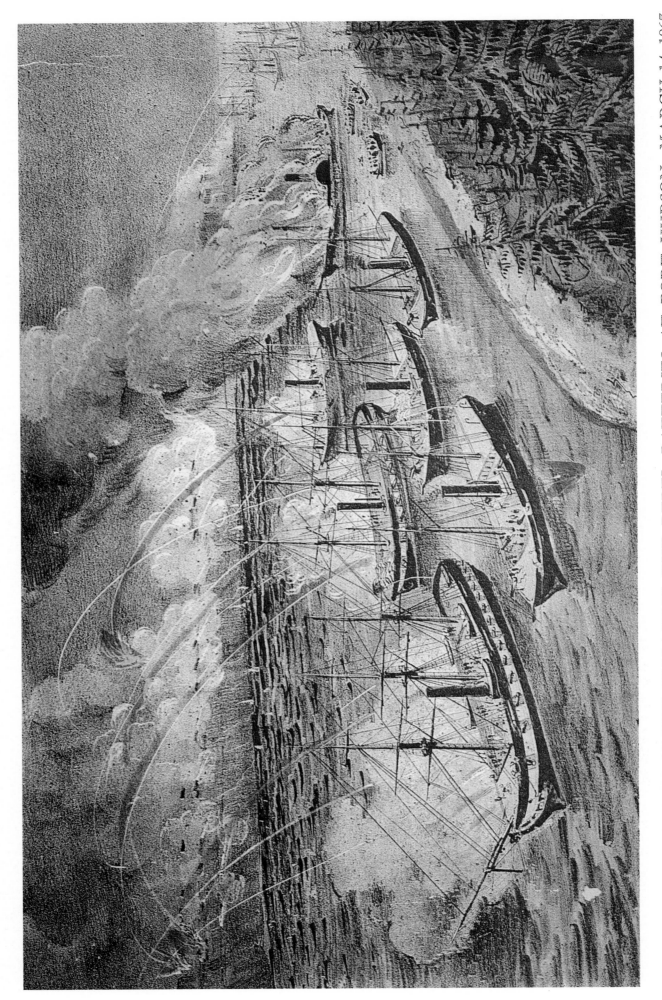

ADMIRAL FARRAGUT'S FLEET ENGAGING THE REBEL BATTERIES AT PORT HUDSON, MARCH 14, 1863

On the night of the 14th at eleven o'clock the Fleet came within range of the batteries and the action commenced. The Flagship "Hartford" with the "Albatross" passed through the terrible ordeal in safety and proceeded towards Vicksburg. The Frigate "Mississippi" ran ashore and was abandoned and set on fire, the other vessels returned without material damage.

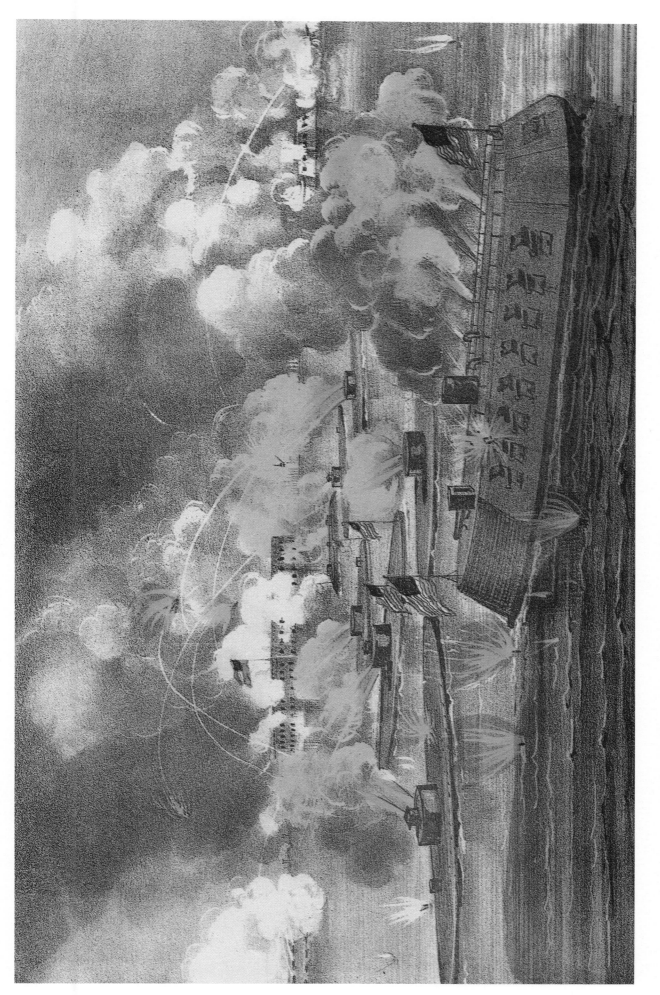

THE GREAT FIGHT AT CHARLESTON S. C. APRIL, 7TH 1863

Between 9 United States "Iron-Clads," of Admiral Dupont; and Forts Sumter, Moultrie, and the Cummings Point Batteries in possession of the Rebels. The Iron-Clads carried only 32 Guns, while the Rebel Forts mounted over 300 of the heaviest calibre, but notwithstanding the great odds, the little Iron-clads went bravely into the fight and for nearly two hours were under the most terrible fire ever witnessed on this earth, but being unable to reach Charleston on account of obstructions in the harbor, the Admiral reluctantly gave the order for the battle to cease, and the fleet to retire from the unequal contest. The Keokuk was the only Iron-clad disabled in the fight.

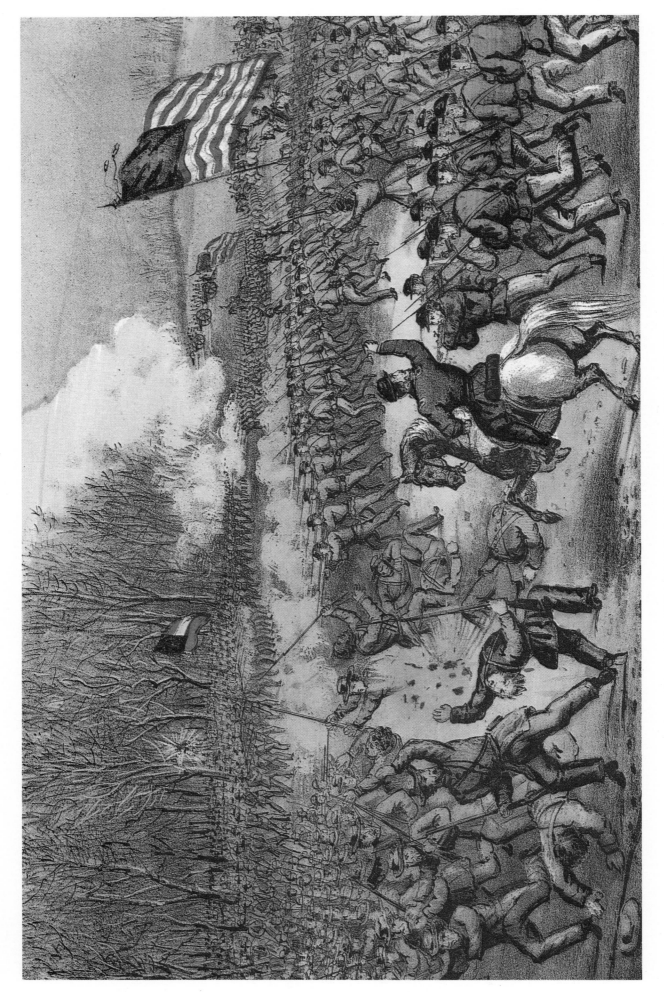

BATTLE OF CHANCELLORSVILLE, VA. MAY, 3rd 1863

This terrific Battle was fought between the "Army of the Potomac" under Genl. Hooker and the Rebel Army under command of Generals Lee, "Stonewall" Jackson, Longstreet and Hill.

The Rebels advanced in overwhelming numbers, but the brave Union Soldiers fought with desperate gallantry, holding the Rebels in check, and inflicting dreadful slaughter among them.

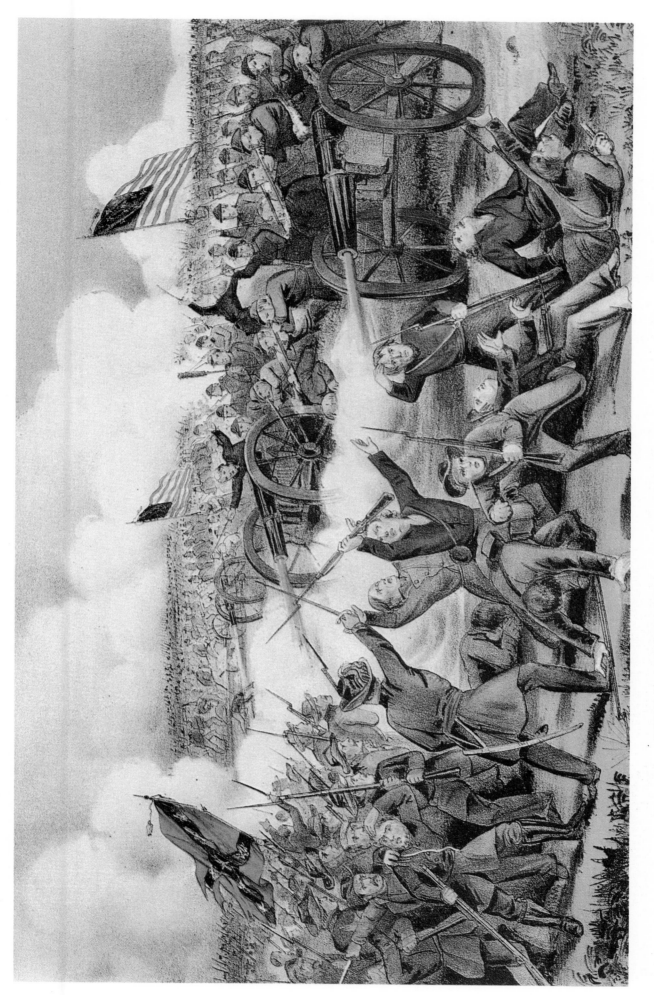

THE BATTLE OF GETTYSBURG, PA. JULY 3RD 1863

This terrific and bloody conflict between the gallant "Army of the Potomac" commanded by their great Genl. George G. Meade, and the host of the rebel "Army of Virginia" under Genl. Lee, was commenced on Wednesday July 1st and ended on Friday the 3rd at 5 o'clock P.M. The decisive battle was fought on Friday ending in the complete rout and dispersal of the rebel Army. Undying fame and a Nation's thanks are ever due the heroic soldiers who fought with such unflinching bravery this long and desperate fight.

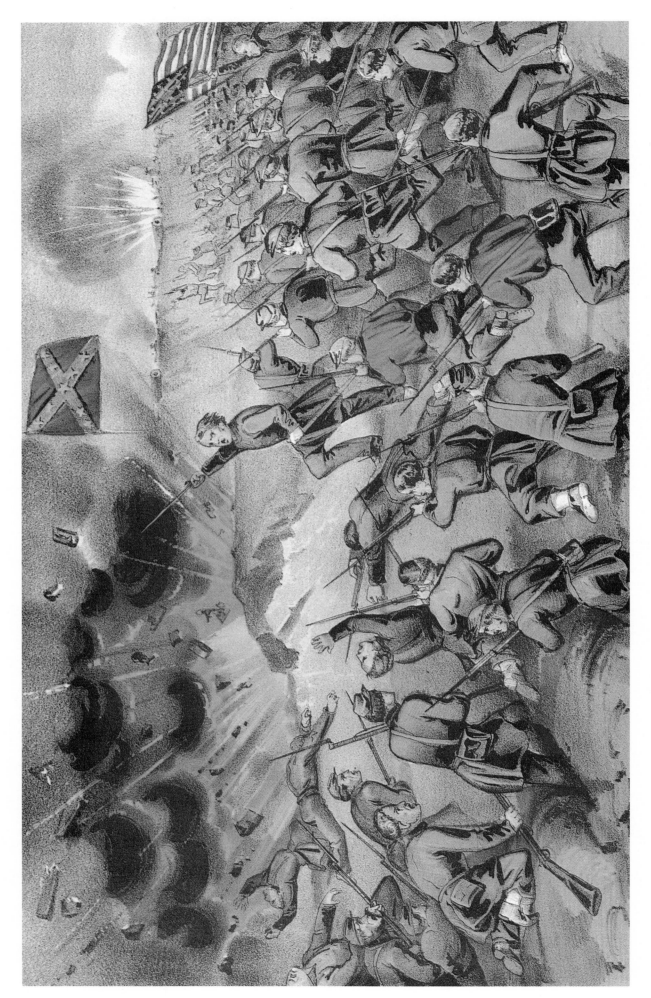

SIEGE AND CAPTURE OF VICKSBURG, MISS. JULY 4th 1863

Blowing up one of the enemy's forts and desperate charge of the Union Volunteers through the breach, June 26th 1863. After which time the Rebels were vigorously pressed on every side by our Army and Navy, when finding further resistance hopeless, they surrendered on the "glorious anniversary" July 4th to our victorious arms, after a siege of 65 days. Over 30,000 prisoners fell into our hands, beside 45000 stand of arms, 211 field-pieces, 90 siege guns of the heaviest calibre, 57 stand of colors, also 1 Lieut. General, 4 Major Generals, 15 Brigadiers, and field, staff and line officers 4,600.

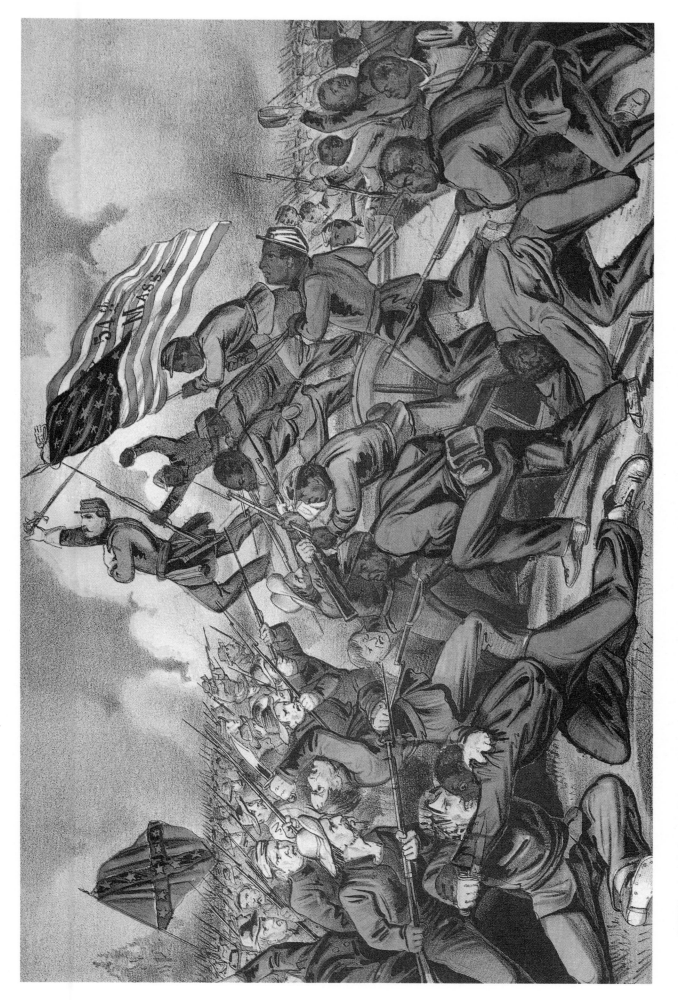

THE GALLANT CHARGE OF THE FIFTY FOURTH MASSACHUSETTS (COLORED) REGIMENT

ON THE REBEL WORKS AT FORT WAGNER, MORRIS ISLAND, NEAR CHARLESTON, JULY 18th 1863, AND DEATH OF COLONEL ROBT. G. SHAW.

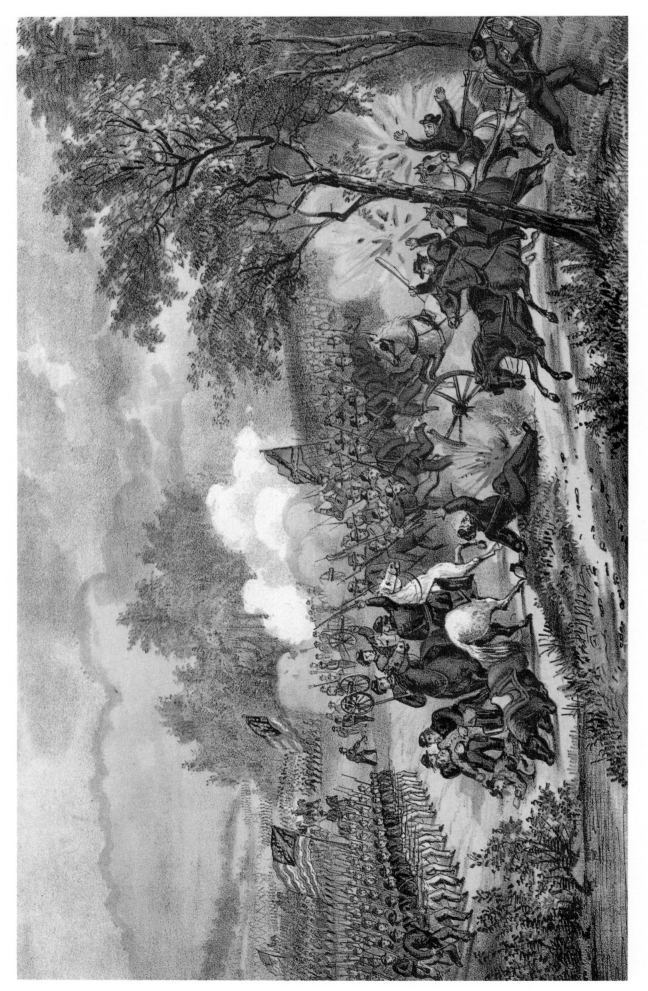

THE BATTLE OF CHICKAMAUGA, GEO.

FOUGHT ON THE 19th AND 20th OF SEPTEMBER, 1863.

Genl. Rosecrans having advanced the "Army of the Cumberland" into Northwestern Georgia, was attacked by the Rebel army in overwhelming numbers, under Bragg, Longstreet and others. But the glorious fighting of Genl. Thomas' Division saved the day, completely shattering Longstreet's famous Corps, and so effectually checking the whole Rebel Army by nightfall on Sunday the 20th Genl. Rosecrans was enabled to fall back in safety on Chattanooga, thus foiling the Rebels in obtaining possession of that strong hold.

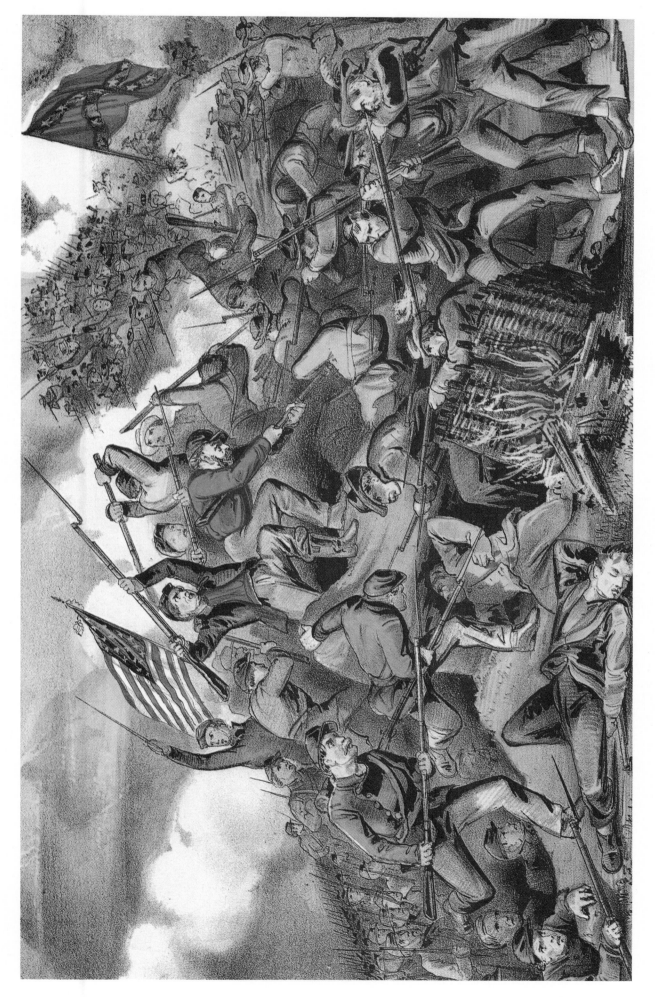

THE BATTLE OF CHATTANOOGA, TENN. NOVR. 24th & 25th 1863

BETWEEN THE UNION FORCES UNDER GENL. GRANT, AND THE REBEL ARMY UNDER GENL. BRAGG.

This great conflict began on Monday Novr. 23rd and lasted until Thursday the 26th, but the main battles were fought on the 24th & 25th, resulting in a complete victory for the Union Arms. The battle field extended six miles along Missionary Ridge, and several miles on Lookout Mountain, but the battle was so well ordered by Genl. Grant, and so heroically fought by his gallant Army, that at last the Rebels broke in utter and total confusion, throwing away their guns and leaving artillery, caissons, ammunition and every thing of value behind them; reckless of all, save safety.

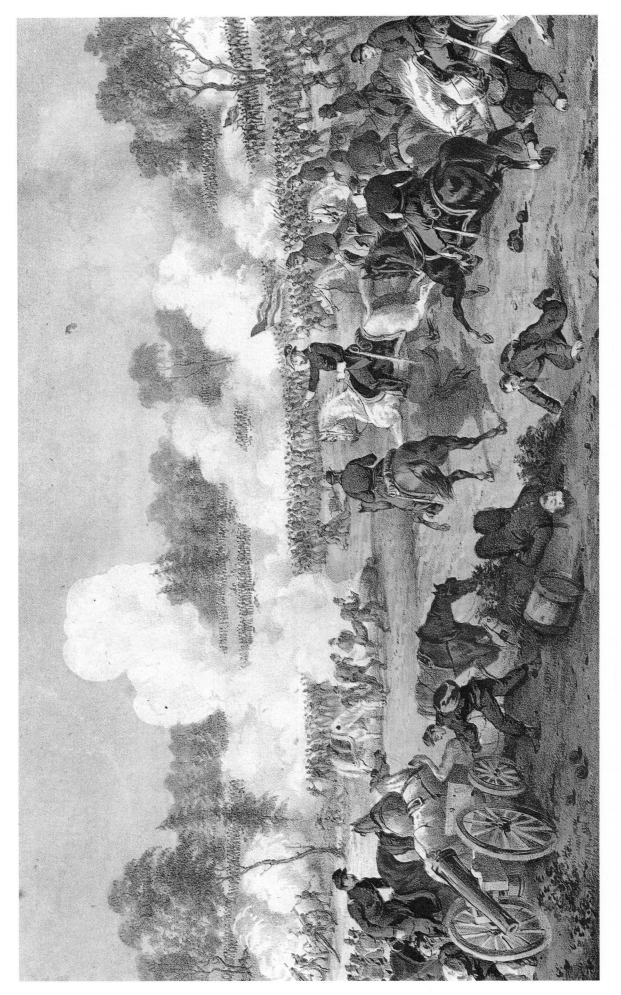

THE BATTLE OF THE WILDERNESS VA. MAY 5th & 6th 1864

This was one of the most desperate Battles of modern times, and was fought between the gallant "Army of the Potomac" under the immediate command of that great Hero, Lieut. Genl. U. S. Grant and the "Rebel Army of Virginia" under Lee and others. On Wednesday, May 4th the "Army of the Potomac" crossed the Rapidan and on the 5th attacked the Rebels with great fury, and after two days of desperate fighting, in which the losses on both sides were immense, the Rebel hordes were compelled to give way, and Saturday, the 7th were glad to save themselves in flight to the South.

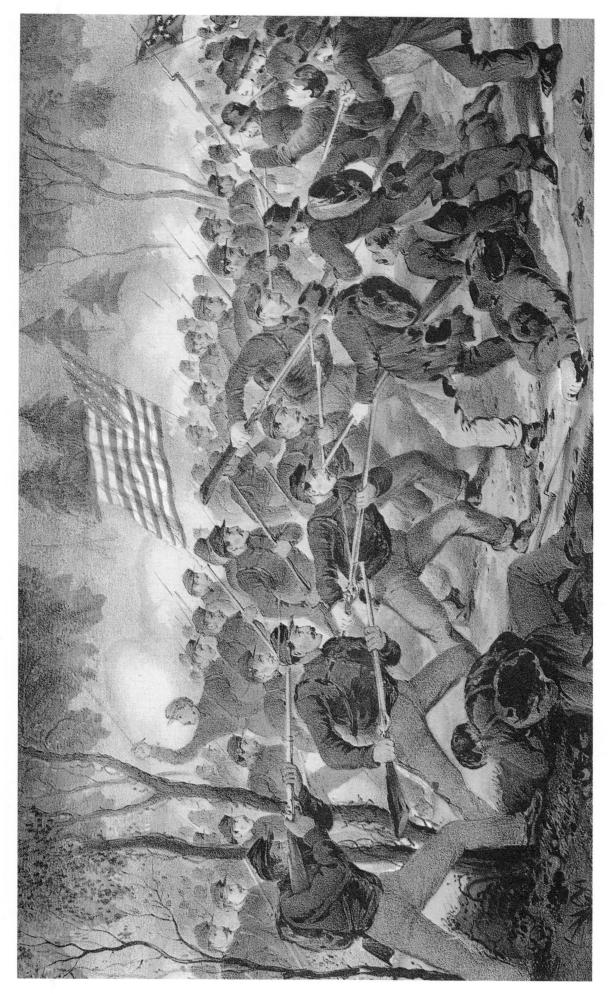

THE BATTLE OF SPOTTSYLVANIA, VA. MAY 12TH 1864

In this Battle, the "Army of the Potomac," after some of the severest fighting ever recorded in history, achieved the greatest victory of the war. In the words of their commander Genl. Meade, "They fought a desperate foe for eight days and nights almost without intermission, compelling him to abandon his fortifications on the Rapidan, and other intrenched positions, with a loss of 18 Guns, 22 Colors and 8000 prisoners, including 2 General Officers." In this great fight, Genl. Hancock made his famous charge, capturing the Rebel Genl. E. Johnson and his whole division, with a party of Early's.

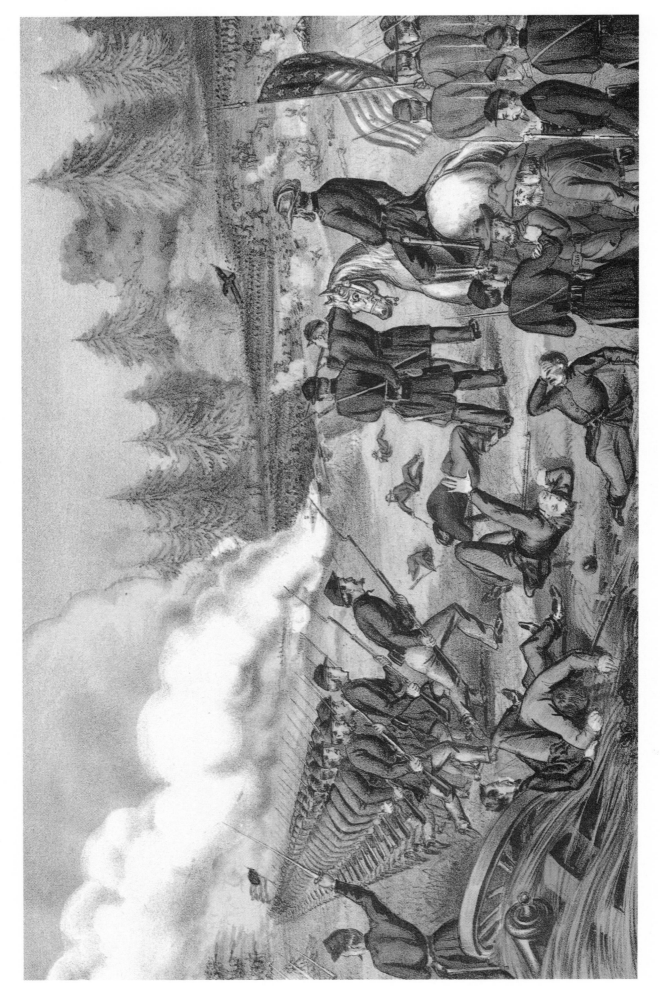

BATTLE OF COAL HARBOR VA. JUNE 1st. 1864

The army of the Potomac advancing towards Richmond encountered the enemy entrenched at Coal Harbor, on June 1st about half past five A.M. The order was given to charge the Rebel works, and the Union troops advanced under a heavy fire of grape and can-nister, driving the rebels before them and taking the position, which was firmly held in spite of the enemys desperate efforts to regain it.

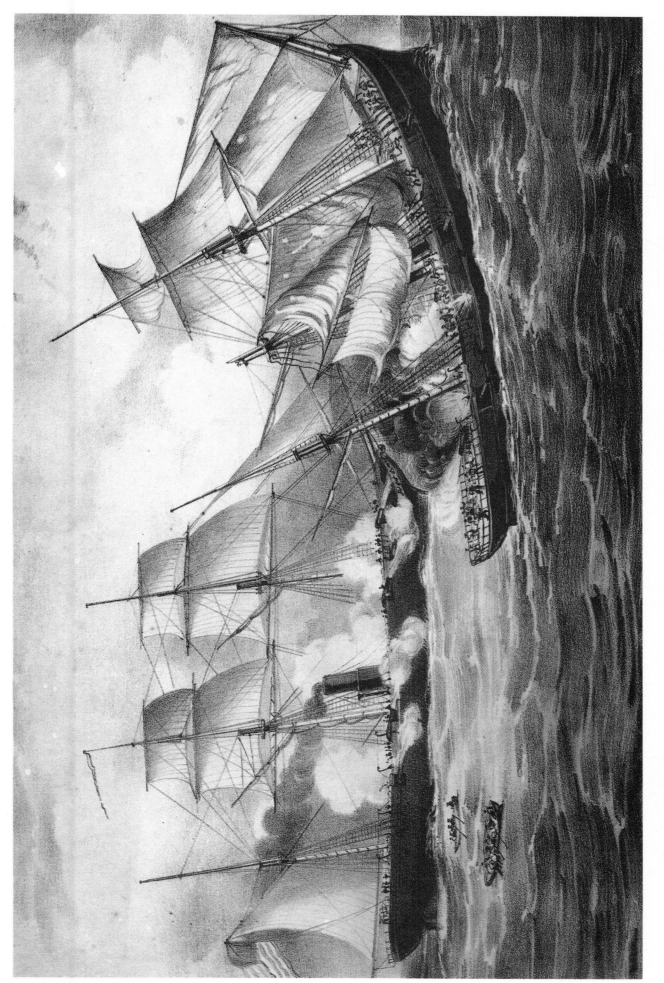

THE U.S. SLOOP OF WAR "KEARSARGE" 7 GUNS, SINKING THE PIRATE "ALABAMA" 8 GUNS,

OFF CHERBOURG, FRANCE, SUNDAY JUNE 19th 1864.

The "Alabama" was built in a British Ship-yard, by British workmen, with British Oak, armed with British Guns, manned with British Sailors, trained in the British Navy, and was sunk in the British channel, in 80 minutes, by the Yankee Sloop of War "Kearsarge" Capt. John A. Winslow.

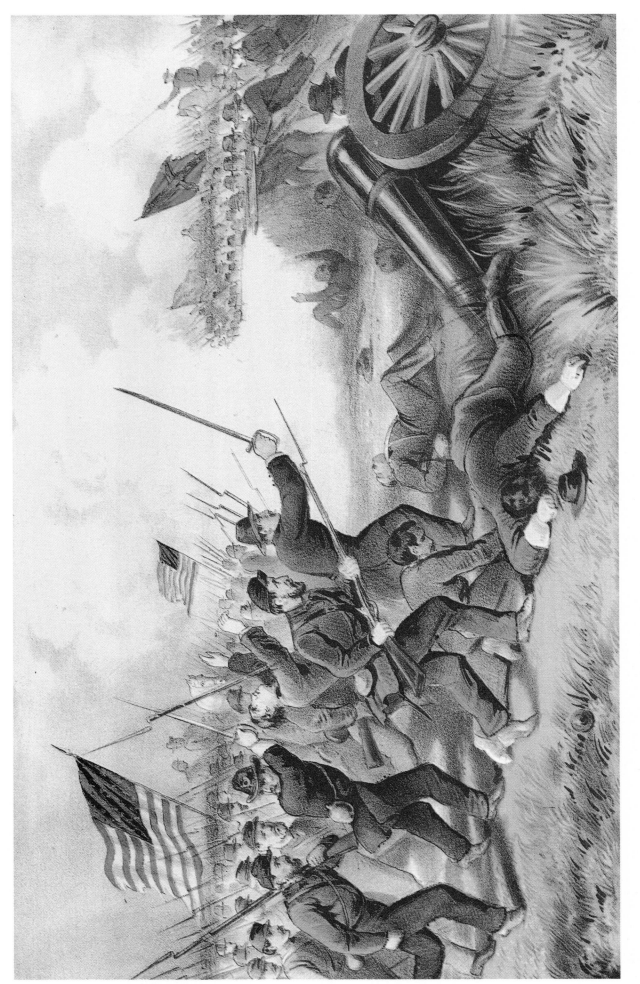

THE BATTLE OF JONESBORO GEORGIA, SEPT. 1st. 1864

General Sherman leaving the Twentieth Corps, withdrew the rest of his army before Atlanta, and the rebels began to rejoice over his supposed retreat, when he suddenly reappeared to their astonished vision fifteen miles south from Atlanta attacked the Rebels at Jonesboro. Capturing their works, ten guns and 2000 prisoners, and inflicting upon them a loss of three thousand killed and wounded, the Rebel Genl. Hood being completely "Hoodwinked" in the words of Genl. Sherman, "blew up his magazines at Atlanta, and left in the night time, when the twentieth Corps Genl. Slocum took possession of that place," adding the proudest trophy of all, to the Conquering arms of our Noble Army of the West.

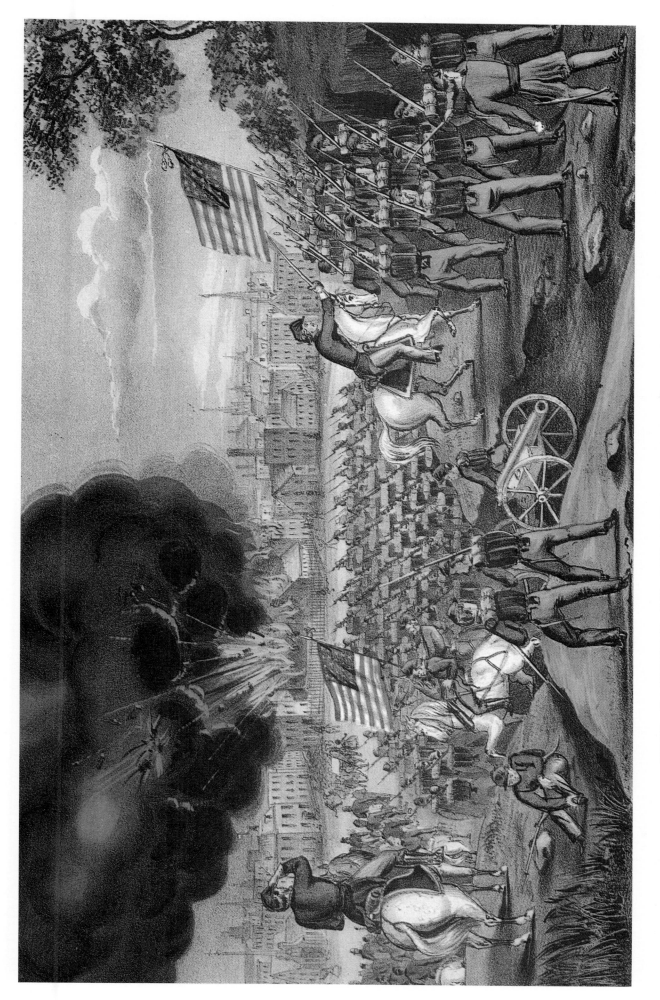

THE CAPTURE OF ATLANTA, GEORGIA, SEPT. 2nd. 1864

BY THE UNION ARMY, UNDER MAJOR GENL. SHERMAN.

On the 30th August, the Union Army, by the masterly strategy of Genl. Sherman, made a rapid flank movement, cutting the Rail Road south of the City, attacking the Rebels at Jonesboro, and capturing their guns and defences there. Hood the Rebel Commander, finding himself completely outgeneraled, set fire to his stores, blew up his magazines and "skedaddled." Genl. Sherman with the 20th Corps occupied the place and thus in the thrilling words of Sherman "Atlanta is ours and fairly won!"

173

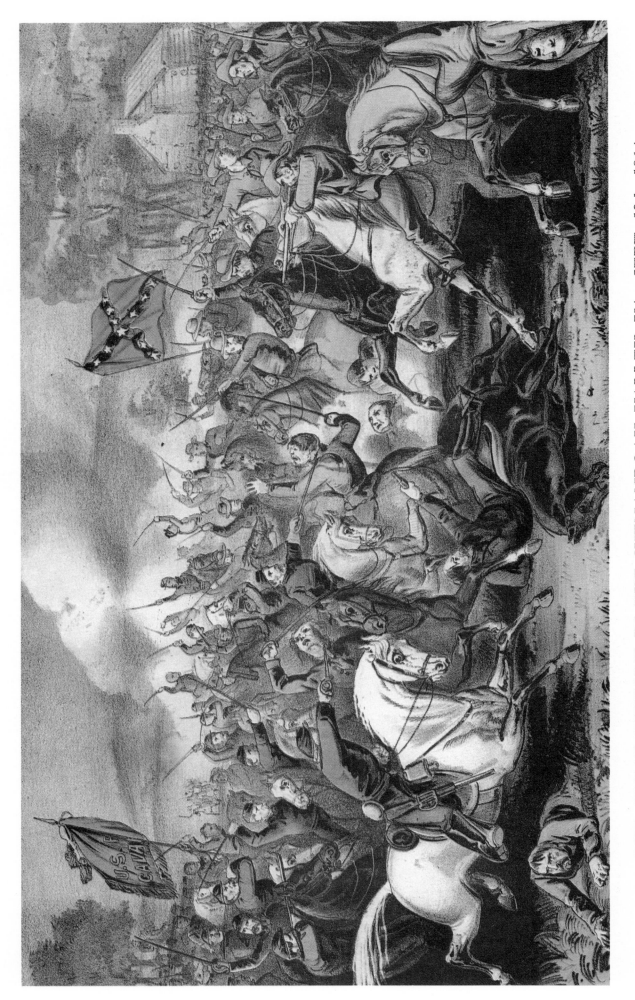

THE GREAT VICTORY IN THE SHENANDOAH VALLEY, VA., SEPT. 19th. 1864

GENL. SHERIDANS CAVALRY CHARGING AND ROUTING THE REBEL HORSEMEN.

THE BATTLE OF OPEQUAN CREEK was commenced by Genl. Sheridan, attacking the enemy under Genl. Early, at daylight, and lasted until 5 P.M. when the Rebels were completely routed, and fled from the field; with a loss of five general officers, and over 5000 officers and men killed and wounded, and leaving in the hands of our brave Union boys, 5000 prisoners, five guns, and fifteen battle flags, as trophies of their well earned victory.

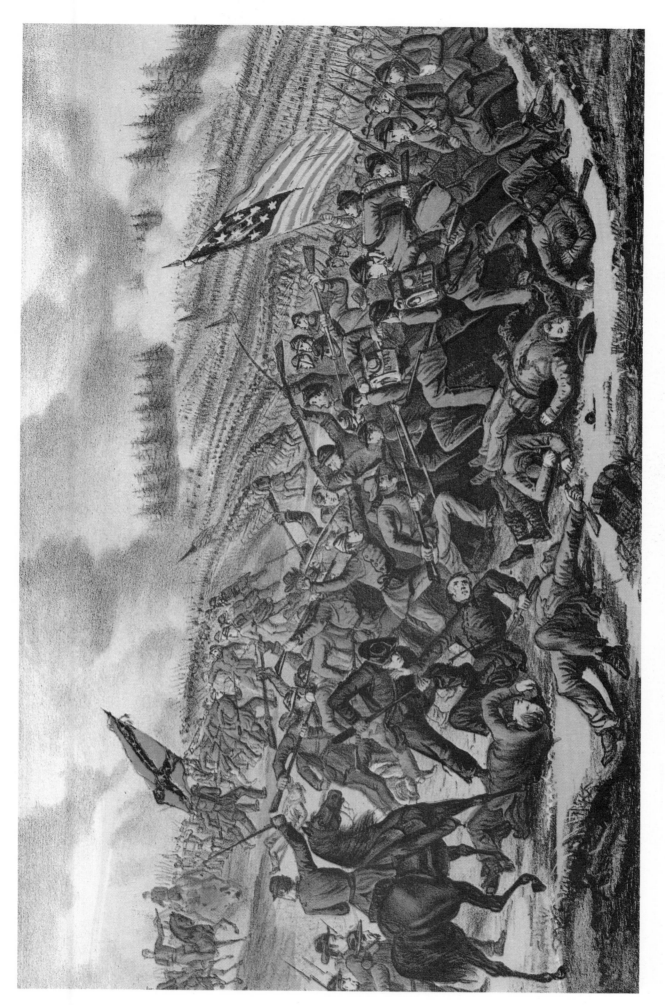

THE BATTLE OF PETERSBURG VA. APRIL 2nd 1865

This great and decisive Battle was fought on Sunday, between the Union Heroes under Genl. Grant, and the Rebel hosts under Lee; result-ing in the total overthrow of the traitors, and the capture of both Petersburg and Richmond, with vast amounts of war material, and an estimated loss to the rebels of 15,000 in killed and wounded, and 25,000 prisoners, while the total Union loss is placed at less than 7000.

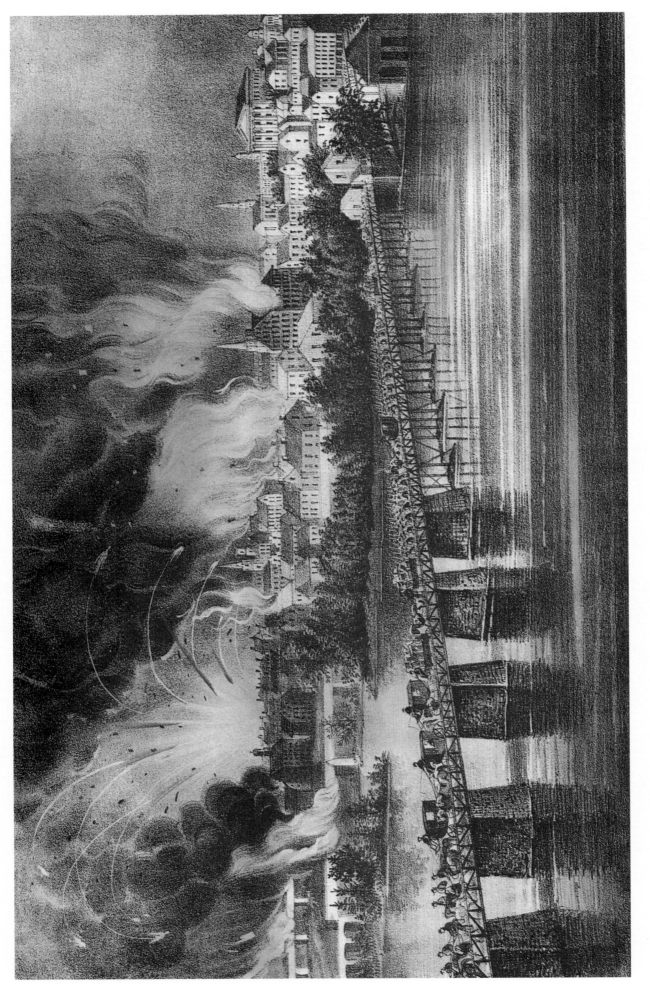

THE FALL OF RICHMOND VA. ON THE NIGHT OF APRIL 2ND 1865

This strong hold and Capital City of the Davis Confederacy, was evacuated by the Rebels in consequence of the defeat at "Five Forks" of the Army of Northern Virginia under Lee, and capture of the South side Rail Road, by the brave heroes of the North, commanded by

Generals Grant, Sheridan and others. Before abandoning the City the Rebels set fire to it, destroying a vast amount of property; and the conflagration continued until it was subdued by the Union troops in the following morning.

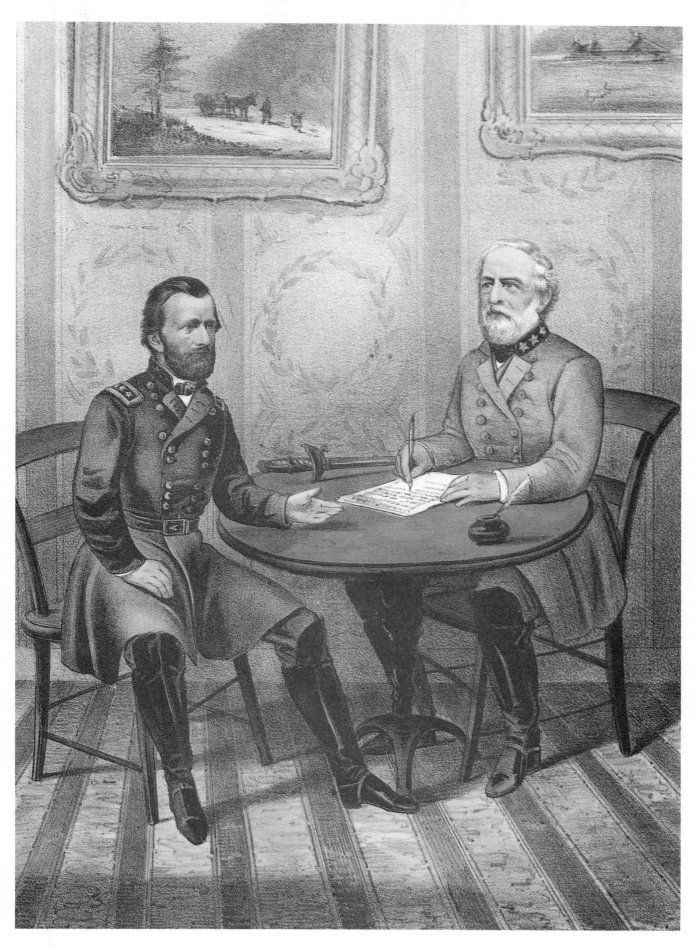

SURRENDER OF GENL. LEE, AT APPOMATTOX C.H. VA. APRIL 9TH 1865

XI SPORTS

In 1865 with the memory of President Lincoln's assassination still fresh, government clerks were excused early for a baseball game between the Washington Nationals and the Atlantics of Brooklyn. President Andrew Johnson himself attended. Obviously, the national obsession with sports was as marked in the time of Nathaniel Currier and James Merritt Ives as it is in the days of Mickey Mantle and Bart Starr. And like good reporters, Currier and Ives recorded the fact.

We have the Harvard-Oxford boat race of 1869 on the Thames — notice that they're four-oared shells. There wasn't an eight-oared boat in the United States until three years later. Of course, the Heenan-Sayers fight at Farnborough in 1860 was an important sporting event.

Judging from the number of copies on the walls of saloons and restaurants today, there must have been a huge demand for the latter print, and indeed the excitement stirred by that battle was enough to keep the lithographer's stone hot. The meeting of America's John Carmel Heenan and the gallant Tom Sayers was the first international bout matching recognized national champions for the world title.

Among the top-hatted spectators shown squatting on the grass were Lord Palmerston, the Prime Minister; half the members of Parliament and a clutch of bishops of the Church of England. Even though the match was called a draw after police and spectators made it a free-for-all, it left New Yorkers so avid for details that they paid two dollars a copy for London papers which a young news vendor named Brentano had had the foresight to order in quantity. When Heenan returned to New York, 50,000 tickets were sold for a festival in his honor at Jones Woods in the Yorkville section of the city and a testimonial purse of $10,000 was raised.

What the Benicia Boy was to boxing, the redoubtable Atlantics were to baseball. In the first nine seasons of the National Association of Base Ball Players they won the championship seven times. In 1866 it was reported that 40,000 saw them play the Philadelphia Atlantics. It was these forerunners of the more or less immortal Dodgers who creamed the Cincinnati Red Stockings after those professionals had won seventy-eight games with one tie.

The print entitled *The American National Game* testifies both to the artist's attention to detail and the unchanging nature of baseball. If the pitcher weren't bowling with an underhand delivery, it could be a game being played today. To be sure, the second baseman is an inattentive slob; he is shaded so far to the left that he obviously expects the batter to pull the ball, but the hitter's grip on the bat, with hands wide apart, makes his intentions clear. With the runner leading off from third base, he's going to lay down a squeeze bunt.

This enables us to identify the batter. He's got to be Dickey Pearce, star shortstop of the Atlantics, who devised the technique of tapping the ball gently in front of the plate and racing to first before the defense could recover. It was considered a loathsome tactic.

The range of subjects is as wide as the range of American interests: from ice skating on a New England pond to prizefighting, baseball and croquet. Usually American scenes are depicted, as in the multitude of prints dealing with the indigenous and immensely popular sport of harness racing, but when the public interest justified it the reporters did not hesitate to venture abroad.

The lasting attraction of Currier & Ives prints lies not so much in their decorative value or their excellence as an art form but rather in their power to evoke the spirit of the times in which they were created. They are the mirror of their period, and sports have been a vital part of our culture in all periods.

RED SMITH

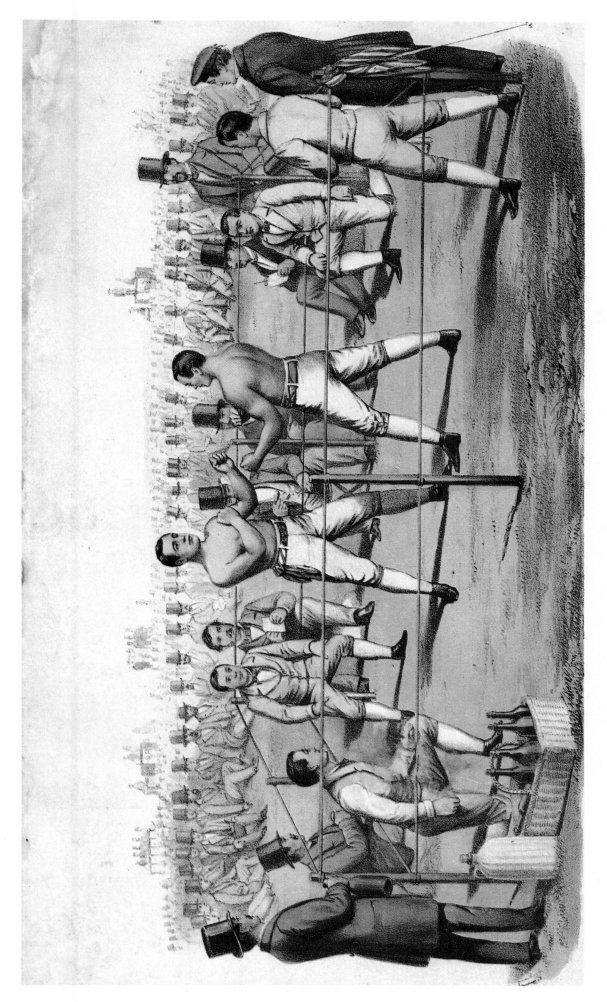

THE GREAT FIGHT FOR THE CHAMPIONSHIP

BETWEEN JOHN C. HEENAN "THE BENICIA BOY," & TOM SAYERS "CHAMPION OF ENGLAND,"
WHICH TOOK PLACE APRIL 17TH 1860, AT FARNBOROUGH, ENGLAND.

The battle lasted 2 hours 20 minutes 42 rounds, when the mob rushed in & ended the fight. HEENAN stands 6 ft. 1½ in. fighting weight 190 lbs. Born May 2nd 1835. SAYERS stands 5 ft. 8 in. fighting wt. 150 lbs. Born 1826.

179

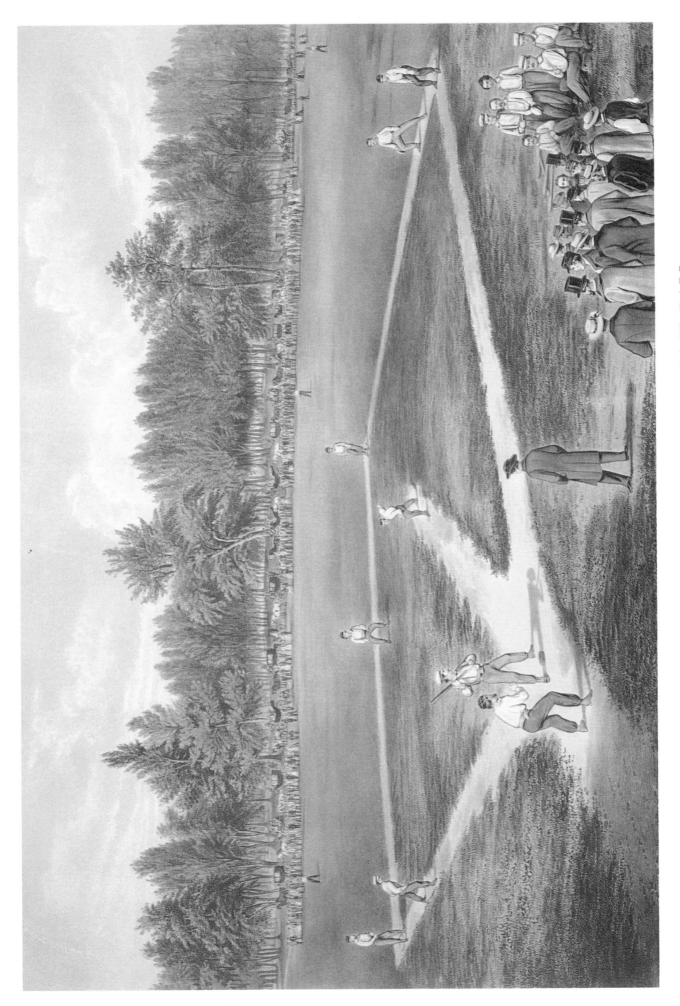

THE AMERICAN NATIONAL GAME OF BASE BALL

GRAND MATCH FOR THE CHAMPIONSHIP AT THE ELYSIAN FIELDS, HOBOKEN, N.J.

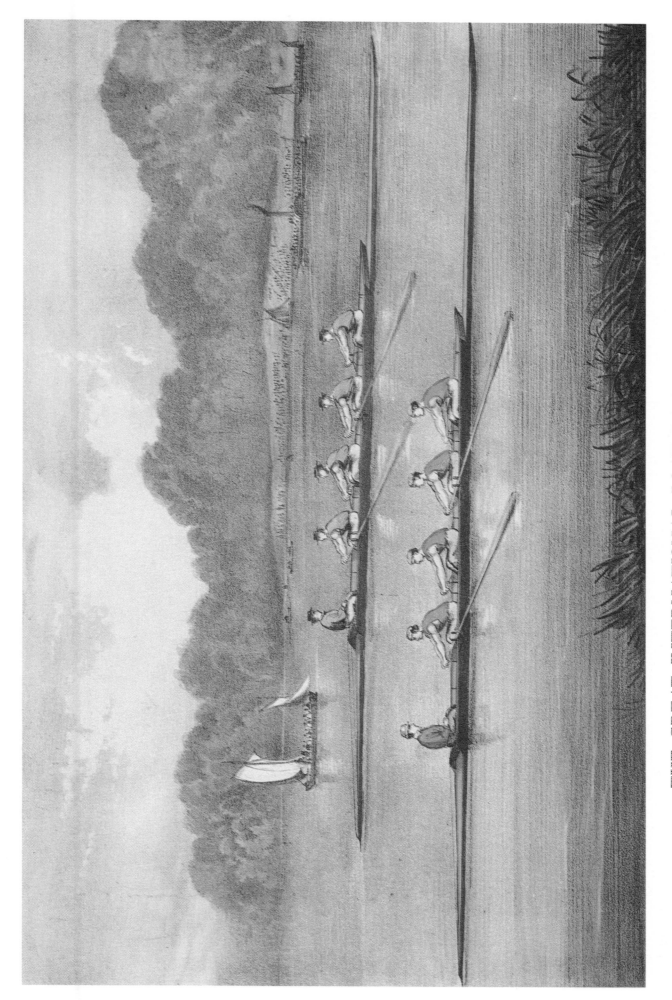

THE GREAT INTERNATIONAL BOAT RACE AUG. 27TH 1869

BETWEEN OXFORD AND HARVARD ON THE RIVER THAMES NEAR LONDON 4 MILES 2 FURLONGS.

Won by the Oxfords by a half length clear water. Time 22 Min. 20 3/5 Sec.

When the great mare Peytona raced Fashion on May 15, 1845, estimates of attendance varied from 70,000 to 100,000 but the crowd at the Union Course near Jamaica, Long Island, wasn't a patch on those that had turned out to cheer Peytona at every stop along the way north from Mobile. The unbeaten heroine of the South had, naturally, walked the 1,300 miles, accompanied by four other horses and a big baggage wagon. The record of this race as given on the print is reprinted below. While the date is given as May 13th, my authority says the race was held on May 15th as noted above.

Union Course L. I. Tuesday May 13th, 1845. Match the NORTH vs. the South. $10,000 aside $2500 Forfeit, 4 Mile heats.

Thos. Kirkman of Alabama entered his Ch.m. PEYTONA by Imp. Glencoe out of Giantess (the Dam of Abdalla, etc.) by Imp. Leviathan 6 yrs. 116 lbs. "Barney" F. C. Palmer 1:1

Henry K. Toler of New Jersey entered Wm. Gibbon's Ch.m. FASHION by Imp. Trustee out of Bonnets o'Blue (the Dam of Mariner, etc.) by Sir Charles 8 yrs. 123 lbs. Joseph Laird 2:2

Time of First Heat 1st Mile 1:54
2nd do 1:53
3rd do 1:57
4th do 1:55¾

Total—7:39¾

Time of Second Heat 1st Mile 1:58
2nd do 1:54
3rd do 1:55
4th do 1:58¼

Total—7:45¼

Yet Peytona's popularity in her region was not greater than the adulation heaped on her rival in the North, where enterprising admen named steamboats and hotels, cigars and ladies' gloves in honor of the mighty Boston's fair conqueror. The story of Boston is pertinent in that it relates the national interest in horse racing at that time. Boston, born a rogue, ultimately became almost unbeatable. He raced until 10 years old and won 40 of 45 starts, 30 of them at four-mile heats. He turned blind in late years, but after his death on Jan. 31, 1850, was born his greatest son, Lexington, afterward called the "Blind Hero of Woodburn."

On Oct. 28, 1841, Boston was distanced in the first heat of a race at Camden, N. J. (It was felt he had not fully recovered from a hard victory a week earlier in Baltimore.) The heat was won by Blount with Fashion second; in the second heat, Fashion won and Blount broke down, so Fashion became winner of the race.

Soon William R. Johnson, who managed Boston for his Southern ownership, issued a challenge to Fashion for $20,000 a side. The race was on the Union Course in May, 1842. On race day, train service from New York broke down and a mob tore down the ticket office. (No news to me; I rode the Long Island R.R. for five years.) One trainload reached the track after the first race, rushed the fence and had to be repelled by bruisers led by Yankee Sullivan, the thug-prizefighter. The crowd was estimated at 70,000, and the grandstand was filled to its capacity of 8,000 at $10 a head. It was said that 40 members of Congress traveled from Washington to see the race, and one New York newspaper set up a press on the grounds and issued extras after each heat.

Though crowds surging onto the track left only a narrow lane for the horses, Fashion won the first heat by a length, Boston suffering a cut hip when he struck the rail. In the second heat, Fashion came from behind to win by about 60 yards.

This was considered the only time Boston was defeated without excuses.

The record of this race also appears on the print of the 1845 race. I assume that Mr. Currier wished to emphasize that the North won both races. Even the sporting world recognized the division of the country. The main caption of the print says the 1845 race was for $20,000, but the record says it was $10,000. However, you will note that the 1842 race was for $20,000. And, either figure was real money in those times.

Union Course L. I. Tuesday May 10th 1842. Match the NORTH vs. the SOUTH. $20,000 aside $5000 forfeit-4 mile heats.

Henry K. Toler's (Wm. Gibbon's) Ch.m. FASHION by Imp. Trustee out of Bonnets o'Blue (Mariner's dam) by Sir Charles 5 yrs. 111 lbs. Joseph Laird 1:1

Col. Wm. R. Johnson's and James Long's Ch.h. BOSTON by Timoleon out of Robin Brown's Dam by Ball's Florizel 9 yrs. 126 lbs. Gil Patrick 2:2

Time of First Heat 1st Mile 1:53
2nd do 1:50½
3rd do 1:54
4th do 1:55

Total—7:32½

Time of Second Heat 1st Mile 1:59
2nd do 1:57
3rd do 1:51½
4th do 1:57½

Total—7:45

RED SMITH

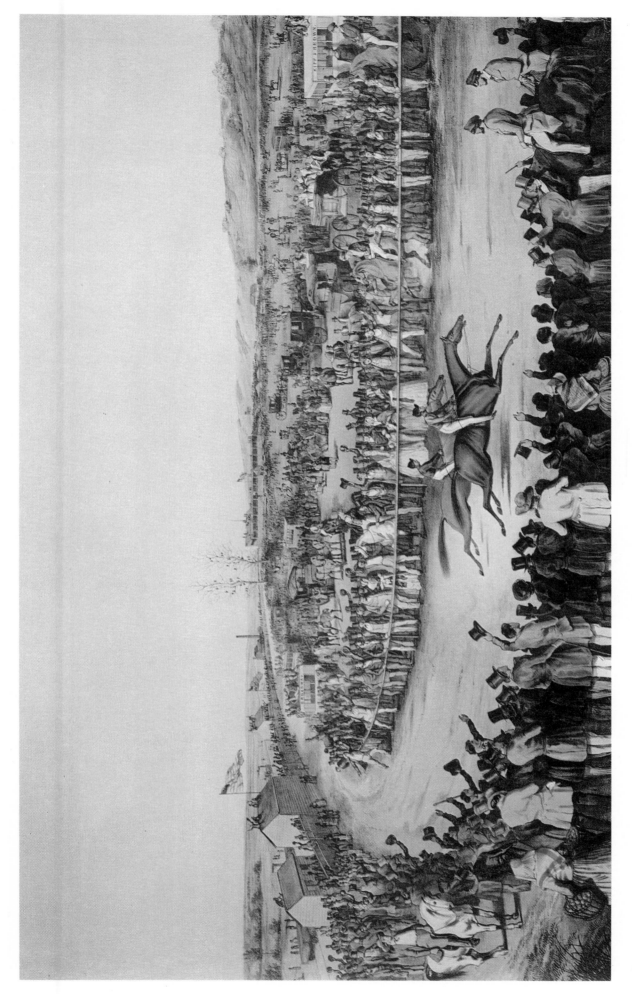

PEYTONA AND FASHION

IN THEIR GREAT MATCH FOR $20,000.

Over the Union Course L.I. May 13th 1845, won by Peytona. Time 7-39¾, 7-45¼.

THE CELEBRATED HORSE "LEXINGTON"

(5 YRS. OLD) BY "BOSTON" OUT OF "ALICE CARNEAL."

Winner of the great 4 mile match for $20,000 against "Lecompte's" time of 7:26 over the Metairie Course, New Orleans, April 2nd 1855. Won in 7:19¾!!!

"TROTTING CRACKS" AT THE FORGE

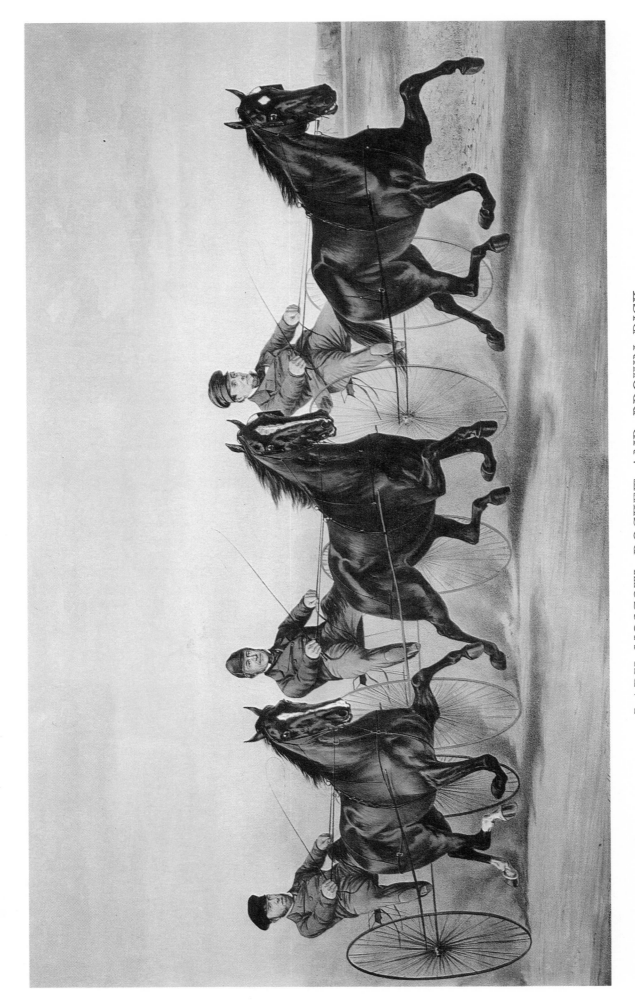

LADY MOSCOW, ROCKET AND BROWN DICK

TROTTING FOR A PURSE STAKE OF $2000. MILE HEATS BEST 3 IN 5. OVER THE UNION COURSE L.I. SEPT. 15TH 1856.

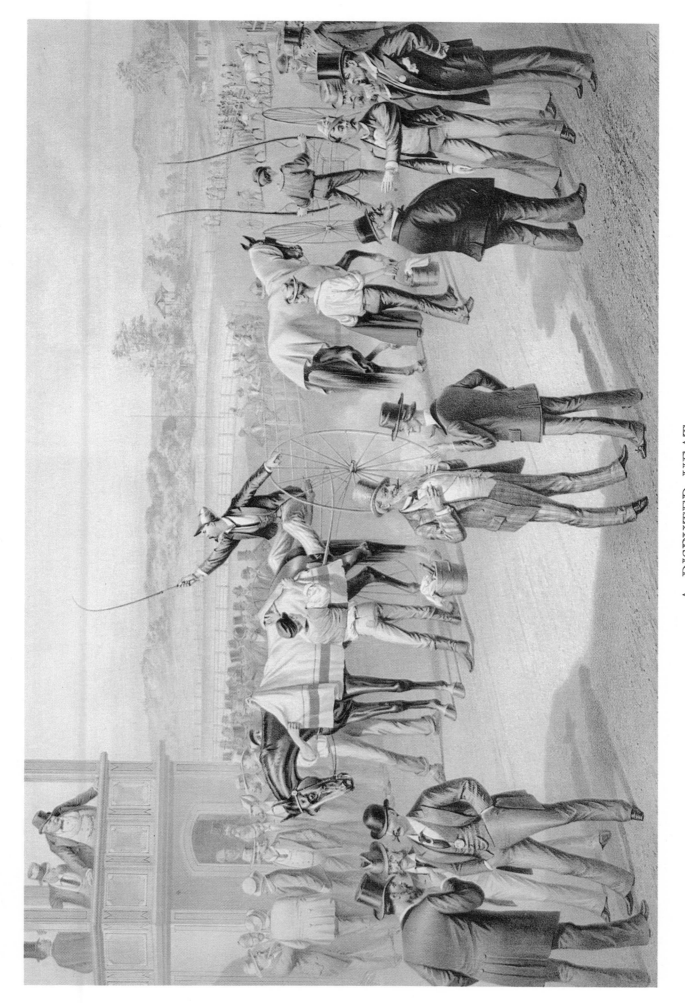

A DISPUTED HEAT

CLAIMING A FOUL!

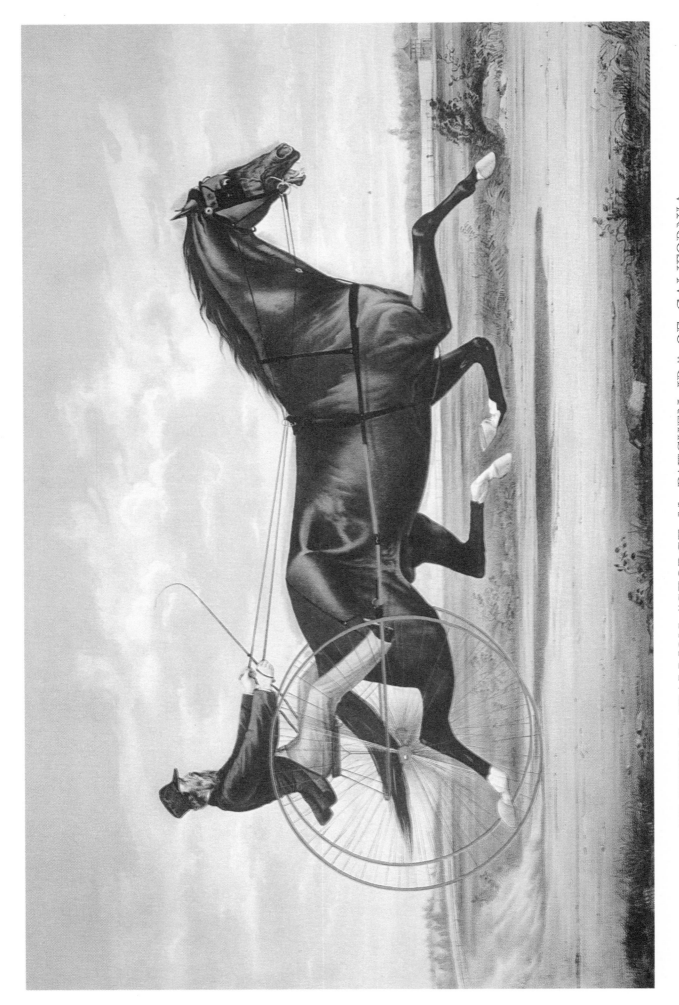

TROTTING STALLION "GEORGE M. PATCHEN JR." OF CALIFORNIA

AS HE APPEARED IN HIS GREAT MATCH WITH COMMODORE VANDERBILT. OVER THE FASHION
COURSE, L.I. MAY 23RD 1866, PURSE AND STAKE $1500. MILE HEATS BEST, 3 IN 5 IN HARNESS.

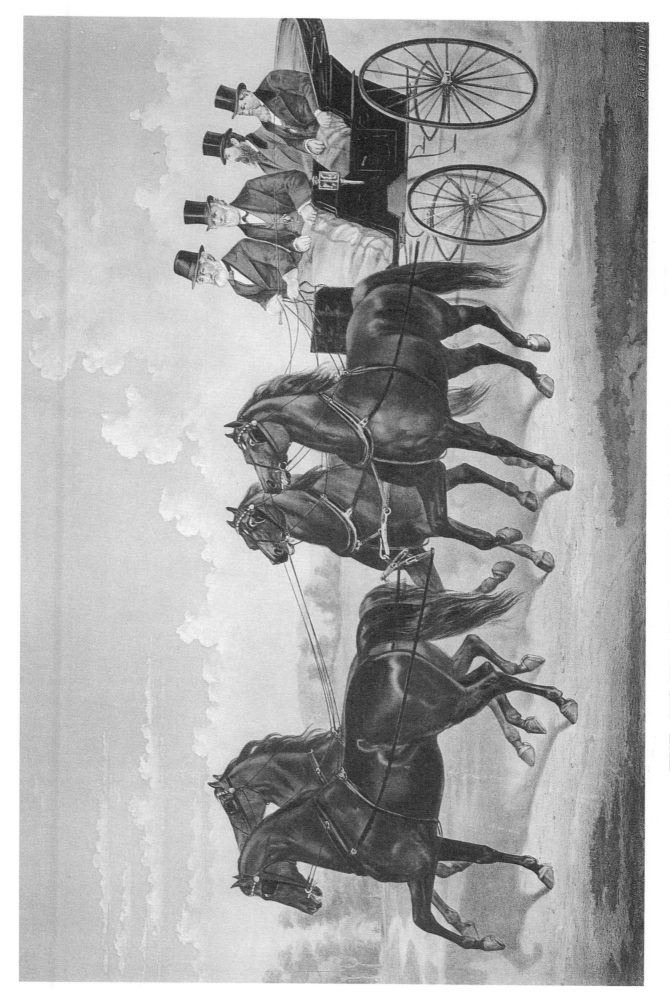

THE CELEBRATED "FOUR IN HAND" STALLION TEAM

SUPERB AND HIS THREE SONS.

XII THE MISSISSIPPI

The Mississippi River mystique has transfixed the imagination from the earliest day: the majesty of its powerful flow, the breathtaking sight of its towering palisades, the terror of its overflows, the gouging of its relentless current, the restlessness of its banks, the bounty of its deposits, the importance of its navigable mile upon endless mile.

The earliest explorers carried back tall tales and crude sketches, fascinated by the natives who used the river for food and for travel. Aside from the settlers who delineated some of the towns carved from the frontier forests on its banks, little meaningful artistic representation emerged from the eighteenth century. The travelers were too busy writing; the inhabitants, too busy surviving.

The turn of the nineteenth century ushered in the iconography of the Mississippi. Boqueta de Woiseri found the river at New Orleans fascinating, the puffing, steam-propelled contraptions which had made their appearance in the second decade equally so. George Caleb Bingham was still captivated by the flatboatmen, and Henry Lewis was making sketches for what would become the earliest definitive artistic effort when collected later into the landmark "Das illustrierte Mississippithal," printed in Düsseldorf. Others were confining themselves to specifics of the great valley, such as Audubon's wildlife, and Catlin's Indians. Gradually the monetary prospects of the river dawned, and the "panorama" artists appeared, making hundreds of yards of continuous scenic views which were unwound before paying audiences on two continents.

It remained for Currier and Ives to immortalize the Mississippi for all ages. They were the "March of Time" of their day. Not content to limit their prodigious output to pleasant river views, they portrayed the turbulence, the disasters, the floods, the battles, as well as the pleasant aspects of the river and life upon it.

It is interesting to note that the Mississippi Valley was termed "the West" for at least half of the eighteenth century. Thus, the "great beyond" needed the Mississippi and its tributaries as the avenues for further westward expansion. Full recognition of the importance of the far West, following Lewis and Clark's momentous trip, awaited the growth of river traffic and colonization of the stepping-off points. By popularizing the river, Currier & Ives certainly led to the mass movement West.

When they undertook to bring the excitement of the river to every home, their enterprise was justifiable. It was not only interesting to look at, it showed the mainstream of mid-America, the artery of trade and traffic, "Rural Route No. 1" for the burgeoning country's communications. It funneled the manufactured goods of Europe and the growing industrialized east coast to the central states and territories. As a channel of commerce, its only rival was the Rhine simply because that river was older. The Mississippi was a magnet alive, enervating, sparkling; and yet, distant from the large centers of population. The river and everything that moved and lived and happened on it were "box office." Currier and Ives thus incidentally became the "advance men," firing the appetite, creating the atmosphere of receptivity, while selling a whopping stock of prints.

The very fact that President Lincoln ordered his forces to "unvex" the Mississippi to the sea demonstrates the strategic military importance of the mighty flow. The steady, bloody campaign to do just that was the beginning of the end of the Confederacy. One eminent historian, Mr. Charles L. Dufour, even goes so far as to offer the theory that the fall of New Orleans in April of 1862 was the *coup de grace*. He entitled an illuminating book, "The Night the War Was Lost," to support this view. It is undeniable that control of the Mississippi was a big difference, and, thanks to Currier and Ives, "You were there."

Who could resist the large folio depicting the white, wooden swan of a steamboat, gliding along the smooth surface of the Mississippi, gulping superheated energy into her iron innards, ejecting them hissfully in plumes of white clouds; while overhead soared the flame-tipped, jet-black columns of spent fuel, all moving coincidentally with polished cabins and plush carpets, gay laughter and clinking chips? Who could resist the small folio, for that matter!

Currier and Ives made the riverboat a national institution which has never ceased to intrigue. Some of the actual scenes were as phony as a gambler's assurance. The *Lee* and the *Natchez* were never alongside each other. The night scenes with the ever-present moon eyeing the vivid racers were a pilot's nightmare. Many of the stock steamboats were used repeatedly with the names on the paddlebox changed.

Currier and Ives were grinding out their views to satisfy a demand, and in doing so, opening up a new way of life to eastern eyes. They were perpetuating the very fiber of a period and a river. They caught the feeling, the tempo, the look of the Mississippi, and they handed it down to us.

RAY SAMUEL

A COTTON PLANTATION ON THE MISSISSIPPI

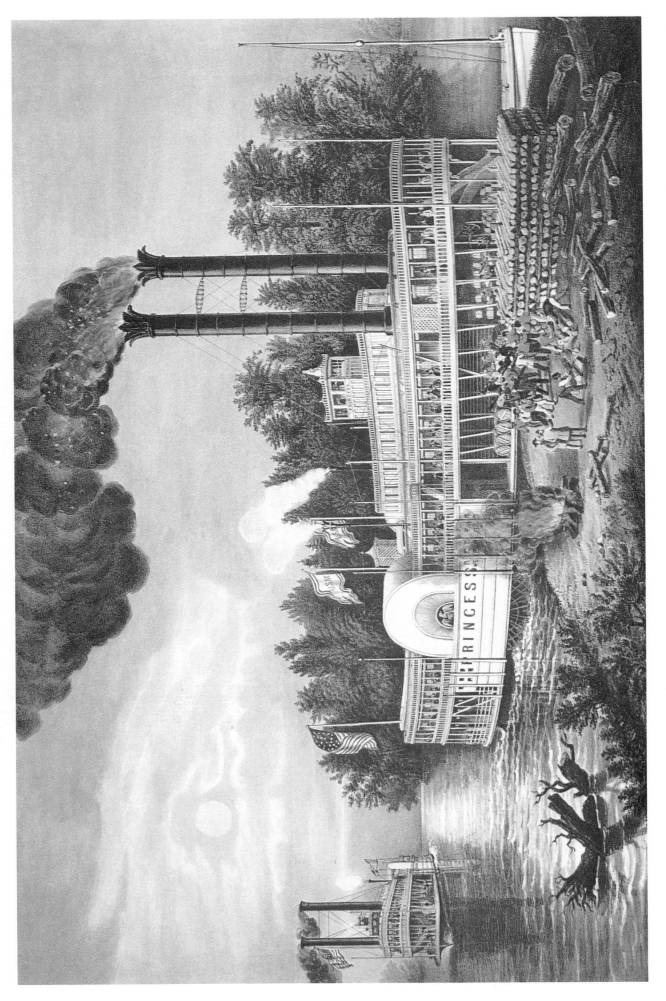

"WOODING UP" ON THE MISSISSIPPI

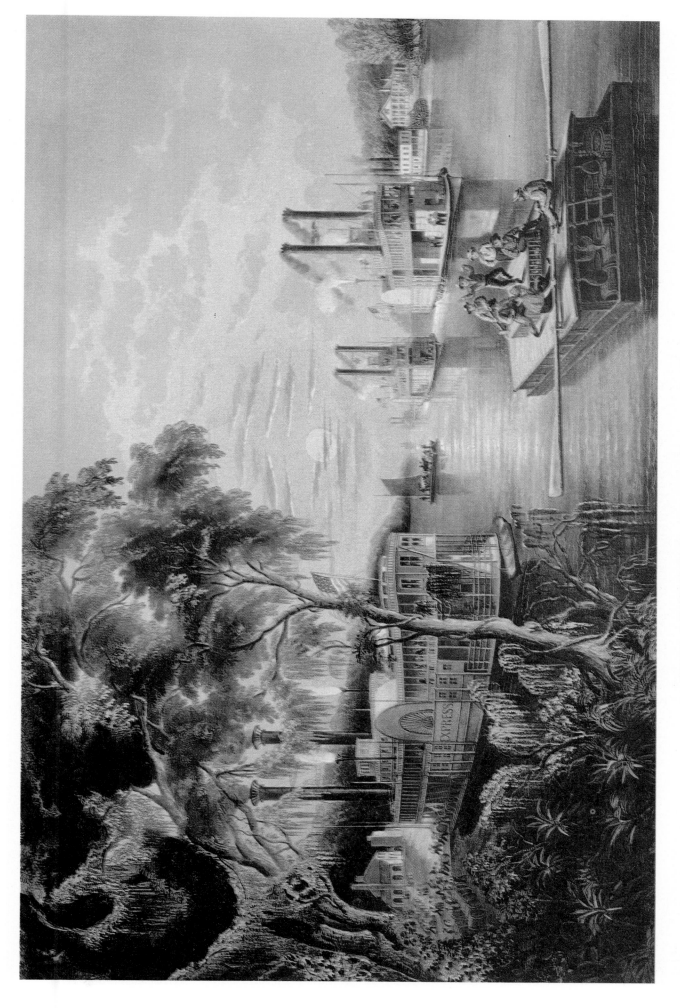

THE MISSISSIPPI IN TIME OF PEACE

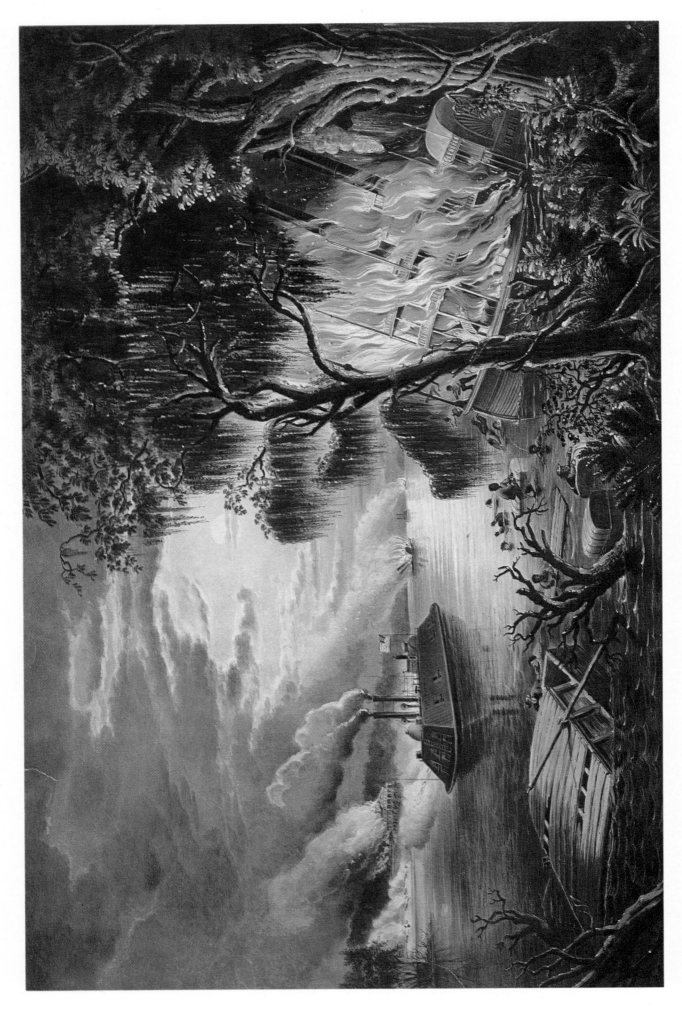

THE MISSISSIPPI IN TIME OF WAR

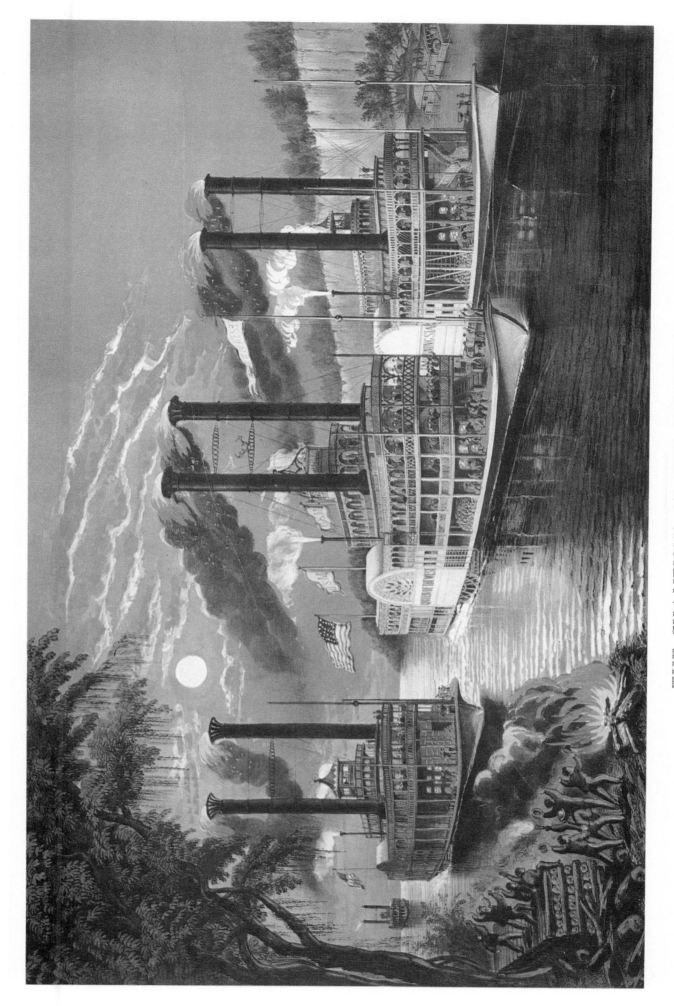

THE CHAMPIONS OF THE MISSISSIPPI

A RACE FOR THE BUCKHORNS

"ROUNDING A BEND" ON THE MISSISSIPPI

THE PARTING SALUTE.

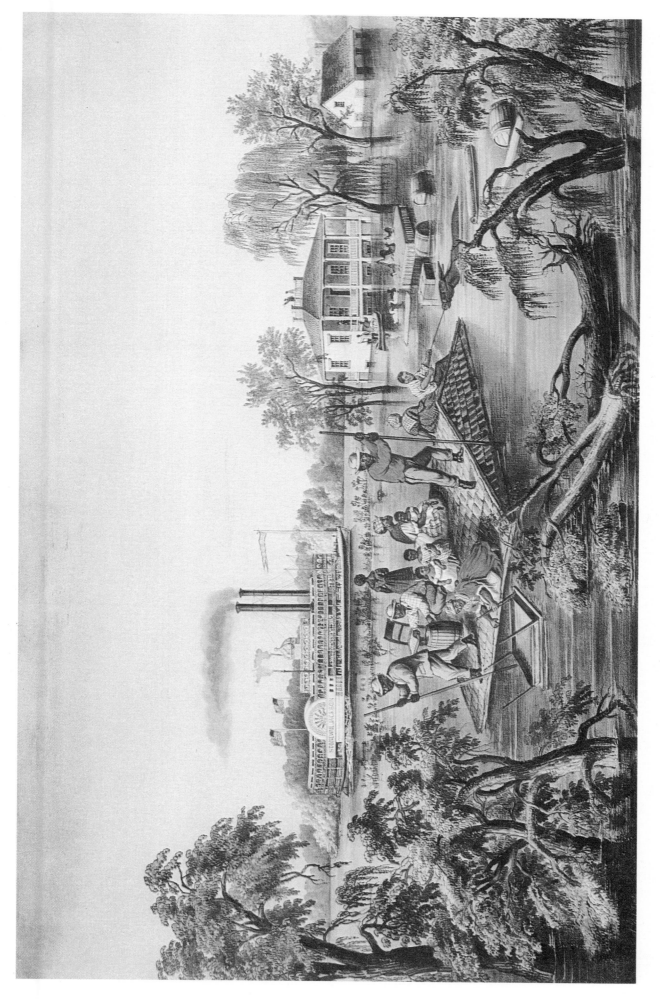

"HIGH WATER" IN THE MISSISSIPPI

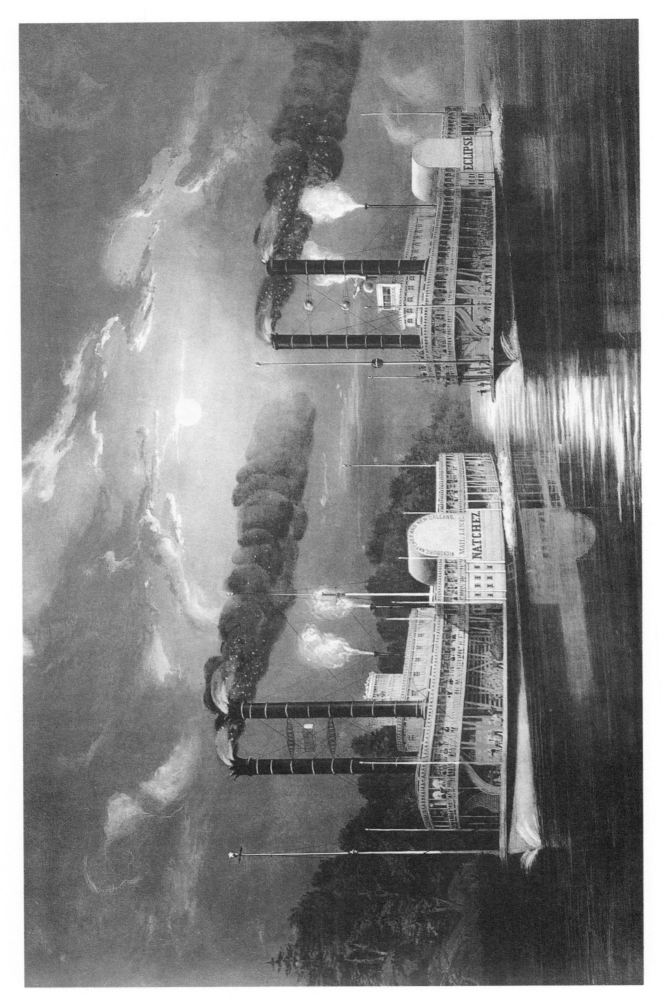

A MIDNIGHT RACE ON THE MISSISSIPPI

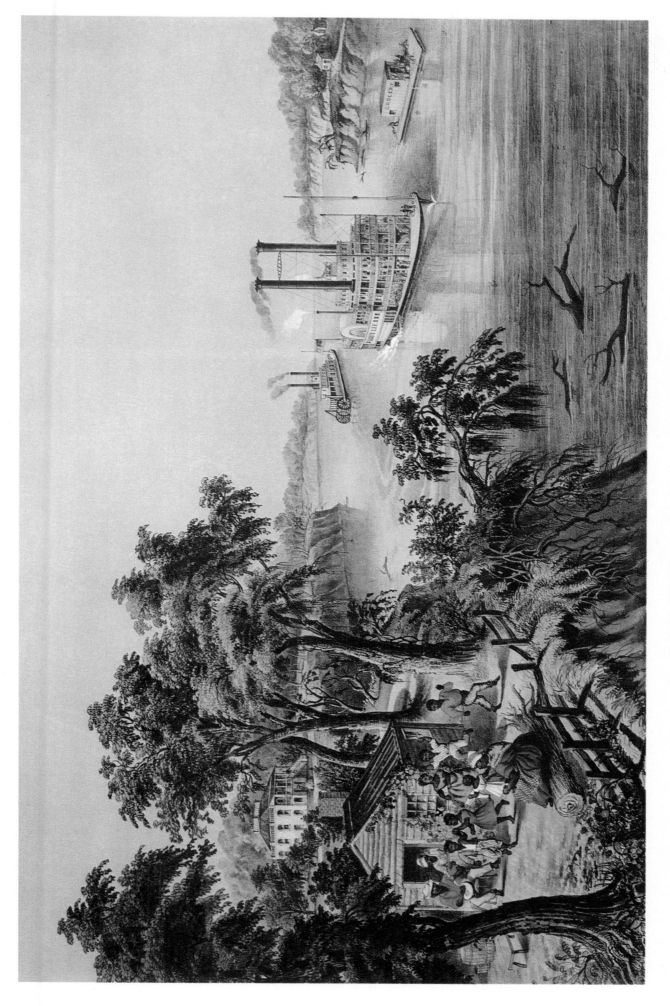

LOW WATER IN THE MISSISSIPPI

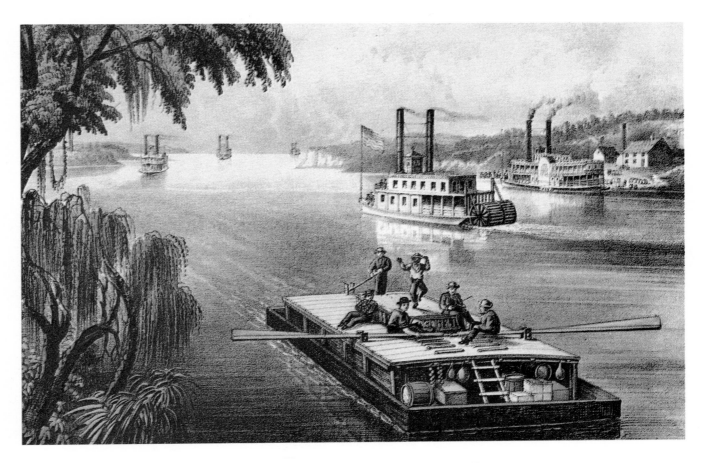

BOUND DOWN THE RIVER

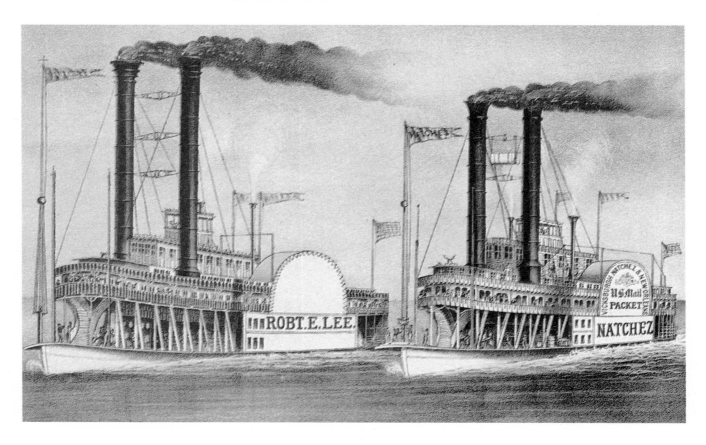

THE GREAT MISSISSIPPI STEAMBOAT RACE

FROM NEW ORLEANS TO ST. LOUIS, JULY 1870.

Between the R. E. Lee, Capt. John W. Cannon and Natchez, Capt. Leathers, won by the R. E. Lee.
Time: 3 Days, 18 Hours and 30 Minutes; Distance 1210 Miles.

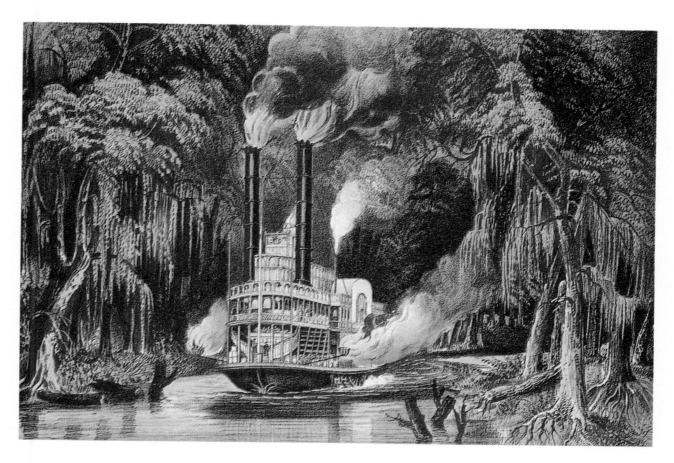

THROUGH THE BAYOU BY TORCHLIGHT

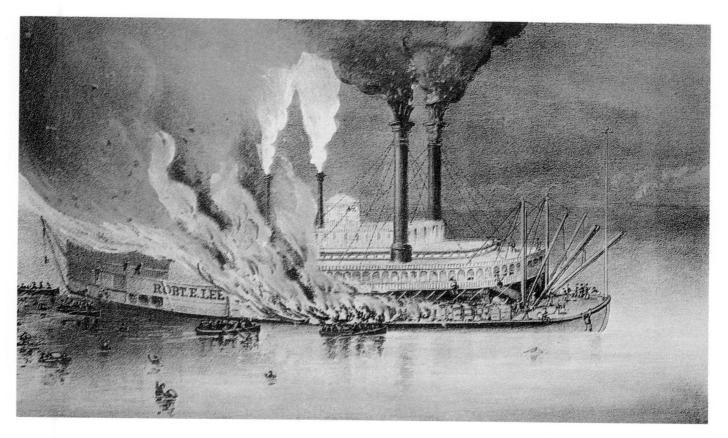

BURNING OF THE PALACE STEAMER ROBERT E. LEE

OFF YUCATAN POINT, 35 MILES BELOW VICKSBURG, ON THE MISSISSIPPI RIVER, AT 3 O'CLOCK, A.M., SEPTEMBER 30, 1882, WHILE ON HER FIRST TRIP OF THE SEASON FROM VICKSBURG TO NEW ORLEANS, BY WHICH CALAMITY 21 LIVES WERE LOST.

XIII HUNTING AND FISHING

Hunting

Hunting and fishing were an integral part of the life of early America. Before the forests were cut down and burned up to make way for farmers' fields, a lot of the food supply had to come from the woods and streams, and getting it was a serious business. But in spite of the seriousness, some individuals no doubt found hunting and fishing to be fun as well as work.

As the years passed and the country flourished, the taking of game and fish became more of a sport than a necessity. By the 1840's, books and magazines devoted to such sports were commanding wide audiences, and gunsmiths and fishing tackle makers were catering to sportsmen all through the already-settled regions. When Currier and Ives began to produce prints calculated to appeal to ordinary male Americans, hunting and fishing scenes must have been an obvious choice.

By good luck, the firm had available an artist who was almost ideal for its purposes. Arthur Fitzwilliam Tait had come from England to the United States in 1850. A dedicated outdoorsman, he soon came to know the woods of northern New York State, and for decades he spent a substantial part of almost every year there; hunting, fishing and sketching. The sketches were worked up in his New York studio, and the resulting paintings sold readily. Although he was never in the direct employ of Currier and Ives, they bought a good many of his paintings and made them into prints which had a satisfying authenticity. Some of the photographic accuracy of Tait's paintings was lost when other men copied the canvases onto lithographic stones, but still his sharp eye for detail and his close personal knowledge of his scenes came through, and must have pleased critical countrymen and city sports when they gathered round to inspect new prints.

To modern eyes, scenes like "The Life of a Hunter; A Tight Fix" and "The Life of a Hunter; Catching a Tartar" look implausible and overdramatized, with their fearless if disheveled huntsmen grappling in hand-to-claw or hand-to-horn combat with enraged wild beasts. Yet our modern skepticism is probably wrong; there is responsible contemporary evidence to confirm Tait's reportage. In 1848, Henry William Herbert — a leading authority on hunting in those days — said in *Frank Forester's Field Sports* that western bear hunters armed with bowie knives had

> . . . no hesitation whatever in going in hand to hand with the brute when at bay, in order to preserve their hounds . . . nor is it once in a hundred times that their temerity is punished by a wound,

and in 1809, Elisha Risdon, a northern New York State farmer who left a remarkable diary, had a personal struggle with a wounded deer which was so like "Catching a Tartar" that one wonders if Tait may just possibly have heard the tale somewhere in the Adirondacks.

H. J. SWINNEY

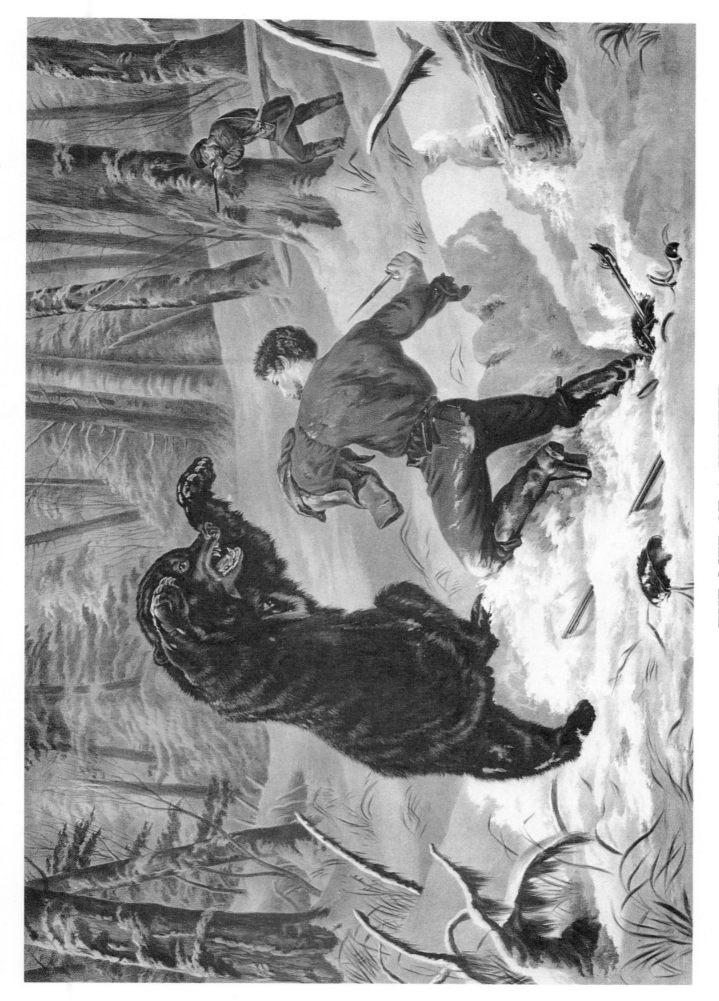

THE LIFE OF A HUNTER

"A TIGHT FIX"

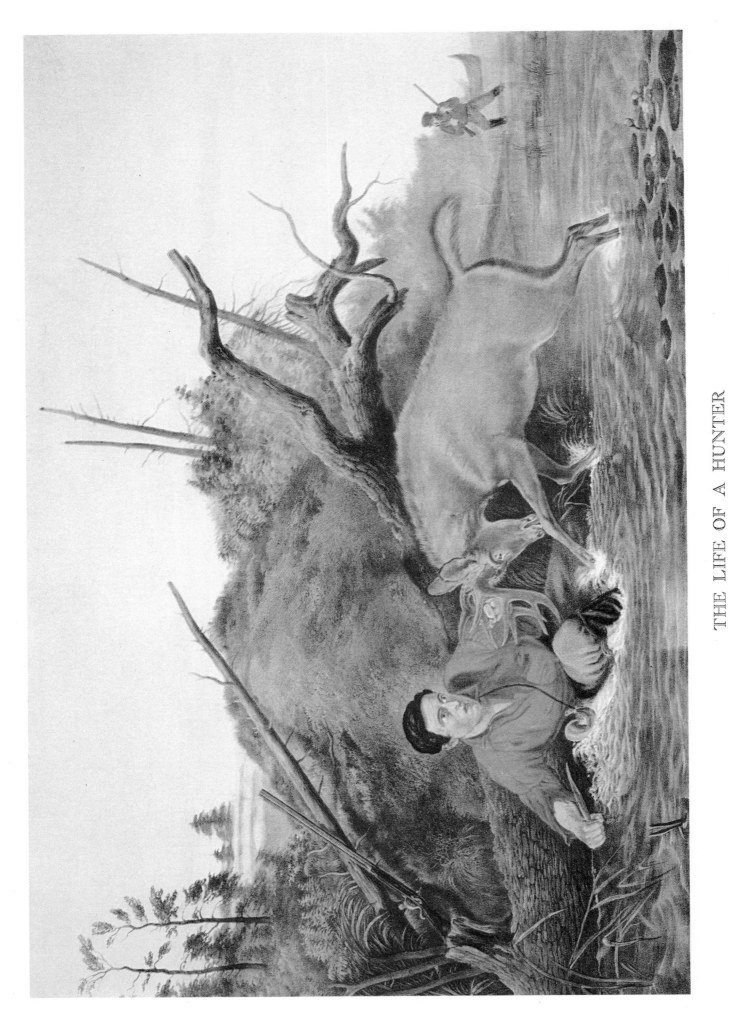

THE LIFE OF A HUNTER

"CATCHING A TARTAR"

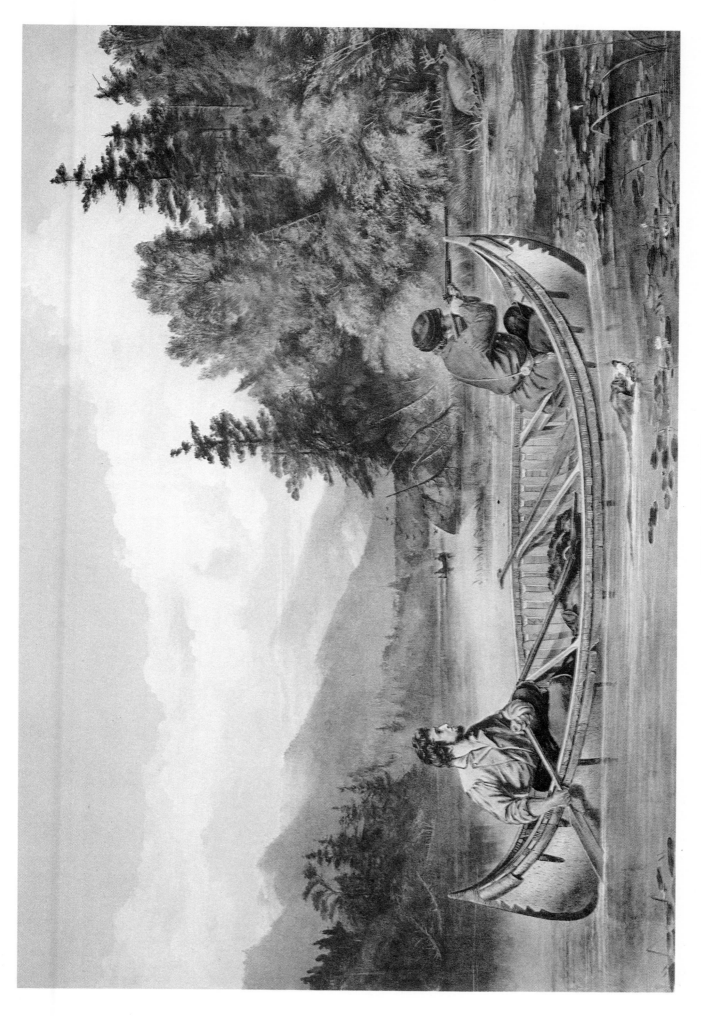

A GOOD CHANCE

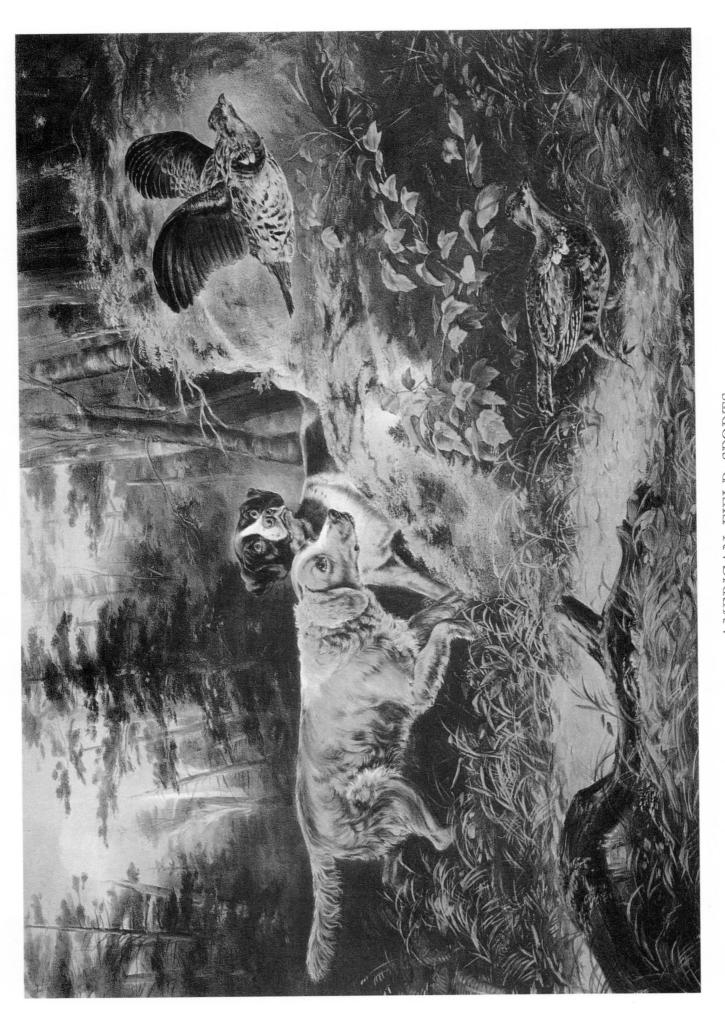

AMERICAN FIELD SPORTS

"FLUSH'D."

AMERICAN FIELD SPORTS
"ON A POINT."

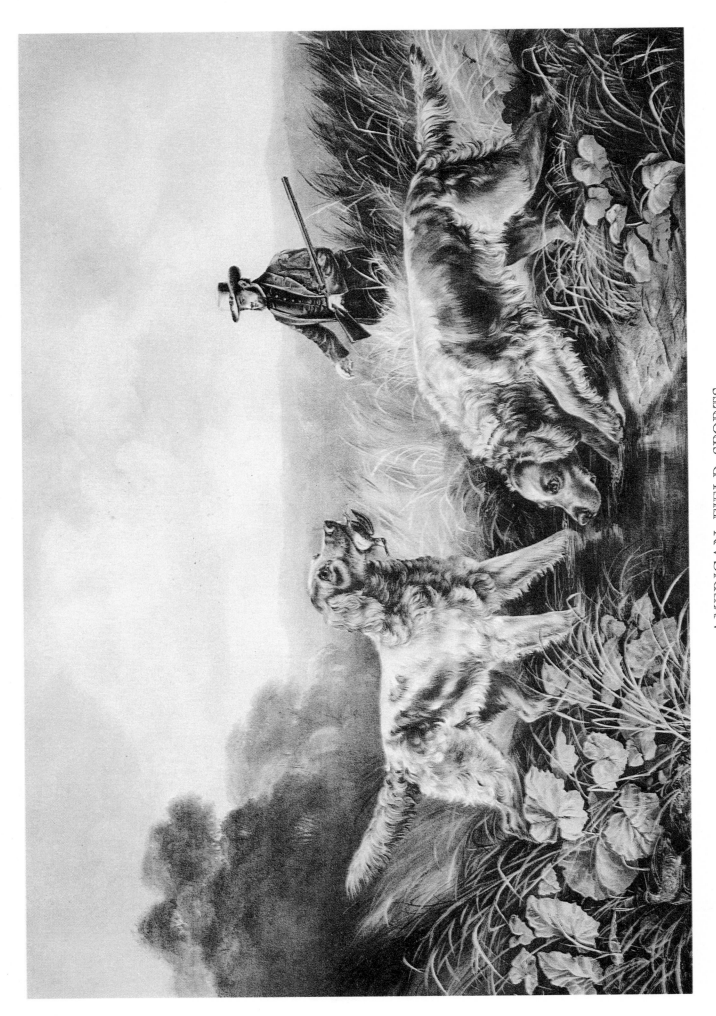

AMERICAN FIELD SPORTS

"RETRIEVING."

AMERICAN FIELD SPORTS

"A CHANCE FOR BOTH BARRELS."

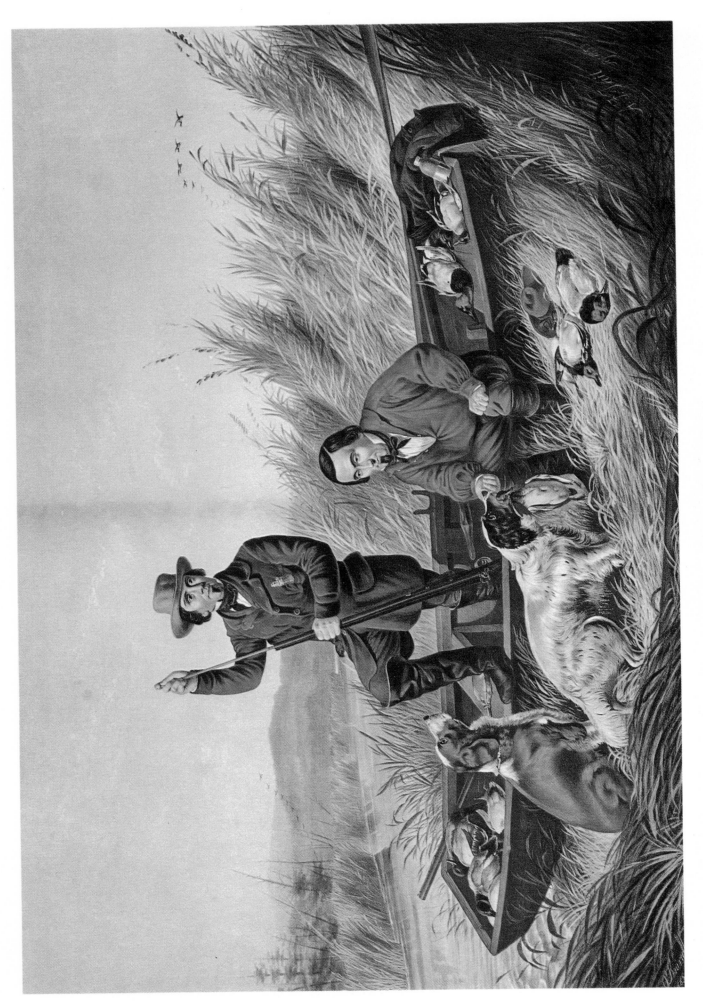

WILD DUCK SHOOTING

"A GOOD DAY'S SPORT."

MINK TRAPPING

"PRIME."

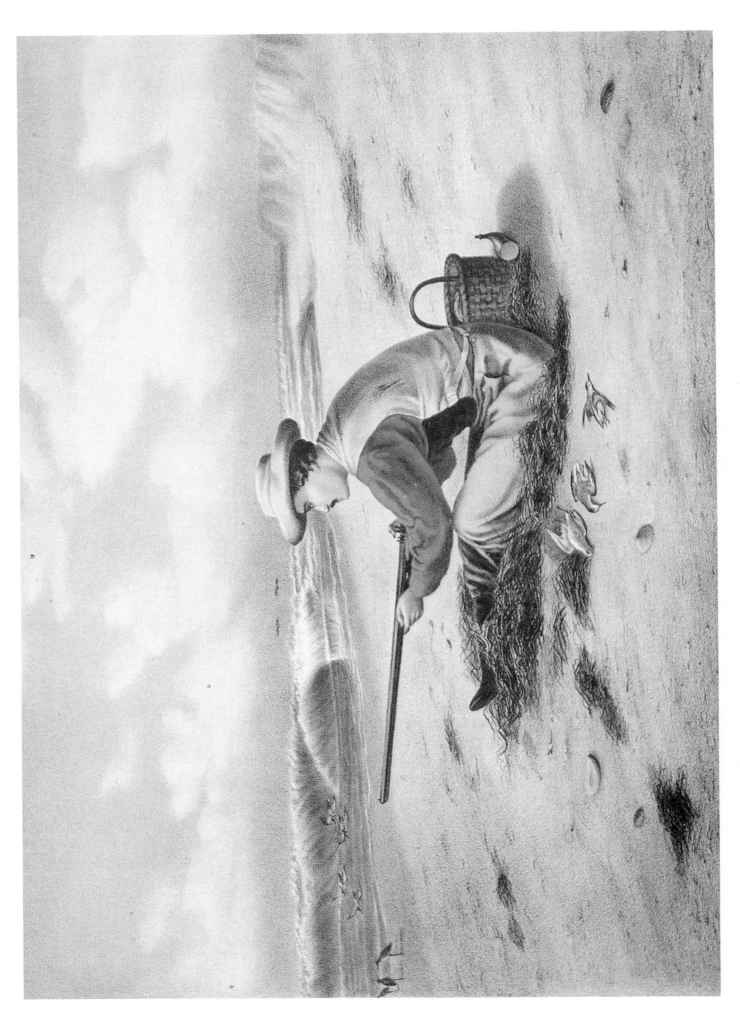

BEACH SNIPE SHOOTING

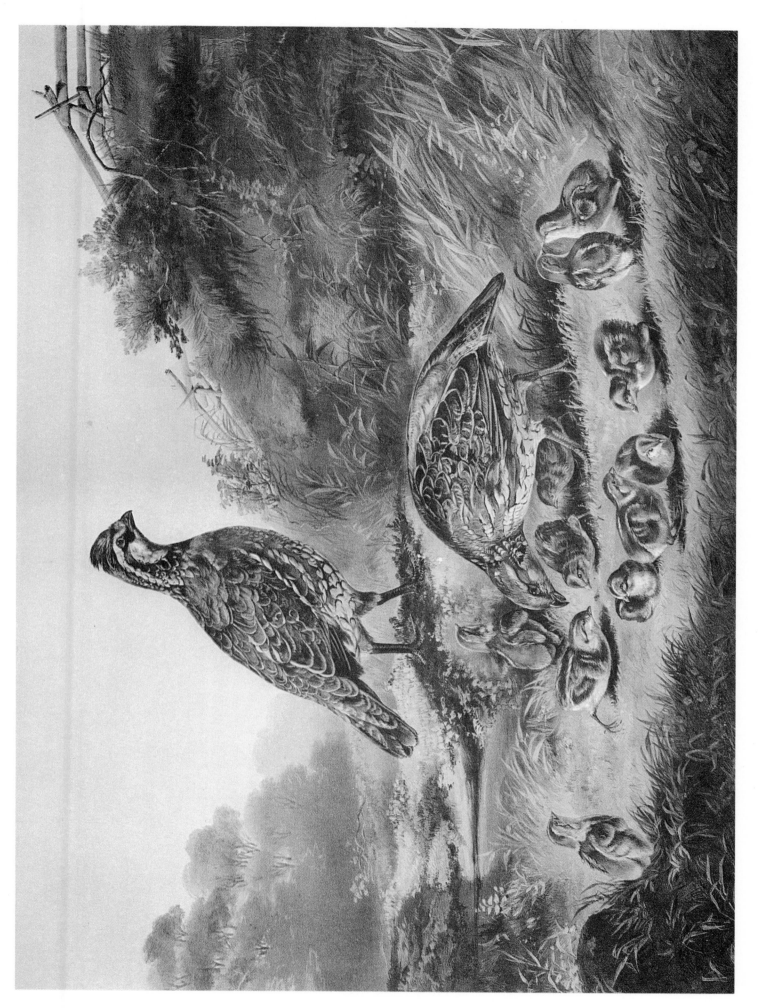

THE CARES OF A FAMILY

AMERICAN WINTER SPORTS

DEER SHOOTING "ON THE SHATTAGEE."

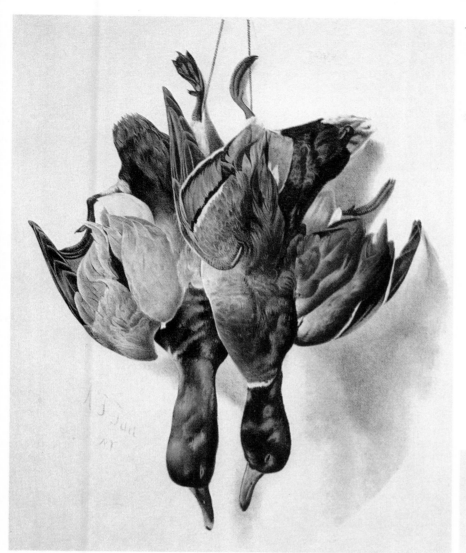

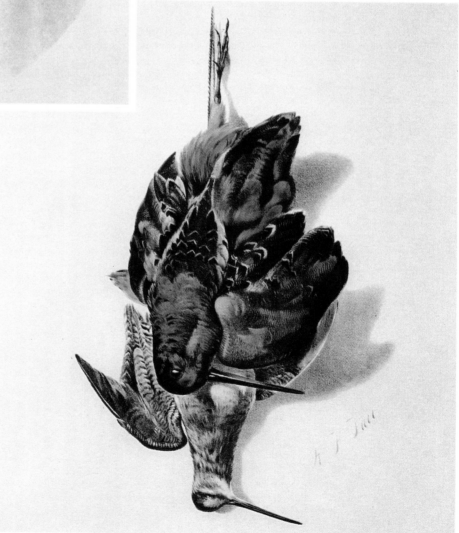

AMERICAN FEATHERED GAME

WOODCOCK AND SNIPE.

215

Fishing

The scenes of trout fishing (which are also mostly based on Tait paintings) show clearly that food gathering had changed to sport. The men in these prints are gentlemen with leisure at their disposal, dressed in conventional coats and neckties, and using sportsmanlike methods to take their game or fish. Fly-fishing was (and is) generally less efficient than using worms as bait, but as early as 1845 John J. Brown had expressed a growing feeling when he said in *The American Angler's Guide*

> Of all the various modes adopted and contrived by the ingenuity of man for pulling out the "cunning trout," this [fly fishing] at once recommends itself as the perfection of the art . . . it is the most gentlemanly, the most elegant . . .

The scenes of these prints must have been familiar to many of their purchasers. In one case at least — the print "Trolling for Blue Fish" — we know that, while the Englishwoman Fanny Palmer did the background and signed the print, the boat itself was drawn by Thomas Worth, another of Currier and Ives' regular artists. His drawing was based on a specific vessel from which he often fished. Furthermore, Brown's *American Angler's Guide* not only describes trolling for bluefish exactly as the print shows it, but even includes a marginal vignette on the table of contents which depicts an almost identical boat and fishing party, though from a different viewpoint. The more closely the prints are examined, the more acceptable they become as evidence of the social scene of their day.

These were unassuming pictures, frankly commercial, making no pretense of being fine art. It is this very quality which makes them at the present time so evocative of the life of those days. In order to sell so successfully, they had to be closely in tune with the realities and the moods of American life. We can accept them today as a collective picture of that life which passed the critical examination of ordinary Americans in depictive detail or in subtle spirit, or both. Had they not satisfied those exacting critics they would not have sold, and the firm would have failed. The western scenes and the Mississippi River lithographs appealed to American pride in a big country and American love of far scenes and strange adventures — and we still respond to the same appeal. The hunting and fishing prints epitomized experiences which many an American had known and enjoyed. They testify to the changes in attitude which came to Americans with a more mechanized, more urban, more affluent and more leisurely social order. Somehow, Currier and Ives captured in these prints something genuine from our collective past — a true moment set down in bright colors on cheap paper, a fragment of the long process by which we became, for better or worse, what we are.

H. J. SWINNEY

BROOK TROUT FISHING

"AN ANXIOUS MOMENT."

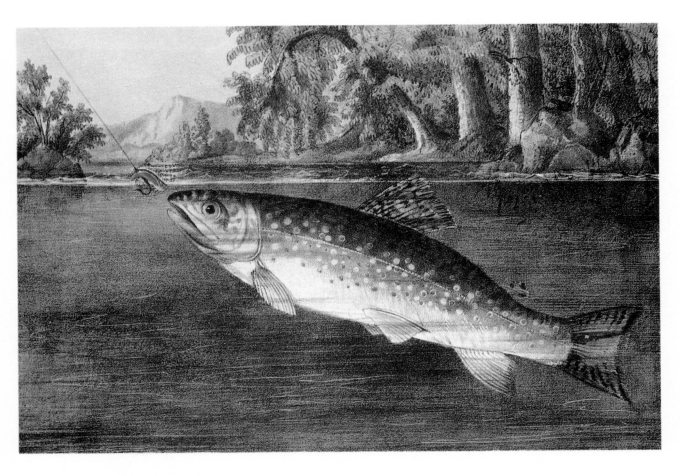

TEMPTED

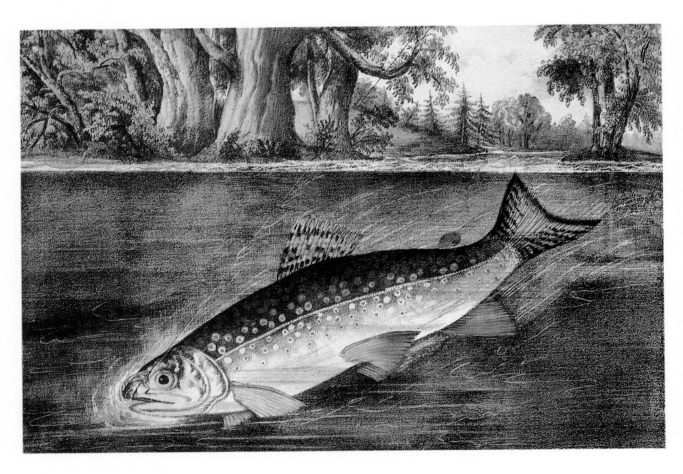

HOOKED

218

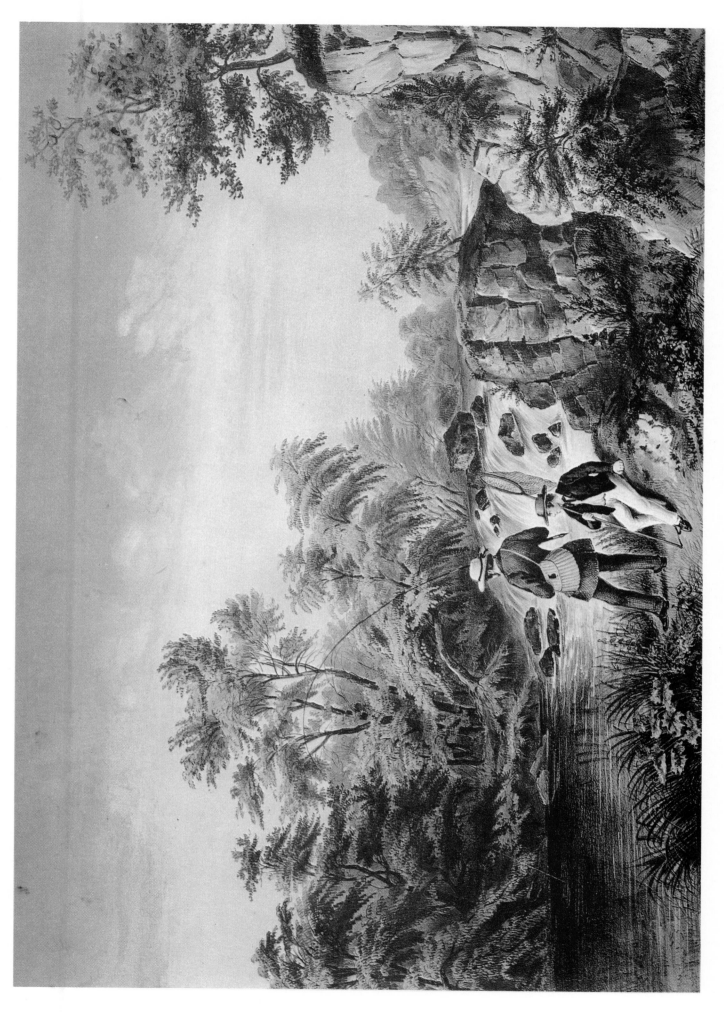

THE TROUT STREAM

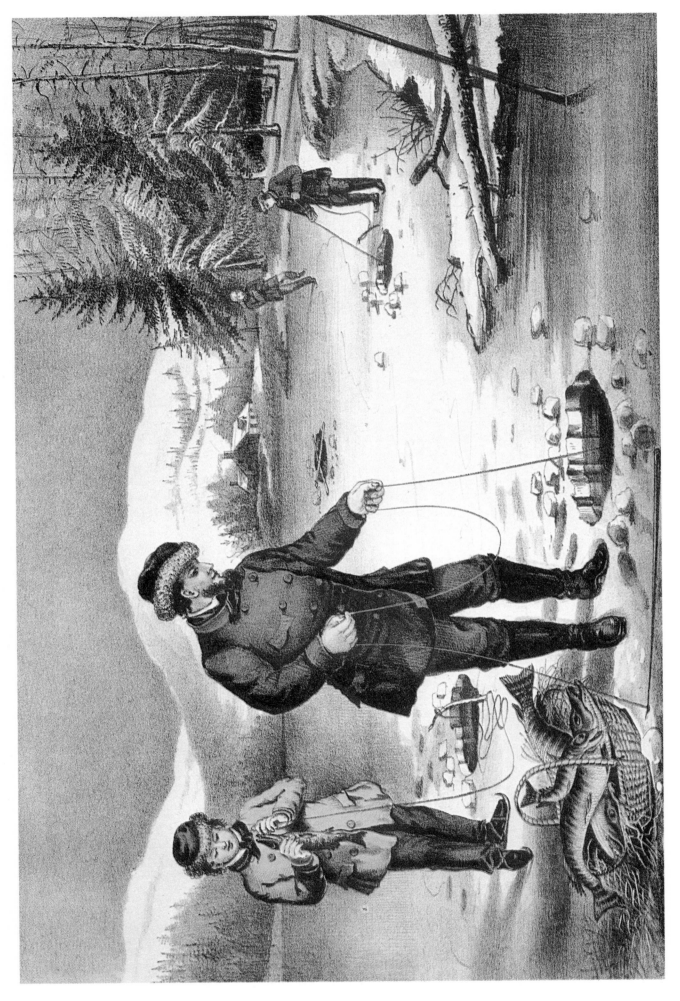

WINTER SPORTS – PICKEREL FISHING

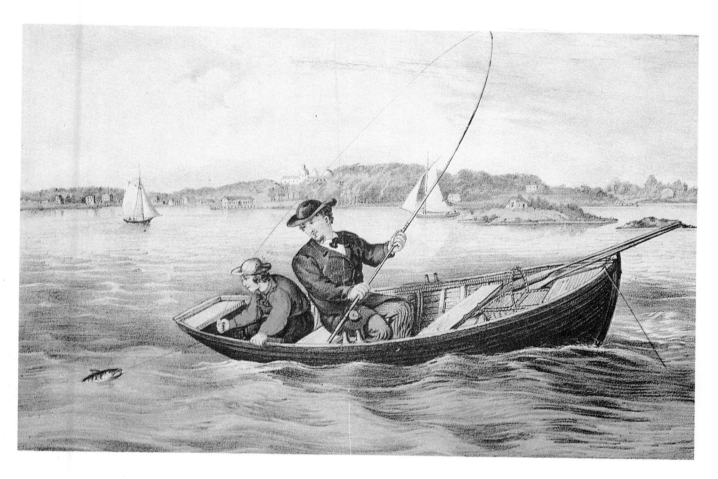

BASS FISHING

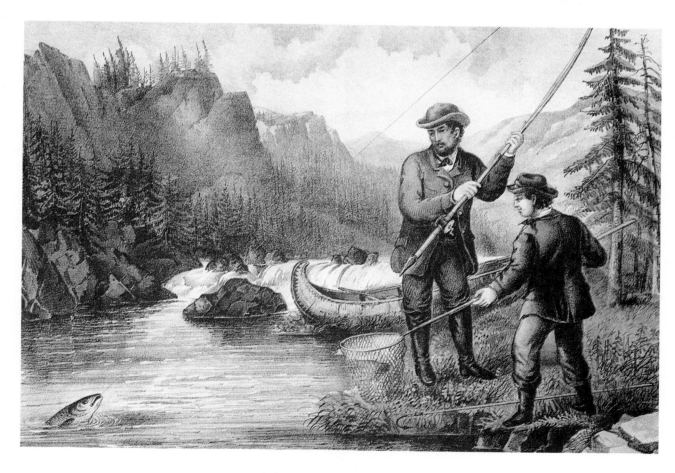

SALMON FISHING

221

CATCHING A TROUT

"WE HAB YOU NOW, SAR."

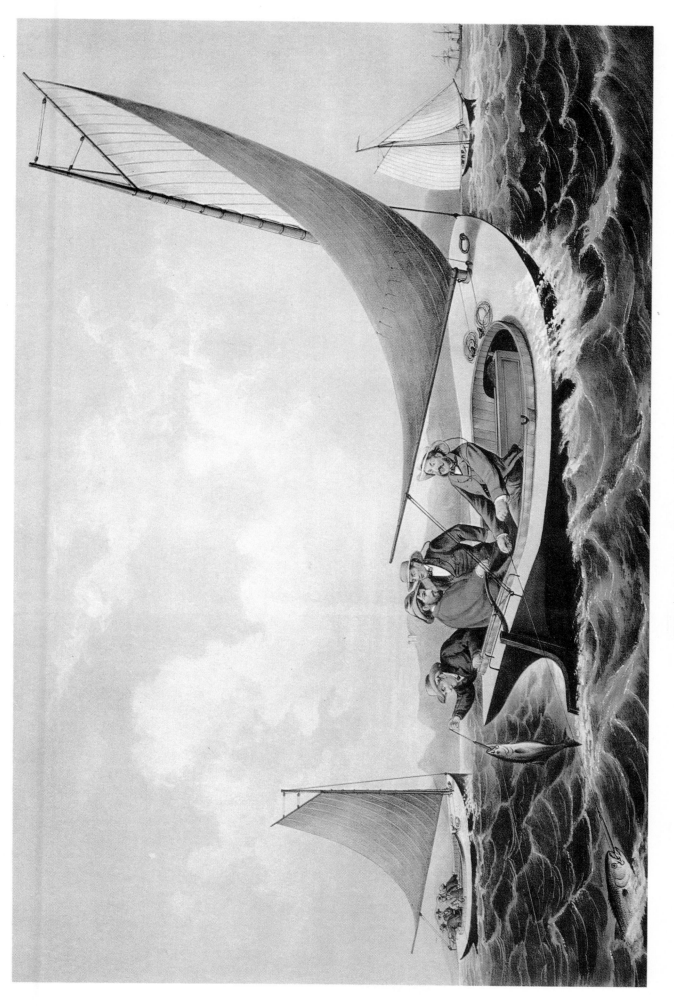

TROLLING FOR BLUE FISH

IV THE COUNTRY YEAR

The prints of Currier & Ives constitute a record of a life that is now past. Amidst the welter of changes which these pictures point up, perhaps only the essential nature of man remains the same, nor is this possibility generally accepted today as a valid assumption. The external trappings in the scenes are different whether the setting is rural or urban. The differences are evident in every field portrayed—sports, commerce, peace or war, transportation by land or sea, even customs and manners. But let the observer study the scenes a little further and it becomes apparent that the essential spirit of life has changed as well. And of all the categories into which these pictures of the past have been divided in this book, none show this frightening fact as forcefully as do those which comprise The Country Year.

We live in a world today which, because of the nature of the transformations wrought by science and technology, seems not to have grown out of the past at all, but to have spontaneously erupted into its own unique pattern. So, those born in the last half century find it possible to turn their backs on the ways of their ancestors, and to view the picture of their lives with detached amusement, if not with downright scorn.

But take heed, you whose lives have not bridged the chasm which lies between the world of Currier and Ives and today; look carefully here and see if there is not something very important that you may have missed. To plough on a spring morning behind a yoke of oxen with a helper at the head of the beasts to keep them in the furrow can be regarded as a comical waste of time and human effort. But there is more to it than this; the tractor, with all its gang of ploughs and its speed, stinks and roars and keeps its master a slave to its nuts and bolts and broken parts. In the end what has been gained? The filth of grease has been substituted for the clean dirt of the earth, and against the doubtful gain in material rewards one must charge the loss of all the delightful sights, sounds and smells of the spring morn. Nor do machines make manure!

Our children are being taught, and we believe, that Nature is Man's quarry to be hunted and brought to heel, and surely, at the end of the chase, to be made his slave. But it is more and more apparent as our involvement becomes at last absolute that we are committed to folly and to destruction. And concurrent with the degradation of our environment runs our deliberately devised disintegration of the family.

What does *Home To Thanksgiving* mean to us now?

Study the scene with care. Is there not here an evocation of peace and contentment, of serenity and adjustment to life which is wholly missing in our lives today? The Maurer print, *Preparing For Market,* should give us pause to think. Today, preparing for market to the average American family means climbing into the car for a trip to the shopping plaza. To what end? That we inhale poisonous exhaust fumes from all the cars around us as we tool along, taking our lives in our hands each moment we are out on the highway? In Maurer's view of it there is a wholesomeness and participation on the part of the family, from the little boy in the nifty checked pants, who swings the bay mare around to be harnessed alongside of the gray, to the baby on the stoop who watches the scene with interest and approval while Father stows the surplus of the farm in the wagon. Mother hands up a basket of eggs, and a pair of biddies in a crate await their turn to be loaded in for the one-way trip. Can you believe that this family and the people in the carryall pictured in *The Morning Ride,* lived lives of miserable deprivation because they had no automobiles or supermarkets?

Nowadays, at *Haying Time,* the wrench-wielding farmer tows behind his tractor a machine which bales the windrowed hay, then shoots the bales by some mechanical device through the air into a wagon which is hitched in tandem to the baler. One man does it all; haying time is machinery time, and between *The First Load* and *The Last Load* there has been no time for fun!

Soon the mechanized farms will be supplanted by factories which will process various raw materials into substances of nutrition, and with the advent of these the last vestiges of human taste will atrophy. Who now knows the taste of freshly pressed cider, or of un-pasteurized, unhomogenized milk, of eggs untainted with the taste of hormones, of vegetables grown without the aid of poisonous pesticides or soil-destroying chemical fertilizers?

Of old-time winter scenes and sport in the country nothing remains. Now it's motor to the ski runs where machines whisk one to the summits of the highest peaks of the one-time wilderness.

So take a careful look, all who pass here. Can you not be persuaded to enter into these scenes with all the vigor your imagination can summon? Thus may be found the clue which will enable us to distinguish between better and worse, and so perhaps the seemingly irreversible trend may eventually be reversed.

SAMUEL R. OGDEN

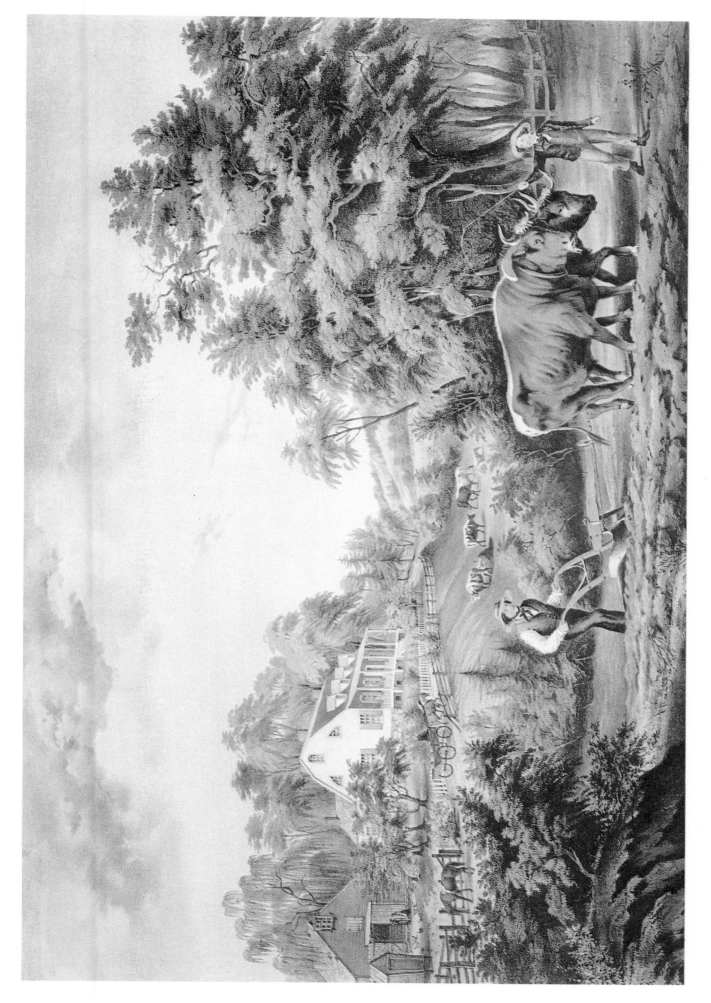

AMERICAN FARM SCENES

NO. 1.

LIFE IN THE COUNTRY

"THE MORNING RIDE."

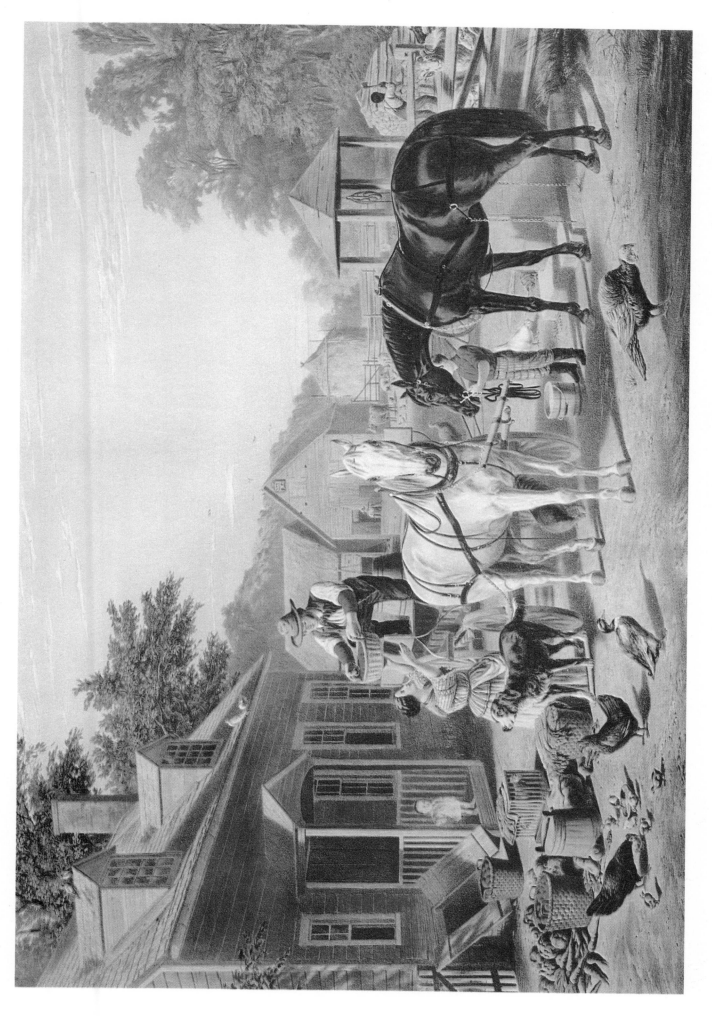

PREPARING FOR MARKET

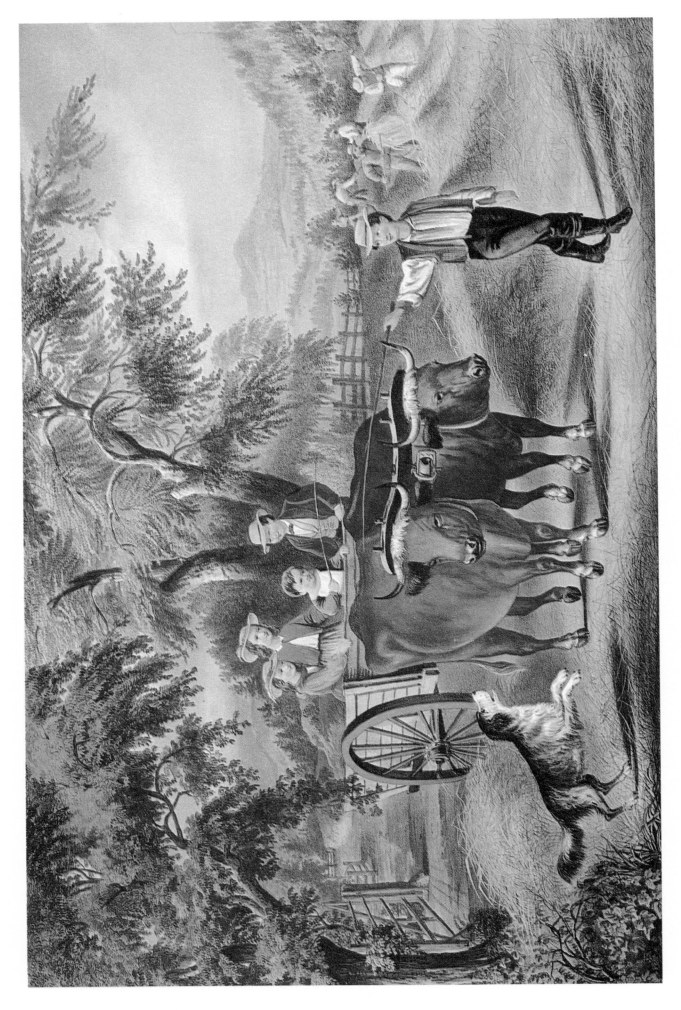

HAYING-TIME. THE FIRST LOAD.

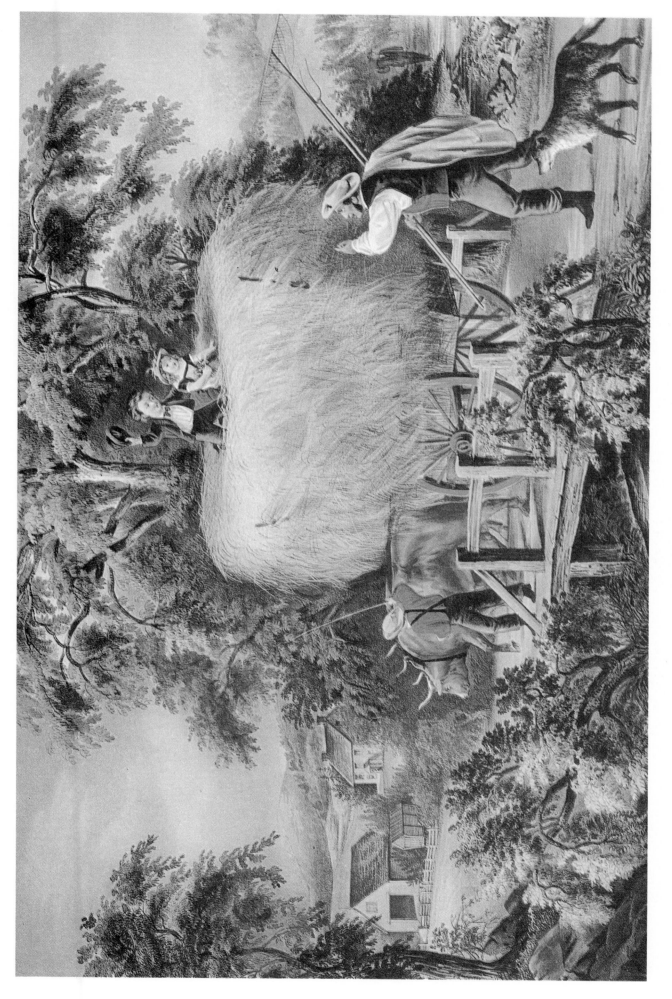

HAYING-TIME. THE LAST LOAD.

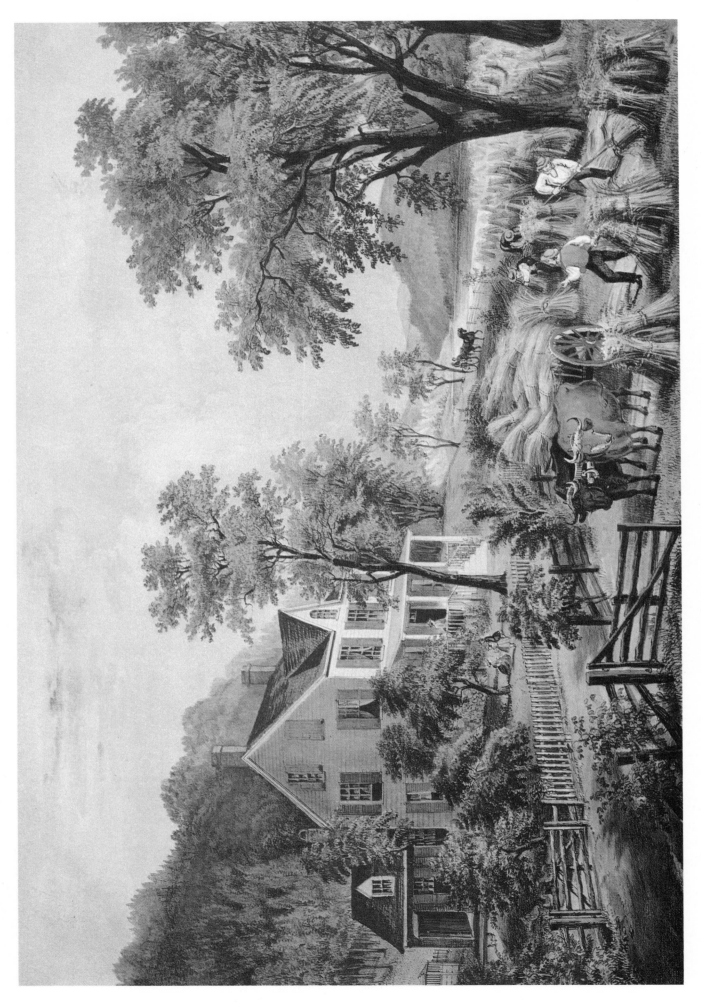

THE FARMER'S HOME - HARVEST

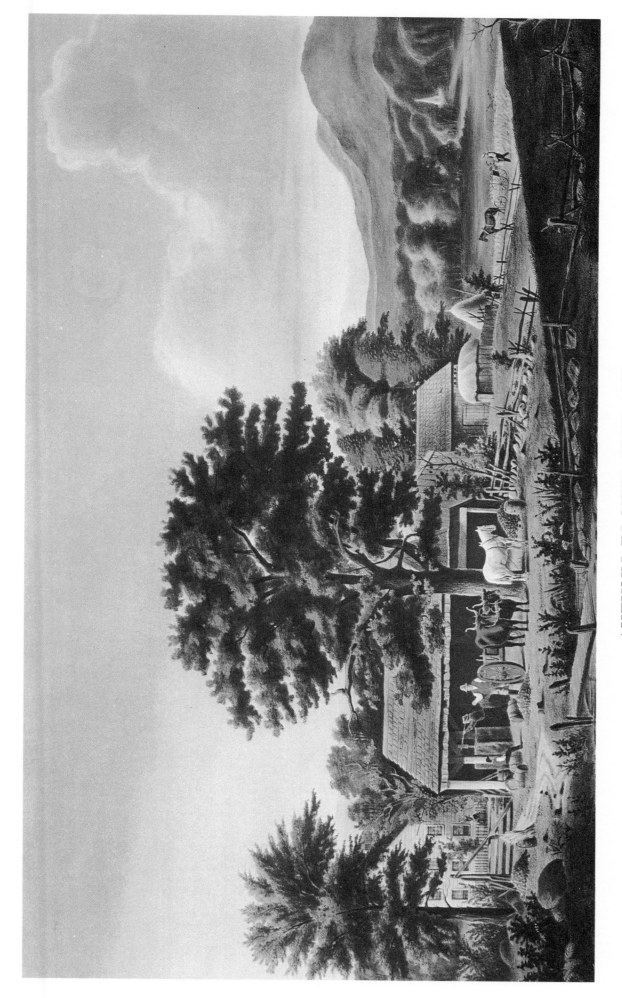

AUTUMN IN NEW ENGLAND

CIDER MAKING

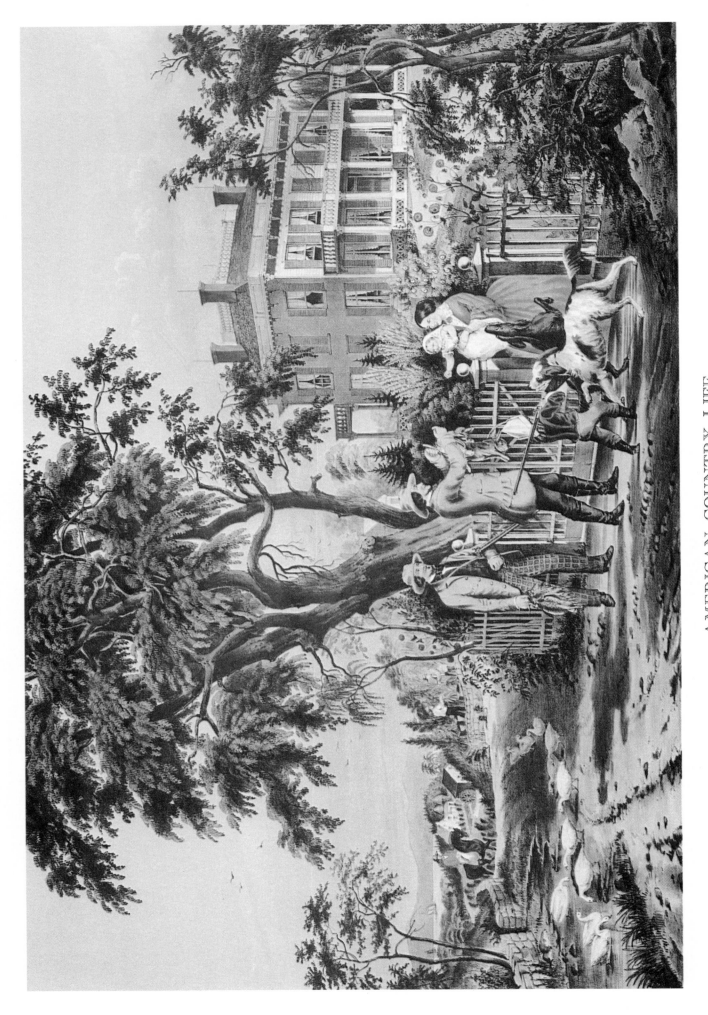

AMERICAN COUNTRY LIFE,
OCTOBER AFTERNOON.

HOME TO THANKSGIVING

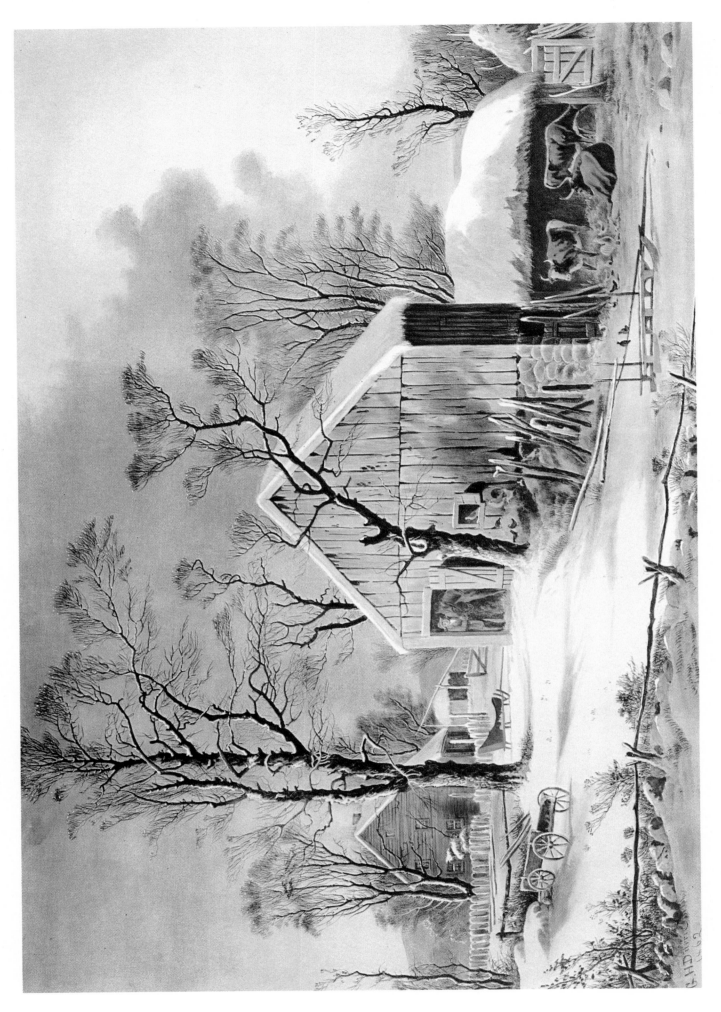

THE OLD HOMESTEAD IN WINTER

WINTER IN THE COUNTRY

"THE OLD GRIST MILL."

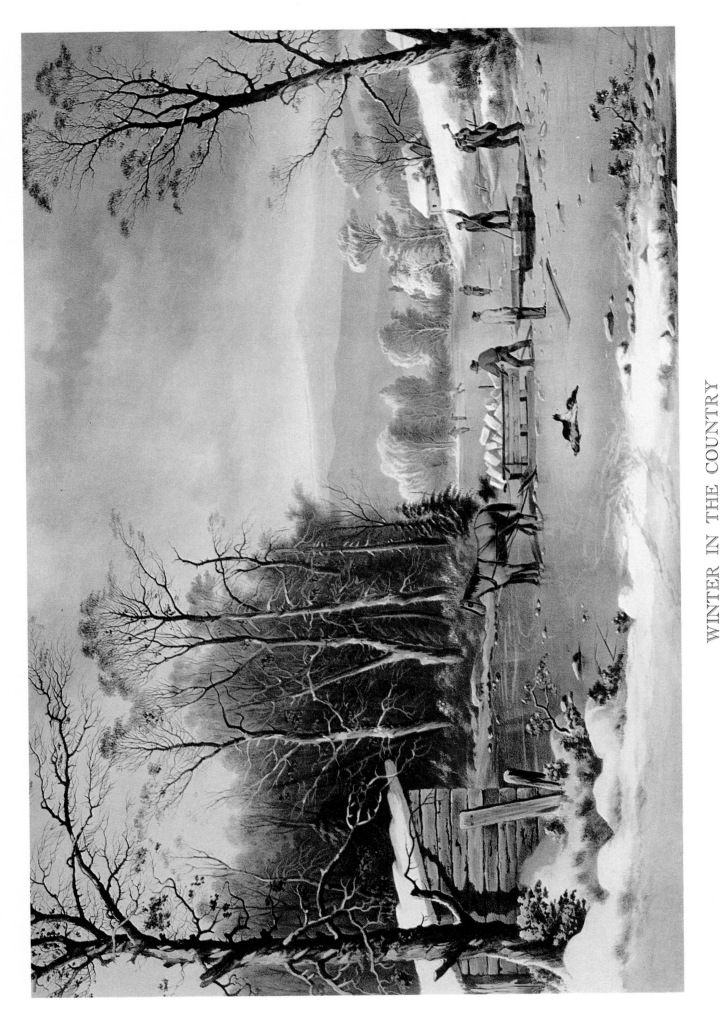

WINTER IN THE COUNTRY

GETTING ICE

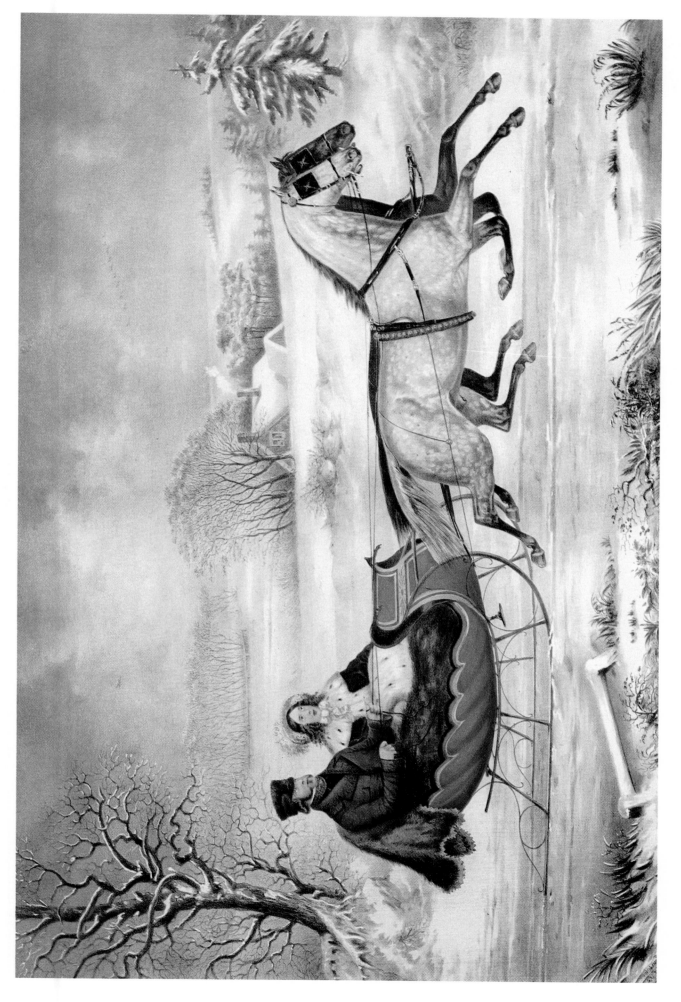

THE ROAD-WINTER

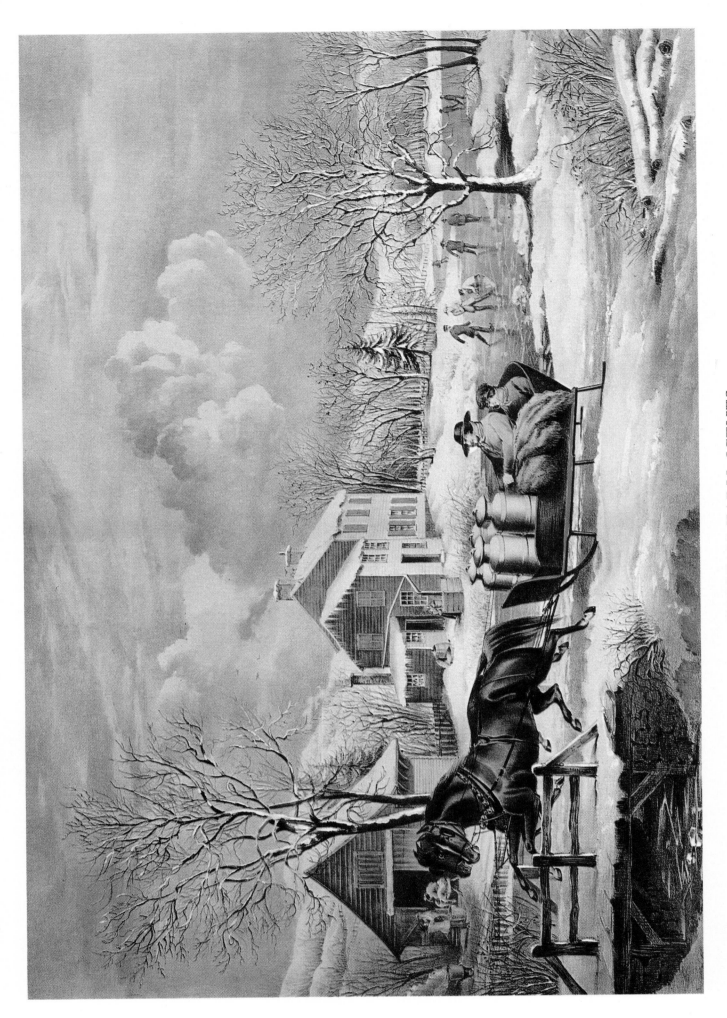

AMERICAN FARM SCENES

NO. 4.

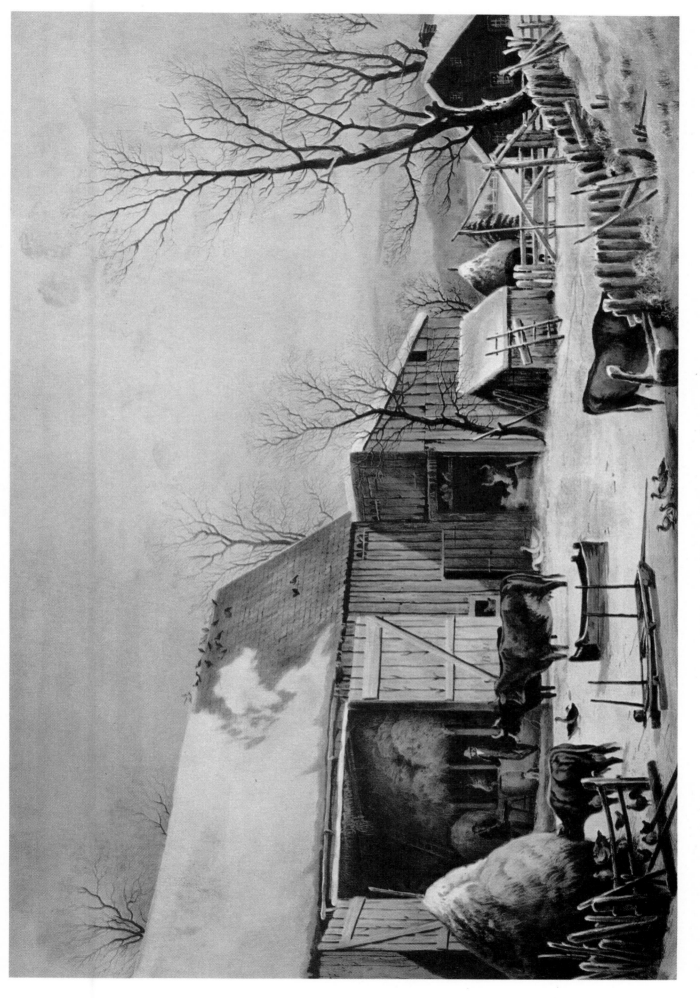

THE FARM-YARD IN WINTER

AMERICAN WINTER SCENES

MORNING.

AMERICAN WINTER SCENES

EVENING.

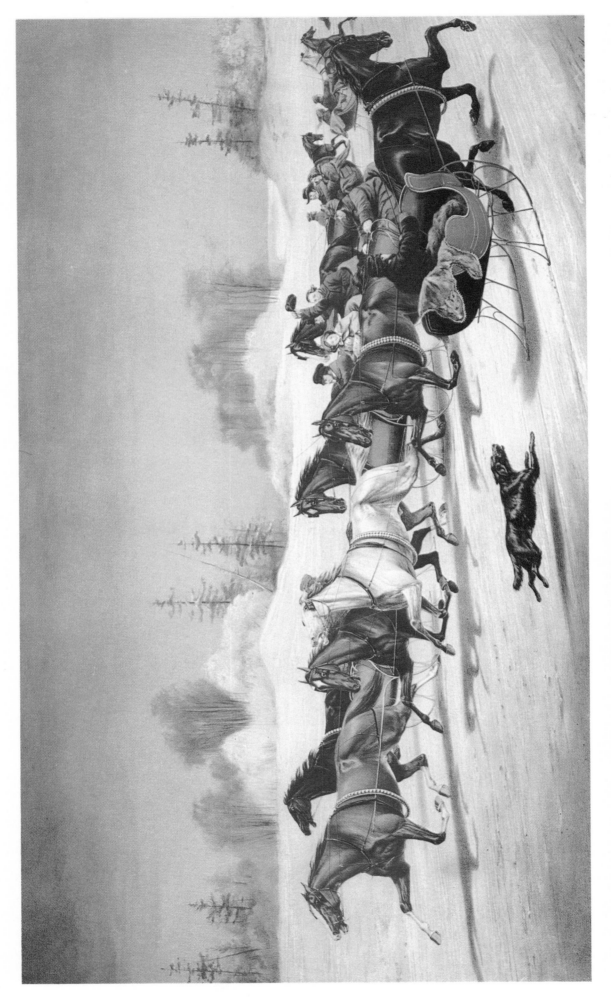

"TROTTING CRACKS" ON THE SNOW

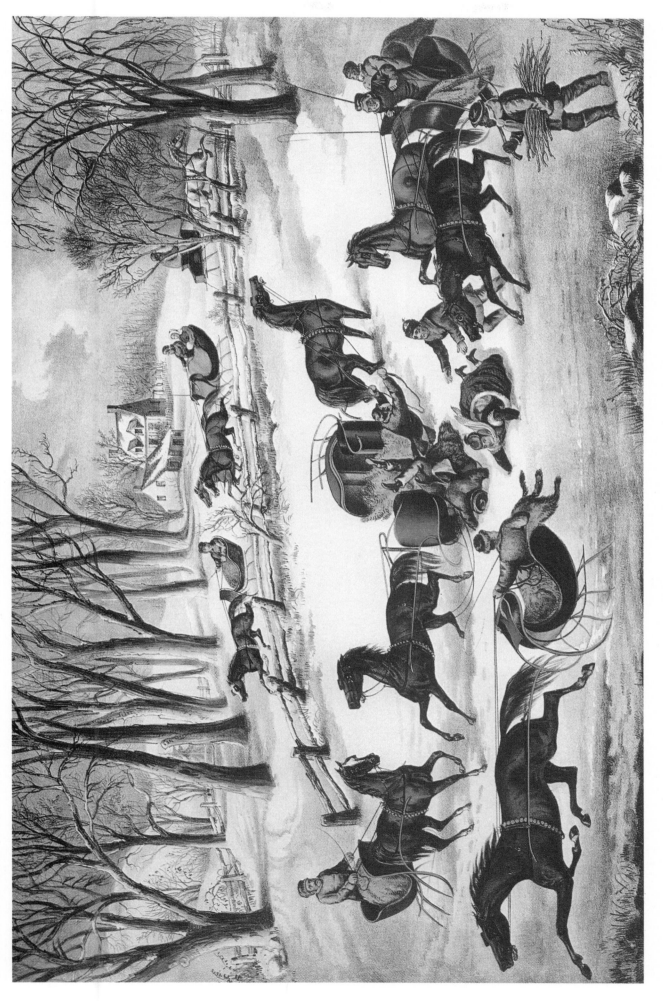

"A SPILL OUT" ON THE SNOW

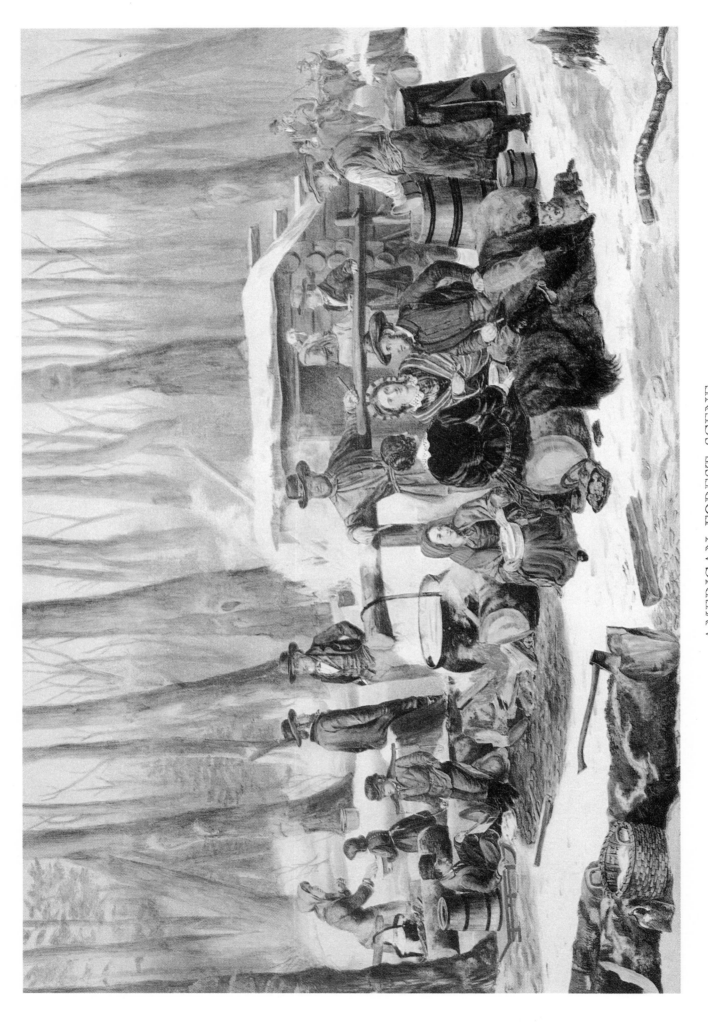

AMERICAN FOREST SCENE

MAPLE SUGARING.

XV POETRY AND PICTURES

The two poets represented in the following four prints are, essentially, story-telling poets. Henry Wadsworth Longfellow (1807-1882) was a contemporary of Nathaniel Currier. His narrative poems have become to America what Bliss Perry called, "a national asset." We all remember *Paul Revere's Ride, The Wreck of the Hesperus* and *Hiawatha* along with *The Village Blacksmith, Evangeline* and *Tales of A Wayside Inn.* Excerpts from the last three appear with the artist's interpretation of the nostalgic verses. It is doubtful that these prints received wide circulation. Poetry, then as now, was probably hard to sell even though embellished with colorful illustrations. However, the prints and poetry were a part of the American Scene as Currier & Ives knew it and, rightly, they deserve a place in this book.

The other poet, Samuel Woodworth (1784-1842) was a newspaper publisher, playwright and author. In 1823 he founded the New York *Mirror* with George Morris, wrote a play, *Lafayette,* and a story of the War of 1812, *Champions of Freedom.* He was an important figure in the literary life of New York in his time. His literary immortality, as such, stems from the poem prosaically entitled *The Bucket* which is most commonly thought of as *The Old Oaken Bucket.* The first line of this remembered piece of pure Americana, "How dear to this heart are the scenes of my childhood," could well be the descriptive head for the prints in the preceding chapter — The Country Year.

Both Longfellow and Woodworth wrote of American history. Longfellow, a descendant of Myles Standish, wove stirring events into legend. Both men were fervent nationalists. It is interesting to speculate as to the possible relationship between Nathaniel Currier and his two authors. All three were in the same business, as it were, because they were trying to tell the story of their country. It is to be regretted that more prints of this nature were not available for inclusion in this book.

The artist for all these prints, F. F. (Fanny) Palmer, was Currier & Ives' most prolific artist and from the works represented in this book it would seem that she was the favorite of the printmakers. It appears from the record that whenever Currier & Ives wanted a particular job done, they would call upon Fanny Palmer. She, sentimentally, has captured the spirit and the story of the poems and, in a way, epitomizes the great contributions of Currier & Ives.

JOHN LOWELL PRATT

THE VILLAGE BLACKSMITH

Under a spreading chestnut tree,
The village smithy stands;
The smith, a mighty man is he,
With large and sinewy hands;
And the muscles of his brawny arms
Are strong as iron bands.

And children coming home from school,
Look in at the open door;
They love to see the flaming forge,
And hear the bellows roar,
And catch the burning sparks that fly
Like chaff from a thrashing floor.
Longfellow

246

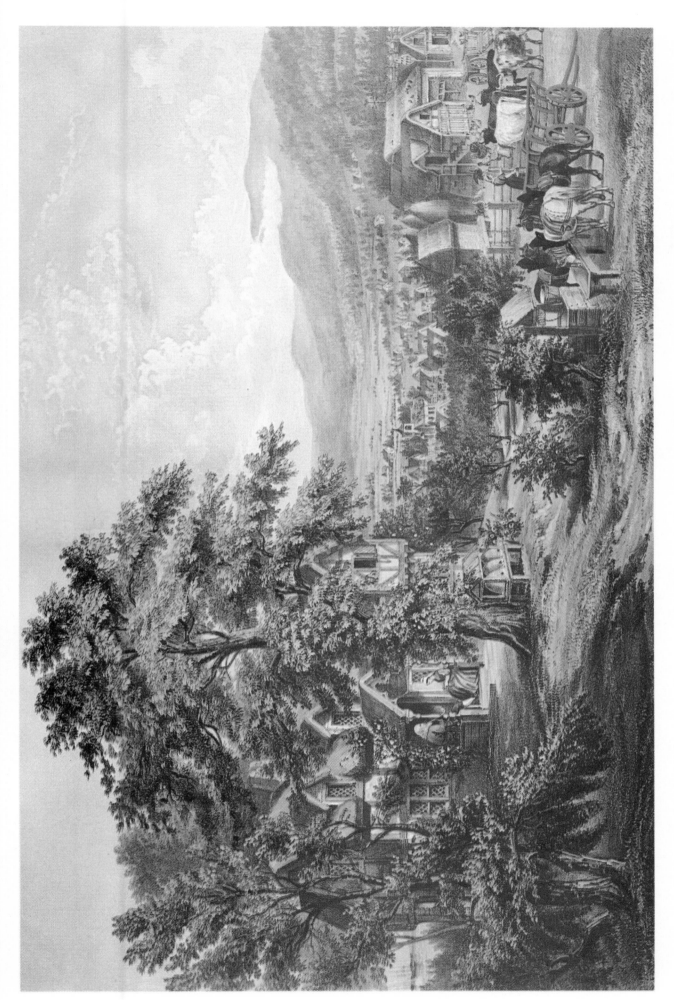

THE HOME OF EVANGELINE,

"IN THE ACADIAN LAND."

Somewhat apart from the village, and nearer the Basin of Minas,
 Benedict Bellefontaine, the wealthiest farmer of Grand Pré,
Dwelt on his goodly acres; and with him, directing his household,
 Gentle Evangeline lived, his child, and the pride of the village.
Firmly builded with rafters of oak, the house of the farmer
 Stood on the side of a hill commanding the sea; and a shady
Sycamore grew by the door, with a woodbine wreathing around it.
 Rudely carved was the porch, with seats beneath; and a footpath
Led through an orchard wide, and disappeared in the meadow.

Farther down, on the slope of the hill, was the well with its moss grown
 Bucket, fastened with iron, and near it a trough for the horses.
Shielding the house from storms, on the north, were the barns and the farm yard.
 There stood the broad-wheeled wains and the antique ploughs and the harrows;
Bursting with hay were the barns, themselves a village.
 Thus at peace with God and the world, the farmer of Grand Pré
Lived on his sunny farm, and Evangeline governed his household.
 She was a woman now, with the heart and hopes of a woman.
Happy was he who might touch her hand or the hem of her garment!
 Longfellow

247

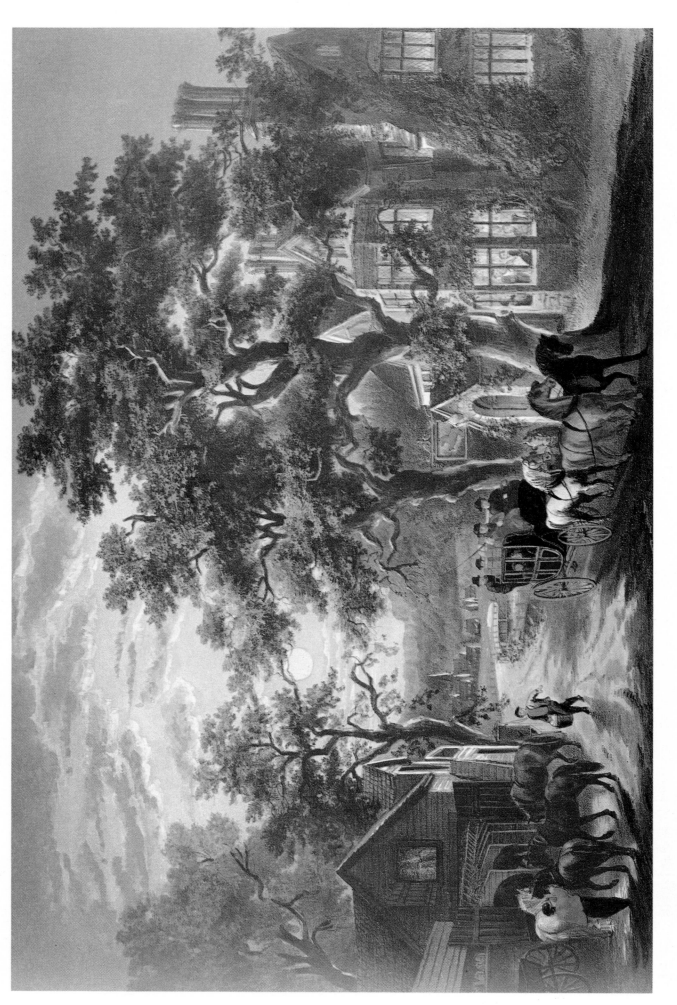

THE WAYSIDE INN

As ancient is this hostelry,
 As any in the land may be,
Build in the old colonial day;
With weather stains upon the wall,
And chimneys huge and tiled and tall.

Across the road the barns display,
 Their lines of stalls their mows of hay;
Through the wide doors the breezes blow,
 And half effaced by rain and shine,
The Red Horse prances on the sign.
 Longfellow

THE OLD OAKEN BUCKET

How dear to my heart are the scenes of my childhood,
When fond recollection present them to view;
The orchard, the meadow, the deep tangled wild wood,
And every loved spot which my infancy know.

The wide spreading pond and the mill that stood by it,
The bridge, and the rock where the cataract fell;
The cot of my father the dairy house nigh it,
And e'en the rude bucket that hung in the well.
Woodworth

INDEX

The following index has been compiled with both the layman and the researcher in mind. In it can be found not only the exact titles and sub-titles to the prints shown and referred to in the book, but listings for all people and places mentioned both on the prints and in the accompanying text pages. Special categories of general subjects have also been made, enabling one to find references to all animal, bird and fish pictures, farm and winter scenes, battles, presidents, and wars under one heading. Both the painters of originals and artists and delineators of prints are grouped together, as are all references to such subjects as sports, ships, fires, railroads and New York City. It may be noted, as has been by Peters, that in the case of the artists and delineators of the prints "Many of the prints were made by several artists and lithographers working together." Prints published by N. Currier (1834-1856) and by Currier & Ives (after 1857) have been listed by page number, and a chronological list of the year of printing has been included. The authoritative check-list of Harry T. Peters, appearing in Volume 2 of "Currier & Ives: Printmakers to the American People," Doubleday, Doran & Co., Inc., Garden City, N. Y., 1931, has been noted under "Peters' Checklist numbers," where a numerical list of prints referred to with page references can be found. The page numbers appearing in up-right type throughout the index refer to pages containing prints, while those in italic type refer to text pages.

In capital letters are the actual titles of the Currier & Ives prints included. Appearing only after the *exact* title, alphabetized without including "a," "an" or "the," is the complete sub-title and, in parenthesis following, the name of the original artist or painter, followed by the delineator or engraver, and lastly the printer (N. Currier or Currier & Ives) and the date of publication if known. Sub-titles are cross-referenced, as are all proper names within either the title or sub-title, to the exact title. Names of original paintings, books and poems, nicknames, names of horses and ships, slogans, and quotes appear in quotation marks. Abbreviations used are: C.-published by N. Currier, C. & I.-published by Currier & Ives, del.-delineator, and orig.-original (painting or drawing).

The indexed names of all people mentioned in the book are followed by the dates of birth and death where available. Place names are identified by the abbreviation of the state, Canadian province, or country. In the case of place names and dates in which Currier & Ives were in error, the correct form follows. Thus on the print on page 51, the dragoon fight at "Madelin" is noted as properly being "Medellín," and is cross-referenced. The same is true of the print on page 170 of the battle at "Coal Harbor," which should be "Cold Harbor," and of the date of "1661" given on the William Penn print on page 26, which should be "1683."

496a	(243)	832	(149)	979	(36)
623	(129)	835	(153)	983	(32)
624	(129)	836	(165)	985	(29)
625	(130)	840	(158)	991	(35)
626	(130)	844	(163)	1005	(31)
627	(123)	849	(172)	1008	(33)
628	(124)	850	(177)	1012	(39)
629	(125)	855	(146)	1014	(37)
630	(126)	858	(154)	1016	(38)
631	(127)	867	(175)	1029 or	
632	(128)	872	(176)	1030	(45)
799	(24)	877	(174)	1032	(43)
803	(26)	879	(169)	1105	(247)
807	(25)	885	(145)	1136	(171)
811	(157)	886	(164)	1137	(42)
814	(173)	888	(168)	1138	(44)
816	(155)	890	(153)	1145	(152)
820	(147)	932	(50)	1148	(150)
824	(162)	945	(49)	1151	(159)
825	(161)	949	(51)	1156	(151)
828	(167)	955	(48)	1165	(160)
829	(166)	966	(53)	1179	(52)
830	(170)	971	(30)	1195	(65)
831	(156)	973	(34)	1200	(63)